Essays on Classical Indian Dance

Essays on
Classical Indian Dance

Donovan Roebert

Jenny Stanford
PUBLISHING

Published by

Jenny Stanford Publishing Pte. Ltd.
Level 34, Centennial Tower
3 Temasek Avenue
Singapore 039190

Email: editorial@jennystanford.com
Web: www.jennystanford.com

British Library Cataloguing-in-Publication Data
A catalogue record for this book is available from the British Library.

Essays on Classical Indian Dance

Text copyright © 2021 Donovan Roebert
Photographs copyright © 2021 Arun Kumar

Cover photograph: Krithika Vellapan, Kalasrishti School of Performing Arts,
Cary (front), Farah Yasmeen Shaik (back), Director of Noorani Dance, Menlo Park

All rights reserved. This book, or parts thereof, may not be reproduced in any form or by any means, electronic or mechanical, including photocopying, recording or any information storage and retrieval system now known or to be invented, without written permission from the publisher.

For photocopying of material in this volume, please pay a copying fee through the Copyright Clearance Center, Inc., 222 Rosewood Drive, Danvers, MA 01923, USA. In this case permission to photocopy is not required from the publisher.

ISBN 978-981-4877-47-3 (Hardcover)
ISBN 978-1-003-12113-8 (eBook)

Contents

Acknowledgements	ix
1 On the Means and Ends of *Rasa* in Classical Indian Dance	1
2 Classical Indian Dance as *Sadhana*: Some Notes Inviting Elaboration	9
3 The Classical Indian Dancer as Poet, Interpreter, and Poem Itself: Some Simple Comments	15
4 Classical Indian Dance and the Western *Rasika*: A Storm in a Teacup	19
5 On the Principle and Significance of *Pratitya Samutpada* in Classical Indian Dance	23
6 On *Nritta*: The Suspended Consummation of the Tale	31
7 Classical Indian Dance as a Discipline of Thought	37
8 On the *Ghungroos*: Ankle-Bells of Servitude, and Mastery	43
9 *The Space Between the Notes*: Heather Lewis's Remarkable *Shastric Tour de Force*	47
10 When is the *Rasika* Really a *Rasika*?	55
11 On the *Gramma* of Classical Indian Dance: A Grecian Perspective	61
12 Writing *The Odissi Girl*: A Literary Analogue for the Dance	67
13 The Presence of the Absent Dancer	77
14 The Triumph of Mylapore Gauri Ammal: A Short Incursion into Dance Genetics	83

15 The Language of the Dancing Body in *Nritta*: Part One	93
16 The Language of the Dancing Body in *Nritta*: Part Two	99
17 Eight Unities Re-enacted in Classical Indian Dance	103
18 Five Ways of Dancing That Get in the Way of Dance	111
19 The Preservation of Classical Indian Dance in Postmodernity	115
20 The Tenacious Survival of Classicism in Indian Dance	121
21 The Humanization of Rhythm and Form in Classical Indian Dance	127
22 The Problem of the *Pushpanjali*	133
23 Surprised by Dance: A Glimpse into my Personal Journey	139
24 Classical Indian Dance is a Humanism	145
25 Dance, Analysis, and the Willing Suspension of Disbelief	151
26 The Multilocality of Classical Indian Dance	157
27 On the Terrible Beauty of *Moksha* in Odissi	163
28 *Jayantika*: Archaeology and Imagination in the Reincarnation of Odissi	169
29 Sanjukta Panigrahi's Contribution to Odissi: 1944–1964	181
30 The Foundational Ambiguity in Classical Indian Dance	257
31 The Karma of Classicism in Indian Dance	261
32 A Note of Thanks	267
33 On the Dancing Feet	271
34 Rukmini Devi and the *Devadasi* Question: An Opinion	275
35 A Note on *Sringara Rasa*	289
36 Classical Indian Dance at the Crossroads	295

Contents

37	On Filming Classical Indian Dance	305
38	*Rasa* in Filmed Classical Indian Dance	311
39	The Ineffable in Classical Indian Dance	317
40	On the Movement from One *Adavu* to the Next	323
41	The Personal Approach to Dance Criticism	327
42	The Sanitizing and Cleansing of Bharata Natyam	333
43	On 'Pseudo-Spirituality' in Classical Indian Dance	339
44	On the Freedom of Odissi to be Itself	347
45	Why I Choose to Write about Classical Indian Dance	353
46	Classical Indian Dance and Social Justice Activism	359
47	In Search of the Basis of 'Spirituality' in Classical Indian Dance	365
Index		371

Acknowledgements

It would be impossible to personally thank the many dancers and dance scholars who encouraged, debated, criticized and sometimes heatedly argued over these essays, now published, but then only available at my blog. To all those who interacted with me during those months I extend my grateful thanks, but especially to Heather Lewis, who believed from the start that this work should end up between covers.

My thanks are due also to Madhumita Raut for some interesting pointers in the development of Odissi and, indeed, to Guru Mayadhar Raut himself, at whose home in Delhi I first became acquainted with the dance at first hand in the company of the exquisite dancer Aadya Kaktikar.

I must record my deep gratitude to Madhavi Puranam and the trustees of the *Nartanam Journal* for the materials they put at my disposal for my long essay on Sanjukta Panigrahi, and in particular for sending to me the edition which deals with the Jayantika papers, edited by Dr Ileana Citaristi. For other kind assistance in this regard I am grateful also to Kedar Mishra and Sabyasachi Panigrahi, Sanjukta's son, who provided many anecdotes, facts and dates that otherwise would not have been available to me. Other sources, too many to list here, are acknowledged in the references attached to the essay.

To Dr Swarnamalya Ganesh, Dr Anita Ratnam and Aadya Kaktikar, I am grateful for reading the essays and taking the time out of their busy schedules to compose reviews of the finished work.

Finally, I must express my heartfelt thanks to Arun Kumar, who generously provided the many beautiful photographs that illustrate these pages, and to the dancers who so graciously agreed to have their photographs appear in this book.

1

On the Means and Ends of *Rasa* in Classical Indian Dance

In attempting to examine at least some aspects of this subject, we must try to determine what we mean by the *rasika* and by the idea of 'classicism' in strict relation to the forms of Indian classical dance.

To begin with the *rasika*, we may make the fundamental generalization that he or she is a close 'reader' of the dance, sufficiently educated, at least with regard to all the 'readable' facets of the living recital, to be able to recognize their formal structure, semantics, signs and grammar, and to know when these are being successfully or imperfectly utilized. Beyond involving only the assembled and fluid aspects of technique, this sort of recognition also implies an adequate cultivation of taste—what we may characterize as the knowledgeable appreciation of subtle combinations of 'flavour' (*rasa*)—which comes by close, repeated and longstanding attention to and experience of the effects of the dance.

The *rasika* is thus involved in two kinds of reading: in the first, emphasis is laid on technical correctness and accomplishment; in the second, focus is deflected to the total mental experience evoked by the technical elements. In the first kind of reading there is an outward flow of attention; in the second there is the reading of an inward experience.

Essays on Classical Indian Dance
Donovan Roebert
Text copyright © 2021 Donovan Roebert / Photographs copyright © 2021 Arun Kumar
ISBN 978-981-4877-47-3 (Hardcover), 978-1-003-12113-8 (eBook)
www.jennystanford.com

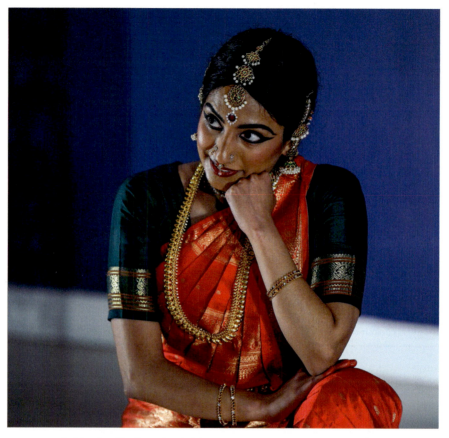

1. Vanita Todkar, Prakriti Dance Company, Los Angeles.

But there is a third reading whose object lies at the nodal point of the two already mentioned, and from which these two themselves arise and are made possible as readable signs: this object is the dancing body. We call it the *dancing body* in order to distinguish it from the *dancer's body* because the latter, strictly speaking, is not present in the recital in the same way in which it is present in the dancer's physical activities outside of the performance of the dance. And we might add that, apart from this distinction being necessarily made on the *rasika*'s part (for purposes of properly objectifying the dance as art), it is a distinction of which the dancer herself ought to be and usually is intensely aware. This is because the dancing body becomes for the dancer as much the object of disciplined performance, and the visible means by which the

work of art is placed before the *rasika*, as it becomes for the critically aware *rasika* an artistic medium completely separable from the everyday bodily person of the dancer.

Infusing the dancing body is, of course, the dancing mind. Here again we are obliged to make a distinction between the everyday mind of the dancer (the dancer's mind) and the dancing mind that is present and functioning, in a myriad ways, to inform, direct and manipulate the dancing body, and to act as the vital channel between the dancing body and the preceding givens on which the dance is based. It also works as the outward channel transmitting the full mental (and mindful) implications of its dancing work to the *rasika*. And again it is incumbent on the *rasika* fully to appreciate this distinction in a formal sense, and to determine by the critical means at his disposal the extent to which the dancer herself is able to keep the personal and dancing minds apart for the full duration of the recital. For what we are pointing at here, and what will be discussed at greater length later, is the self-limiting, self-constraining and self-effacing qualities that establish the essential character of classicism in the dance.

Beyond the dancing mind and body stand the prescriptively determining forces of choreography and the delimiting classical tradition from which the choreographer must access and develop the suitable tales and combinations of steps, expressions and postures available for conveying them, and, as is regularly the case, for contriving the geometry and flux of the pure dance, or *nritta*. It is on this continuum (tradition—choreography—transmission) that the dancing mind and body are situated and from which they may be said to emerge as the vital superstructural expression of the deeper underlying, foundational and predetermining blueprint. We allude to this layered and complex dynamic, for all its obviousness, in order more clearly to illustrate the multiple components with which the *rasika* has to deal both critically and self-critically if he or she hopes to experience the dance in its detailed and impersonal, yet personally alive, fullness.

In addition to the elements already described—as it were in passing, for the description offered here is sparse indeed and sparing of a host of finer constitutive aspects—we have to consider the music and sung vocalization of the dramatic tale, or *natya*, which together imprint into the dancing mind an inward and immediate rhythmic and melodic path

on which the dancing body dances outwardly, in space and time. And these too present themselves as supportive concrete forces throwing up into the purview of the *rasika* futher conventions of technique and taste having their own criteria for success or failure—and, quite apart from their individual prerequisites, implying the equally important question of the balance of elements within the whole. Clearly this balance must be posited on a fundamental imbalance which ensures that all of these contributing activities (because that is what, chiefly and emphatically, they ultimately are) are working efficiently among themselves to tilt the balance in favour of the dancer, while at the same time acting to constrain and 'capture' her within their compound dynamism.

Finally, some mention must be made of the customary ornamentation proper to the dance, by which we mean such things as costume, make up, vermilion *aalta*, jewelry, headdress, and so on. Naturally one would include in this category the ornamentation of the stage itself, in terms of backdrop, lighting, props and so forth. These ornaments and adornments, taken together, provide what may be called, on the one hand, the frame (as distinguished from the formal framework) within which the dancing body is contained and, on the other, a system of highlights by which certain of its salient points— hands, feet, eyes, lips, hips, and so on—are rendered more prominent and more sensual through beautification and latent symbolism.

The dancing mind and body, as we see then, perform upon, and, during a successful recital, emerge fully and fully-articulated from, a cooperative mass of supportive objects and activities whose own prerequisites for technical success must each be met if the performance is to succeed as a whole—and by this we mean that every supporting element is doing neither more nor less than supporting the dancer in exactly the right way, through sustaining each their own due proportionality (especially their subtle 'secondariness') throughout the entire recital. There can be no latitude allowed for the kind of virtuosity that might distract the *rasika*'s attention from the dancer, any more than allowance can be made for reticence or other flaws arising from insufficient ability.

Now it is this balance, unity, wholeness and efficacy of the secondary objects and activities which, if properly utilized by the dancing mind and body, cause the ensemble working in unison in

this way to cross the threshold that transforms them from a complex, interdependent mechanism into an harmonious organism, of which the dancer represents the presentational form or *rupa* which we have called the dancing body, and whose vitality is expressed through the inwardly directing and energizing dancing mind. It is this transmuting intensification from mechanism to composite living being that takes the *rasikas* out of themselves to become included as an onlooking extension of the same vital entity and its transmitted or radiated energy or *tejas*. We argue that this kind of inclusion cannot be effected by an ensemble working together only at the level of a mechanism, even that of a perfected mechanism, because the purely mechanical and mechanistic cannot absorb or even address the personal mind in a living way—it cannot, that is, awaken that mind to love.

Now let us look at this transformation from the inward standpoint of the dancer herself, albeit ideally and—some might say—with a certain degree of presumptuousness. We have said that classicism demands of the dancer a high degree of self-effacement and this is an unanswerable postulate, offered on the grounds that the purely and cleanly classical has very little tolerance for whimsicality and mere novelty, distortions and excesses, and general waywardness of the personal stamp (for all individuality is a form of waywardness) or, what is worse, of the marks of the persona desiring to express itself on account of its self-cherishing nature. The poet, if he wishes to devise a classical poem, must absent himself from the final text as far as this is possible.

But this does not mean that the dancer as a personality is simply not present in the dance in the same way that a turtle with wings is not present in the universe. Such utter absence is neither possible nor, so far as both dancer and *rasika* are concerned, even desirable. Classicism wishes to a very high degree to restrain and constrain the practitioner, but never to eliminate her or him entirely, which would be tantamount to making of itself, through such an absolute exclusion of the creatively active and personal selfhood, a mere ritual or exemplar of pure method, which is to say, a thing of no life.

The point of classicism in this regard lies in the effect on the dancer's person of the very high extent of personal constraint imposed on her or him by the classical methodology. So far from completely eliminating the personal aspect of the dancer (which is after all the

only finally real one), these constraints are devised to act as a prism through which the subtle remainder of the classically limited and disciplined dancer's personal selfhood becomes intensified in such personal 'touches' as humour, warmth, irony, strength, grace and so forth. Not only is the personal dancer permitted, within the limits of taste and technique, to peep out personally through the dancing body (to the extent that the dancing mind knows its personal restraints and purposes), but this is in fact expected by the nature of the classical.

It is expected by the nature of the classical because that nature is, in an extremely refined manner, a lyrical one, and no evocation of the lyrical is complete in its vivacity without the personal grace note, the personal style, the personal energy that inform it—however subtly and, it may be, unconsciously. In fact we may take the personal selfhood as itself being impersonally made available, as is the personal tenor and timbre of the singing voice, be it ever so classically trained and technically accomplished. What the hearer responds to in the deepest, fullest and final sense is the nuanced personal use of those disciplined impersonal acquisitions.

In classical Indian dance, the lyrical voice of classicism is expressed in the first place as the sensuous, for we are confronted here with a dancing body informed by a dancing mind. That is to say, the *rasika* is brought, by means of the dancing flux of the sensuous, to the flavour or *rasa* of the particular instance of lyricism evinced in that specific dramatic context (in the *nritya*) or in the story-less form of the pure *nritta* dance.

But the point is not that the sensuous is present and operative but rather that it exists only as the cruder basis of the poetic mode that is to be transformed by a critical and tasteful refinement into the lyrical. This is one of the reasons why the preponderance of the impersonal over the personal in the dance is so crucial: it is the impersonal character of the dancing body and mind that facilitates the switch from sensuousness to lyricism because the dancing body and mind are working towards this end by means of conventional structure, mechanism and technique. They are eliciting in the *rasika* by these impersonal means a response that is equally impersonal because it is responding not to a person but to a series of artistic devices. But we are speaking here only of the penultimate phase.

The final phase, the completion of the *rasa*, occurs when the experience of the sensuous, having been transformed into the impersonal mode of the lyrical, makes a sudden connection with the classically constrained personal force of the dancer and, in so doing, awakens a correspondingly constrained person in the *rasika*, so that we must allude here to the meeting of two extremely subtilized selves—so subtle, indeed, that the mutual recognition goes, as it were, unrecognized.

This subtle meeting and interplay of subtly personal minds is typical of the classical in every form of classic art and is really indispensable to the full representation and appreciation of any classical recital. For, just as there cannot be anything genuinely sensuous in the sharing of the completely impersonal, so there can be nothing truly lyrical unless its creative realization is graced by the personal presence made evident in the personal 'touch' and style, however constrained and even ultra-refined these may turn out to be.

The reason for this, as classicists have always and universally known, is that lyricism is finally as inseparable from love as love is inseparable from persons and impossible of realization in the realm of the purely impersonal.

So that we may conclude that what the *rasika* wants, and is in fact owed, in the course of his or her full intelligent appreciation of the dance, is a relational experience of responsive and answering love on an unusually rarefied plane of refinement.

2

Classical Indian Dance as *Sadhana*: Some Notes Inviting Elaboration

1. The practice of *sadhana* can tentatively be traced back to 'participation mystique' rites in prehistoric magico-religious activities and, with more certainty, to the very early historical religious ceremonies involving varieties of trance and meditation (sometimes aided by hallucinogens, such as the Harappan *soma*). Sadhana practice becomes methodologically stabilised in the high period of Hindu and Buddhist formalism i.e. from around the 6th Century AD.

2. Essentially, *sadhana* is an interior practice, often involving ritual (*puja*), visualisation, meditation, contemplation, imagination and *mantra-mudra*. Its aim is to identify the mind-body continuum of the practitioner with the deity invoked. The practitioner, that is, by embodying the god or goddess, becomes identified with the divine mindset, attributes and energies ('the deity-in-action') for the duration of the *sadhanic* practice. This practice naturally involves the displacement (total effacement) of the practitioner's 'ego selfhood' because, it is theorised, the deity cannot be fully manifested or 'realized' in a mind preoccupied by a present and active personal selfhood.

3. As a *sadhanic* practitioner, the dancer, in addition to the elements described above, should be thoroughly grounded in prior doctrinal and

Essays on Classical Indian Dance
Donovan Roebert
Text copyright © 2021 Donovan Roebert / Photographs copyright © 2021 Arun Kumar
ISBN 978-981-4877-47-3 (Hardcover), 978-1-003-12113-8 (eBook)
www.jennystanford.com

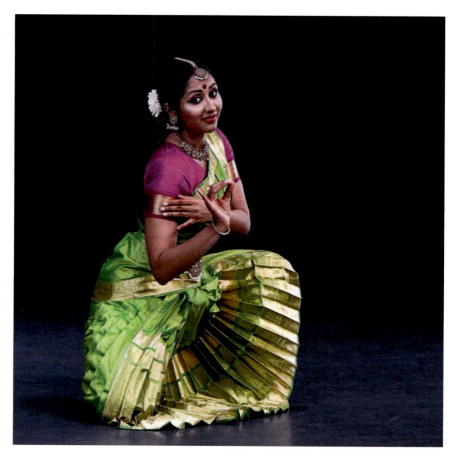

2. Nitya Narasimhan, Prayukti Arts, Sunnyvale.

religious practice relative to the deity in question. By this combination of means the dancer representing, say, Krishna, is able, it is thought, not only to represent the god in an imaginative 'theatrical' manner, but actually to embody the deity himself. Such an embodiment of the god's qualities and energies becomes the basis and method for transmitting the divine energies (*tejas*) to an audience of educated, receptive *rasikas*. Thus the dancer, by means of the perfected *puja*, makes the god present to the audience who partake of the *tejas*. A 'religious experience' is thus sustained for the duration of the recital.

4. This theory inevitably invokes two questions: (i) how is the *sadhanic* practice to be interpreted in a postmodern, rationalist

environment, and, (ii) how is it to be explained in terms of the varieties of critical theories of art?

5. One way is simply to ignore these questions as irrelevant. *Sadhana* is *sadhana*, and requires no explanation beyond its own religio-mystical theory and practice. This is in any case the course adopted by some dancers and dance teachers, who sometimes use it as a means for excluding Western dancers, *rasikas* and theorists from 'authentic participation' in the dance. Westerners, it is held, are simply incapable of the real experience of the *sadhanic* dynamic.

6. This stance is sometimes also used to downplay the central importance of dance technique (as opposed to *sadhanic* methodology) insofar as the genuine identification with the deity is viewed as essentially independent of techniques which relate solely to the grammar of the dance. The 'spiritual' evolution of the dancer is viewed as more important than mere technique. The god, it is thought, is quite capable of manifesting in the 'empty' dancer without the need for, say, perfect footwork or *mudra* formation. Or, rather, these technical perfections are not considered to be the main vehicles by which the god is made present. They play a strictly aesthetic role. What matters more than technique are a high degree of devotion (*bhakti*) and the self-emptying voidness (*shunyata*) of the dancer.

7. To adopt a negative stance towards this approach is, I feel, unproductive—not least because it has regularly proved effective. It has its own value within its own tradition of religio-mystical theory and practice. If we wish to attempt positive answers to the questions posed above, then, we should do so in ways that do not diminish or demean the value of the classical understanding of *sadhanic* potency, even if we cannot accept it on its own terms.

8. Bearing this in mind, we return to the first question: how is the *sadhanic* element to be understood in postmodern rational terms? Or, put another way: how is a non-religious audience to grasp the significance of the *sadhana* in such a way that its energies are not simply discounted, and the dance not reduced to mere aesthetic experience? This is rather like the problem confronting an atheist attending a religious ceremony. How can the atheist benefit from it? How can it be experienced as something more significant than ritualized 'myth' by one who at the same time stands critically above it?

9. If there is a remedy at all (and if a remedy is considered necessary), it seems to me that it is all in the hands of the dancer, which is not to say that the dancer has the responsibility to 'make the blind see.' All the dancer can do is practise the *sadhana* in its existential fullness, believing that, in such a situation, there is always the possibility for the 'irrational moment' to break through, as it may do, repeatedly, for even so severe a logician as Wittgenstein. But to say this is really only to emphasize two related points, that (i) the rational-materialist should not be excluded from the audience only on account of his or her *avidya*, and (ii) the *sadhanic* aspect of the dance should not be eliminated or downplayed in order to accommodate the mystically 'blind' but aesthetically appreciative enthusiast.

10. The *sadhanic* function of the dancer is, then, to open up the irrational 'space,' to make it available also to a merely rational audience. This is in any case the chief function of the *sringara rasa* or mystico-erotic aspect of the dance, but that is a matter for another discussion.

11. As regards the second question: in artistic-critical terms the accomplishment of a successful *sadhana* cannot be viewed as separable from successful technique, in just the same way as the communicative power of a poem is inseparable from the linguistic, syntactic, grammatical and lyrical devises used in its construction. This is the main reason why, for instance, the power of a poem is always altered or diminished in translation. Homer in Greek is not Homer in English. And insofar as the 'language' of classical Indian dance is constructed to accomplish the *sadhana*, it can only do so by a perfect use of that particular language. The *sadhana* cannot be fully or 'rightly' accomplished in, say, a modernised version of dance linguistics, which would be to deprive the *sadhana* of its classical force.

12. That is to say—however controversial the saying so might be—that the embodied manifestation of the god is dependent as much on the dancer's 'spiritual' accomplishments as on her technical abilities. This is because, so far as tantric methodology itself admits, 'the deity is inseparable from the practitioner's own mind.' The more refined that mind is, the more 'spiritually pure' and meditatively advanced, the more that refinement will be reflected in 'conduct,' i.e. in technique. It is only by means of these interrelated facets of refinement that the

Classical Indian Dance as Sadhana 13

mystico-erotic element becomes a vehicle for (irrational) transcendence on the part of both the dancer and the *rasika*.

13. Now coming to what the embodied. *sadhanically* manifested 'deity' may actually be—this must remain a matter for dogma at the shallow and conjecture at the deeper end. Both dancer and *rasika* can know it only as 'divine energy' (*tejas*). The rest, the merely pictorial and aesthetic, is supplied by the imagination. What is important is the embodiment and transmission of this energy in so potent and pure a form that the *rasika* is rendered unable to 'rise above it' in order to look down upon it as a mythico-aesthetic moment open to a merely technical critical assessment. The notion that the experience might be only an aesthetic moment should be allowed to occur only some time after the dance has finished. Until then it should be experienced as an energy. Otherwise, in the presence of a mind split by doubt, no *sadhana* has actually taken place.

3

The Classical Indian Dancer as Poet, Interpreter, and Poem Itself: Some Simple Comments

1. As a 'poem being created in motion,' the dance demands of the dancer that he or she fulfill three functions simultaneously: those of poet, interpreter, and 'living poem.'

2. The function of the dancer as poet in the dance is to unify the elements that make up the poem: the story (*natya*), the pure dance (*nritta*), and their meaningful combination in the *nritya*. The unification of these aspects is further complicated by the need to unify their underlying elements: general choreography, melody, rhythm and metre, lyrics and movement, which constitute the basic factors that are the subject of technical interpretation. Thus the dancer as poet resembles in this aspect the poet of the written poem, who must unify the fragments of the poetic data into a structurally coherent whole. And, like any ordinary poet of any accomplishment, this act of unification involves the effacing of the poet's personality from the work. It is therefore a strenuous task.

3. But it is also demanded of the dancer that he or she act simultaneously as interpreter of the poem which, in the course of

Essays on Classical Indian Dance
Donovan Roebert
Text copyright © 2021 Donovan Roebert / Photographs copyright © 2021 Arun Kumar
ISBN 978-981-4877-47-3 (Hardcover), 978-1-003-12113-8 (eBook)
www.jennystanford.com

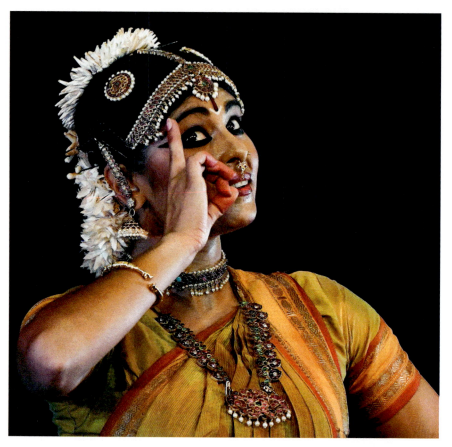

3. Ashwini Ramaswamy, Ragamala Dance Company, Minneapolis.

the performance, he or she is bringing into wholeness. Within the classical context such interpretation involves, in the first place, a full understanding of the technical means available for interpretative work and, in the second, the ability to employ the full repertoire of available technique in technically excellent ways. It is only by these means that the 'dancer as interpreter' can present the elements unified by the 'dancer as poet' in a communicable and understandable form.

4. Still, the 'dancer as poet' and the 'dancer as interpreter' are not in themselves a combination sufficient for touching the *rasika* because the *rasika* is moved to response not by unification of materials and technique alone, but by the poem which is generated by them in the course of the dance. What this means, among other things, is that,

The Classical Indian Dancer as Poet, Interpreter, and Poem Itself 17

unlike other poets, the dancer, though she may present the same dance several times, must do the work of creating a new 'living' poem with each fresh act, in performance, of unification and technique. Unlike the written poem, the danced poem presents a new creation with every new performance, being newly engaged in the course of every fresh recital with new possibilities and new pitfalls.

5. The crucial factor for the transmission of *rasa* is the poem itself, the 'dancer as poem' emerging from the 'dancer as unifying poet' and the 'dancer as technical interpreter.' This emergence, when successfully accomplished, constitutes the living element of transmission on the *abhinaya-rasa-tejas-rasika* continuum.

6. The 'dancer as poem' relies on the perfection of the unifying and interpretative acts even though, as a dancing poem, she is not merely identical with these acts. The 'dancer as poem' is more than the sum of her unified and interpretative parts. This 'poem which is more than the sum of its parts,' which transcends its parts, must first be embodied in the moving dancer.

7. Only as an embodiment of the poem itself is the 'dancer as poem' able to touch the *rasika*. Yet, the poem embodied in the dancer is not simply identical with the dancing dancer, anymore than it is simply identical with the perfect unification of materials and technical interpretation. The 'dancer as poem' transcends the 'dancer as embodiment of the poem' in the same way that the written poem transcends the unified materials and technique which have gone into making it. The 'dancer as poem' must also generate the abstraction of poetic energy that crosses the mental 'space' between dancer and *rasika*.

8. It is only in perfectly embodying the poem that the dancer is able to transcend his or her effaced selfhood to touch the *rasika* by the poetic energy generated by the presentation of the poem, and it is only for as long as this perfectly embodied poem transcending itself as 'poetry' is sustained that it is able to 'exist' for both dancer and *rasika*.

9. This is like the written poem which, though its unified materials and technical elements co-exist on the printed page, does not become a living poem until it exists in the abstract space between the printed page and the reader's receptive mind. It is only there, in the potentially

energized mental space, that it acquires the potency to communicate its vitality. In the language of dance this is called *tejas*.

10. Of course this leads immediately to the necessary role of the *rasika* in cultivating the sensibility adequate to receiving the *tejas* as it is transmitted by the 'dancer as poem.' But even in the case of an unreceptive individual, it is surely not too much to ask that he or she respect the sheer complexity and energy of the process needed for the dancer to do the work completely. Those without at least this preliminary respect should stay out of the auditorium altogether, just as the dancer who has not yet mastered the three degrees of practice should try to avoid the public stage as well.

4

Classical Indian Dance and the Western *Rasika*: A Storm in a Teacup

> It is always the westerner who keeps harping on our glorious tradition. That is because the West would like to see us as Oriental Barbie dolls while admiring our classical arts. Dance, especially, is prone to this Asian *Kama Sutra* babe phenomenon. The classical can exist but contemporary India is bursting free with ideas and expression ... and these are not contained in the classical form.

The above is a comment recently made by a well-known Bharata Natyam/contemporary dancer, much of whose work, incidentally, I admire. It raises a number of questions about the negatively perceived relation (or misrelation) between the Western *rasika* and the Indian classical dance forms, and implies a certain Western crassness of approach to the dancer in general, and to the *sringara rasa* in particular.

To confine myself only to classical Indian dance, leaving aside the broader 'glorious tradition,' three central questions seem to be asked here: Is the Western *rasika* capable of appreciating the dance on its own terms, and for what it inherently is? Does the Western *rasika* have

Essays on Classical Indian Dance
Donovan Roebert
Text copyright © 2021 Donovan Roebert / Photographs copyright © 2021 Arun Kumar
ISBN 978-981-4877-47-3 (Hardcover), 978-1-003-12113-8 (eBook)
www.jennystanford.com

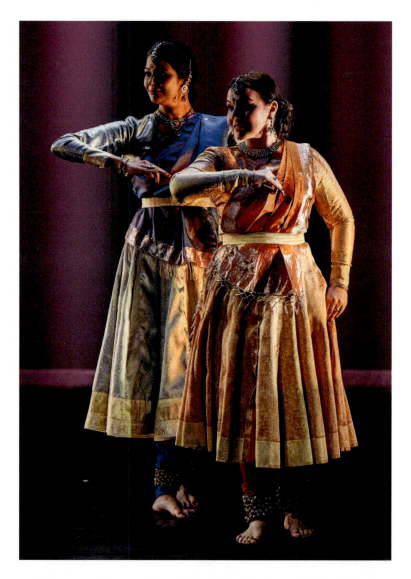

4. Sowmya Viswanath and Angelina Haque with the Kathak Ensemble, New York.

a right to assess and comment on its nature and value? And, does the Western *rasika* inevitably view the dancer only as an Asian 'doll' or 'babe'?

The easiest way to deal with this question is to assert at once that the dance and the dancer are as liable to be misperceived by an Indian

as by a Western *rasika*. Both would be equally incapable of correct assessments if they lacked adequate insight into the philosophical and technical elements of the dance, as well as of its history.

But there's also a more subtle aspect to consider. I once heard a dancer from Chennai doubting out loud whether the Westerner is humanly equipped to experience *rasa* at the deepest level, that of the transmission of the *tejas*. Some Indian dancers, it seems, view Westerners as deficient in this regard, as though there were a specifically Indian 'spiritual' or aesthetic gene that Westerners are born without.

To tackle the most vexing question first—the assertion that the Westerner is disposed to view the dancer as an 'Oriental Barbie doll' or a '*Kama Sutra* babe'—it would be helpful to remind ourselves that the *Natya Shastra* itself prescribes certain standards of physical beauty for the aspirant *shishya*. Second, there are prescriptive details of costume and make-up intended to heighten the aesthetic-erotic effect. The performing female dancer, clearly, is intended to represent a prescribed, classical ideal of feminine beauty; an ideal that is universally recognizable.

The dancer, that is, ought to transcend the projection of her own individual beauty in order to place before the *rasika* (whether male or female) an ideal that is immediate and universal, and which invokes an inward response to a notion of beauty separate from individuality. The quality of eroticism also becomes transformed and idealized in this process. One might say that it is returned to its essence, as an energy of *bhakti*. This is, of course, a simplification which will have to suffice for my purposes here.

Is the Westerner, then, capable of entertaining this sort of transcendent or essentialized experience? My answer would have to be: Yes, very obviously, because the experience is not an exclusively tribal or racial one, but one that is connected with our common humanity.

Every human being can, through cultivation of the necessary insights, learn to make the connection between the aesthetic-erotic experience and the 'spiritual' one. And this is certainly not foreign to Western culture. The highest products of Western art have always been viewed in this way, from the earliest epochs of Greek, Norse, Celtic and other mythologico-artistic expressions. The Grecian Dionysian and Eleusinian rites, as well as the choral odes which form

an integral part of classical Greek tragedy (whose purpose, as drama-*natya*, was religious) are full of the notion of *tejas*, achieved through the combination of music, song and dance.

As for understanding classical Indian dance in terms of its grammar and the elements of structure, geometry, flux etc., these are not supra-intellectual exercises. Anyone from any culture can study and understand them. Even the more esoteric aspects, whether seen and experienced as 'spiritual' or merely mythological qualities, don't stand outside of the common human experience.

This being the case, it seems hard to argue against the view that Western *rasikas* (or, more plainly, any educated audiences) are as qualified and have as much right to assess, evaluate, and indeed fully to appreciate classical Indian dance as Indian *rasikas* do. They have at least as real a right as Indian commentators have to comment on and appreciate Western art forms and culture. This sort of exchange seems to me fundamentally valid, useful, good and necessary.

In a more general way, I would have to say that I find it impossible to discover a clear dividing line, an absolute hiatus, between Indian and Western culture as a whole. Anyone who cares to study these matters in sufficient depth and detail would, I think, have to agree that there are many more similarities than differences in these two cultural spheres.

As to the last point, that 'free ideas and expression are not contained in the classical form'—with this position I would have to disagree. The most cursory philosophical insight will make it clear that there's nothing either completely 'new' or completely 'free.' Every new phenomenon arises as an innovation derived from a pre-existing condition, every novelty has its roots in the classical seed. This can easily be demonstrated by tracing it back to its source.

5

On the Principle and Significance of *Pratitya Samutpada* in Classical Indian Dance

1. Let us begin by offering the premise that the dance does not exist in the way we ordinarily think it does, that it has no existence in and of itself, or from its own side - from which perspective (and it is a genuine one), we may say that it is *shunya*, void of being in inherent terms, and that it follows necessarily that this absence of concrete facticity and singleness is the sole means by which it is able to 'exist' at all for both the dancer and the *rasika*.

2. In order properly to ground this argument, we need to say something about the properties that constitute a thing that does exist in its own right and by its own power. Here, the most decisive qualifications are that such an entity would have to act as its own cause—which is to say, to come into existence causelessly—, and that acting as its own cause would necessitate its being single, whole and simple: it could not come into existence having component parts—whether concrete, temporal or spatial—or else these, in order also to exist from their own side, inherently, and by their own ontological power, would have each to act as its own cause too. The corollary of this view is that all phenomena made up of parts can be conceived only

Essays on Classical Indian Dance
Donovan Roebert
Text copyright © 2021 Donovan Roebert / Photographs copyright © 2021 Arun Kumar
ISBN 978-981-4877-47-3 (Hardcover), 978-1-003-12113-8 (eBook)
www.jennystanford.com

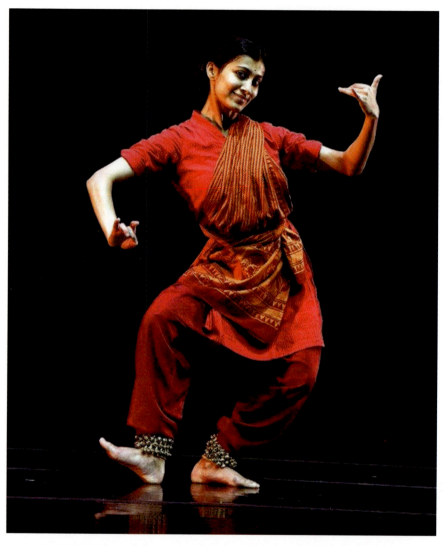

5. Prithvi Nayak, disciple of Guru Bijayini Satpathy, Bengaluru.

to exist conditionally and in dependence on and interrelatedness with all the components, facets and moments that add up to their composite wholeness. This being the case, as we take it to be, they are said to be void of essential being because, if all their composite constituents were to be removed, there would be no existent thing of any kind remaining. And so it is with the dance.

On the Principle and Significance of Pratitya Samutpada 25

3. It would hardly surprise us to learn then that the causes of the components that make up the dance—such constitutive parts as the *hasthas, mudras, padabhedas, adavus, thirmanams* and so forth—are provisional products of the mind. We say that they exist provisionally because they come into being and are sustained as phenomena only on the basis of a dependence for their appearance and for their apparent wholeness on the components and conditions that work or, indeed, play together to keep alive the illusion of an apparently single entity, which we identify as the dance, and hold in our minds as the dance, for the duration of its appearing. Now, all of this is mental work; from the patterns created by the choreographer to the interpretation of them by the dancer and, in secondary form and activity, by the *rasikas* who take them in for consideration from the perspective of their own particular education in the dance—and any further elaboration of these mental faculties involved, would naturally confront us with yet more components that actively contribute, not only to the 'being' of the dance, but to its way of being. Where then, in all of this, do we espy the dance that is one-in-itself and separable in its self-unity from these myriad props from which it arises into 'reality,' and upon which even the abstract idea of its existence itself depends? It would seem that such a self-unity, whether pre-concretely notional or nominally present in its actual appearing, is nowhere to be found.

4. But this does not mean that there is no concrete-seeming phenomenal appearance at all. It is there, and who can doubt it, since its unfolding is occurring in an objective mode and would continue occurring even if there were no one to observe it, except the dancer and, it might be, as some believe, the deity. It is only that, without the presence of at least one perceiving and informing mind, the motions of the dance can no longer be called 'dance' because, in the absence of an organizing mental perception, principle and knowledge, the steps would be as arbitrary as the patterns of falling trees in an unseen forest or the pattering feet of random passers-by.

5. The presence of at least one mind, then, is one of the necessary preconditions for the revealing of the dance as dance. But there are a number of other fundamental conditions too, whose influence detracts from the usual sense of the solidity of dancing physicality.

We will not deal here with the numerous constraining conditions and conventions which go towards the existential definition of what is classical about Indian classical dance, though we will refer to them later in this piece. What we want to consider now are only those implacably radical conditions which illustrate, from this special point of view, how tenuous is the elusive 'thingliness' of the dance.

6. The first of these, with which we have already dealt, albeit cursorily, is the ontological impossibility of its inherent existence outside of the degree to which any such existence from its own side may ordinarily be wrongly imputed. The second condition is that of its being prone to accident, error, and other missteps and mishaps that may act to undo its perfection. The possibility of such a change for the worse, which implies both a kind of degeneration and a capacity for suffering, is not a condition to which anything existing in and of itself can ever be prone, since any such thing must always abide self-perfected in itself—which is one of the reasons why, if it exists at all, we are unable not only to see but even to imagine it, another reason being that it cannot be thought to exist in dependence on our knowing it to exist. Which is to say that the dance's subjection to this sort of conditionality is one of the qualities on account of whose outworking we are able to conceive of the dance at all. The third and last condition to which we will refer is that of transience: the coming into and going out of being in the course of a recital not only of every mobile component of the dance but of the dynamic structure-in-time of the whole, from the first steps, gestures and expressions to the last. In all of these ways, under all of these pressures whose force is directed at undoing and cessation, the dance is exhibited in the light and lightness of a tenuity that verges, so far as its material actuality is concerned, on the brink of sheer non-existence.

7. Yet we do not claim, nor do we wish to, that the dance in all its intensity of physical exhibition, performed on an external objective plane, is somehow not taking place 'out there' at all. Such a view would merely work, in reaction to the subtleties we are trying to grasp, if we try to grasp these by suggestions of an extreme kind, to thicken the illusion of its utter externality and corporeality. We

On the Principle and Significance of Pratitya Samutpada 27

are merely attempting to bring about the efficient recognition that its existence—its *ex-sistence* or 'standing forth and apart from' the general background of being—is attenuated to the extent that it is always in danger of tilting towards a brute nullity, unless it is made firm and by that means sustained by the group of attendant human minds that lend to it, through reflecting it, its vital realization in the only mirror that can live and move together with it.

8. And this, then, is what we mean when we speak of the complex fullness of its voidness, a repleteness that is attained by raising the dance from its all-but-insubstantial external mode of being into the vivifying light cast upon it by the minds in which its motions—those motions supplied by its transitory collection of mobile components and sequential moments—are touched into a unity by the life-giving attentions of a mental continuum that courses from the first creative impulse of the choreographer, through the dancer, to the *rasika*, and back again. We are trying to insist, in short, that the very existence of the dance as dance, and not as some other, emptier thing, depends for its full realization on being transferred into a communal theatre of minds conjoined in an act of common mindfulness.

9. It is in any case only when we adopt this view (by understanding it rightly in the first place) that we can with any credibility consider the dance, both in its devotional and theatrical manifestations—those of the *mahari* and the *narthaki*—as being in any sense an efficacious carrier of truth, as a life-imparting '*rasaic*' ritual, having its own sacramental liturgy and a range of vital meanings that go far beyond mere entertainment, and which are shared by a community of devoted minds. It is only here, in this vast mental theatre of unending reach—for where do we mark the boundaries of a single mind, much less those of minds dwelling in communion?—that the essence of dance, of living dance, is brought to completion through being illumined by all the facets of a collective insight.

10. But if we are saying what we believe we are saying, that the enjoyment of dance at the level of communal mentation, even in its secular or *narthaki* form, has about it a 'religious' quality, we do so with understandable reservations and reluctance—on account of the dangerous misunderstandings touching the possibilities of

shallowness and depth that such an implication holds. Rather than trying to expound these in detail, which would be out of place in an essay of this range, we might better explain with Platonic simplicity that the insight to which we are alluding—and the ritual and liturgy which place them at our disposal through the grammar, mimetics, patterns and philosophy of the dance—give entrance to the beautiful, the good, and the true, which come to us in the dance respectively through its structural and kinetic aesthetics, its moral seriousness (by which we do not mean any particular moral lesson), and by the access it offers to the experiential knowledge of the fullness of the voidness of being-from-its-own-side.

11. In the moment that we become capable of knowing these things at all, we see, too, how important it must be that the community of minds working together to bear this experience in all the fruitfulness and intensity of which it is capable should, ideally, be imbued with sufficient education in and mature appreciation of the ways of the dance in all their aggregated entirety. In such a theatre of cooperative lucidity, the elevation and clarification of the means, ends and meanings of the recital, and of its essential way of being, stand as the truest homage that can be paid to the gift that is being offered, not only in its presence, but as part of its own living, perceiving fabric: a dance occurring both under the scrutiny of and within the provenance of its own gathered lights.

12. As soon as we admit at least this possibility, we become much more acutely aware of the unifying role played by the settled formalities and conventions of a pure and austere classicism. We see at once how this particular language with its old agreed codes, signals and idiom, works to facilitate and enhance the agreement of these minds-in-communion as to the nature of that which is being born in their light, as well as the unity of attentive presence that binds them together in the selfsame thrall. We see, too, how the veil of classic convention, for all the emptiness it displays when its conventional components are laid bare as mere fragments of an unrealized potential, is rendered quick and quickening through the very mental oneness it engenders and sustains while the dance endures.

13. Having said all of which, it seems incumbent on me to remark, what is in any case self-evident, that the classical Indian dances depend for their continued provisional existence on the minds that are willing to host them—not the dry, collating, examining minds only, but more especially those that both enliven and are enlivened by them.

6

On *Nritta*: The Suspended Consummation of the Tale

For the purposes of this essay, the nicest way of setting out for what I am aiming at—and, I hope, the most convincing one—involves the comparison at certain telling points of the *nritta* with the *nritya*. There is in any case nothing unusual about this procedure, though I hope in this case to draw a few contrasts that will serve to show what, in essentials, the difference may be, and what those essentials are.

I propose to begin with the obvious statement that the *nritya* is a representational and referential form of dance that is often delineated as 'dance-drama,' and that the thing to which it refers is the tale it represents, together with the sentiments and discursive meanings associated with that tale. It refers, that is, to something other than itself, something that must necessarily have existed—in the realm of story-telling—before it could be danced. The *nritya*, therefore, is not the thing it represents, but only one way of representing it. It represents that thing, moreover, by means of the techniques, grammar and conventions of the dance, which may be summed up as the cooperative dynamics of *abhinaya* and *bhava*.

Now these are techniques, conventions and a grammar that are shared with the *nritta*, although they may not all be present in it. The

Essays on Classical Indian Dance
Donovan Roebert
Text copyright © 2021 Donovan Roebert / Photographs copyright © 2021 Arun Kumar
ISBN 978-981-4877-47-3 (Hardcover), 978-1-003-12113-8 (eBook)
www.jennystanford.com

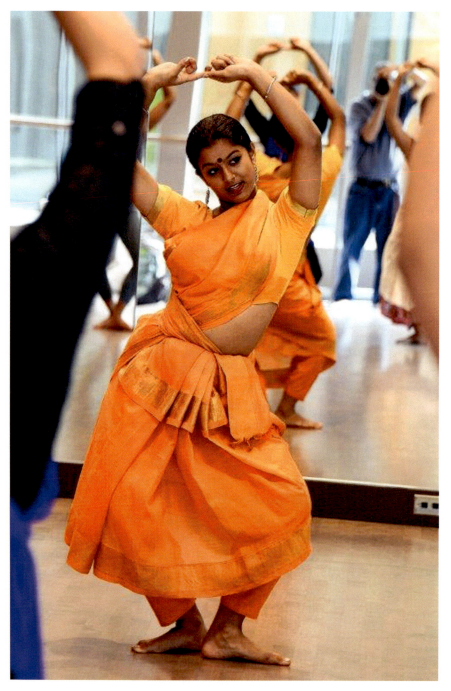

6. Urmila Basu Mallick, Nrityagram Dance Ensemble.

nritta thus uses the selfsame units and motions in dancing flux, but in a non-representational way: the *nritta*, on the contrary, *is* what it represents.

Insofar, we may fairly say, that the *nritya* refers to something that is not itself, it constitutes one possible manner of that thing's being made to appear through a symbolic enactment. The *nritya* places before us a representation of the thing that it dances into mimetic being, but the *nritta* makes present to us the thing-in-itself because the thing that it represents is at the same time a *being the thing whose appearance it also is*.

What, then, is this thing-in-itself that the *nritta* itself is?

Before I go on to try to answer this question, let us dispose of one of the common approaches to 'placing' the *nritta* in the context of the whole repertoire, which is that of considering it an opportunity for the dancer to demonstrate his or her skill—a virtuoso piece in the manner of the cadenza.

If the *nritta* were intended only for this end, its whole purpose would be to draw applause for the relative perfection by the dancer of a dancer's craft, which would make of it an interlude of mere craftsmanship embedded within the broader unfolding spectrum of a communicative work of art. The thing-in-itself that it must in such a case be would be merely a display of technical mastery—and we know that good technique, even perfected technique, while it is an unmissable aspect of any piece of finished art, falls far short of being the whole of it. If, then, the *nritta* were only a matter of presenting a sequence of technical excellencies, no matter how exquisitely done, it could be nothing more than the sum of its workmanlike parts, while the sum of the parts of a vital work of art regularly generates more than itself: it has, that is, *something vital to say*.

Returning, then, to the question above, we might perhaps agree that, whatever the *nritta* may be as a thing-in-itself, that thing must add up to more than the sum of its technical parts if it is to do the work that art is expected to do. It must yield a felt life imbued with meaning of some sort, even if that meaning is inexpressible in the language we ordinarily use for rendering it communicable, even to ourselves—it must render at least the kind of meaning that we associate with music or abstract poetry, or, indeed, with mystical experience

Which is to say that the more-than-the-sum-of-its-parts inherent in the thing-in-itself that the *nritta* is must be an element of intentionality: the intention to pass on a meaning so ineffable that it can only be construed by a logic surpassing that of ordinary thought and speech: the logic of form and formlessness itself, as in mathematics. This might be one reason why the *nritta* is so regularly described as 'pure,' with the implication that it is an unvitiated form of dance, uncontaminated, we might reluctantly say, by everyday meanings and the taint of the coarseness of story-telling. (I put it this way in order to evoke a just notion of the level of subtlety which I take the best exposition of the *nritta* to occupy).

But if I were to leave my consideration of the *nritta* stranded at this point, I would have gone no further than others have, who have likened its pleasures to those resulting from the play of a set of geometric and algebraic equations, in this case based on the fluid structures and the rhythm and tempo of music and dance.

Instead, I would like to offer a fancy that I have for some time entertained around this question, and it is this:

> In the *Raasleela*, the story of the divine dance between Krishna and Radha—one of the most often-recurring themes enacted throughout the spectrum of the classical Indian dances—there is a point beyond which the unfolding of their relationship never dares, because it never can, go. For all the lovelorn passion that they bear and suffer for each other, Radha and Krishna never arrive at the crisis of consummation, though every facet of their love, from the most carnal to the most spiritual, often depicted as mutual isomorphic symbolisms, is explored in anticipatory fashion, as can be seen in the most poignant *Radhamadhavan* poem, Jayadeva's *Gita Govinda*.

There are good reasons, both ostensible and mystical, why this final consummation must always be delayed. Proper to the humane sphere of the story, we have the mundane moral reason that Krishna is already married to Rukmini, Radha to Ayana. By the principles of a good didactic myth, this snag in the progress of the tale makes for a nicely tantalizing quandary that is also a perpetual endpoint. It leaves

the hearer of the tale stuck in a deliciously insoluble conundrum in which perpetual irresolution marks a ticklishly lingering climax-in-anticlimax.

So far as the mystical dimension is concerned, however, this permanently unresolved motion-in-stasis denotes what, in the spiritual life of people, is irresistibly true: that the striving for union with the divine is never finally satisfied but is characterized, rather, by an unending yearning for ever more intimacy. How could it be otherwise, since what is divine is infinite in its possibilities for exploration? But, so far from being a necessary postulate which only the mystic can genuinely grasp, it is easy enough to transfer this sentiment of suspension to the dimension of the search for human certainty about ultimate meaning in any sense of the idea.

And it is this protracted remaining in the state of unconsummated union with whatever final truth may reveal itself to be—as my fancy leads me to believe, or at least to wish to believe—that is expressed in the otherwise 'meaningless' language of the pure dance. For its duration we are caught up in the smitten yearning for an experience of truth-in-love that can spoken by means of no other lexicon than that provided by the purity of the story-less *nritta*, and through its being that experience-in-itself.

No wonder, then, it seems to me, that the *pallavi* in the Odissi repertoire must always receive its consolatory compensation in the *moksha* that regularly succeeds it.

7

Classical Indian Dance as a Discipline of Thought

I had better say at once, in embarking on this essay, that I am conscious of the potential for going astray in any *rasika* who thinks of all the multifarious work that goes into the dance as anything other than the *discipline of the dance* in the fullest implications of that complex idea, an idea that may begin with, but stretches far beyond the operations and applications of thinking only.

That much is perhaps not so self-evident that it need not be emphasized at all: the dance, for the dancer, is a stringent, exacting, painfully stern and remorseless taskmaster whose disciplining attributes, at their highest office, reach to the taming of the egotistic sense of selfhood itself. There is no helping the sense, therefore, that any attempt to deal with the dance as a disciplining force exerted on the *rasika* must have about it an air of guilty presumptuousness. One makes the attempt with one eye apologetically fixed on the travailing dancers without whose dedicated labour no *rasikas* would have any reason for existing, much less for theorizing about the disciplining by the dance of their thought.

And yet, their thought, if they are serious about what they are dealing with in the dance, will be disciplined by it whether they choose

Essays on Classical Indian Dance
Donovan Roebert
Text copyright © 2021 Donovan Roebert / Photographs copyright © 2021 Arun Kumar
ISBN 978-981-4877-47-3 (Hardcover), 978-1-003-12113-8 (eBook)
www.jennystanford.com

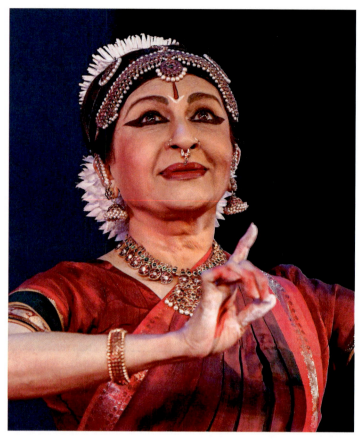
7. Ranee Ramaswamy, Ragamala Dance Company, Minneapolis.

to write about it or not. And, that being the case, one does well to try to grasp something of what is involved in this process because, among other things, it is this process itself which sharpens the faculties into a keener appreciation of all that classical Indian dance implies and is, and makes possible a clearer insight into all of art and the philosophy of art—bearing in mind, while saying this, that art is a vital influence on mindful life and on the way we decide to live it.

The discipline of thought is a large topic which in its largeness is prone to many vagaries and much vagueness. In order to limit my approach to it in the context of the dance to what is both credible and digestible, I will confine myself here to three aspects of cognitive discipline that I assume the classical forms of Indian dance capable of

Classical Indian Dance as a Discipline of Thought 39

exercising on the quality of our thinking. These are: the concentration of thought, the just constraints placed on diffuseness and liberty of thought, and the cultivation of good taste in thoughtful formulation and expression.

Anyone familiar with the dances of India will know that they are intricately composed of an almost bewildering assemblage of variegated parts, including, besides the gorgeous static elements of costume, jewellery, make-up and so forth, the codified units, shifts and modes—units, shifts and modes incorporating every visible part of the body, up to and including the pupils of the eyes—whose sequential flux in momentary motion is brought by its magical kinetic symmetries and asymmetries to a dancing life (whose own varieties of *nritya* and *nritta* in their turn make available an infinitude of expressive possibilities).

These, in a manner of speaking, are the dancing atoms and organic molecules which confront the *rasikas* as it were under the microscope of their attentive gaze during the unfolding of a recital, vexing and coaxing them, in the course of seducing them, towards making sense of the scattered kaleidoscopic puzzle by drawing its fragments together into a single, patterned, architectonic whole.

But this challenge marks only the beginning of the dance's irresistible lure towards wholeness of grasp and concentration of mental vision at a centre-point that is the dance's formal heart and rhythmic heartbeat. The place to which it is fashioned to lead meditative, studious thought lies not at the boundaries of wholeness, nor at the glowing light of the exact *omphalic* centre, but a little beyond them—at the fire of the essence.

What the essence of the dance is for me, and may be for others, is not what I want to discuss here. I have in any case pointed to its meaning in others among my essays. More to the point under the rubric of this one is that the essence, once it has made itself known, is carried in the organizing principle of the *rasikas*' inmost thought, and in the structure of their thinking, even when no dance is taking place externally, except, of course, the dance of life—to whose meanings and revelations the *rasikas* are able to transfer the ability to unify, centralize and essentialize, as they can to any object of their attentive study.

But of course one never can remain transfixed by the essence because to do so would be tantamount to abandoning all intellectual search.

One's reckoning faculties are drawn out again towards the periphery and towards the possibilities for wider and more intricate speculation that show themselves at its shimmering, dappled boundaries.

And here we touch on—even as we are constrained by—the real and insuperable boundedness that is inseparable from what is genuinely classical about the classical dance. Our ranging investigations are kept in check by its intellectually verified forms and codes, the transgression of which leads onward to untried notions and the perils of loose thinking that are their concomitant temptations. We see these perils demonstrated over and over again in the repeated attempts at snatching unconsidered freedoms from classicism, 'liberties' which so often result in those 'daring' novelties in Indian dance that turn out, on a closer reading, to possess neither oneness, nor centre, nor essence, because they make no concessions to classical discipline.

But this does not mean that, as a discipline of choreographic thought, the classical dances allow no room for the new and the really original. On the contrary, it is precisely on account of what they do not allow that the genuinely new can be born from them and be recognized as their legitimate offspring.

In this way, too, they teach a discipline of the researching mind, holding it back from fruitless wild-goose chases after the gimmicky and the merely novel—so that the thought involved in consideration of the multiform and manifold particulate phenomena that exist at the periphery of all studies worth undertaking, as they certainly do at that of the dance, remains grounded in the kind of thinking that remains both serious, relevant and worthwhile, which qualities are paramount in the constitution of any thought that we can think of as being in good taste.

And the dance teaches nothing to thought if it does not draw it towards the cultivation of good taste in all its ways of thinking. Because there is a very real sense in which the classical dances can be defined as nothing other than the quintessential expression of good taste through the language of dance. We come to know this far better when we arrive at a greater familiarity with its discerning tenets and are liable to experience through a developed instinct what a moral shock a lapse from taste actually is at such a high level of refinement.

Classical Indian Dance as a Discipline of Thought 41

So that we are brought to see, at the same time as the shock is felt, that the lapse from good taste into bad, besides being a breach of good manners, is a moral matter, involving as it does such defects of thought as intellectual dishonesty, absence of integrity, and error of judgment. Though we do not, of course, when we encounter them in the dance as we do in the thinking currents of the examined life, consider them immoral unless they are stubbornly persisted in.

8

On the *Ghungroos*: Ankle-Bells of Servitude, and Mastery

Every dancer cherishes her *ghungroos*, and no wonder. From the time she first learnt to use her feet in step, they have been with her in ever-increasing numbers, and now, at the height of her artistic maturity, two-hundred or more adorn her ankles where once there had been only ten or twenty. They have grown in number as she has grown in skill, their many brass mouths and little iron tongues acknowledging in rhythm the slowly unfolding stages of her graduated blooming. But she honours them not only as companions but also as soft-spoken teachers whose demands could never be feigned in the doing because their tongues would always expose the lie.

The *guru-shishya* relationship that obtains between the *ghungroos* and the dancer implies, then, a kind of subordination. Like the teacher in other aspects of the dance, the *ghungroos* act as mediators for tying the dancer down to a given set of metric principles and through this enchainment to encourage her proper surrender to them. They serve this purpose for indispensable reasons—reasons which go far deeper than the mere display of skill, that have to do rather with awakening the mindset of essential servitude in which skill itself has its classical source.

Essays on Classical Indian Dance
Donovan Roebert
Text copyright © 2021 Donovan Roebert / Photographs copyright © 2021 Arun Kumar
ISBN 978-981-4877-47-3 (Hardcover), 978-1-003-12113-8 (eBook)
www.jennystanford.com

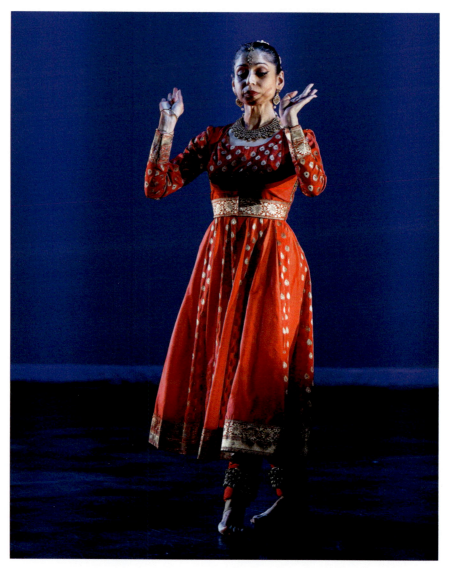

8. Anjali Nath, Kathak dancer, disciple of Pandit Chitresh Das.

We are told that the higher the number of *ghungroos* the dancer wears (within the limits of what is feasible and tasteful), the more clearly her rhythmic footwork can rise above the music and be emphasized on the *rasika's* behalf, who would otherwise not hear them and not be enticed to pay sufficient heed to the dancing feet.

On the Ghungroos 45

And this is plausible enough. But, from the point of view of the dance in itself—that sign of itself which is inscribed in space and time when we think of it quite apart from both dancer and *rasika*—the rhythms of the *ghungroos* take on a far less utilitarian aspect. They reveal themselves as the fundamental supporting line on which the whole living work of art depends, and as its essential trajectory.

In order to hear and see this more clearly, let us imagine (what is in fact technically possible) a dance from which all the other elements have been silenced and effaced so that only the *ghungroos* remain.

Or, to establish in our minds a more concrete instance, let us imagine that we are observing a dancer dancing to music that only she can hear because she is wearing headphones. All that strikes us, if we close our eyes, is the rhythmic tinkling and chinking of the *ghungroos*. Then let us, when we open them, see only these *ghungroos* in elegant motion, tracing a continuous line unfurling itself like a bright fast-moving star against a black night sky.

What we would hear and see in such a case would be a rhythmic line in time accompanied by its evolving form in space. But we are also to know it counter-intuitively for the single thing that it is, just as space-time, the dimensional realm in which it is being realized, is, against all that our experience tells us, a single dimensional continuum.

What we perceive then may strike us as a thin and simplified remainder if we fail to grasp the real nature of this rhythmic line, which is much fuller and far more pregnant than it seems—because this filigree of rhythm and form, for all its seeming-simplicity, contains in itself the subtlized strength that carries on its fibres the whole of the dancing superstructure. And it is ultimately to this superfine but powerful tracery that the dancer learns to become subordinated, as the body is subordinate to its skeleton or an organism to its genetic code.

The labour of servitude leading up to this refined obedience to an object of such subtle potency is not, for all its relatively workmanlike stolidity, one of which any *rasika* would dare to think less on any merely philosophic grounds. Because this work, the practice of the dance itself, when it has been perfected, is the aesthetic face that clothes the essential line with the full loveliness of dancing poetry.

The submission of the dancing body not only to the principle of tempo and rhythm but to the actual metric beats which the *ghungroo-*

clad feet are accentuating in any particular recital is a poetic feat of a high artistic order. Its attainment has come through years of servitude enacted under the correcting strain of the tell-tale *ghungroos*.

I should like to go one step further and try to know inwardly the final nature of the *ghungroo*-tongues riding on the surface of the spoken syllabic *bols*. If, in so doing, I should turn off all sight and sound, the image evoked by the *ghungroo*-line is that of a lacework of fine-leaved branches reflected on the surface of a quiet pond. It can be perceived but never touched because the attempt at touching, besides corrupting the reflection by stirring up the water, would be a striving after something that can only be grasped in its coarser, material body—the body of the tree above the water whose realness differs utterly from its evanescent reflection.

This analogy, to my mind, justly depicts the relation of the swaying tree of dance to the essential *ghungroo*-line, which in its elusive ultimacy is the attenuated mirror-image of the tangible inscription drawn by the dancing dancer: an enchanted reflection that somehow also precedes the reality it finally engenders.

When, as sometimes happens, this degree of subtlety is comprehended, the dancer's period of servitude to the *ghungroos* opens its true face too, and discloses itself as the ripened seed of mastery. She now possesses, at their true depth, the ankle-bells that have for so long possessed her at the surface.

'*Durch die Beschraenktheid zeigt sich der Meister*,' Goethe says: 'through the constraints imposed upon him the master declares himself.'

Which is to say that the masterliness of the master comes in the first place by being in step.

9

The Space Between the Notes: Heather Lewis's Remarkable *Shastric Tour de Force*

Bharata Muni, the inspired compiler of the *Natya Shastra* was, it seems, not only a sage and classical pragmatist but something of a 'character' too. A dominating and fastidious stickler to the codes and conventions of the dance-drama that he knew himself to have received from the *devas*, he was, like all the great and genuinely original master-teachers, quite capable of compromising with the tricks of his trade if this meant pleasing his royal patrons and, to some extent at least, the theatre-going public—but always with one devoted eye rigidly fixed on the *natya-nritta* formalisms entrusted to him by the gods. He is shown to us not only as larger than life but as almost as large as the *devas* themselves, from whom he received his Vedic instruction.

So that we can hardly wonder at his rigid stubbornness. The *Natya Shastra* is a work of glorious *richesse* and minutely recorded detail. Indeed, the detail is of the copious and meticulous kind that allows researchers to reconstruct today the original dances of the ancient *marga*, based on Bharata's 108 postures of the *karanas*. It is a 'handbook' of ancient classical dance-drama that is, to the best of my

Essays on Classical Indian Dance
Donovan Roebert
Text copyright © 2021 Donovan Roebert / Photographs copyright © 2021 Arun Kumar
ISBN 978-981-4877-47-3 (Hardcover), 978-1-003-12113-8 (eBook)
www.jennystanford.com

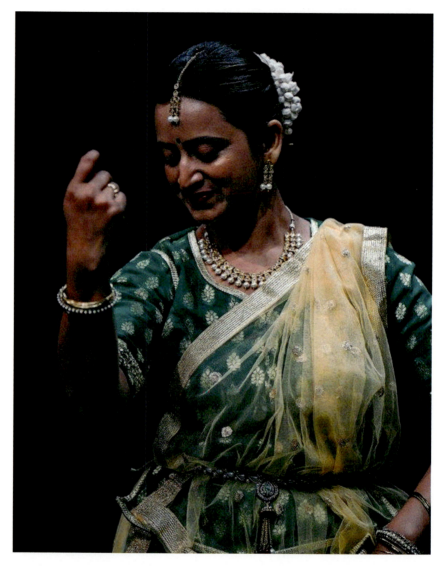

9. Sampurna Srivastava, Gurukul Kathak Dance Academy, Cary.

knowledge, unparalleled in any other classical literature in the world. How invaluable it would have been to us, for instance, if some Hellenic Bharata had noted down for our enlightenment the elements of the dances of ancient Greece. As it is, we know little more about them than the hints offered us through the tentative conjectures of Hellenist

The Space Between the Notes

scholars. The *Natya Shastra*, at any rate, constitutes the first major pole in Lewis's historical account.

The other is Pandarika Vitthala's *Nartananirnaya*, a treatise on dance and music from the 16th century which, though it makes reference to Bharata's work, and in particular to the original *karanas*, speaks about these as curtailed from the ancient 108 to a mere fifteen. This is because, by the time of Vitthala's writing around 1570—a compendium presented to the tolerant, polymath Mughal emperor Akbar, who married Jodha, a Hindu princess—the *desi* forms of classical dance had overwhelmingly supplanted the *shastric marga*.

Between these two seminal treatises, it is largely Bharata's treasured text that Heather Lewis explores and illuminates in the essays comprised in *The Space between the Notes*, a crammed, vivacious and compact work that leaves the reader all but surfeited. And because the book is so brimful with information, names, terminology and nomenclature—much of it left insufficiently elaborated or explained—the most profitable way of approaching it might be by way of the three core historical threads that it identifies, traces and unravels, and which lead us forward to the dances that we rightly call 'classical' today.

The first of these is the evolutionary line, with its series of continuities and truncations, that runs from the *karanas*-based *marga* of the *Natya Shastra* to the advent and rise of the *desi* dance forms described in the *Nartananirnaya*, and beyond this crucial medieval marker to the work of the Tanjore Quartet in the early 19th century, in which the 'modern' styles of the classical dances have their most recent and unmistakable roots. This is the line that eventually runs, with an historically coerced inevitability, to the renewal of the dance in the second half of the 20th century by the great teachers, choreographers and theorists of those decades.

Lewis painstakingly disentangles her narrative from the dance-drama and musicological literature, both ancient and relatively recent, that provides the basis of our knowledge of these developments, a knowledge that is still embroiled in controversies and uncertainties. This record of the treatises and fragments of treatises spins out the second thread woven through the essays.

The third is concerned with the gradually changing roles played by the temple dancer, court dancer, courtesan and *narthaki*, whose

combined labours—sometimes at odds with one another—have led in the end to the present styles and status of the classical Indian dances.

Parts of the *Natya Shastra*, written about the 3rd century CE, were only translated as a recension into English by the American orientalist, Fitz Edward Hall—who had discovered eight chapters of the work—for the first time in the late 19th century. Scholarly research into the gradually rediscovered text gathered slow momentum until the first definitive recension was made by Manmohan Ghosh in the 1950s. Our fuller knowledge of the treatise has thus come very recently. Indeed, we hear that the modern dance revivalists, including such activist gurus as Rukmini Devi Arundale herself, had not themselves read the text and had only a second-hand knowledge of its contents.

Until the time Ghosh made available his recension, the *Natya Shastra* had been for more than a century a seminal work that had been almost completely obliterated from the collective memory of the dance-drama. Only some of its elements remained in play, a few *karanas*, a distant recollection of the short *marga* dance sequences that Bharata called *angaharas*, and the generalized and almost indifferent inheritance of the insistently classical codification that it espoused.

We find allusions to it in the *Nartananirnaya*, but Vitthala's compendium is mainly concerned with elaborating on the *desi* styles that, by the time his work was being composed, were already exerting the keenest and most widespread influence on the regional classical dances then being performed throughout the subcontinent. There was, it seems, a glut of dance styles, none of whose varieties of complex and often novel elements-in-combination would have been either readily recognized or approved by Bharata Muni.

Lewis's book leads us quickly on from Vitthala's treatise to the work of the Pillai brothers, all geniuses in their grasp, research and codification of the prevailing styles of dance, drama and music in their time and environment. Known collectively as the Tanjore Quartet, and working under the watchful patronage of the cultured humanist king, Serfoji the Second, they accomplished in their sphere and with the knowledge available to them—drawing largely on the text of Nandikesvara's *Abhinaya Darpana* (500—1000 AD?)—something in the order of importance of Bharata Muni's own work. On the tide of their dedicated scholarship and creative originality, classical Indian

The Space Between the Notes

dance was set in the direction in which it was finally fixed for our time during the revival of interest in the dance, especially in its *narthaki* or secular form, in the course of the 20th century.

Now, this historical account would, in spite of its twists, spurts and sudden culminations, seem straightforward enough if it had been the accepted and received one, but it is far from that. And this fact touches on one of two controversies that make Lewis's work as important as it is absorbing. It has been for decades the self-declared agenda of most dance scholars in India to impose the idea that modern classical Indian dance demonstrates a continuity that can be traced back to Bharata's *Natya Shastra* and to the *marga* he describes in his work. But this view—to a large extend entrenched by the dance politics of the academy—is rendered unsustainable when Lewis's thesis is brought to bear on it. It is in any case liable to collapse under the burden of its own over-neatness, as most such tidied-up theories eventually do in the light of disinterested scrutiny. That Lewis has cast her well-researched and adequately documented alternative light on this complicated development of technique, codification and philosophy places her work in the category of the bravely seminal. And this alone, whichever view one settles on as the most likely one, makes for her book's indispensability. Its place is on the bookshelf right beside the *marga*-based historical theories of Dr Padma Subrahmanyam and others who have embraced her point of view.

The other, more human and more tragic controversy dealt with by Lewis is that of the shouldering-out of the traditional temple dancers, the *devadasis*, as well as the hereditary court dancers, the *rajadasis*, by the exponents of the new styles of classical dance whose aims were to revive the art and bring it into the public forum in a form both classically and morally purist, and with its openly erotic facets expunged from the *gurukul* and the repertoire, except in their subtlest manifestations. What had always been *sringara* in its essence should no longer be seen to be so.

It seems possible that the *devadasis* were the first female performers incorporated into the stage productions of Bharata, on loan as it were from the temples. They, at any rate, must have played many-sided roles as prominent and vital in the dance recitals at court and theatre as those they performed more secretly and obscurely when they danced at

the shrine of the temple deity. As living practitioners and transmitters of the *marga* their work as teachers and exponents must have been invaluable.

Lewis is at pains to show their honoured status as *nityasumangali* or ever-auspicious: they were to be distinguished, as Bharata himself makes the distinction, from the courtesan. They were accomplished women, thoroughly versed in their art, having a genuine piety and familiarity with temple rites, and of an unusually high level of cultured education. They therefore enjoyed freedoms, benefits and dispensations that accorded with the crucial importance of their work both in the temple and at court. More importantly, in historical terms, they may have been the longest- and last-surviving repositories of what remained of Bharata's *karanas*-based *marga*.

But the dance, growing ever more secular in its performed expression as sophisticated entertainment with a quasi-religious edge, could in the nature of things offer far less scope for the unique position and activities of the *devadasis* and *maharis*, whose dedicated *parampara* and its artistic-religious labours were increasingly confined, out of sight, to the temple sanctuary. By the late-19th and early-20th centuries their hereditary vocation was being denigrated as a cover for mere temple prostitution.

By the time the *desi*-based modern forms of classical dance were beginning to flourish in expurgated schools of dance such as Rukmini Devi's *Kalakshetra*, the exclusion of the *devadasi* on moral grounds was already a *fait accompli*.

The tale of this incremental castigation and casting out of the *devadasi* from her once central position in the history and hierarchy of classical dance is presented cursorily but with sufficient insight to awaken an interest in the fuller picture and the devastation of a tradition that it implies.

Having dealt, insofar as an article of this scope is able to, with the first and third threads mentioned above, let us take a quick look at the second, which involves the list of relevant classical writings on dance-drama and music provided by Lewis.

Though her book deals thoroughly and insightfully with the treatises of Bharata Muni and Pandarika Vitthala, it gives us only a cursory look at other important texts. This, I feel, is as it should be in

The Space Between the Notes

a work whose chief aims are to provide a thorough grounding in the general historical unfolding of the dance (with its central controversial *marga-desi* subtext) while pointing at the much vaster field which still lies open to further study by the enthusiastic researcher. The list of works enumerated and briefly described at the start of Part II certainly offers the enterprising student more than enough to get on with.

Taking Lewis's book as a whole, it is perhaps not altogether a criticism to say that it is probably only half the length it should be. In any case the saying so is one measure of its ability to stimulate further interest. But it really is too crammed at places, and one feels that it would benefit from the kind of expansion that would give its readers more space in which to organize its many intricate allusions. The absence especially of a glossary and index are very much to the book's disadvantage. But these, in the context of what Lewis's work does render, and render magnificently, are quibbles raised only because they would work to improve the excellence of what we already have before us.

Incidentally, I find it both delightful and serendipitous that the *Natya Marga*, under the brilliant leadership of *Kalamandalam* Piyal Bhattacharya, has made public a video clip of a *karanas*-based *marga* reconstructed from instructions in the *Natya Shastra*. In addition to its own deep interest and comeliness, this dance clip demonstrates how very different the *shastric marga* is from the modern classical forms, though of course a recognizable similarity is discernible too. But it is the sort of likeness that clearly derives from a very old shared and familiar history rather than from a direct and unbroken technical transmission.

This reconstructed *marga* raises the distinct possibility that Bharata's *karanas*-based dance may find itself being revived and expanded from its roots in the *Natya Shastra* to take its place as yet another classical form growing vitally among the more modern styles already extant and codified. It is worth mentioning here, as well, that Lewis herself is currently engaged in reconstructing some of the *shastric angaharas*.

The widely perceived need to revive Bharata's *marga* goes a long way towards confirming Lewis's *desi* theory as being at least the more credible of the two we currently have, though it may still continue for some time to stand as the less favoured.

10

When is the *Rasika* Really a *Rasika*?

There are many possible opinions as to what the *rasika* ought to be, and I am only too aware how little, in fact, I have to say in the short essay I am attempting here. That is why I caution myself to be constantly aware that what I am trying to grasp is to be comprehended only as part of a much larger context whose other elements I must perforce exclude. I am setting out to pursue a single line of thought among many other potential alternatives.

I would like to begin my line of thinking on a short *via negativa*, along whose course I will try to find out what the *rasika* is *not* and in which guises the *rasika* is *not* being a *rasika* even though he or she may appear in that guise to be one. And I will use only three brief examples.

The first and most obvious is that of the dance critic: of him or her I wish to say that, in the period in which they are being critics of the dance, doing the work that dance critics do, they are not doing the work of *rasikas*. When they make their case, say, for the imperfection of a *shukatunda hastha*, or when they claim that a *prenkhana pada bheda* does not exhibit the right elegance of curve, that the curvature does not facilitate the just balance of flux both downwards to the ground and upwards to the eyes, they are not doing the work of the *rasika* but that of the critic. It may be the case that there are times when these

Essays on Classical Indian Dance
Donovan Roebert
Text copyright © 2021 Donovan Roebert / Photographs copyright © 2021 Arun Kumar
ISBN 978-981-4877-47-3 (Hardcover), 978-1-003-12113-8 (eBook)
www.jennystanford.com

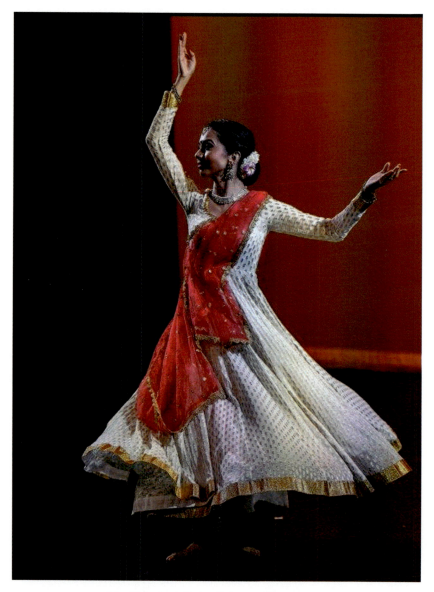

10. Shivangi Dake Robert, Singapore.

critics are *rasikas* too, but those times will always exclude the periods during which they are being critics.

The second example of what a *rasika* is not is that of the dance student or researcher. While these students or researchers are

When is the Rasika *Really a* Rasika? 57

attentively engaged in their task of analysis, description and assessment, their work is research work and not *rasika* work.

And so on to the third example: the dance enthusiasts or 'lovers' of the dance. Let them be ever so enthusiastic or 'in love' with the dance, even at the very moment of the recital itself, still their enthusiasm and love are not the sentiments and insights of the *rasika* when the *rasika* is being a *rasika*. They are only those of the enthusiast and 'lover.'

I have used these examples not in order to denigrate the types of work and sentiment described as proper to them but only to make clear to myself a certain separation of function, sentiment and insight that will bring me closer to a purer idea of *rasikas* in their role as *rasikas* only and not as some other thing.

What these instances do clarify for me is that the *rasika* is not a given type of person involved in some way with the staging, criticizing or appreciation of the dance as dance. The *rasika* may be anyone at all. But the point I am making is that, no matter what kind of person the *rasika* may be, he or she will only be a *rasika* during the protracted sequence of moments when they are experiencing *rasa* as *rasa*, and not as some other form of mental activity.

This statement raises the question what *rasa* as *rasa*, and not as some other thing, really is. In raising it I am again made aware of the many possible theories about *rasa* that I will have to leave aside in order to make the tentative case I have set myself the task of trying to make here.

This case, a very limited one indeed, I should like to advance in terms of three stages of transmitted emotion and sentiment. In other words, because I am concerned with *rasa* in the context only of classical Indian dance, I should like to look more closely at three possibilities of sharing between dancer and *rasika* on the *abhinaya-bhava-rasa* continuum, leaving aside for the moment the vexed question of *tejas*.

The first stage I will call the stage of sequential emotions. By this phrase I mean the arising and falling away of the various emotions that are transmitted by the dancer to the *rasika* in the course of a full recital. These may be emotions shared in the course of either the *nritya* or the *nritta* dances. They are of the kind that we ordinarily experience while watching a gripping film or reading a novel with a strong emotional story-line. We share, moment by moment, as the story progresses,

the feelings conveyed by the actors or the novelist—if they are any good. Emotions of exactly this kind are shared with the audience in the course of any *natya*-tale that is danced with adequate *abhinaya* and *bhava*.

But do these sequentially transmitted emotions have anything at all to do with the kind of *rasa* that we associate with the deepest artistic motives of the dance? I would like to suggest that they do not.

The second stage I will call the stage of cumulative sentiment. By this I mean the generalized 'flavour' or 'perfume' that is inwardly distilled from the accumulation of the sequential emotions experienced during the course of a performance. It is the subtle, uninterpretable scent that arises from the mixture of the emotions felt one after the other while being subjected to the felt life of the dancing work of art. It is akin to the kind of ineffable sentiment one might feel at the end of a beautiful film. I am thinking here of such films as Shoojit Sircar's *Piku* or Imtiaz Ali's *Tamasha*. When these films have run their course and the credits roll down the screen, one is left in the grasp of the abiding sentiment aroused by them. This is not a sentiment that can be described by breaking it down into its component emotional parts. One cannot say that this scent of sentiment is made of one-half happiness, one-quarter perplexity, an eighth of love and two-sixteenths anger and anxiety. The perfume has been distilled beyond the point at which its component flavours can be identified.

This is the perfume that engenders, as I see it, real *rasa* as *rasa* and not as some other thing. I say that it engenders *rasa* because I do not believe it to be the completion or fulfillment of the particular kind of *rasa* that is afforded the *rasika*, during those moments when he or she really is a *rasika*, by the *bhava* emitted by the dancer. I think of this sentiment rather as an open doorway that leads directly into the real chamber of *rasa*, and I think of that real chamber as a shrine.

But before moving on to consider this shrine, I want to look more closely at the inward dynamic that is experienced by the *rasika* after entering by the doorway to the subtilized scent that engenders full *rasa*. And I would like to opine in a preliminary way that at this point a threshold is being crossed that passes from mere sentiment to insight.

When is the Rasika *Really a* Rasika? 59

What sort of insight, then?

Speaking for myself, I have come to see it as an insight into the oneness of all existing things, a flowering insight which springs from the seed of the perfumed sentiment in which all the single particles of the sequential emotions are mingled together to become one greater and higher thing.

The unity of all being is our profoundest evidence that the whole of creation is the product of a single cosmic dance. This, of course, is to speak metaphorically. But what, after all, other than metaphor, do we have at our disposal if we want to describe the interdependent and interrelated coming-into-existence of all that is?

Such an insight into oneness must be for us human beings nothing other than an experience of love in the whole of its deepest and broadest nature, a love that we understand most concretely in terms of the *sringara* mode when it attains to its noblest manifestations and functions.

As *rasikas* abiding in this full insightful *rasa*, we come into the presence of the creative force, the *deva*, which in those moments we also recognize as the ground of our own personal being, our *purusha*. And it is to this Ground-of-Being within ourselves that both the dancer and we are doing simultaneous homage from the moment we pass through the doorway of sentiment into the shrine of love-in-oneness, whose *sloka* is *tat tvam asi*.

We may therefore with a great deal of considered legitimacy hold that the dancer, for the duration of those moments of pure and full *rasa*, is worshipping the *deva* within the *rasika's* shrine.

And if the argument I have attempted to advance in this essay has any intrinsic merit at all, I must end by saying that the *rasika* can know the genuine and full experience of *rasa* only when the dancer becomes the *dasi* that at the heart of her she ought in those moments to be.

11

On the *Gramma* of Classical Indian Dance: A Grecian Perspective

For decades now we have all been speaking about the 'grammar' of the dance, and this is a fitting term to use, especially in English-language writing about dance technicalities. I suppose that most contemporary articles and books on the dance are written in English in any case, and this seems to me a good reason to explore what we ought to understand when we refer to 'grammar' in this context.

Before turning to the Greek etymon of the word itself, let us make a brief excursion into the way 'grammar' is understood today and what was meant by it when it was a central object of study in the *trivium* syllabus of medieval European universities. This will help us to arrive more soundly at the conclusions I hope to reach by the end of this essay.

Nowadays we mean by 'grammar' the study of the elemental structure of a given language: the ways in which verbs, nouns, adjectives and so forth are used, together with the more subtle aspects such as verbal tenses, moods, idioms and the many other related grammatical fiats and rules. Beyond this, we may move on to syntax and semantics, which do not concern us here.

Essays on Classical Indian Dance
Donovan Roebert
Text copyright © 2021 Donovan Roebert / Photographs copyright © 2021 Arun Kumar
ISBN 978-981-4877-47-3 (Hardcover), 978-1-003-12113-8 (eBook)
www.jennystanford.com

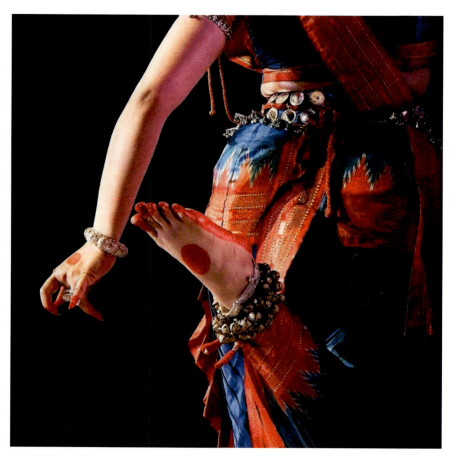

11. Anindita Anu Nanda, Master Odissi Artist, Soor Taal School of Dance and Music, Danbury.

In the *trivium* and *quadrivium* syllabuses of the medieval universities, however, the idea of grammar held far wider and more thoroughgoing implications. The study of grammar included the entire way in which a classical language, usually Latin or Greek, was used in extant works. It dealt with the whole spectrum of linguistics as written thought, and the ways in which language was used to convey both thinking and sentiment with all its directnesses and inherent ambiguities. Through the study of grammar one was introduced to the subtleties and sharpness of the thinking conveyed in that language, and

the whole subject was directed towards learning the best manner in which the student ought to think and express him- or herself. Attentive and deep-going scrutiny of the dead letter was gradually turned into an understanding of one's own living mind.

It is in this latter sense that I wish to consider 'grammar' in relation to its uses in classical Indian dance. In so doing I would like to turn now to the Greek etymon, *gramma*, from which the word 'grammar' so obviously derives. 'Gramma' means 'something that has been written' as opposed to something that has only been spoken. It points at that which has been visibly inscribed, just as the dance, while it is being danced, is an inscription of the language of dance on the palimpsest of time and space. It writes itself before our eyes, inscribed in our presence by the moving dancer, the grammarian of the language of dance. And we perceive it not only as a bare exposition of the structural elements of grammar, but as the full use of the whole language. We encounter it in the same way that an experienced medieval grammarian would have encountered an ancient language revived in a classical text. Indeed, we meet it in the dance in its highest usage, that of the language of poetry.

Now, if we can agree that the language of dance is also that of poetry, we are led immediately to consider the kind of use that was made of written thought when poetry was its only use. We are led, that is to say, to the earliest inscriptions of human thought, which dealt only with the religio-mythical experience, the *mythos*. That this is an historical fact in the evolution of language reveals to us why both *gramma* and 'grammar' came into existence in the first place.

The grammar of dance reflects the same history, which has its beginnings in the dancing 'inscription' of the religio-mythological tales and their important meanings for the whole of our culture. It was one of the languages used for worship in the temples, as well as for public and royal instruction in the *mythos* of their own time. And it has the same use for us today. Indeed it is one of the very few vital art forms that are still able to connect us directly with the primal realm of the mythological. The crucial reason why it is still able to do so is that the grammar for expressing the *mythos* has been largely preserved. Though classical Greek, Latin and Sanskrit have become dead languages, the classical language of the dance is still alive precisely because the nature of its *gramma* has not been modified beyond all recognition.

But let us turn now to a short consideration of the importance for us of the *mythos* itself, that same *mythos* which the classical dance, through the preservation of its classical grammar, is still capable of fully expressing for us, even in the postmodern world.

As touching the classical world of thought and its development, it is known that the *mythos* was eventually transformed into the formulaic *nomos*. This, at least, is how scholars ordinarily view this particular historical line of cultural and societal development in antiquity. But I should like to look a little more closely at this interpretation once we understand what is meant by the *nomos*.

Nomos is the classical Greek word for the laws, rules, regulations and structures that govern a society or a community of persons, or any complex system at all. Used in this last sense—and I will return to this sense in due course—it can legitimately be used also to denote the system of codified laws that govern the grammar of the dance.

As I have said, it is held by historians that the *mythos* gives rise to the *nomos*. The tales with which the world's great myths are pregnant— the *Odyssey*, the *Aeneid*, the *Mahabharata*, the *Ramayana*—contain the sceds of the codified legal systems, as well as the systems of philosophic and even scientific thought, that we later come to extrapolate from them. Discovering in our myths, by the employment of mother-wit and feeling, the formulable reasons and sentiments appropriate for our cultural and societal well-being, we excise them from the *mythos*, then capture and codify them into laws of thought and conduct.

And so it also is with the dance in its classical forms. The myths directly communicated by them contribute to the formalization of our patterns of moral and aesthetic thought and sentiment. The dance is thus seen to be a living unit supporting our total culture, and if our culture, then our society.

Let me now return to my idea of the *nomos* as something that is not merely the systematized product of the *mythos* in time but also as it were in space. I mean by this (what historians of ideas never speak of) that the *mythos* in itself necessitates and creates a *nomic* form, a set of coded regulations, which becomes the sole means by which the *mythos* can properly be expressed—and these regulations become the grammar of the myth: the instrument that transforms it into a shared and perceptible *gramma*. (In poetry, as in dance, the most indispensable prior grammars are based on metrics and formal harmony.)

It will be obvious, then, that what I am advancing here is the notion that the classical dances afford a unique example of the concurrent manifestation of *mythos*, *nomos*, grammar and *gramma*, and that this manifestation is also uniquely a living one, transmitted as it is by a living dancer to an onlooker equally alive. It should be clear that, viewed in this light, there is nothing in all of art quite as vitally classical as the classical dances themselves.

Beyond only this fact, astounding as it is, it should also now be clearer that, as vital cultural units, the classical dances contribute to the health of the broader culture by working to sustain and invigorate its *mythos*. And the *mythos* it preserves for that culture, it also renews for its society.

I would like to close this essay on a note of caution concerning the possibilities for absurdity, caprice and waywardness in the adaptation and incorporation of classical Indian dance into so-called contemporary or fusion types (because one cannot with any honesty yet think of these experiments as 'forms').

T.S. Eliot memorably described heresy as 'a truth pushed so far that it becomes a falsehood.' Another word for heresy is 'antinomianism,' which means the flouting or rejection of the orthodox *nomos*, a flouting that is often conveniently carried off by placing an undue emphasis on only one or two of its orthodox or classical aspects to the detriment of every other.

I think we do well to bear in mind, whenever we contemplate the more unattractive antinomianisms of contemporary Indian dance, that, if the *nomos* is in some way vitiated or artificialized, the *mythos*, the grammar and the *gramma* too are bound to be subjected to the same malformation.

Then, if as a result of such repeated injury they all should eventually perish together, there will be nothing of the classical ground remaining for the dancer's feet to dance on. The evanescent air will be all that is left for the inscription of some strange new *gramma*.

12

Writing *The Odissi Girl*: A Literary Analogue for the Dance

What I had in mind when I set out to write *The Odissi Girl* was not at all a novel about the dance. Such an endeavour, as I saw it then, would have seemed a waste of writing-effort. I wanted to do something far more intimately bound up with the dance and with the ways in which I had experienced its effects: I wanted to write a literary work that in itself would be a kind of dance, a pattern of plot, narrative and lyrical language that danced on the page for the *rasika*-reader.

This meant, in the first place, that the novel I had in mind must be a classical poem. The prose I was to use in its construction must be firm, lucid and simple, but imbued with a lyricism that, while it illumined the work with subtle flashes of beauty, would be held in check throughout by a solidly classical architecture and a severity of language approaching the austere, like that of the poetry of dance.

But to these necessary choices of form and style it was incumbent on me to add the emotional flavours of the felt life, without which any dance or novel can only ever be a formal gesture. And because this novel should be a dancing novel, I naturally resorted to the ancient methods of *abhinaya* and *bhava*, the first being the outward technique

Essays on Classical Indian Dance
Donovan Roebert
Text copyright © 2021 Donovan Roebert / Photographs copyright © 2021 Arun Kumar
ISBN 978-981-4877-47-3 (Hardcover), 978-1-003-12113-8 (eBook)
www.jennystanford.com

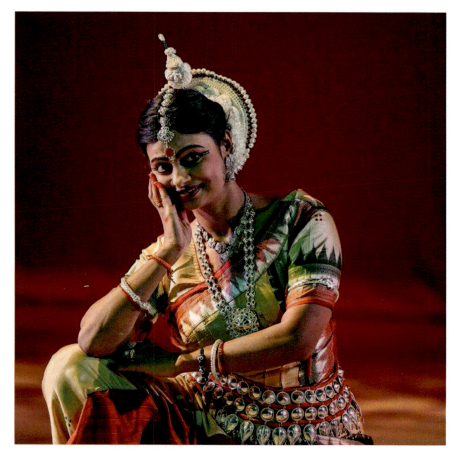

12. Krishnaveni Putrevu, Odissi Dancer.

of concrete expression and the second the inwardly engendered force of the living sentiment one wants to convey.

Here is a passage from the novel—the one in Jay first meets Ananya—which may give some idea of the way in which I conceived this task:

Then I saw that Mr Das was leading Ananya towards me. She walked at his side holding herself very upright, so that the top of her head was just at the level of his shoulder. Unlike me, she was at home. She advanced, I felt, with a certain ferocity. She drew nearer with just the hint of a curious smile, very impersonal and self-possessed.

Writing The Odissi Girl

They came closer. I was still conscious of my nervous eyes taking in her features like the details of a portrait, trait by trait, when I was suddenly so staggered by her animal beauty that I didn't know where to look.

I heard Mr Das saying, 'And this is Mr Wild.'

I said, 'Namaskar.'

She returned my greeting and, seeing my embarrassment, frowned: a touch of displeasure scribbled above her very admissive eyes. I couldn't make out their colour. Were they black or green or both? I felt myself drawn into them while they answered my helplessness with a calm rebuke. They were open, wide open, but I shouldn't feel in the least entitled to enter on that account.

I had a confused thought of the Taj. Of its insignificance.

Mr Das continued, 'Mr Wild is a very talented photographer. He's done a number of interesting things. Now he's become interested in India and he's developed a real love for the dance.'

'A love?' asked Ananya, addressing me.

I saw the beautiful parting in her very black hair and I wondered how it would feel to run my fingers gently across it.

'A strong attraction,' I said.

'You'll be photographing me?'

'With your permission,' I said.

'I want good pictures.'

She actually levelled a finger at my chest.

Mr Das smiled at me on her behalf. She turned and walked back to the other end of the hall.

The combined purpose of *abhinaya* and *bhava* is to rouse in the *rasika* the particular *rasa*-flavour it is intended to evoke. No novel worth its salt can vitally exist for the reader unless all the *rasas* are touched in the course of its examination and representation of life. This, indeed, I tried to accomplish while still believing that, as in the dance, certain major *rasas* should stand out among the minor ones.

For *The Odissi Girl*, which is essentially that universal, never-ending tale of love and death, I felt that the more prominently expressed *rasas* should be, for obvious reasons, the *sringara, karuna, bhayanaka* and *raudra*.

70 ESSAYS ON CLASSICAL INDIAN DANCE

My decision to settle on these four had not only to do with the kind of dance that I wanted to weave in the book. There was a stronger, more urgent reason too: I have always been struck by the insistent knowledge that beauty appears to us human beings against a vivid backdrop of ugliness and violence. There is no getting away from this truth, however much we might forget it in those exalted moments of dance when beauty is fully present to us, unfolding its wings.

Thus we find in the novel this kind of mingling of the four *rasas*:

Of course I wasn't normal. Who could be normal having done and seen the things I had? The bloated corpses and maimed survivors, the chaos of bombardments, the higgledy-piggledy of urban warfare, the smashed bridges leaning into rivers while the bombers flew high overhead. What was the point in being normal?

'She did it to you!' my mother shrieked. 'She started it all!'

She knew she was pleading for the last time.

'What will she start next?'

I saw the tears in her eyes and restrained myself, gulping down the vodka.

'I'm older now.'

'You should marry again, Jay.'

I gaped and began to laugh.

'My God! You're an Indian mama after all! You want grandsons from a nice looking daughter-in-law.'

'Yes,' she said. 'That's what I want.'

My father, hearing her shrieks, had come up from the boudoir. He stood in the doorway, clouding over with a red displeasure. He shook his head at her and shot me a look of bland disapproval.

'Come on, darling,' he said. 'Let's go down.'

'I'll be kind to her, Jay.'

'You'd better be kind,' I said.

My father turned round.

'That's quite enough.'

When they'd left I felt drained. The things they didn't know! They'd only seen the endless streams of photographs in newspapers and magazines and on a thousand websites. They'd insulated themselves from the impact of the truth by labelling these pictures as work, the work of a successful professional.

Writing The Odissi Girl

But this outburst (a rare thing in our home, where we loved each other in our composite brokenness) had cleared things up for me. The attempt to view Ananya as a stranger had been one of those inattentive inversions of intent.

It was I who was the stranger, lost amid the battle zones of people I no longer considered human. I'd frozen and thawed, frozen and thawed, and then frozen up entirely. If Ananya recognized me at all, it could only be in the reflection of herself still mirrored in the frozen river that could no longer be churned up to dispel her image.

I put on an old Amitabh Bachchan film. It was *Sooryavansham*, the story of the estranged son and his bitter father, in which both roles were played by Amitji. I nursed the soporific vodka, thinking, as the film compelled me to do, of the madness of my heart.

In the open fields of his father's estate lovelorn Amitji sang about his crazy heart: '*Dil mere tu deewana hai, pagal hai maine mana hai, pal pal ahein bharta hai, kahne se kyon darta hai . . .*'

I let myself go in the vodka haze, and wept.

Having settled on the kinds of *rasa* I wanted chiefly to convey, I had to choose what I believed would be the classical Indian dance form most suited to the task, and I decided on Odissi. I chose it not only for its exquisite beauty that is also somehow appallingly exquisite, but also on account of the soft, rounded loveliness of its *lasya* expression and, on the other hand, the dense, compact sinuous quality of its *tandava*. These qualities together seemed to me to offer the best possibilities for the kind of literary dance-analogue I had in mind.

It remained for me, then, to structure my tale in conformity with the Odissi repertoire—which presented no small difficulty—and also, more importantly, to make use of its two central stances as entrance- and exit-points for the myth at the heart of the story I was telling.

The first of these stances is the basic one, the *chauka*. In its stolid, energic squareness, it showed itself to me then (and still does) as the underlying vacuum from which the dance arises into existence and falls away again into nullity, and at the same time as the solid framework within which the entire motion is restrained and contained.

72 ESSAYS ON CLASSICAL INDIAN DANCE

This is how Mr Vishnu Das, the guru-figure in the novel, explains it to Jay:

'This is *chauka*, the dancer's basic stance,' said Mr Das, pointing at the drawing. 'One could see it as the hewn stone block in which the divine form, at rest from mischief, waits to be extricated by the sculptor. The process of extrication is called art. What follows, when the statue takes on life and begins to dance, is *jadu*, magic ...'

And again, in the context of the dance of life itself:

'Or, from the perspective of the *rasika, chauka* might be the surprise waiting to spring itself on you. Do you recall how surprised you were when you first saw Ananya's poster? But that was as nothing, wasn't it, when compared to the surprise of the dance?

'What things surprise us, *beta*? Only things of two kinds, the beautiful and the ugly. The rest, the mediocre, is merely boring. But there's a principle involved in the waiting to be surprised. It's this: those who open themselves to be surprised by beauty will eventually be surprised by its opposite. You see, Jay, you either take both for granted and become dead within, or you make yourself vulnerable and remain innocent and alive.

'*Chauka*, in the *rasika*, is the vulnerable bird waiting in perfect stillness to be elevated into the bliss of flight, or appallingly hurt by the hungry hunter. That's the inherent risk ...'

And in its spiritual nature:

And, lastly,' Mr Das said with a gleam in his eyes, leaning forward across the table, 'You should understand it as the moment of awakening.'

He paused, taking in the sense of his own words, his head full of dancing and love for the dance.

'It's an eternal moment. How can anyone describe it, such an impossible paradox? It's the moment in which all action has ended before it has ever begun. In its quality of attendant equipoise everything is completed, fully understood, replete with a meaning that can't be spoken. Do you understand this, *beta*? It can only be danced. Which is why we're compelled to such devotion for the dance ...'

Writing The Odissi Girl

'And the dancer,' I said.

Mr Das laughed out loud at my eager insistence. It was the first time I'd seen him so swept up by a responsive mirth.

'Yes,' he concurred when his laughter had subsided, 'Only, don't go around saying that to everyone. You'll be taken for a fool with no respect for the art.'

'You can't separate the art from the artist,' I said.

'No, of course you can't. But don't tell that to the *rasikas*. They hate hearing it, my boy. It makes them feel that they're only human. It puts them at a disadvantage in the presence of the dance.'

'And the dancer,' I said.

Which fanned up such a blaze of laughter that the lesson had to be ended.

The other posture inseparable from Odissi is the *tribhangi*, which, with its sensuous triple curve and reversible flux, I felt compelled to use as the channel that flows between Jay's mythical dream-sphere and the real, hard, beautiful and ugly world in which the love-tragedy of his life is mundanely played out.

Here is Mr Das again, speaking about the *tribhangi*:

'The *bhangis* are bends of the knees or body, and the *tribhangi* is the most elegant of them all. In that stance is captured the beginning of flux, the awakening of stone to life.

'Everyone will tell you of the statuesque nature of Odissi but how many know that the statues themselves were once alive? Or do you think that somebody one day started chipping at stone without any prior vision?

'It's not untrue to say that goddesses once danced for men. Men saw them and remembered and made clumsy attempts to capture the essential motion of the divine ... rather like the attempts you've been making with that camera of yours.

'But see this too: how the *tribhangi* lies dormant in the *chauka* like the energies of life in the unperceived vacuum. I can never see the *chauka* without seeing the *tribhangi* hidden in its stillness, as life is held in the stillness of death.

74 ESSAYS ON CLASSICAL INDIAN DANCE

'That's why, when the dancer in *chauka* shifts into *tribhangi*, we know that we're being shown a truth, a beautiful and painful truth, that hurts us while we're being lifted up with joy.

'Because both are one, really; stillness and motion, solid and fluid, mind and transcendence. And in the *tribhangi* (I'm telling you this because of your special circumstances) love is revealed, arising from karma, complex, ineffable ... but undeniable, *beta*.'

As to the story itself, it was natural that I should choose the kind of love-adventure that would reflect and embody in modern terms the Krishna-Radha myth. And, seeing that I was resting the whole of my work on the foundation of the Odissi dance, it was natural, too, that I should turn to the *ashtapadis* of Jayadeva's *Gita Govinda* for the lyrical music that should inform my work:

'And you, white wine-flower, don't think that you alone are the intoxicant. Sweet sugarcane, you are bitter by comparison. Who will look at you, o swelling grape, with yearning from now on? Undying nectar is dead; milk has the taste of water; the sweetest mango is mournful. And even you, my love-girl's lip, can't be sweeter than this path to *Hari* ...'

And:

'Speak to me Radha; let your sweet speech shine from your face like moonbeams. I am removing from your rounded breasts the bridle of your breast-cloth, together with the anguish of long separation. Now follow me, the mover of all beings, who is well disposed to you ...'

Infused and inspired by this tremendous cache of lyrical plenitude, with its deep spiritual currents overlaid by entrancing sensual shallows, the details of the story seemed to grow within me as though I myself had very little to do with its self-unwinding. It took on a life and a *tala* of its own. It danced for me of its own accord, radiated its own *tejas*, and warned me in the way that the dance, when we come to know it deeply, warns all of us:

'Over here we have tigers,' Mr Das said, 'but of course there are a number of big cats in Africa too. I'm sure you've noticed how they all pause with such a wild intensity, gathering themselves, in the moment before they pounce. In that moment their eyes become concentrated with a singlemindedness that frightens the onlooker. Nothing else exists for them. Every muscle is tensed and poised in an immobile raptness. It's the moment they were made for, the highpoint of their meaning, the crux of their survival.'

I had to smile at his tendency to over-dramatize. But, yes, I had seen those cats and photographed those moments.

'What's the dancer pouncing on then,' I asked, joking. 'What's the dancer's prey?'

He saw that I was taking it lightly.

He said, 'You're the prey, *beta*. To live fully you have to live in that awareness. Do you think the gods dance only to entertain us? Only to give us something? Do you think the dancer is only giving without taking anything in return?'

'No,' I said.

'That's right. Think about it carefully, Jay. What does the tiger want to take from you?'

'Everything,' I said.

'Can you render it?' Mr Das asked in his old-fashioned way.

I blushed with the sense of being suddenly exposed.

'Yes,' I said. 'I think I can.'

It would be quite wrong and dishonest of me were I to omit mentioning that there was a muse stirring at my elbow and breathing at my neck as I wrote my dancing novel. But, while any honest writer must confess this truth, it would be very unwriterly to say any more than that. The muse is too sacred to be spoken of above a fleeting whisper.

The dance belongs to Shiva Nataraja in the first place. Brahma saw fit to share it with our fallen race. But Saraswati inspires it with the life it lives within the human mind:

'Oh, Arjun, *abhinaya* isn't just expression. It's expression sent out on waves of energy, divine energy, *tejas*. That's why it should do more

than only touch the *rasika*, the way a poem or a musical composition does. It should consume the *rasika*, like love-yearning.'

'Mr Das told me you have a very powerful *abhinaya*.'

'That may be, but still it doesn't depend only on me. You have to open your doors to let it in. More than that, you have to know what it is that's entering your innerness, your *atma*.'

'What is it, Ananya? What's this *tejas*?'

Millions of leaves were trembling with light in the noon-bright Lodhi Gardens. She pointed at them and said, 'That.'

'I'll open my doors to the *tejas*,' I said. 'But I want even more. I want the cup that holds the *tejas* too. Otherwise it's only a passing experience.'

'That's what everyone wants but only very few can have.'

'My Nani told me that everything can be had if you only want it badly enough.'

'She was right and wrong,' said Ananya. 'It's not only a matter of wanting it. You have to deserve it too.'

When all is said and done, then, I wrote my dance-novel out of a sense of obligation. I wanted to do what little I could to try to deserve my portion of *tejas*.

13

The Presence of the Absent Dancer

A question which, as an observer of the dance, I have often asked myself, and on which I have touched in several of my other essays, is this one: why do some dancers seem more fully present to the *rasika* than others? The answer has over time begun to articulate itself for me in two paradoxical-seeming assertions: that some dancers seem more fully present on account of their absence while others seem more fully absent on account of their presence.

Let me add at once, before I lead myself astray in the argument I intend to make, that I am not referring here to the presence or absence of good technique in the dancer. A dancer's technical abilities may be sufficient or even excellent and yet might still fail to contribute to the sense of his or her presence during a recital. I will not say that the opposite holds good: that dancers having poor technique can be either present to or absent from the *rasika* in their dancer's *avtaar*, and in the ways that I am thinking of, because I don't consider, nor does my experience lead me to believe, that this can ever be the case.

My reason for saying this is that it seems to me impossible that a dancer can claim the *rasika*'s attention at all—whether present to or absent from the *rasika* in the dancer's persona—if the dancer does not command an external technique sufficient at least to generate a correlative interplay of internal forces. Even a dancer who is absent

Essays on Classical Indian Dance
Donovan Roebert
Text copyright © 2021 Donovan Roebert / Photographs copyright © 2021 Arun Kumar
ISBN 978-981-4877-47-3 (Hardcover), 978-1-003-12113-8 (eBook)
www.jennystanford.com

13. Pavithra Reddy, Nrityagram Dance Ensemble, Kodihalli Village.

from the *rasika* in his or her dancer's *avtaar* can still elicit an absorbed fascination through a display of technique alone, while dancers having poor technique offer little or nothing that can interest us, though we can't but love them all the same.

The Presence of the Absent Dancer

Before taking the question of the dancer's presence or absence any further, I want to pause to define more neatly for myself the dynamics and interrelationship of external technique and the internal forces generated by them. I will try to do so by means of the following mathematical analogy:

> If we linger even a little over any algebraic problem (instead of only rushing to solve it by means of the external techniques it puts at our disposal), if we stop long enough to contemplate what lies beneath its tidy, crystalline surface, we are likely soon enough to realize that the equation itself is really only a symbol for the mathematical truth contained within it. It is an inner truth that, so far from being the numeric or alphabetic symbols which express it, actually belongs to such aesthetic and spiritual categories as harmony, resolution, revelation and inevitability. When the problem is liberated by the revelation of its solution, we are confronted by the sense of the obviousness of this answer and this answer alone. No other solution would be possible unless it were absurd.

This obviousness and singularity of the only right solution is not, then, a property derived from the technical symbolism that describes the method by which it is solved, but from the interplay of the internal forces inherent in the problem itself, and in the inexorable solution which it cannot but attract.

The technicalities of the dance, it seems to me, reflect in their surface symbols and codes—the language of the dance—the same sort of internal forces which underlie any equation whose solution is inevitable, single and immutable, unless absurd. The external kinesthetic codes of the dance point to an unchanging inward system whose ultimate residence is not in the language used to convey it but in the human mind. It speaks to us of the sanity of what is inevitable on account of its unanswerable balance, harmony and rightness. It speaks to us about what is, in the final sense of the word, humane; about the fullness of our human potential to see at the same time the boundaries of our knowledge, as well as what lies beyond them. Because, to revert to my algebraic analogy, while we can know and understand the principles of harmony and balance that underlie their symbols, we are

lost when we ask why those principles themselves are what they are. We have arrived at the border of the transcendent.

Returning then, while bearing these qualifying notions in mind, to the question of the relative presence or absence of the dancer's persona (as dancer and not as some other thing), I am inclined to proceed in the following way:

> In the case of the dancer who is present in the course of the dance to the external codes and symbols of the dance but absent to the internal forces signified by them, there is a modicum of awareness that remains unutilized, and which must be directed elsewhere. It must be directed elsewhere because that dancer is not fully present to the whole of the dance. Usually, then, if it is not channelled into an area of vacancy, that awareness is concentrated partially on the external dancing self and partly on the *rasika*.

This kind of dancer I will designate a *narthaki-virtuoso*. What he or she is primarily concerned with transmitting are the twin charms of good technique and of the personal dancing self. And very charming indeed these may well be! But what is gained in the course of this delightful recital is only an admirer of its various charms (for there is no end to human folly) at the cost of losing a *rasika*. To the extent, then, that dancers have deliberately made themselves present to the potential *rasika*, They have in fact become absent from him, except in their personae as charming dancers in possession of a thrilling technique. The equation is being enjoyed at the surface level of the codified symbols only: an algebraic game being played only for the entertainment it yields. And this, as I see it, falls far short of the full experience which dance as classical dance ought to bring to fruition— both in the *rasika* and in the dancer.

The dancer who, for the duration of the recital, is fully present both to the external, technical symbols and to the interplay of their correlative internal forces, I will call the *narthaki-devadasi*. The key to understanding what this dancer is accomplishing lies in the recognition that she is as fully present to these dance-dynamics as she is fully absent from the *rasika*. The *rasika*, indeed, does not concern the dancer in the slightest because her only concern is with the dance itself, with the wholeness that reaches from its surface down to its depths, and

on to those frontiers of inevitable harmonic logic that border on the transcendent, as they do in mathematics too.

Yet it is here, in the full presence to the dance and in the full internal absence from the *rasika* that the dancer becomes most fully present. This is because their meeting occurs in the place where it ought to, in the dance itself—because the *rasika* is actually as little concerned with the person of the dancer as the dancer is with that of the *rasika*. They share an intention to enter into an experience of dance that goes far beyond the mere titillation afforded by technical grace and personal charm. They want to arrive together at the heart of the equation, whose essence is the interplay of the internal forces of *sringara rasa*. In being present to this ideal logic of the dance, the performer becomes for the *rasika* the ideal dancer.

On this last point I don't intend to dwell. I will only say that the intimacies offered by the dancer's full internal presence to the dance and full internal absence from the *rasika* are of the order that make the charms of the *narthaki-virtuoso* seem quite adolescent by comparison.

We see, too, the obvious implications for the theory of *abhinaya* and *bhava* that are raised in this kind of consideration of the dancer's ideal presence and absence, or else of her relative vacuity.

But of the non-possibilities offered us by vacuousness it would be futile to say anything at all.

14

The Triumph of Mylapore Gauri Ammal: A Short Incursion into Dance Genetics

In recent months one has become accustomed to reading articles bemoaning the tragic life of Mylapore Gauri Ammal. These pieces often exhibit a resentful vitriol in search of a blameworthy scapegoat. Many of them in the end, and predictably enough, pounce on the controversial person of Rukmini Devi. The process is both unprofitable and intellectually tiresome because, in its rush to identify a convenient object of resentment, it ignores the contextual historic dynamic in which Gauri Ammal's story reveals itself as a triumphant imprint on the psyche of Bharata Natyam.

Mylapore Gauri Ammal (1892–1972) lived her whole life in Chennai. As a young hereditary *devadasi* she was dedicated as (some say 'chose the career of') a temple dancer and became attached to the Kapalishwara Temple in Mylapore, where she danced for the deity in the inner sanctum until the banning of the *devadasi* system in 1947. With the severe enforcement of this law by the newly-independent Government of India, Gauri Ammal forfeited the benefits, including her house, to which temple dancers had for centuries been entitled,

Essays on Classical Indian Dance
Donovan Roebert
Text copyright © 2021 Donovan Roebert / Photographs copyright © 2021 Arun Kumar
ISBN 978-981-4877-47-3 (Hardcover), 978-1-003-12113-8 (eBook)
www.jennystanford.com

14. Veda Gopal, Kalasrishti School of Performing Arts, Cary.

and was forced to seek other means for earning a living by dance and music tuition outside the temple precincts. She was then in her mid-fifties.

By that time, though, she had been for more than a decade tutor to a number of private students as well as being a respected teacher at *Kalakshetra*. Indeed, she had been the first instructor to Rukmini Devi herself. This had come about through the offices of E. Krishna Iyer, who had invited Rukmini Devi to a *Sadir* performance by Gauri Ammal at the Madras Music Academy in 1932. Obviously, then, her vocation as a *devadasi* did not keep her confined only to temple duties.

It seems clear that Gauri Ammal was a sought-after teacher during the high period of the revival and renewal of the classical Indian dances and that her role in the formation of the *Kalakshetra-bani* was an indispensable one. Though Rukmini Devi had a broader and more cosmopolitan view of the place that Bharata Natyam should occupy among the world's classical dance forms, as well as holding to her own somewhat Westernized notions of the nature of classicism itself, she recognized immediately that Gauri Ammal was an outstanding embodiment of the austere classical qualities that she herself so highly prized.

Still, the banning of the *devadasi* tradition from the temples brought real sorrow into Gauri Ammal's life. She felt bereft of her deepest reasons for dancing and it is said that she never recovered from this shadow of spiritual injury. In the house in which she afterwards lived, situated near the temple, she regularly performed *Gopuram Darshan* at her bedroom window.

Yet she seems by no means to have been, as she is too-often nowadays depicted, a repining ascetic longing only for the numinous seclusion of the shrine. Her background, after all, does not endorse this view of her. She was raised in a family with a long tradition of eminence in classical dance and music. Her mother, Doraikannamma, was a celebrated dancer in the Tanjore tradition and a woman of 'ravishing beauty.' Gauri grew up in an atmosphere of cultured refinement and was taught dance and music, in both of which she later became expert. Her career prospects, therefore, in spite of her heartbreak at the destruction of the *devadasi* way of life, were very promising in the vivacious, activist atmosphere of the re-establishment of classical dance, and especially of Bharata

Natyam. Above all, she was renowned as the foremost exponent of *abhinaya* and *bhava*, and as an accomplished choreographer.

The accusations usually levelled at Rukmini Devi derive from the way she seemed always to want to snatch at the limelight, to lead autocratically the renewal process, and to dominate the form it should take, and this at the expense of more qualified dancers (with rather differing opinions) such as Gauri Ammal and Balasaraswati. And, looking into the anecdotal record, we can hardly doubt that there is some substance to these complaints. Yet, even if we don't doubt it, there is surely more profit in understanding the person of Rukmini Devi and why she believed that she should stand at the forefront unopposed and be permitted to exert such an extensive control.

Though she is often accused, too, of appropriating the hereditary dance tradition and turning it over to the Brahmins, it is hard to see, given her shrewd grasp of the politics involved, what else she could have done. The Anti-*Nautch* Bill that had been launched with such vehemence by Dr Muthulakshmi Reddy and others had placed a formidable barrier across the path of the resuscitation of classical dance. Though Reddy's insistence on the debaucheries associated with the *nautch* were clearly overwrought and often misapplied in the case of the hereditary dancers, it would be naïve to assert (as some nevertheless do) that malpractice and sexual exploitation were absent from the general scenario in India at that time. It was admitted after all by Balasaraswati herself that *sringara* had been debased into common lewdness in the majority of dance performances. Given the new ethos that was then developing in an India heading rapidly towards independence, including independence in the cultural sphere, it would have been impossible to re-launch the dance unless certain well-publicized compromises were agreed on. And in this regard Rukmini Devi showed herself as pragmatic a cultural politician as she was an instinctively appreciative classicist.

We should also bear in mind the extent to which she was able to assert her own individual independence at a time when women's social roles were far more strictly delineated and upheld than they are even today. Her marriage at the age of sixteen to George Arundale, the leader of the Theosophical Society at Adyar, who was then forty-two, is the preeminent case in point. But, quite apart from the controversy

she endured through the fact of the marriage itself are the ways in which she was influenced by the internationalism of the Theosophical creed, which imbued her with the cosmopolitan flavour of a worldwide movement of orientalist 'spirituality.' We would do well to recall that the Theosophical movement had tap-roots stretching all the way back through New England Transcendentalism to early German romanticism, and thence to the artistic vision of Goethe himself. It was the vision of *Bildung*—an artistic-classical-spiritual refinement through education of the full human being. And it was this vision that was brought to bear on the founding principles of *Kalakshetra*, her 'Temple of Art,' whose basis should be the dance.

It is hard to know to what extent Rukmini Devi's apparent collaboration with Reddy derived from her own sense of tasteful classical restraint and, on the other hand, how far she was forced by circumstances to submit to conservative political moral dictates. What we do know, at any rate, is that she proved herself extremely capable of negotiating her way ahead through these difficult options in order to realize her own conception of classical Indian dance and its place in the world—so that, in the end, she was able to compel Dr Reddy's admiring assent to her work at *Kalakshetra*.

Throughout these years of struggle and compromise Gauri Ammal continued to teach the principles and spirit of the dance that were hers by hereditary right. The list of her illustrious students includes such luminaries as V.P. Dhananjayan, Balasaraswati, Kalanidhi Narayanan, Sudharani Ragupathy and Padma Subrahmanyam. In 1959 she was awarded the gold medal of the *Sangeet Natak Academy*. By then, despite her seminal and ongoing association with *Kalakshetra*, and her tutorship of some of India's most talented dance students, she was already experiencing the beginnings of a poverty that was to eventuate in penury. 'Of what use is this gold medal to me,' she later asked, 'who do not know from where my next meal will come?' She later sold it to meet her living expenses, though she was still teaching at *Kalakshetra* in 1963. By that time, too, her eyesight was failing.

The accusation often implied in the newest discourse on Gauri Ammal is that she was neglected in her old-age and in her period of greatest need by all of her former students and especially by Rukmini Devi. These trends of retrospective blame may well be fallacious.

88 ESSAYS ON CLASSICAL INDIAN DANCE

Paying tribute to Gauri Ammal near the end of his life, S. Rajam, the eminent musician, recalls that

> Gauri Ammal once came to All India Radio when her eyesight had dimmed and she could barely recognize me, but she patted me with great affection. She died a month later. My memories of Gauri Ammal are unforgettable—her majestic posture, her singing replete with *suswaram*, with *bhava* reigning supreme.

And earlier, in the course of the same conversation:

> I think Kalanidhi Narayanan was probably the first to learn dance from Gauri Ammal. Rukmini Devi came later, realized her worth and invited her to teach at *Kalakshetra*. Rukmini Devi provided her with every comfort and care.

A large clue to the reasons behind Gauri Ammal's penurious last years lies in a stark admission made by Dr Padma Subrahmanyam in an interview with Aruna Chandaraju in *The Hindu* (3 April 2009):

> The penury was caused by her drunkard son's wasteful ways. Gauri Ammal was teaching at *Kalakshetra* and also teaching many reputed dancers outside the institution. But all her earnings were thrown away on liquor by her son. The grand-daughter, who was her only support from the family, did not have enough money to buy even a garland for Gauri Ammal's body when she died. The last rites were performed by whatever was organized by Rukmini Devi.

A rather different and surprising picture emerges, then, from these first-hand accounts. They reveal to us a woman active in her art right up to the last months of her life They also point to the real nature of the tragedy under which she laboured in those final years. But I don't want to speculate on the involuted hardships that emanated from what should have been the bedrock-support of her own immediate family. I want to move on instead to consider what seems to me her inevitable and ineffaceable triumph.

The Triumph of Mylapore Gauri Ammal 89

Before venturing to explain myself on that score, however, I must provide at least some of the reasons why I think it was inevitable that Rukmini Devi should stand in the public vanguard as initiator and custodian of the revived classical dance, and why Gauri Ammal should have been kept so steadily and silently in the background.

At the realistic political level it seems clear to me that the support lent to Rukmini Devi by the Theosophical Society, potent in Indian politics as it was in those days, and by George Arundale himself, was one of the chief enablers of her ambitious and eccentric project. Combined with the empowerment of her own self-liberation from petty prejudices, such overt moral support placed her in a unique position in the contemporary culture, as it were above the fray. Through her shrewd capacity for dealing with worldliness, which amounted to a worldliness of her own, she was bound to stand out and take the lead from someone as inward and otherworldly as Gauri Ammal.

It was not that Rukmini Devi had an axe to grind with Gauri, whose classicism she had already openly admitted at that first recital in 1932, and whom she had invited to be her first teacher. There were no clashes of the notorious kind that she had with Balasaraswati. But Rukmini Devi had to steer a fine course between the public-political perception of a debased *sringara rasa* and the *devadasi* stigma that had by then been current for some decades. There was really no option but to keep Gauri Ammal out of the 'moral' glare.

As S. Rajam recalled with regard to one of his fellow artists:

> Not many know that the great Ariyakudi too learnt a few songs from Gauri Ammal. I accompanied him on his visits to her house. In those days it probably would have been disastrous to his career if this had been known! We can talk of it today, as it only goes to prove the superiority of her *pathantaram*.

But I want to turn now to some recollections of her former students, starting again with S. Rajam, who gave us probably the only fleeting account we will ever have of her grace and beauty as a temple dancer:

> I had the good fortune of seeing Gauri dance for the Lord's *aradhana* every day. Her dance costume was quite simple—

90 ESSAYS ON CLASSICAL INDIAN DANCE

pyjamas and an *uttareeyam*, ankle-bells and minimal jewellery. Her *punnagai* or smile was more bewitching than any *nagai* or jewels. It was a treat to watch her. Hands held just so, torso erect, she looked like a beautiful bronze icon. With her hands on her waist, she would begin to dance by taking lilting steps forwards and backwards. The musicians accompanying her would also move along behind her. Her entourage comprised the *nattuvanar* who also sang, a *mridanga vidwan* with his instrument tied to his waist, a flute player, Balu the clarionet player, and two or three persons playing the *kai talam.* Gauri would not perform without Balu and his E-clarionet ...

And Sudharani Raghupathy:

I had the good fortune to meet and develop further the art of *abhinaya* from doyennes such as Mylapore Gauri Ammal and Balasaraswati. I soon found that learning under them was anything but formal. After commencing with the primary piece, be it *Aasai Mukham Marandu Poche* or *Velavare*, Gauri Ammal would launch into an hour-long elucidation of the same *kirtanam* or *padam*. I would watch astounded as her creativity took flight and she embarked on these fascinating descriptions.

And finally Rukmini Devi herself:

To a certain extent, all her pupils have benefited from her. Yet there was something they did not capture. A particular posture of the body, a dignity of movement combined with grace and expressiveness of face which had an element of surprise all the time. These were some of the special features of her dance. Perhaps this comes from someone who has inherited by birth the quality which others are not able to have.

It is on record that Gauri Ammal would not teach in any home that did not receive her with the respect she considered her due, as well as that Rukmini Devi most certainly afforded her that respect. She was the dancer in whom Rukmini Devi first recognized the true Indian

classical spirit of dance, a recognition that re-moulded and tempered her own romantic-balletic first conceptions—false notions that she had drawn from her acquaintance with and admiration of Anna Pavlova. That Gauri was asked to become her first teacher at the late age of twenty-nine must surely have had an abiding impact on her subsequent development too.

The rest of the evidence assembled here, slender though it is, should surely convince us that Gauri Ammal was one of the foremost guiding spirits in the formation of the style that later became the *Kalakshetra-bani*, and that her contribution remains one of the strongest elements in this enduring classical genetic code. That her legacy dwelt for a while veiled within the person of Rukmini Devi might be considered a temporary tragedy, but only if we allow ourselves to forget the facts.

Mylapore Gauri Ammal brought the temple back into the 'Temple of Art' and ensured that the highest refinements of the *devadasi* tradition would not go entirely lost in the new secularization of dance. Her place and role in the transformation of Sadir into the Bharata Natyam that we know today is as sure as it is historically and undeniably discernible.

We can therefore say with reasonable confidence that, though she may be remembered or misremembered as a tragic figure, she will certainly not be forgotten. And, given the renown of the *Kalakshetra* form of Bharata Natyam in the world today, it is just as surely no small triumph to be perpetually remembered as its *devadasi* mother.

15

The Language of the Dancing Body in *Nritta*: Part One

In this essay I want to try to discover what kind of language is being spoken by the dancing body in *nritta*, and in what ways that language ought to be understood. I am confining myself to the language of the dancing body in a *nritta* recital because the *natya* and *nritya* modes are designed to convey certain discursive narratives and their accompanying images and sentiments whose meanings are pre-symbolized in the codes of dance. Thus, if in the course of a *nritya* performance we are presented with the *tribhangi* posture, with feet in the *dhanupada* and the flautist's arms and fingers, we know that we are being referred to Krishna. In the *natya* and *nritya* modes then we are to a large extent being addressed by means of a dancing sign-language whose meanings we can interpret easily enough if we are familiar with its significations.

In the pure *nritta*, on the other hand, we are confronted with a dancing body whose signs are not intended, or ought not to be intended, to convey any meanings other than those contained in the geometry and flux of the dance as pure dance, and from which all the language of drama is necessarily excluded. We are dealing, that is, with the language of the geometry and flux of a given form-in-motion, and

Essays on Classical Indian Dance
Donovan Roebert
Text copyright © 2021 Donovan Roebert / Photographs copyright © 2021 Arun Kumar
ISBN 978-981-4877-47-3 (Hardcover), 978-1-003-12113-8 (eBook)
www.jennystanford.com

15. Jessica Fiala, Ragamala Dance Company, Minneapolis.

with no other language besides. How then can we begin to decipher its kinetic-glyphic meanings?

I would like to turn for help here, as I have done in other essays, to the kind of language used in poetry, because poetry is in some ways the linguistic-literary equivalent of dance. It is dancing language. And for my purposes here I want to distinguish between two kinds of poetry, the mimetic and the imagist.

In mimetic poetry, whether narrative or descriptive, we are able to discern directly, by the usual processes of thinking and feeling, what the poet is saying to us—because the meanings intended in this kind of poetry can be written down as a statement or summary in prose.

The Language of the Dancing Body in Nritta

Though the language is raised to that of poetry, we are still essentially dealing with the kind of language which we normally speak or write in order to make ourselves understood through the usual usage of words.

In imagist poetry, however, we are confronted by a language made up purely of juxtaposed images, the flow and sequence of which have not the discursive logic of ordinary linguistic syntax but instead the logic of imagery-in-motion. Here is an example from T.S. Eliot:

Sightless, unless
The eyes reappear
As the perpetual star
Multifoliate rose
Of death's twilight kingdom
The hope only
Of empty men.

Now quite obviously this stanza offers nothing to discursive thought. We cannot hope to rewrite it in prose and try to get at its meaning in that way. It is a completely different and far more difficult language which speaks to a different and more obscure aspect of the reading, interpreting mind. What it offers to the surface mind is not much more than the images of eyes, a perpetual star, a multifoliate rose, sightlessness, and so forth, in addition to its stanzaic form and metrics, which we can analyze if we want to. But what then? We are left with a meaningless assemblage of linguistic units, with an *adavu* of language that proffers at the surface only its geometry, flux, shape, rhythm and pictorial imagist units.

As an *adavu* then, or perhaps as a short *jethi*, the discursive mind can discover nothing more in it than its elegance. If we wish to uncover its inner meaning, to force it to communicate with us in a living way, we have ourselves to turn inward and try to get at the sense of what it is saying at the subconscious, pre-discursive mental level. We have to grasp its logic in the areas of mind that precede ordinary, everyday logic, and which in preceding it reveal themselves as the obscure regions from which that logic arises into clarity.

Now in the language of the body as it is used in the *nritta* we discern a similar principle at work. The instruments of geometry, flux, metrics and rhythm are being used to communicate at the pre-cognitive level, at the level of the primal. In addition, this formal communication is enhanced by the lyrical qualities of the *hastha mudras* and facial expressions which belong to the special category of abstract *abhinaya* that is proper only to the *nritta*. What is at play before us, therefore, is a complex combination of geometric elegance and lyrical sensuality. At the primal mental level where it does its work, this combination-in-motion asserts a pre-logical logic of its own, a logic of sentiment whose task is to make conscious a particular flavour of experience whose meaning resides in the flavour itself.

In the *nritta* the dancing body is using the principles of geometry, flux, metrics, rhythm and *nritta abhinaya* as a composite force for generating and containing a powerfully concentrated lyrical elegance. In asserting this, let us pause to remember that geometry, rhythm and so forth are not human inventions but the discovery of certain inward principles that form the basis of human thought and sentiment. That is why it is in our nature to put them to use for both practical and aesthetic ends once we have found them in our primal subconsciousness and brought them to formal refinement through reflective thought.

But the dancing body departs from poetry (and here the analogy also touches it limits) in that it is a living body, alive and dancing in our presence. It differs fundamentally from poetry, which is a communication from mind to mind. The language of the dance is in the first instance a communication from body to body. This is as undeniable as it would be absurd to say that we experience the geometric flux of the dancing body in the same way as we do the changing patterns in a twirled kaleidoscope.

There is nothing at all abstract in the direct and immediate communication between dancing flesh and onlooking flesh. And this speaking from body to body is made all the more intense by the coded geometric concentration of physical lyrical elegance, which is the foundational method of dance, the method underlying the surface codes by which its methodical purpose is achieved.

And, though we usually do, we ought really not to blush when we write or read that, in the course of the dance, body speaks to body in

the language of body. Rather, we should tremble because the gateway to inner unity provided for us by the language of the dancing body is as undeniable as the force of *sringara* itself—a primal force that every one of us knows instinctively and intimately in him- or herself.

We could go on to speak then of the sublimation of *sringara* as though *sringara* could ever exist as a rarefied abstraction, as though knowing it in its essence could ever be similar to knowing and thinking about the kaleidoscopic patterns we recall after we have laid the kaleidoscope aside. When we speak of sublimation we are theorizing, not living in the presence of the dance.

Because, in the presence of the dance, being addressed in its language, we are really being driven not towards the abstract but into the primal regions, where union through *sringara* is both beautiful and terrifying. We need not wonder at this. Anyone stopping long enough to look closely and deeply at all its implications will know why it can and always must be as fearful as it is lovely.

Then, at this primal stratum of inward experience to which the language of dance has driven us, as poetry never can, we find the terror and beauty of *sringara* reconciled in a unity that we are used to calling *ananda*, bliss. And we all know, too, what that means.

But to speak in the language of devotion, of *bhakti*, we can surely agree that union with the divine, or with the living principle of what some call the divine, can never be an abstract matter. The mathematical formula for the deity, if such a formula existed, could not be the deity. It could only be an escape from the deity into a dead abstraction. It could not be the divine embrace.

Whereas the union with that living principle to which we are led by the language of the dancing body touches us at the very roots of our hair, and raises it.

16

The Language of the Dancing Body in *Nritta*: Part Two

In the essay immediately previous to this one I discussed the language of the dancing body in its communication at the level of the primal, and I said that this interaction occurred between body and body. I knew, however, even while I wrote it, that this could not be, and ought not to be taken as, the only kind of communication that occurs in the course of the dance. Still, I wanted to make what I have always felt was an obvious though largely avoided case for the primal language of classical Indian dance, and I wanted that case to stand alone there, and on its own naked feet.

In this continuation of my discussion of the language of the dancing body in *nritta* I want to try to comprehend the kind of communication that takes place, at the same time as the primal speaking from body to body, between the dancing body and the attendant mind—because it is at least as obvious, though certainly less controversial, that the observing mind is also being addressed by the body dancing within its purview.

Before looking more closely at this interaction I want to say at once, what I also insisted on in my previous essay, that I don't consider the communication between dancing body and onlooking mind to

Essays on Classical Indian Dance
Donovan Roebert
Text copyright © 2021 Donovan Roebert / Photographs copyright © 2021 Arun Kumar
ISBN 978-981-4877-47-3 (Hardcover), 978-1-003-12113-8 (eBook)
www.jennystanford.com

16. Ramya S. Kapadia and Kasi Aysola, Natyarpana School of Dance and Music, Durham.

be occurring in an abstract mode. While the dance is in progress and the *rasika* looks on, the communication is a living and palpable conversation, in which the dancer expresses herself and the *rasika* agrees—if the dance is any good—with what is being expressed by the dancing body.

Afterwards, as an exercise in mere criticism, we may resort to abstract notions of the theorizing kind. But, while the dancing body is speaking its language in an atmosphere charged with immediacy and directness, the communication can only be concrete, physical and existential because the mind is being appealed to by a living dancer

The Language of the Dancing Body in Nritta 101

dancing in codified motion. And it is precisely in this juxtaposition of the living dancer with the codified principles of the dance that we find the clue to the kind of communication that is taking place not at the primal but at the conscious level.

What we are witnessing here is the vivification of a set of lifeless principles through the living dance that brings them into quickened motion. This is akin to actually hearing the music that has until now only been codified in its score, the score which is the appropriate object, too, of any abstract analysis we may wish to undertake.

So that, in the vitalized oneness of code and dance, which we are experiencing in our minds while the dancer dances, we discover the first unifying mental principle offered us by the language of the dancing body. We are imbibing a kind of visual music, made alive in our presence by the resurrected quickening of the underlying musical notation.

More than only this, the things that are being made alive-in-oneness in our presence are the fundamental creative principles (as Pythagoras knew) of geometry and motion, the principles inherent in the shaping and quickening of the whole of the universe and the life through which its wholeness is known.

This then is the first act of unification represented to us through the body-to-mind mode of the language spoken by the dancing body.

The second act of unification comes through the creative aesthetic process by which these now vivified elementary principles are harmonized through elegant arrangement and constrained into a single continuity by the formalism of classicism. Classical dance is not arbitrary, not capricious. It is not a 'feeling out of forms and movements and hoping for the best.' It is form with a beginning, a middle and an end, and within this tested continuum it renders patterns of meaning proportionate to the principles of geometry and motion which it has brought to a splendour of livingness in the onlooking mind.

But even here, in the accomplished unification of principle with life and of life with harmonious arrangement—as in a living *mandala*—the unifying work of the dance is not brought to completion. It remains incomplete, even at this height of the plenitude of oneness, unless we discover what the language of the dancing body already knows and is already telling us through the rhythms of its dancing feet:

That both of these acts of unification come into existence and pass out of it again in accordance with the irresistible cycle that drives it, the wheel of being and not-being, the cosmic dance of Shiva Nataraja.

This cycle is the essence of the language of the dancing body, the aboriginal 'sound' which grants it existence as a living, communicating language in the first place. We can know this immediately and without recourse to philosophy because we know that the lifeless codes of choreography, which precede the living dance, are devised by a living mind in just the same way as the first principles of geometry and motion were put in place by the creative force that brought the cosmos into being. This cyclic continuum is the third act of unification impressed on the attendant mind by the dancing body.

And these three acts of unification—this triune miracle of art uniquely performed by the thaumaturgy of classical Indian dance— ride on the surface of the primal waves raised by the body-to-body mode of language, and calm them into *shantih*, or recollected peace.

To speak again in the language of *bhakti*, as I did near the end of my previous essay, we may say that the divine embrace transmitted by the dance at the primal level of *sringara*, through the visual 'music' transmitted from body to body, is lifted up to its concordant stratum of transcendence by these three essential mental unities, of lifeless principle with living substance, of vivified principle with harmonious arrangement, and of the unifying cycle that drives them into the oneness on which the language of the dancing body so elegantly insists.

17

Eight Unities Re-enacted in Classical Indian Dance

In my last two essays, *The Language of the Dancing Body in Nritta: Parts One and Two*, I wrote briefly about four unities re-enacted in *nritta* in the body-to-body and body-to-mind modes of dance transmission. But I was more concerned there with the language of the dancing body and the ways in which that language is used to convey the unities I briefly described. In this essay I want to list and cursorily analyze eight of the many re-enactments of unification that take place in the course of a classical dance recital. These eight unities achieved in the dance seem to me the most salient and vital ones, though I am sure that many others can also be detected when the dance is studied closely enough.

Before going on to elaborate a little on them, I must explain what these enactments of unification mean, what they signify and accomplish in both the dancer and the *rasika*, and why the idea of the weaving of unities in dance is such an important one.

The simplest and most well-known way for getting at this idea is by recalling that the dance, in its *dasi attam* purpose, is to enact the uniting of the *deva* with the *devi*, to both of whom the dancer has been spiritually wedded as a bride that is *nityasumangali*. This design for unification with the vitally divine has been carried over into the

Essays on Classical Indian Dance
Donovan Roebert
Text copyright © 2021 Donovan Roebert / Photographs copyright © 2021 Arun Kumar
ISBN 978-981-4877-47-3 (Hardcover), 978-1-003-12113-8 (eBook)
www.jennystanford.com

17. Tanvi Prasad (top) and Dr Aparupa Chatterjee (Artistic Director), Odissi Dance Company, Chappaqua.

grammar and intention of the secularized dances that we rightly call classical today. Indeed, one of the reasons for our calling them classical is that this prime motif of spiritual unification has not been disowned by them.

At the heart of the matter then is the *nritya*-ritual enacted to arrive at the unity of gods and goddesses and the sharing of that unifying experience with the *rasikas* who partake in it by themselves being present to the inner meaning of the dance, and to the living dancer dancing it.

This *dasi attam* enactment of transcendental union, though it is the primal one, is augmented and heightened in the course of the dance by the vitalized expression of the other unities, not only because these express philosophic-psychological and aesthetic truths in themselves, but because they are integral aspects of the act of primal union in the divine realm, which lies at the core of classical Indian dance, even when that primal act is not overtly displayed.

Each of these augmentative unities, in short, is integrative in an essential way, and interacts integratively with all the others to re-assemble and reconstruct the wholeness of the dance, whose essential purpose is the re-enactment of a cosmic holism resting on the primal union of all things, both inanimate and living, in and through the divine. The dance becomes then the re-enactment of all those creative cosmic principles and forces emanating from the creative divine, to which the dancer and *rasika* are also uniting themselves through the primal *dasi attam sringara* energy.

Let us now to move on to a short consideration of each of these unities in turn:

1. The unity of the individual mind with the mind of the divine

As outlined above, this is the mystic union of dancer and *rasika* with the universal creative force that 'dances' behind the veil of all appearances: the essential behind the phenomenal. In the first steps of the classical dance it is acknowledged by paying homage to it, and by dedicating and submitting the whole of the subsequent recital to revealing it through embodying it. This force is personified in such deities as Shiva but we may conceptualize it as an unconscious creative personal drive (if we wish to confine ourselves to the debilitated notions of modern psychology). In religio-mystical terms, however, we ought to understand the *deva* and the *devi* as existing in their own right, though inseparable from the individual mind perceiving them.

2. The unity of the dancer with the rasika

Here I am referring to the physico-mental union of dancer and onlooking *rasika* that takes place by means of the intimate sharing of the dance. This sharing cannot be other than intimate—it cannot be

abstract—because it is an interaction between two living beings united in a single creative corporeal and mental endeavour. Not only is this dancer-*rasika* union the vital and vitalizing symbol for the mystical union with the divine; it is experienced also as the intensely alive human bondedness that occurs when two or more people are striving to realize, through a shared act of beauty, their oneness with the essential creative force: when their dancing together is a common reaching for its comely presence.

3. The unity of abstract code and sentient being

As I have discussed in part two of the essay mentioned above, this is the unification through dance of the dead letter and the living being, through which unification the blueprint for the dance—its choreography—is brought to life by the revelation of its patterns in living motion. It is akin to the written musical score being brought to life by being performed and heard. The musical score can never be known in its living manifestation by those not having ears to hear, just as the dance can never be known by those who do not have eyes to see. Moreover, this union in dance of dead letter and living soul, through which the dead letter is granted physical and psychic life, reflects the way in which the underlying design of the living cosmos is given meaning and fullness through its physical and mental manifestations and through its being perceived by mind: a cosmic design which the dance accurately reflects in its reliance on the underlying universal principles of geometry, flux and rhythm.

4. The unity of vitalized principle with harmonious arrangement

In this unity the blueprint for dance that has been brought to life by the dancer is made one with the balanced, elegant and harmonious language of the classical dance. It is clothed with a form that is both lovely, meaningful and good: the dance does not unfold its patterns and rhythms in an arbitrary, futile way, but is imbued with meaningful signs that are a reflection of the meanings with which we human beings endow all of existence and the lives we live in its context. Furthermore, the code of classicism places necessary constraints on

the shapes and metrics through which this arrangement of meanings is conveyed, so that we are together enabled to speak and understand a common language whose transmission of meaning does not spill over into gibberish. This, too, is a trait inhering in any means of agreed communication, and is no small element in the forging of our common humanity. If we all tried to express the same meaning in a language that knew no limits to the meanings its words implied, we would have no means of communicating at all. And commonality of language, together with its precisions and agreed ambiguities, is one of the most necessary constituents of classical form both in art and in life. The visible form of this harmonious arrangement and its constraints is conveyed in the dance by the harmony of all the parts of the dancing body and its balanced motions through time and space.

5. The unity of form-rhythm and space-time

This unity and its functions are more easily grasped when we understand that form and rhythm exist as a simultaneous and inseparable continuum in the same way that space-time does. Every form vibrates with an inner rhythm and every rhythm gives rise to its appropriate form. This is why we legitimately speak of the rhythm of a visual pattern or of a work of art, and of the rhythms that infuse and inform the universe, its life and the minds proceeding from that life: the rhythms of the seasons of existence itself. In the dance, the inherent unity of form and rhythm are made explicit at the very root of the art. Without this unity the dance could not exist any more than the existential realm in which it exists. More than this, it is our perception of the balanced presence of rhythm and form throughout our universe that makes our world seem beautiful to us, because it finds an echo with its rhythmic-formal counterparts in our own minds.

6. The unity of the expressive arts

In classical Indian dance all the arts are presented and made to flower for us in the course of single unified recital. There are music, lyrical poetry, story, the pictorial and tactile arts, and of course the dance itself. All of these are brought together in augmentation of the art of dance which they necessarily subserve, and which could not be performed

unless they served it. Now this bringing together in one place and in one sitting of the whole repertoire of artistic forms is representative of the universal oneness of and interaction between sound or energy, visible manifestation or light, and the verbal Word, whose essence is meaningfulness. For us *rasikas*, the unification through dance of these fundamental arts is a way of addressing and satisfying our correlative human senses in the course of a single composite artistic act, and in so doing to emphasize the singleness of our senses themselves in the mystical-aesthetic experience which we are undergoing. And here is further proof, if proof were needed, that the path of dance towards the ineffable is bent on engaging both dancer and *rasika* by sensual and sensuous as well as mental and transcendental means. Otherwise any of the arts would be useless for this purpose; we would have to resort to abstract philosophy for accomplishing a lived, personal experience of cosmic unity, only to discover that this is a service which philosophy alone cannot possibly render us.

7. The unity of the male and female principles

It is well known to dance scholars (and probably to many dancers and *rasikas* too) that dance before the *shivalingam* was part of the temple-dancer's ritual from earliest times. This fact is one of the most certain pointers to the conjoining of *sringara rasa* and *bhakti* in a ritual act of dedication. And, because there is nothing to wonder at in this fact, and because this conjunction is so well-documented, I see no necessity for dwelling on it here. I would rather make use of a less esoteric instance, that of the interrelatedness of the *lasya* (gracefully feminine) and *tandava* (virile and vigorously masculine) modes of classical dance. It is said that Nataraja himself introduced the *tandava* mode as a necessary pole and potential in the counterpoint of the *nritya*. We can easily see why this should have been so: this basic unity-in-polarity reflects not only the progenitive aspect of the cycle of existence but also the sustaining tensile forces at work in cosmic physics and metaphysics. Without acknowledgment of this fundamental principle all the other unities would themselves be thrown out of balance.

Eight Unities Re-enacted in Classical Indian Dance 109

8. The uniting of all the unities in the cycle of being and not-being

In this final and inclusive act of unification re-enacted in the dance, we are made aware of the *samsaric* cycle in accordance with whose dancing wheel all things come into and go out of existence. The universe itself is always emerging from and returning to the vacuum, and we human beings pass from the dance of life to the abstraction of death by whose blueprint other lives are danced into existence again. It is the dualistic dance of *Shiva-Shakti* into whose details I will not enter here. In the dance we see it enacted in two main ways. In the first we are brought to recollect, by the rhythms of the *ghungroos* and the steps of the dancing feet, that there is an abstract pattern, a pattern full of potential yet having no life in itself, from which the dance draws its life and meaning. In the second we perceive the dance coming to its end in the finitude of the recital, so that all we have left is a mind infused with *rasa* and a remembered dance that is no more. Only the choreography remains intact, awaiting yet another quickening. In this cyclic uniting of all the other unities we espy, too, their inherent interrelatedness and interdependence, just as in the dance each major and minor limb moves in interdependence on every other.

Postscript

It will be obvious that my treatment of the unities discussed here is neither systematic nor exhaustive. I have only cast some small light on their meaningful presence in the dance and on the fact that they are present at all, a fact that is often and surprisingly unknown.

It seems to me that both dancers and *rasikas* would do well to contemplate their hidden presence as essential and potentializing forces in the classical dances which they so thoroughly inform, even when the dancing dancer is not aware of them.

18

Five Ways of Dancing That Get in the Way of Dance

In every art there are perils of exposure which mar it by getting in the way of its full flowering, its *dharma*. I am not speaking here of the kind of forgiveable errors we usually associate with inexperience, immaturity of expression or the sort of over-confidence that confuses ease of execution with accomplishment, although these faults may persist even in dancers of outstanding ability. I am referring to errors of judgment, rather, that may insinuate themselves quite unconsciously and as it were innocently, into any artist's mature and serious practice.

The first flaw is that of ostentatious technique, in which an experienced and able dancer flaunts her technical skill at the expense of the underlying design which the technique has been invented to reveal. Virtuosity gets in the way of what is classically impersonal and impersonally subdued, and we are left with only the superficial layer of artistry that confuses the means with the end. It is of course a question of balance: skilled technique should be brought as perfectly as possible into alignment with the force of the inner design whose revelation it is meant to serve. Otherwise technique ceases from being a skill and becomes instead a self-serving feat which, while it may draw admiration on its own account, leaves the rest of the art stranded and suppressed

Essays on Classical Indian Dance
Donovan Roebert
Text copyright © 2021 Donovan Roebert / Photographs copyright © 2021 Arun Kumar
ISBN 978-981-4877-47-3 (Hardcover), 978-1-003-12113-8 (eBook)
www.jennystanford.com

18. Maithili Patel, Gurukul Studios Dubai, Bangalore, Zurich, and Taalim School of Indian Music, Montclair.

in the background. Adequate technique is recognized by its being transparent enough to allow unimpeded access to the inward substance for which it is the outermost sign. Only then can it be appreciated for what it is in its true nature and rightful place.

The second flaw is that of the inadvertent revealing of devices, which is like the illusionist's exposure of his own tricks. It takes away the magic of the created illusion by destroying the basis of its credibility. In the context of dance I am thinking of such elements as *abhinaya* and *bhava* and of the control of geometric flux. Their credibility is annihilated by imbalances obtaining between outward expression and inner conviction, when, for example, full *abhinaya* is not supported by a

fully convinced *bhava*, and we are confronted by a lifeless mask. We see only the trick riding helplessly upon a palpable absence of inspiration. In the case of geometric flow, which is the device enabling us to believe in the continuity of the thing being expressed, and which is a form of *abhinaya* in its own right, we are left with only a streaming motion going nowhere in particular because the dancer has no belief in the goal towards which the dancing pathway is unwinding itself. Devices that ought to be hidden from view are thus laid bare in consequence of bad faith and an intellectual dishonesty whose first causes often lie in choreography.

The third flaw is that of excessive vocabulary through the misuse of which the dance is rendered disproportionately gorgeous in its grandiloquence or 'wordiness.' Its essential fault is that of luxuriousness. The classical dance, like any other classical art, has its own proper language whose communicative units have separately to be used in a sparing balance exactly sufficient and proportionate to the narrative meaning or descriptive image they are intended to convey. Thus we may see *bhangis* which are far too deep in exaggerated service to a lyrical sensuousness displayed for its own sake. Or we might encounter rapid sequential flourishes of *hasthas* and *bhedas* which in the ostensible service of plenitude attain only a sort of garrulousness. We can no longer hear the thing being said because there is too much utterance.

The fourth flaw is that of blatant authorial intrusion. Any experienced reader will know how novels are degraded when authors use their characters, plots and stories merely for putting across their own ideas or ideologies: the result is that their puppet-protagonists and contrived narratives are left with no convincing life of their own. In the dance a similar danger is approached when the dancer insists on visibly obtruding her own personality across the surface of the thematic repertoire. Of course we do not mind the occasional spark of personal presence and interpretation or even its constant lurking beneath an appropriately subtle veil—what would the classical dance or any other classical art be without this kind of irony and wit?—but personal imposition at the cost of the stringent impersonality and impartialism of the classical form is always a lapse of taste. To the extent to which it places us at the disposal of the dancer's personality it removes us from contemplative converse with her art.

The fifth flaw is that of over-insistence on personal style. In this context we are immediately led to think of the kind of musical performance in which the solo instrumentalist has his own detrimental way with the composer's original work. He speeds up or slows down the tempo for instance, or insists on incorporating flourishes of his own. If only he can add a grace-note or two, he feels that he has improved on Bach. Now, far be it from me to make the case that the *shishya's* only purpose is accurately and pedantically to reflect and recreate her guru's style *ad infinitum*. I do not believe this for a moment. It has nothing to do with the creative spirit of either classicism or the *parampara*. No, *shishyas* who have come of age, who have come into their own right, have a duty to add their own layers of style to the stylistic forms they have received. In the genuinely creative classical dancer these augmentations can hardly be avoided. Dancers will be compelled by their own informed instincts to add their own 'touch.' But this touch becomes a peril when it is insistently brought to bear in places where it cannot possibly add any lustre to the forms that have been handed down. I am thinking now, as an obvious example, of the kind of *gati* whose curvaceous flow, though ever so high-hipped and laden with *sulu*, is yet so impregnated by an inappropriate personal idea of graceful 'style' that it becomes a parody of itself.

These lines from T.S. Eliot's 'Little Gidding' spring to mind as a fitting summary of what I have said above. They also serve as a perfect example in poetry of the proportionality after which classical dance ought always to strive:

> The end is where we start from. And every phrase
> And sentence that is right (where every word is at home,
> Taking its place to support the others,
> The word neither diffident not ostentatious,
> An easy competence of the old and the new,
> The common word exact without vulgarity,
> The formal word precise but not pedantic,
> The perfect consort dancing together).

19

The Preservation of Classical Indian Dance in Postmodernity

It would be hard to argue that the mindset of any given era doesn't influence, for better or worse, the arts that are created and practised in its atmosphere. To the extent to which that mindset is revolutionary it will want to revolutionize, in the measure in which it is conservative, to conserve. The worldview of postmodernism is at root an agitated, activist, revolutionary one, and the classical Indian dances are not, for all their classicism, impervious to its spirit. I had better admit at once then, before going any further, that it is a spirit which I consider largely pernicious and injurious to the inward purity of all that is traditional.

Its traces are becoming increasingly apparent throughout the register of writings on dance, colouring the idea of classical dance—which ought to be a pure idea—with such extraneous impositions as identity and gender politics, 'social justice,' radical intersectionality and all the other what-nots derived from French postmodernist critical theory and its hypercynical critiques of culture and art. It is no wonder then that the most blameworthy texts in this mould emanate from the academic milieu, where novelty, 'originality' and virtue-signalling cant are prized above true scholarship.

Essays on Classical Indian Dance
Donovan Roebert
Text copyright © 2021 Donovan Roebert / Photographs copyright © 2021 Arun Kumar
ISBN 978-981-4877-47-3 (Hardcover), 978-1-003-12113-8 (eBook)
www.jennystanford.com

19. Kuldeep Singh, multidisciplinary visual and performing artist, Brooklyn.

The Preservation of Classical Indian Dance in Postmodernity 117

I can't spend time here enumerating the follies that pass for legitimate disciplines of study in postmodern academia, and which are passed on willy-nilly as 'expertise' by the unreflecting media. Readers interested in my treatment of this subject are referred to my extended essay, *The Bearing of Culture on an Inhumane Society*, which is available in printed form and online. I have said there all that I probably ever will say on the vitiating impertinences perpetrated on culture and the arts by a trend whose keynote is radical superficiality. My concern here is only to address specifically the problem of loss faced by the classical Indian dances and how they may be preserved against this corrosive tide.

The first and most obvious route to loss is that in which a classical entity is wiped from the face of the earth in a sudden lapse into extinction that follows on a protracted period of gradual decay and neglect. We might argue that this is no longer possible in an age of information-storage such as we have never seen before. But I am not at all convinced that the mere retention of information is a sure safeguard against the death and mummification of an art that was once robustly alive.

The second type of loss is that which occurs when a classical tradition is dismembered and then buried beneath a cumulative slag-heap of irrelevant commentary, extrapolation and quasi-criticism, so that the aboriginally pure and concrete object of critique fades almost imperceptibly from sight and is visible only as a dim reminder of an art that once existed in its own right and not merely as an occasion for critical debate. Where once there was a dancer there remains only a dance theorist.

Politico-cultural repudiation is the occasion of the fourth kind of loss in which a traditional art-form is defaced or destroyed outright in an iconoclasm aroused by some new notion of artistic value and public morality (because these two are always inseparable), peddled usually through politics and the academy. Two evils normally flow from this: The wholesale rejection and abandonment of the art-form or its being forced to conform, by shedding the most indicative aspects of its classicism, to the new ideal that has by this time been established as the received wisdom of the uncritical mob. The keynote here is the

adulteration of the classical tradition through violation by an ethico-political ideology which always disposes over its own ideas of art.

The fifth form of loss comes by the introduction of heedless novelties which, in a climate of shallow intellectual activism, are transformed into a celebrated norm. There are many reasons, some of them ostensibly unavoidable, why this enfeebling trajectory should be embarked on in the first place. Not the least of these are pragmatic ones having to do with a perceived need to make a classical form more accessible to the paying public by updating it in accordance with the public taste. But there exists too, of course, the persistent force of the misguided notion that what is new and untried must necessarily constitute an improvement on what is old and tested. Now, while genuine innovation indwells the very soul of the classical, it is distinguished from mere novelty in that it grows naturally from the classical soil which brings it to birth and nourishes it.

The means for the preservation of classical Indian dance in a postmodernity that I have characterized as largely pernicious lies therefore in the effective countering of these five paths to loss. This means avoiding the several pressures they exert on the purity of the classical forms and philosophy in order, if not to break them entirely, at least to bend them into conformity with postmodern prohibitions and approvals, if only for the few decades normally needed to efface a traditional entity outright.

The task of preservation ought obviously to fall in great part to theorists and critics, not only in the academic sphere but also in the media and in the field of independent research. To the extent to which their commentaries become increasingly obscure, wayward and cleverly recondite, usually at the expense of real erudition, the original classical forms and their intentional values are withheld from the public consciousness. And, if authentic classical Indian dance is no longer entertained in a sufficiently large cross-section of the cultured public mind, its meaning, values and standards are bound to decline into petrifaction. Because a classical form can have no life to speak of once the cultured public no longer cherishes it in a living, conscious and contemporary way. It becomes then a matter of immense importance that writers about dance find the insight and courage to comment on and document the dance in a measured but purist voice.

Teachers of dance are under the same obligation, and well they know it, though they sometimes disavow it for expedient ends. But, above all, the preservation of true classicism lies in the hands of the dancers themselves, once they have been enlightened by the spirit of classicism. If they fail to nurture and even to cosset this spirit by the rigorous upholding and propagation of its outward embodiment, it is hard to see who else will remain to do the job.

I will end by making the self-evident observation that classical Indian dance is particularly fragile amid the general fragility of all the other classical arts. Its resuscitation during the last century or so has had to rely heavily on renewal, reconstruction, reformation and, I must suppose, on a good deal of educated guesswork too. For this reason there is a real sense in which it is still a work-in-progress. And, this being the case, it is all the more vulnerable to undue influences ranging from misapplied scholarly research at one end to the absorption of whim at the other. It faces, too, the ongoing danger of unwarranted adaptation to new contours, lines and streaks of fashion assailing it from newly-emerging cultural trends in India, as well as from abroad.

20

The Tenacious Survival of Classicism in Indian Dance

In setting out to explore briefly the idea of the survival of classicism in Indian dance, it would be less than honest of me not to admit that I make no pretensions to any degree of scholarly insight here. I am approaching the subject as a layman and a *rasika*, recalling rather than re-examining the books and articles which I have read on this topic across the years. Apart from these books, which I don't have at hand as I write, I am relying on some personal convictions which inform my own opinions about the history of the dance. These have their origins not only in my personal readings but also in other cultural readings through which the appreciation of both classicism and orthodoxy are awakened in a critical mind.

Anyone wanting to make sense of the ramifying continuities of classicism as they are evinced in the dance today must resort in a preliminary way to a simple classification of several broad streams of historical tradition which have their fountainhead in Bharata Muni's *Natya Shastra*. It is in this treatise from the late 2nd Century CE that we find the first mention of the two foundational dance traditions of the *margam* and the *desi*.

Essays on Classical Indian Dance
Donovan Roebert
Text copyright © 2021 Donovan Roebert / Photographs copyright © 2021 Arun Kumar
ISBN 978-981-4877-47-3 (Hardcover), 978-1-003-12113-8 (eBook)
www.jennystanford.com

122 ESSAYS ON CLASSICAL INDIAN DANCE

20. Shinjini Kulkarni, Lucknow Gharana Kathak dancer, disciple of Pandit Birju Maharaj.

The *margam* was a strictly codified system of dance that would probably have been performed in a similar way throughout those parts of India which knew and practised it. It is thus the earliest form of codified dance of whose existence we reliably know and of whose postures we have certain knowledge through the sculpted preservation

The Tenacious Survival of Classicism in Indian Dance 123

of its 108 *karanas* on a number of temple panels. But we know also, through the convincing research carried out by Heather Lewis* and others, that the *margam* form of classical dance had disappeared from view well before the middle-ages, and that it is the *desi* or regional forms which actually survived to shape the secular classical dances as we know them today.

Before passing on to the *desi* form, however, we must make the qualification, as touching the *margam*, that it constituted the formal classical basis for both secular performances on the public proscenium and for the ritual temple dance whose practice in the shrine-room was normally hidden from public view. We may therefore speak of the *margam* as divided, at least in terms of the uses to which it was put, into a ritual-religious practice on the one hand and a secular recital on the other. In its secular uses it regularly formed part of the dance-dramas whose particularities are described and indeed prescribed in Bharata's *Natya Shastra*.

The *desi* tradition, meanwhile, was being formed and performed alongside it, as an alternative and probably more popular form of dance adapted to regional preferences. It is likely that both the *desi* and *margam* styles were enjoyed at the royal courts, usually as an enlivening but also as a sanctifying element contained within the dance-drama, the *natya* of Bharata's time. But it is probable too that both *margam* and *desi* were performed as dance for their own sake.

At any rate, we are left with two basic dance styles, or ideas of dance, the one set in stone and the other evolving, that make up the two broad aboriginal streams from which all the classical dances we know today derive the historical right for asserting their classical beginnings.

The *desi* goes on to become the varieform basis for the various 'modern' classical dance styles, while the public aspect of the *margam* dies out completely—with the exception of some 16 or so *karanas* still in use later—and its temple-dance aspect goes underground and disappears from sight too.

By the time of the writing of the *Abhinaya Darpana* (1000–1500 CE?) we are dealing with classicized regional dance forms that owe very little to the *margam* in terms of particularized codes and forms.

*Heather Parker Lewis, *The Space between the Notes* & *Dance of Bliss*, Ihilihili Press, Cape Town.

We are in the age of a new classicism almost wholly derived from the *desi* dances but influenced largely, too, by the *devadasi* temple dances still being practised in a number of areas (and especially in Tamil Nadu and Odisha) in which the renewed *desi* classicism was coming into its own.

So that, by the time this new classical derivation was being reformalized and refined by the genius of the Tanjore Quartet in the early 19th century, we are left with only two actively surviving classical traditions, that of the revitalized secular *desi* forms and that of the *non-margam* temple dances being practised concurrently with them. The secular forms that stand out for us are *Sadir* and *Odissi*, and the Mughlai *Kathak* style with its recognizably Persian influence. And all the while, in the unseen background, the temple *dasi attam* of the *devadasis* and *maharis* continues on its own persistent way.

Then suddenly, from the late 19th to the early 20th centuries, the attack on the classical dances is initiated and gathers momentum under the quasi-moral and officious disapproval of various social reformist movements. Both the secular and the temple dances begin to wither as patronage is withdrawn and patrons deposed, and as the cumulative taint of public scorn is added to real exigency. The secular dances lose status and visibility while the temple dances struggle to survive and go into virtual hiding amid the new moralities and political foment that have taken over the foreground of Indian cultural and civic life.

It was into this dire situation that the revivalist movement had to make its circumspect way in order to rescue and reconstruct what it took, on its own terms and by its own standards, to be genuinely classical in Indian dance and therefore genuinely worthy of resuscitation. So that the secular dance forms that we recognize as classical today are largely the result of their choices, views and notions of classicism, strongly influenced as these no doubt were by a variety of upper-class cultural and political prejudices together with their associated pragmatic considerations. One inevitable result of these agitations was the suppression of the *devadasis* and their ritual art.

To say that the revitalization of secular classical Indian dance took place at the expense of the temple dancers is only to tell one part of a truth that is no doubt true as an aspect in itself. But it seems to me

at least as true that the *devadasi* and *mahari* lineages had long-since fallen victim to a variety of historical forces which could not have been reversed even if the revivalists had wanted to reverse them—which clearly they did not. But this is material for another discussion.

Nevertheless, the temple dances surreptitiously lived on, determined, it seems, to outlive the transitional period, relatively brief in historical time, during which they were viewed with public distaste and effectively outlawed by government decree. Today they themselves are being revived in an atmosphere of public, scholarly and political approval.

But what is the point, for a layman like myself, in rehearsing this brief overview, with its vast omission of details, of a ramifying and variegated classical tradition that is still subject to cautious and incautious development, and to argument, strife and faction, and whose canon is therefore still far from closed?

The first point is that I am able to say, in order to reassure at least myself, that this is a classical tradition that is still very much alive and evolving and therefore in a condition of sufficient vitality to defend its living dialectical classicism. It is hardly short of a miracle that the classical Indian dances have not been reduced to a few barely legible texts and some scattered archaeological remnants. Their stubborn resistance to final petrifaction is surely a triumph of a kind that no other classical art-form in the world can celebrate with any conviction.

The second point I want to make is that there really is no room for activist factionalism of the kind that seeks to disrupt, displace or destroy any of the classical dance forms that so splendidly exist for us today, whether they have come into renewed existence through means that we now judge unjust or expedient, or whether, as struggling victims of history, they have barely survived the storm.

They exist and are alive in our living presence. What reasons can we then worthily entertain for harbouring any factional bitterness, seeing that these dances have together survived—by any and all means, it is true—the abrasive forces of the dance of life itself?

21

The Humanization of Rhythm and Form in Classical Indian Dance

Let us begin this cursory examination of the interdependent operations of rhythm and form by looking at a simple abstract example, that of the triangle, of which we know that its rhythm is made up of three points, or beats. We can experience how these points become beats by moving our eyes from one point to the next until they come to rest at the third: *tha*. In so doing we experience at a fundamental level how form is infused by a structural rhythm, even when that form is an abstract, silent one.

If we wish to change the form of a triangle into that of a square, we can only do so by introducing, from outside, one extra point, or beat, which we may call *mi*. When our eyes now follow the four points of the square, they come to rest when its four beats have been completed: *tha ki de mi*. These beats are moments in time of like or varied duration, and are the temporal equivalents of points in space.

In three-dimensional forms, such as the cube or pyramid, there are a correspondingly greater number of beats reflecting the greater degree of complexity inherent in their shapes. We can say that the formal rhythms have become not only more complicated but more involved in the reciprocal interactivity needed to achieve the complex

Essays on Classical Indian Dance
Donovan Roebert
Text copyright © 2021 Donovan Roebert / Photographs copyright © 2021 Arun Kumar
ISBN 978-981-4877-47-3 (Hardcover), 978-1-003-12113-8 (eBook)
www.jennystanford.com

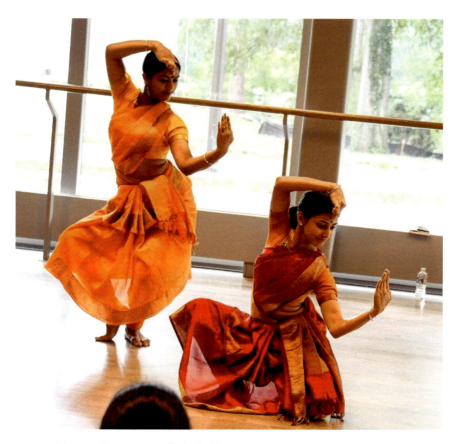

21. Urmila Basu Mallick (left), Nrityagram Dance Ensemble, Holden & Akshiti Roy Chowdhury (right), student of Guru Bijayini Satpathy, Bengaluru.

outward form. We see then the inseparability of form and rhythm both structurally and kinetically, and in the motive dynamics that bring structure into motion.

Working on the same principles as these abstract rhythm-form complexes, there are a number of such complexes operating in nature too. There are mechanical rhythms bound up with inert forms, such as stones, rocks or lumps of metal, and these rhythms gain in complexity when inert forms become fluid, as they do in molten rock, water, or vapour. But even while these transformations are happening, the

The Humanization of Rhythm and Form in Classical Indian Dance 129

principle of the weddedness of rhythm and form, though its dynamic is changed in the process, remains irremovable and immutable.

Of course this dynamic becomes infinitely more complex when applied to the human body and mind. There are vital rhythms of infinite combination informing a vital body. And there are rhythms of human mentation that shape the infinitude of human consciousness. But still the principle of the inseparable unity of rhythm and form remains intact.

It remains intact throughout all the manifestations of shape and motion in the dance of life. It operates in and through all existent things and beings, and inheres in the coherent principle of the fact of existence itself. At least part of the answer to the question why there is something rather than nothing is that rhythm and form exist inseparably as twin aspects of the something that does exist.

We human beings are living forms sustained by living rhythms. It is easy to confirm this merely by looking at our biochemistry: at every level, from the DNA through the enzymes and onward to the larger organic and physiological structures, all our biological processes are informed by a myriad interlocking beats: the *bols* that infuse and enliven the growing, changing shapes we assume in the course of our lives in nature. We live in a form informed by the natural rhythms which arise in dependence on the primal rhythms undergirding and infusing the fact of existence itself.

Therefore, we know dance—because we are made of dance and live in, through and by it. It lives in us before we ever encounter it outside ourselves, and even if we never do. But, if we do dance, we dance in the first place because dance is at home in us as a fundamental principle of nature. If this were not so, there would be no dancing.

We have spoken, then, of abstract, mechanical, vital and mentational rhythm-form complexes. And we have seen how these interact with one another inseparably to bring things into being and to sustain them there. And we have seen how the influence of a rhythm inserted from outside a rhythm-form system can alter its shape by modifying the number of its beats, its metre.

But there is more to rhythm than only its potential to bring about a variety of static changes in form, an unending sequence of frozen *karanas*. And though we know this is so because it is intuitively obvious

to us, it is nevertheless important to add that rhythms in a vital system initiate and govern the movements that system is capable of making, and actually does make, as it moves through the medium of rhythmic time—because, for us human beings, time is rhythm. We may say, even before we have said this, that the degree of complexity in the rhythm-form structure determines the point at which an inanimate thing is transformed into a living being.

Such, then, in short, are the natural powers of rhythm and form which are captured and put to use in classical Indian dance for the purpose of humanizing them. But what do I mean when I say this?

In order to get more easily at the idea of the humanization of nature, let us consider first the ways of its unhumanized forces. We know them as powerful and ultimately mysterious, no matter how much detailed insight into them has been given us by science. And though we have been to a very large extent enabled by scientific knowledge to protect ourselves against any number of natural existential threats, we remain powerless in the face of its chief caprices, including love, the many forms of human suffering, and death.

The nature of nature is a tragic one: it offers us no guarantees against the sorrows and terrors it still inflicts on us despite our vast increase in knowledge and its associated technologies. We remain in a natural world that is unpredictable and dangerous even when its beauties and goodness are most apparent. Art, then, is one of our means for humanizing nature by representing it in ways that are ordered, secure, safe and lovely—and these ways serve as indicators for the manner in which we may live lives that are dignified and beautiful, still submitted to nature but also transcending the effects of its chaos and sudden terrors of loss.

In classical Indian dance such humanization is achieved through the stylized manipulation of rhythm and form. The rhythms of the dancer's natural form, of its vital and spontaneous shapes and movements, are transmuted and controlled by the introduction of external rhythms and made to conform to a stylized geometric flow which radiates its own array of codified meanings.

These meanings may be either verbal or non-verbal. We may be able to describe them in words or we may not, depending on the type of dance to which we are attending. The *nritta* relays to us non-verbal

The Humanization of Rhythm and Form in Classical Indian Dance 131

meanings because it is the pure language of dance, the language of pure rhythm and form. The *nritya* on the other hand conveys to us meanings, such as the story of Krishna and Radha, or Sita and Ram, which we can repeat to ourselves in words.

In either case a meaningful humanization of nature is taking place through a stylized compression of rhythm and form and their containment within a humane framework of proportionality. The capricious, overbearing and overpowering ways of nature are being retold in a humanizing manner with the restraints, qualifications and meaningful aesthetics proper to the classical form.

The excellence and effectiveness of the classical Indian dances in this regard lie in their balanced subtilization of a very raw and basic geometry best suited to the revelation of its own inward interrelatedness to the cosmic rhythm-form dynamic. In utilizing geometry at this level of obviousness and clarity, Indian dance is uniquely able to achieve a stylization that, despite its stylized angularities and curves, and indeed because of them, demonstrates its unity with the formal forces that permeate and underpin nature. It is a not, therefore, a primitive type of stylization. The subtleties it attains through its careful and complex rhythmic systems bring us to a sort of double-vision in which what is natural and what is stylized themselves become inseparable. And this is the ultimate degree of its humanizing work

Ultimate because it is able to take us away beyond this refinement of its achieved stylistic-natural monism to the living principle that is its source, the rhythmic-formal embodiment in dance of the *deva* or *devi* as *avtaar*. In other words it is empowered by its own consciously structured rhythmic formalism to bring home to us the idea of humanization in its highest meaning, instilling it in us by portraying it.

Beyond this point, to which the dance is eminently suited to lead us, we may, if we are able and if we are ready, go on to touch the ineffable realms where rhythms and forms have their unknowable origins in a rhythmless, formless infinitude.

I would like to end with a personal finding, which may be disregarded if it doesn't ring true:

It seems to me that, in its unique use of the mnemonic syllables, the *bols* or *sollukattus*, classical Indian dance evinces a profound

comprehension and achieves the most compact expression of the indissoluble unity of rhythm, form and meaning through an uttered, versatile mantra.

When the dancer dances on the *bols* the whole of cosmic nature is humanized instantaneously along the thread of their beats. We know it, and succumb.

22

The Problem of the *Pushpanjali*

We know that the *pushpanjali*, the ritual offering of flowers to the deities at the start of the *natya* (dance-drama), has been an integral part of the staging of classical dance since Bharati Muni first recorded the practice in his *Natya Shastra*. The *pushpanjali* or *angahara paryastakah* is there situated, as it still is today, at the outset of the performance, and as the second of the *angaharas* to be danced as a ritual introductory to the other dance movements performed for the sanctification of the drama, its producers, the actors and dancers, the audience, and the stage. Insofar, then, as we can speak of those early dance-dramas as secular pieces—at least to the extent that they were performed for a various public, outside of the ritual temple practice—they were regularly preceded by the offertory *anjali*.

We must assume that the *pushpanjali* was an indispensable part of the temple dancer's ritual-liturgical-devotional dance from earliest times as well. It seems self-evident that Bharata's dance sequences for sanctifying the stage were adopted and adapted from a temple tradition that preceded from time immemorial the public *natya-nritya* spectacles.

It was natural that this *anjali* should be incorporated into a dance-drama believed to have been given to the world as a purificatory religious practice rather than an entertainment in the first place. The

Essays on Classical Indian Dance
Donovan Roebert
Text copyright © 2021 Donovan Roebert / Photographs copyright © 2021 Arun Kumar
ISBN 978-981-4877-47-3 (Hardcover), 978-1-003-12113-8 (eBook)
www.jennystanford.com

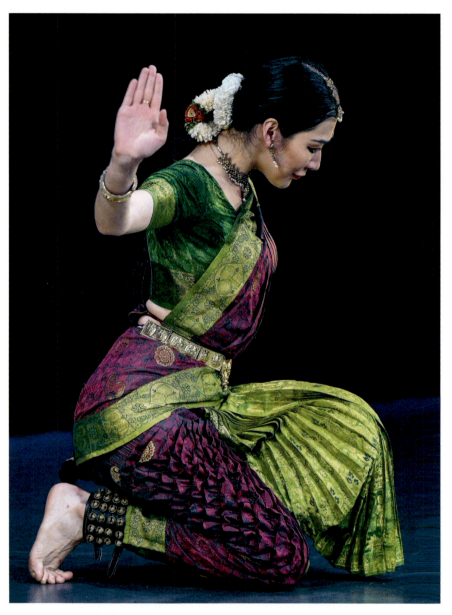

22. Kassiyet Adilkhankyzy, Cupertino, Bay Area, California.

natya was staged as an embodiment and re-enactment of the teaching of the Fifth Veda, the *Natya Veda*, which was its doctrinal source. It had been devised by the gods for the spiritual edification of a human race seen to have declined into an age of dullness and degeneration. It was meant to be performed as a regenerative spiritual remedy.

In this brief recapitulation of its earliest recorded use in dance and drama, we see that the *pushpanjali* was integral to both public and ritual temple dance. In both cases it served an invocatory and offertory purpose whose intention was to elicit the tutelage of the deity and by this means to sanctify the space in which the dance was carried out.

This practice has persisted down to our own time, both in the *devadasi* and *mahari* temple dances (insofar as they have continued authentically to exist since the *devadasi* ban in 1947) and as part of the repertoire of the Indian classical dances resuscitated over a period of some fifty years (roughly 1930–1980) and still in the process of being dialectically refined.

The practice has persisted, but what has it become? Can we still speak of an authentic ritual with an authentic offertory, invocatory and sanctifying purpose? Can we even speak of these spiritual motives as being genuinely present in the dancer's awareness while she dances the *pushpanjali* on the public proscenium, or present in the minds of those dancers who are reviving the *devadasi* tradition outside of the temple? And what of the meanings it might or might not have for the attending spectator-audience?

This question is one of real rather than only theoretic importance precisely because the *pushpanjali* is one of the hallmarks of classicism in classical Indian dance. Without it the classical repertoire, at least in the whole of its formal tradition, would be truncated at one of its nodal points. It is therefore a question that wants thorough addressing.

Now, the only part that I am willing or able to play in addressing it is to put forward some of my own assumptions and to pass these on to expert hands more capable of dealing effectively with them.

The first set of assumptions I will make has to do with the history of a *pushpanjali* tradition that has gone into decline, or has fallen away from its original religious purity of intent, in both the secular and *devadasi* praxis. This is of course to speak very sweepingly, but my own aim is not to raise any particularities that contradict the general trend.

In the case of the temple dance, it would be fair to assume that the practice, on the whole, suffered severe confusion and vitiation during the period of its effective persecution and abandonment from the late 19th century until its outright banning in 1947. Though it is true that a limited number of hereditary artists—belonging to the group sometimes characterized as 'elite'—were able to continue their devotional dancing relatively unmolested because surreptitiously, it must also be true that the *pushpanjali* suffered alongside with those temple dancers who had lost legitimacy and patronage and were cast adrift and into the hands of many types of exploiter and predator.

It must at least have become a *pushpanjali* strained to a large extent by fear, agony, doubt and even despair—a far cry indeed from the trusting, confident *anjali* that had been offered for thousands of years before the ban. It is certainly the case, at any rate, that it was no longer a devotional service deemed indispensable enough to deserve patronage by any means. On the contrary, it was largely scorned.

I am in no position to say to what extent the authentic flower-offering with its pure religious idea has survived and is still practised today. One sees its choreographies being rediscovered, reconstructed and actually danced, but one simply doesn't know how far the dancers—even the hereditary temple dancers—feel themselves in service of a real, living deity. To what extent, that is to say, is their *pushpanjali* identical in spirit with the offering danced in Bharata's day? And if it is not identical, except perhaps in some aspects of its form, then what has been the nature of its spiritual evolution or devolution as the case may be?

Now coming to the secular 'modern' classical dances, the question becomes much more vexed. We know that the formal unit of *pushpanjali* was considered a necessary part of the whole of the classicism which the revivalists undertook to re-establish. It exists for this reason in the repertoire we have today. But what purely religious meanings has it retained? In reviewing the whole range of dance recitals as we see them advertised and performed today, I would suggest that there is very little left of the aboriginally pure *pushpanjali* idea.

It may be, despite my own skepticism, that some dancers have retained and are practising it whole and wholly in its devotional purity. Indeed many dancers speak as if they do. And yet one doesn't see it

The Problem of the Pushpanjali 137

infusing their dance with the kind of conviction one would expect to see if their claims were authentically grounded. No, it has become largely a formality, a gesture.

And this brings us to the heart of the matter, and to the question at the heart of that: how can this gestural remnant of the pure practice be re-infused with an effective meaning, one that can really address the religio-aesthetic convictions of both dancer and *rasika*? Because, like it or not, we are living in a time when the purely spiritual idea with its associated acts of pious ritual devotion has run out into the sand of the postmodern worldview. And I myself don't claim to be unaffected by this view. And what then?

Even supposing that some dancers are still performing the genuine *pushpanjali* in the same spirit in which it was danced 2000 years ago, we have to assume that this is a spirit which is rapidly declining under pressure of the need to conform to the new irreligious conception of dance and of the dance of life too. Its survival is not sure, even in India. And the real religious sentiment, once it has become only a memory, cannot be replaced by any other thing, whether artistic, cultural or merely moralistic. There is very little religious spirit left, but there are many dancers.

One way of trying to fill in the gap may be simply to accept that the once-genuine *anjali* has been reduced to a formal classical posture, a thing of nostalgic poetry. We certainly do accept this kind of empty gesture in a number of small orthodoxies still in formal use for a variety of formal reasons, mainly aesthetic ones. Thus, we can retain the dance offering merely as a thing of artistic beauty in itself, which may or may not arouse its correlative emotions. But this would be a romantic point of view, which really has no place in rigorous classicism.

Or we may resort to Karl Jaspers's existential resolution of the problem, which is to think, feel and act *as if* the deity really existed. Now this seems to me one of the stupidest propositions ever made by anyone who thought of himself as a philosopher. Because, if once we begin in any matter whatever to act as if a deity existed, we would soon be playing fictitious roles in a life transmuted into a story in the third person. Instead of partaking in an authentic dance, we would be living a drama, not as persons but as personae.

My own best instinct, so far as the *pushpanjali* is concerned, is to pay

heed to a technical directive in the theory of *Mahayana* tantrism. Here, in the course of devotional exercises aimed at *sadhanic* embodying of the *deva* or the *devi*, we are instructed to understand the deity and to visualize it as existing inseparably from our own minds. The instruction takes us no further than this. We are not told whether the deity does in fact exist in its own right, as a being-in-itself, or whether it is only an aspect of our own mind, or even a figment of the religious imagination. We are left to work out this conundrum for ourselves.

Yet, when we do eventually succeed in this embodiment, at least to our own satisfaction, we find the practice wholly efficacious. We find that it does not really matter how exactly the *deva* or *devi* exists. It is sufficient to know that the energy, insight and blessing derived from the practice rouse one to making a right *pushpanjali*—a gesture of offering that comes from the heart.

23

Surprised by Dance: A Glimpse into my Personal Journey

By the time I was a teenager I was already surrounded, in my boy's untidy bedroom, by a clutter of Indian paraphernalia: some *rupas* of the Buddha Shakyamuni, a cosmic Shiva, a variety of books on Hinduism, boxes of fragrant incense, and my bedside reading, the *Bhagavad Geeta*, which had been generously given me by a local Indian tailor, an act of kindness that I have never forgotten.

So, by means of these gathered clues, my course was set towards the dance. It was set because I soon gained the understanding that life itself was a dance. With Shiva present in my bedroom, how could I fail to see that? It was in any case in the air. In those days India was coming closer to the West in many scattered ways: the ISKON Foundation, the dozens of popular *rishis*, Ravi Shankar, the Beatles' foray into popular Hinduism, Cat Stevens's Buddhism, and the pervasive adulation of Gandhiji.

I was then fourteen years old, and it was in my fourteenth year that I saw a lengthy and detailed television documentary on *Kathakali*. It dealt not only with the dance itself, but with the stringent and even tortuous preparations involving costume, make-up, body and mind, demanded for its performance. I was captivated, but also stunned. I

Essays on Classical Indian Dance
Donovan Roebert
Text copyright © 2021 Donovan Roebert / Photographs copyright © 2021 Arun Kumar
ISBN 978-981-4877-47-3 (Hardcover), 978-1-003-12113-8 (eBook)
www.jennystanford.com

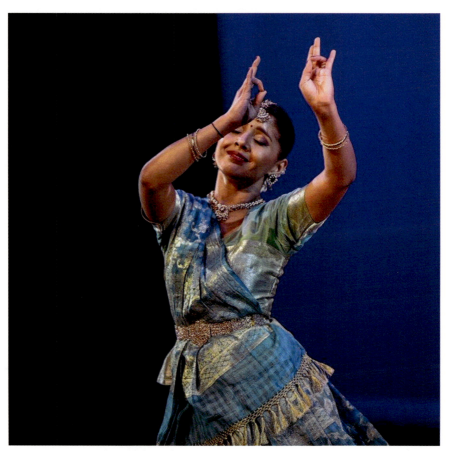

23. Barkha Patel, Barkha Dance Company, New York.

understood, though probably only in the vaguest way, that there was an inwardness to dance, and that dance could become not only a way of life, but a way of being.

These things went down into my soul and there took on a life of their own, a life which has since then in some ways both enchanted and tormented me. There were times when I wanted to put it aside, to throw it out and forget about it. But dance would not leave me alone.

In those days, too, you could catch glimpses of classical dance on the Indian television channels, and you could enjoy the dances that were always appearing in those old Bollywood mythological sagas:

Surprised by Dance

you got to know the *devas* and the *devis*, and you saw that they were always moving in dance and living in a variety of elegant postures. Yet it was more confusing then enlightening. You had no idea where this persistent undercurrent of your sentiment about dance was leading you. Was it going anywhere at all?

Even as a young man in my military years the idea of the dance, its interior imprint, continued to haunt me. I understood then that it was as much linked with death and violence as it was with life and beauty. Behind it all the same *raga* could be heard, and the same sighing *ghungroos*. But its fragmentary meanings still shied away from my approaches. How best to put it? My conceptions of dance, my memories of the meagre sightings I had had, and of the succumbing sentiments awakened by these, were mingled inside me as a fragrant blend whose presence, though subtle and constant, lingered like an absent lover. Yes, I knew even then that it had something to do with love.

Trying to get to grips with it all, I looked to the Western ballet, which was so much more approachable and available to me. There were regular performances even where I lived. But it wasn't the same. It was delightful enough of course, but there was no pain, no yearning, no wily admonition, no sense of something overwhelming yet to come.

So I had to wait. And isn't it just like the dance to make you wait in the first position until you can no longer stand it? But there was no helping it. I turned to the other arts, and to the varieties of intellectual and religious escape offered to a frantically searching mind, the mind of disillusioned youth. But the Indian dances were never forgotten. They had come to stay, and to stay with a nagging impetuousness.

The years went by. There were other glances at dance. And there were books and pictures and classical music of the Ravi Shankar kind. And of course there were the Indian movies too, which I made it my business never to miss if I could help it.

Then came Buddhism, not the sham Western thing, but the real impactful Tibetan blow to the gut, the mind and the ego. I became empowered, through years of struggle, to meditate. And in these formless hours of meditation the dances reappeared, of Avalokiteshwara, of Tara, of the *dakinis* and *apsaras*. Later I understood why Buddhism in

India could not disown dance. It was itself a dance. I knew then that I was absolutely obliged to go further and deeper into the life and heart of dance—because it dwelt in me and wouldn't depart.

So I did the only thing I could: I bought videos and DVDs of dance recitals, and not only these, but also the documentary types that explained the history and at least enough of the technique to enable me slowly to begin clearing and ordering my basic grasp of what I was seeing and experiencing. This was a wonderful time, a time of joy. I could feast on dance whenever I wanted, and feast I did. But of course there was much ignorance too.

Then I went to India to spend time in the company of my *dharmaguru*. This was a period not only of further enlightenment but most decidedly of suffering too. I had fallen into a pit of confusion. Did the *dharma* of dance really matter? Shouldn't I be moving beyond all that into a dimension of mind whose state was motionless? But my Teacher only laughed at me, seeing down to the core.

It was then that it happened, the thing I won't speak of publicly, except to say that I knew afterwards that the dancing *devi* existed, whether I wanted to know it or not. Of course there were many reasons why I decidedly did not want to know it and did not want to know her. But from that time I have really been wedded to the dance. From then on there could be neither escape nor evasion because dance had become a living truth. I wonder how many can really understand this: that there can be no 'loving the dance' except in knowing that the dance, the dancer and the *devi* are all one thing.

It fell to me then to study as much as was available to me concerning the dances, their grammars, techniques, and their tricks. Because dance, like the *devi*, is full of tricks. And though I certainly came to understand much more at the surface, and to grasp more at the depths, none of this could come close to the existential revelation of the *devi*. But enough of that. My teacher, though he heard me out, dismissed it as 'neither good nor bad' in the way that all good gurus do. They want you not to hold onto it, so that it can hold onto you.

Later, on another visit to India, I attended live performances and had my breath taken away by them. Through the good offices of a friend, I was able to attend an Odissi practice session in the presence of one of the historical masters of this art. Then I knew what it was to

Surprised by Dance

be smothered in beauty, and to be cosseted in the smothering. Dance had come alive in me.

It had kept its early promise.

Of course there's so much more to recall and to relish in the telling. But why go on and on? I think I have made the point, if only to myself, that this brief recapitulation of my beautiful journey was intended to make:

That dance isn't really dance until it has possessed you wholly.

24

Classical Indian Dance is a Humanism

After the primal and rudimentary creation of the world (*illam novam ac rudem mundi creationem*) ... everything that surrounds us is ours, the works of man: all dwellings, castles, cities; all the edifices throughout the world, which both by quantity and quality seem to resemble the works of angels rather than of men. Ours are the paintings, sculptures, trades, sciences and philosophical wisdoms. Ours are all inventions, diverse languages and genres of literature, all of which, when we contemplate their necessary usefulness, compel us to a yet higher admiration and even astonishment.

Gianozzo Manetti, 1396–1459 (my italics)

Taking man as a creature of indeterminate nature, ... (God) addressed him thus: 'I have given you, Adam, neither a fixed abode, nor a form that is only yours, nor any function peculiar to yourself; so that, according to your own longing and your own judgment, you may have whatever abode, form and function you may yourself desire. The nature of all other beings is bounded and constrained by us. But you, constrained by no limits, according to your own free will, in whose hand we have

Essays on Classical Indian Dance
Donovan Roebert
Text copyright © 2021 Donovan Roebert / Photographs copyright © 2021 Arun Kumar
ISBN 978-981-4877-47-3 (Hardcover), 978-1-003-12113-8 (eBook)
www.jennystanford.com

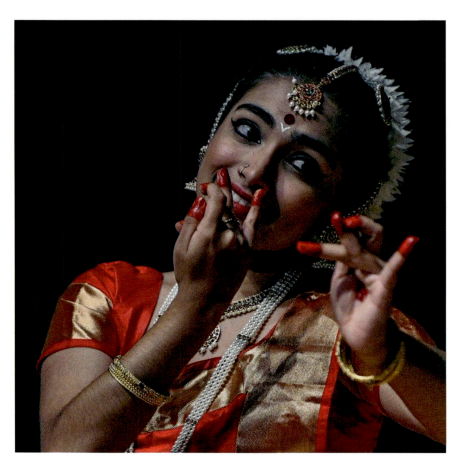

24. Anupama Joy, Kalasrishti School of Arts, Morrisville.

placed you, will yourself ordain the limits of your nature ... We have made you neither of heaven nor of earth, neither mortal nor immortal, so that by free choice and honour ... you may fashion yourself in any shape you prefer. You will have the power to degenerate into lower, brutish forms of life, or the power, by the judgment of your own soul, to be reborn into higher, divine forms.'

Pico della Mirandola, *De dignitate et excellentia hominis*, 1487

The epigraphs above, taken from the writings of two of the foremost contributors to the thought of the Italian Renaissance, set the tone

Classical Indian Dance is a Humanism 147

for the idea I want to elaborate a little in this essay. Before going any further though I must state, for the sake of readers not familiar with this episode in Western history, what the Italian Renaissance meant for Western religion and for its conception of the human being. I will do this as briefly as possible.

Until the Renaissance movement began, the condition of humanity had been for more than a thousand years considered fallen, debased and incorrigible. The aim of religion was to cultivate in people this profligate and humiliating view of themselves so that they would live and think in terms of their utter subjection to the merciful and sanctifying work of God. Man was a defiled and sinful creature whose only hope of eventual salvation lay in his humble self-abasement in the divine presence.

One sees then immediately, from the extracts cited above, how the force of Renaissance humanism turned this idea of humanity on its head. Henceforth the despairing idea of fallenness would be transformed into something resembling almost an apotheosis of the human creature, a view the humanists considered justified by their readings in the Greco-Roman *bonae litterae* ('good letters'), which they were just then rediscovering—a classical pre-Christian outlook on the world and the place of humanity in it, in which human beings were viewed as creatures possessing, at least in their potential, the highest qualities of *dignitas* and *excellentia*.

Now this view is not at all foreign to the Vedic religious tradition and to its philosophic refinement in the *Buddhadharma*. In both of these traditions, birth as a human being is taken to be the most auspicious kind among all other lesser-endowed beings, exceeded only by that of the high *devas* and the buddhas themselves. It is the form of life most suited to—one might more precisely say more calibrated towards—the highest spiritual and intellectual attainment possible to the creatures in this world, higher even than that of some of the lower *devas*.

In Western humanism, as in its Eastern counterpart, one of the signs of this human excellence is its physical beauty, a beauty that was affirmed and celebrated by the painters, sculptors and poets of the Renaissance as much as it has been in the religious and artistic traditions of India. In India, as in Renaissance Italy, the Platonic qualities of beauty, goodness and truth are seen as potentially realizable

148 ESSAYS ON CLASSICAL INDIAN DANCE

by anyone who makes the effort fully to attain them. And this is a humanist opinion. It places humankind just a little lower than the gods whom our race so closely resembles. And it puts human beings at the centre of all earthly experience while seeing them as the link between two essentially spiritual realms.

I would like to suggest that this humanistic conception is not only present in but is actually a position central to the idea of classical Indian dance. Dance is not a dragging down of the dancer into a situation of servility to the notion of the *deva* or *devi*. On the contrary, it is a raising up and an affirmation of her quasi-equality with the divine. As soon as this is seen, all kinds of possibilities are opened up.

The exaltation of the dancing human form might constitute the first, because it is the most immediately apparent, aspect of this elevation. It is not only the beauty of the human physique both in stasis and in motion that is celebrated and affirmed here, but its actual *glory*. So that, from the perspective of the *devadasi*, we may say that in this regard she makes a worthy bride. No other earthly being, considered in its loveliness only, is so fit to endow this position with the gorgeous comeliness appropriate to it.

The second humanistic quality residing in the dancer is that of her potential for goodness. Now here we are dealing with a Platonic term whose meanings are quite wide-ranging. It has about it elements both of virtuous attainment and efficaciousness, of being the kind of human being that a human being ought fully to be in the particular position which she occupies in life—which is to say, in her personal *dharma*. Thus, the dancer's prowess at dancing is not only an achievement of elevated beauty but of elevated technical accomplishment too, and this accomplishment is part of her goodness. Apart from this, we know only too well that the practice of an art and the craft of it are closely tied up with virtue. The failure of artistic honesty, which is a lapse of taste, is only one of the failures of virtue that spring immediately to mind. So here, too, in the accomplished dancer, the virtue of human excellence is openly affirmed.

The third quality is that of truth, by which humanism means the human capacity for coming into alignment with what is highest in our human potential. And this potential, in the Renaissance view as in Vedism, is deemed to find its fulfillment in oneness with the divine, so

that what is excellent and worthy and dignified in the dancer is lifted up just a little higher to attain what in a real sense we may call equality with *herself*: because to her applies the dictum *tat tvam asi*.

Having said all these things, though, it seems to me that this humanistic concept will find far more resonance with the secular dancer when it is understood in the first place as a thorough affirmation of her personal dignity as a woman and as a human being.

But her *dignitas* and *excellentia* as a dancer are what chiefly concern us here. In her art she makes clear to us not only the outward but also the essential beauty, goodness and truth of our humannness. She achieves through the formal classicism of her craft the clearest expression and confirmation of it, and brings us to an identification with it. She points us towards our full humanity in all of its gracious potential. That is why we honour her, and why she delights our souls.

Does she not after all demonstrate to us, in her easy assumption of the *tribhangi*, the *chauka*, the *nataraja* posture, the forms of Krishna, Jagannath and Shiva, how relatively small a step it is for us human beings to grow fully into what we already almost are?

25

Dance, Analysis, and the Willing Suspension of Disbelief

The Coleridgean formula for the 'willing suspension of disbelief,' set out in his *Biographia Literaria*, is as follows:

> The transferral from our inward nature of a human interest and a semblance of truth sufficient to procure for these shadows of imagination that willing suspension of disbelief for the moment, which constitutes poetic faith.

The idea is that a literary work can be so constructed as to convince the reader that the imaginative world it presents to the receiving mind is, at least during the time spent reading it, a credible one. The reader is able to enter and remain in it without the immediate sense that it is, after all, only a work of fiction. A work of prose or poetry properly devised is therefore able to detain the onlooker as it were in its own world and on its own terms. Its frightening aspects arouse a corresponding fear, its joyful episodes a feeling of joy, and so on. We all of us know, for instance, how a harrowing film can hold us in its grip and leave us exhausted in the aftermath, or how a happy movie can lift our spirits—not because it presents us with a story that

Essays on Classical Indian Dance
Donovan Roebert
Text copyright © 2021 Donovan Roebert / Photographs copyright © 2021 Arun Kumar
ISBN 978-981-4877-47-3 (Hardcover), 978-1-003-12113-8 (eBook)
www.jennystanford.com

152 ESSAYS ON CLASSICAL INDIAN DANCE

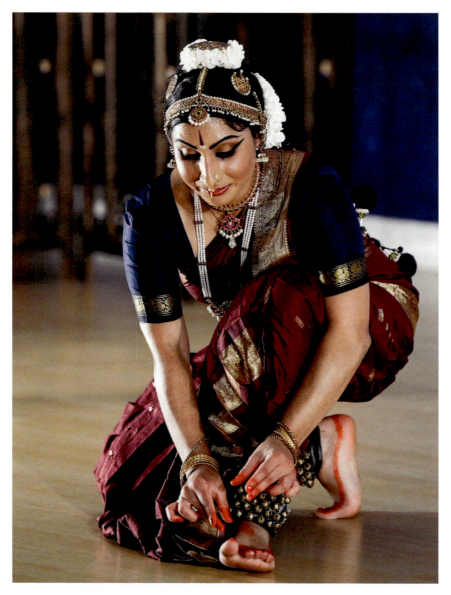

25. Madhvi J. Venkatesh, Prakriti Dance, Brooklyn.

is true but because it conveys its fictional narrative so grippingly and so persuasively. And this is a matter of technique.

What we are suspending during our reading or viewing, and perhaps for some time into the aftermath, are our critical faculties.

Dance, Analysis, and the Willing Suspension of Disbelief 153

The construction and technique have been sufficiently unobtrusive and sufficiently smooth in their interactive functions to lull us into accepting the *rasa* which they were intended and developed to convey. Our belief (in the reality existing outside of the work of art) has been willingly suspended, and we abide, by means of our awakened 'poetic faith,' in the 'reality' offered us by the work of art.

In the dance, the intention is to evoke a given range of *rasas* (the *navarasa*), and this intention cannot be achieved, or fully achieved, if our critical faculties are stimulated during the course of the recital. There are several types of criticism to which a dance recital may be subjected, but I will deal with only two possible instances of critical analysis here.

The first is what we may call a surface analysis of technique, in which we examine the qualities or defects of such elements as footwork, hand and arm movements, facial expressions, and so forth. We need not spend time enumerating these: it is sufficient to say that they constitute in their totality the visible details of which the outward form-in-motion of the dance is made up. They are part of the regular province of the dance critic, and a quick survey of dance reviews will show how closely these elements can be pursued, praised and decried in technical language.

Our suspension of disbelief at this level is shattered when we are surprised by a noticeable flaw or series of flaws that break the harmony and flux of the dance. Immediately these occur, we return to the real world existing outside of the dance, we come back to ourselves, and our analytical faculties are awakened. Our faith in the magic is scattered.

The second level of analysis goes deeper than the first and is concerned with the Eliotic 'objective correlative.' What we are analyzing at this level are the forms and images by means of which a particular kind of *rasa* or blend of *rasas* is being transmitted to us. Instead of examining the technical minutiae, we are trying to discover why a particular combination of them, resulting in an image-form such as the *nataraja* posture, is able to elicit from us a corresponding burst or flowering of sentiment. And we are concerned also with the question whether that sentiment is merely personal and individual or if it transcends individuality to operate in a universal way. This is of course a far more difficult analytical endeavour because it requires

of us that we gain an understanding, without taking anything for granted, concerning what is essential in any image-form that results in a universal *rasa*, a sentiment which we all experience in more or less the same way.

Now here again, if the image-form is misconstrued by the dancer, we are immediately put outside of its spell though we may not at the moment be able to say precisely why this displacement has happened. We only know that our attentiveness has been alerted to a detail that stands outside of the dance because it is not strictly speaking a detail of dance but of the critical analysis of dance.

The dancer's chief task, therefore, is to keep us unaware of the machinery of technical detail that may draw our attention away from the dance-as-dance and not as an assemblage of analyzable particularities. Because it is only through this displacement of our attention that we are able at all to see dance as dance and not as a transitory collection of choreographed units-in-motion.

So, through the fluency and unobtrusiveness of his or her technique at these levels, and through the apparent naturalness and spontaneity of expression, the dancer coerces our attention on the dance—but I do not want to dwell any longer on this rather obvious point. I want rather to go on immediately to add what I consider the most important thing here, which is that such seeming effortlessness translates for us into intimacy.

Let us consider this word in terms of its application to conversation (for dance is nothing if not a conversation). Immediately we see how vital it is for the genuine transference of sentiment that the language in which it is conveyed be fluent, unhesitating, and apt. I think we will all agree that sharing our feelings in words—by which I mean sharing them truly, so that the hearer is drawn into full empathy with our feeling minds—is at the best of times an almost impossible task. It all depends on the way in which we use words and the imagery that blossoms from words, and our honest use of these is not the least important aspect here.

But when the right words are easily to hand, when the vocabulary is both precise and ambiguous enough, and when what is spoken is spoken from the heart, justly and uprightly, we can come close enough

Dance, Analysis, and the Willing Suspension of Disbelief

to making ourselves understood, to passing on our *rasa* to the *rasika* with whom we are speaking.

Then only do we arrive at intimacy, which is a merging of minds. But how easily such intimacy can be broken when the false or brash word is spoken, or when the language is too cunningly wrought, or when it uses phrases that are hard to seek. Then immediately intimacy takes on shades of manipulation: the suspicion that technique is being used for selfish or showy ends.

All good art is intimate and honest, but dance is the art-form in which these qualities can be shared with us in the highest degree of directness and immediacy, not only because it is a living dance but on account of its transient momentariness. In every passing moment there is only one quick opportunity for sustaining the sentiment of intimate sharing, for accomplishing the willing suspension of disbelief, and that moment is therefore all the more poignant, like the dying moments of life itself.

Of course there is always the chance that some external factor will disrupt the magic: the sudden blaring of extraneous noise, the member of the audience who must make a spectacle of himself, the preposterous hat on the head of the woman just in the seat before us. But even these eventualities can't do irreparable damage to the illusion of intimacy created by the skillful dancer.

For illusion it is, though it is only in the aftermath of the dance that we realize the illusoriness of its intimate moments, just as sometimes, when our minds shift between one possible universe and another, we glimpse the illusion of existence itself.

26

The Multilocality of Classical Indian Dance

In the last few years I have been involved in a number of small controversies involving my right, as a 'Westerner,' to involve myself with classical Indian dance. I am not speaking of my right to comment on the dance (which I take for granted anyway) but the mere entitlement to have any interest in it at all. The implication here is that, insofar as I have shown an interest and taken the trouble to examine that interest for myself, and in terms of my own cultural perspective, my interest and my findings merit only outright dismissal. But let me add at once that this doesn't deter me, though I admit that it has sometimes tried my patience. I mention it here only as one of several reasons that have prompted me to write the present essay.

We have been experiencing for decades now the ways in which postmodern critical methodologies have insinuated themselves into writing about dance and the history of dance, and how it is tacitly required of scholars and commentators that they make at least a gesture of obeisance to the 'critical theory' school of thought at some point in their writings. Here is one of the more ludicrous examples I have recently come across, taken from a review of a volume of essays

Essays on Classical Indian Dance
Donovan Roebert
Text copyright © 2021 Donovan Roebert / Photographs copyright © 2021 Arun Kumar
ISBN 978-981-4877-47-3 (Hardcover), 978-1-003-12113-8 (eBook)
www.jennystanford.com

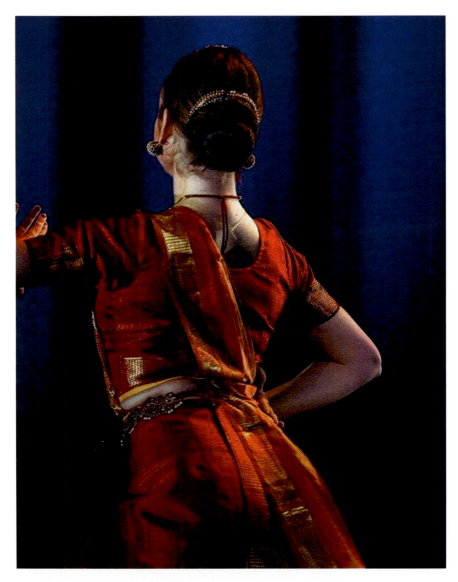

26. Sophia Salingaros, New York.

on Manipuri dance:

> ... The open inclusiveness of this kind of genealogy that acknowledges patron-performers outside the hereditary lineage of the dancers, can be seen as a generous acknowledgment of

The Multilocality of Classical Indian Dance — 159

> their attainment and devotion to the forms. A kind of reversal of this generosity is evident within the same book in the hegemonic tone of the article on 'the Celestial Inheritance' contributed by E. Nilakantha Singh. His chapter offers fascinating and somewhat tantalizing glimpses of the mythology and esoteric aspects of Manipuri dances, provided one can resolutely ignore the patronizing colonial tone of such terms as 'animism,' 'primitive religion,' and 'Tantric cult,' in his references to the ancient religious beliefs of the indigenous Meitei people. He also informs us that a singer is considered fit to to perform only after his (sic) body has been gradually transformed through stages of yogic attainments i.e. in Nilakantha Singh's value system Hindu practices are clearly superior to those of the native Meitei tradition.

And so on. We are to note that Mr Singh is being 'hegemonic' and 'superior' quite apart from his being awarded a '(sic)' for writing 'his' instead of 'his and hers,' thus exposing himself as a misogynist too.

What we are dealing with here is the imposition of an ideological principle posing as a principle of scholarship. But we are also being offered a pointer towards the nature of the fundamental question underlying this kind of silliness. It is, as I see it, a question concerning locality, by which I mean having to do with a number of qualifying loci at which classical Indian dance in both its practice and meanings may occur and at which it undergoes renewed assessment, interpretation and modification.

And this is surely nothing new. It is a dialectic inherent to every classical form always and everywhere. In the West we see the Hellenic classical forms being taken up and reworked in Alexandrian Hellenism, then put through its scholastic and Renaissance paces, and at last being delivered into the hands of its modernist imitators and postmodernist critics. And so it stays alive—because it generates the kind of penetrating and enduring appeal that keeps it alive as an object of enjoyment and study. It passes through these extralocal loci of place and time in its endless journey back towards its first and purest expression at its own primal locus.

That first locus, then, is where we ought always to begin—insofar as we are able at all to discover it in its primal purity—if we want to

probe into the first meanings of the classical dance forms which we are apprehending for ourselves. Because, if we are not prepared to make this effort, how can we claim to be concerned with what is classical about the dance, anymore than we can claim to be concerned with flowers despite knowing nothing about their seeds?

But this does not mean that every subsequent locus at which the dance reappears, every sequence of local prisms through which it is appreciated and understood, is necessarily a vitiation of the intention of the primal locus. It means, rather, that the interest and appeal of that seed-form has about it both a beauty, a power and a truth that are essentially universal and timeless.

Classical Indian dance is apprehended, appreciated, understood and misunderstood throughout the world in a way that any number of other classical art forms (including other forms of dance) never will be. And there is no one to blame for 'appropriating' it. It has made itself eminently appropriable by the universal fascination which it exercises on a variety of receptive minds. So, if poor Mr Singh had not felt the urge of this irresistible appeal, he would not have bothered to study the Manipuri dances at all.

But to return to the loci themselves, we must note first their interactivity in sustaining the life of what is classical in the Indian dances. We may say that they are themselves involved in a dance at nearer or greater distances from one another. Yet they are always concerned with the classical, whether supporting or opposing certain points of departure, which they do from their own considered perspectives.

So, passing through its various loci of time and place, we find classical Indian dance taken up across the last century or so in an amazing multiplicity of interpretational guises, both in India and throughout the world. And everywhere there are echoes of the chatter of its forceful appeal, and there is the chatter that is ongoing even as, myself contributing to it, I write this piece.

We see the classical Indian dances located internationally in the *guru-shishya parampara* in its various kinds, at universities and dance institutions, private schools of dance, in innumerable online forums, and so on—but also, increasingly, we are witnessing some of its primal loci being opened up for us anew by scholarly research.

The Multilocality of Classical Indian Dance 161

Of course this multi- and extralocality of the classical Indian dances poses its dangers for vitiation too. But is it not in the dangerous but fruitful tension obtaining between these multifarious loci, in their genetic potential both for sustenance and mutation, that the classical tradition is kept not only vital but vitalizing?

Let this be a reminder then, at least to myself, that both Mr Singh and his critic are contributing to the dance of thought about dance— though his critic will never be my cup of tea.

27

On the Terrible Beauty of *Moksha* in Odissi

I wonder if anyone else feels as I do that the last item in the Odissi repertoire, the *moksha*, cannot at the heart of it be what it seems to think it is. What I mean is this: can it really have anything credibly experiential to do (apart from its surface value as a symbol) with the authentic idea of hopeful cessation understood at the *Vedic* or *dharmic* level as a ceasing from the strife of being-as-becoming, and a cessation, therefore, of illusion?

From the dancer's side this problem (if it is a problem) can be solved quite easily if superficially by taking the *moksha* to represent the tranquil and relieved sense of contented accomplishment at the successful completion of a rendering of the repertoire. That certainly does make sense, though it obviously still falls far short of the full idea of *moksha*. Some other, less spiritually laden term, must better have served our turn here.

Still, it is a starting point which provides me with three positive emotional indicators: tranquillity, contentment, and relief. And these I suppose we may safely assume to be at least notionally present to the dancer's subjective experience at the very end of the *moksha*. What

Essays on Classical Indian Dance
Donovan Roebert
Text copyright © 2021 Donovan Roebert / Photographs copyright © 2021 Arun Kumar
ISBN 978-981-4877-47-3 (Hardcover), 978-1-003-12113-8 (eBook)
www.jennystanford.com

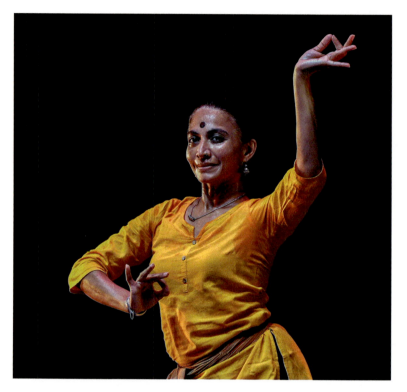

27. Bijayini Satpathy, Odissi dancer and teacher, Bengaluru.

has been aimed at has been accomplished (if it has) and the beautiful struggle, which the dance among other things also is, is finished.

(But let me add, if only in order safely to traverse a contentious part of the theoretic terrain, that it may be the case, for all I know, that dancers in some cases actually achieve at this point of completion the full experience of *moksha*, the transcendence of selfhood—though I rather doubt it. And, having said this much, let me return at once to my own more mundane speculations.)

I will look then more closely at these purely human sentiments and try to see what they may mean for both the dancer and the *rasika*, and whether they can in any case denote the same experience for both in the same moment of completion. And I think they can, though in very different contexts, because the dancer is experiencing release from the successful travail of the dance (for it is a travail, no matter how joyful

On the Terrible Beauty of Moksha *in Odissi* 165

and fulfilling) whereas the *rasika* is experiencing the completion of an act of absorption.

The sentiments of tranquillity, contentment and relief experienced by the dancer-subject are modified through their transmission towards and reception by the *rasika*-object. I do not mean by this that there is not in the course of the dance a changeable reciprocity of subject-object relatedness, which might be worth a study of its own. I am only positioning the dancer and *rasika* in this way, and momentarily, for the purposes I have in mind here.

Put simply, then, I am imagining the dancer-subject as transmitting a given quality and quantity of *moksha-tejas* to the *rasika*-object by the interactive devices and energies of her *moksha-abhinaya* and *bhava*. I say this even though it is theoretically clear to me that the *moksha* movement in Odissi is a *nritta* dance that is supposed not to rely on any conveyance of a *nritya*-type *bhava*. But to this qualifying proposition I will return a little later.

Meanwhile, speaking for myself, I am imagining that the commingled sentiments of tranquillity, contentment and relief are experienced by both the dancer and the *rasika* as an inward surge of elation, and that this force of elation differs in the quality of its realization in each respectively. This is because the dancer knows it as a distilled sentiment arising from the fact that she has generated the beauty that causes it to arise. The *rasika*, on the other hand, as object of that radiation, knows it as a moment of loveliness being received at the hands of the dancer. The dancer is the creator of the gift of beauty—which also in her dancing self she is—while the *rasika* is the grateful and enthralled recipient.

But, though the ways in which they experience the moment of the completion of beauty are qualified by this fundamental difference, it is precisely in and through this difference that the dancer-donor and the *rasika*-recipient are united and become one thing.

It is this dualistic and apparently divided experience of giving and receiving that constitutes the singleness of the *moksha* act itself. If one half of the experience were missing from the equation there would be no *moksha* in Odissi at all. It is the singleness-through-union of this disparate experience that lends to the *moksha*-moment its completeness-in-*sringara*. That, at any rate, is what the idea of *sringara-bhakti* seems to me to comprehend.

But let me look now at the nuances of this moment-of-completion-in-unity itself. What do these nuances signify for me?

From the point of view of the dance as dance, and not as an enactment of philosophy, the *nritta* of the *moksha* signifies the coming to an end in this recital of all the preceding *nritya* and *nritta* repertoire movements, of all the multiplications of the *rasas* together with the elements of *abhinaya* and *bhava* on which they have depended for their transmitted dynamism.

Certainly the *pallavi* has also been a *nritta* piece, but it was after all embedded in the body of the whole of the *nritya* repertoire, an interlude of pure non-discursive joy in the midst of the celebration of the *nritya-nritta* continuum. The *pallavi* does not in any way constitute a completion, a coming to an end, a cessation, though it may subtly prefigure the end. And this I see as at least one clue to its poignance. But the *shariraja abhinaya* in the *pallavi* is orientated differently from its counterpoint in the *moksha* in that it is enacted, together with the *nritya-natya* narratives with which it is involved, on this side of the *moksha* completion.

The *shariraja* of the *pallavi* points to the relativized activity of thisworldliness, while that of the *moksha* indicates the absolute stillness of otherworldliness. Therefore the *moksha shariraja*, for all its expressive liveliness, bespeaks the end of that liveliness itself.

And so it seems to me that the union of dancer and *rasika* in the moment of *moksha*-elation must always be suffused, on the *rasika's* side, with a nascent sense of tragic regret: a regret that this dance, though successfully accomplished, could only be accomplished by arriving at a finished point.

(I place the sense of regret specifically on the *rasika's* side because, for the metaphorical purposes of this essay, I conceive of the *rasika* as the human aspect of the equation—the human being embodying the *rasika*—while I take the dancer to represent the divine aspect—the dancer-*mahari* embodying the *devi*—in which case there can be no talk of regret on the dancer's part.)

In the seed of the beautiful *moksha*-accomplishment the principle of nullity seems also to reside. And what then?

Speaking for myself again, I am confronted only by an ultimate nescience, though others may claim to see clearly what lies beyond the

moksha-of-cessation. All that I can see and affirm with any clarity and real enthusiasm is the beauty of the whole repertoire that has preceded it, including the *nritta* of the *moksha* itself before it has been stopped in the nothingness of its completion.

The *moksha* evokes reverence and gratitude for the dance that has been and is now no more. But the *moksha*, in the stillness of its completion-in-annihilation, does not communicate to me a hopeful prospect of any dances yet to come. What else it may evoke regarding what awaits us on the other side of its completion still evades me, though I don't deny that others may see it with a bliss that remains incomprehensible to me—because it is associated with the annihilation of a myriad differentiated particularities vibrating in dance together with the *rasika* that perceives them—but here we are touching on a metaphorical riddle concerning life and death and what may or may not lie beyond these.

28

Jayantika: Archaeology and Imagination in the Reincarnation of Odissi

My intention here involves nothing more ambitious than an attempt to clear up for myself the workings of a certain congeries of factors that went into the reincarnation of Odissi. In trying to do so I am aware that I am re-examining matters that are already quite obvious to others. I therefore don't expect to arrive at conclusions that can pretend to be original.

In recent days I have been reading, and in some cases re-reading, a number of books and articles on the work of the Jayantika Movement, whose toils can nowadays quickly become the object of heated debate. About the issues that prompt these quibbles I won't say anything here. They have nothing to do with, and indeed are rather a distraction from, the kind of summary and conclusion I am hoping to make here on my own behalf.

In reading these books and articles, then, I have been insistently accosted in afterthought by recalling that the name 'Odissi' was hit on by Kalicharan Patnaik in 1948, and then only as useful tag for the Odiyan songs he was broadcasting on the newly-founded All India

Essays on Classical Indian Dance
Donovan Roebert
Text copyright © 2021 Donovan Roebert / Photographs copyright © 2021 Arun Kumar
ISBN 978-981-4877-47-3 (Hardcover), 978-1-003-12113-8 (eBook)
www.jennystanford.com

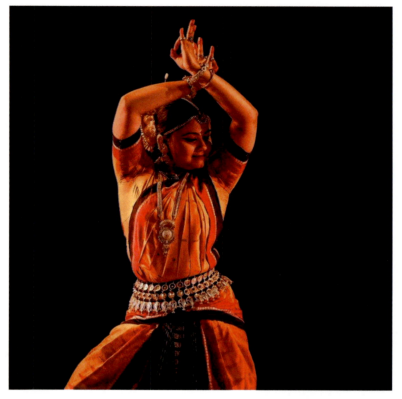

28. Arpita Rakshit Sabud, India International School, Virginia.

Cuttack Radio Station. And this denomination was then immediately adopted by the gurus who were working to re-imagine a classical, though regional, form of dance. It was adopted, and it stuck, though it had never been heard before.

The story of the gurus' labours, frustrations and successes is a marvellous one but also one that is so well known—at least in outline—that I need not recount the details here, except to remind myself how very few resources in every way these practitioner-researchers had at their disposal. Theirs is a narrative that stretches from poor rural villages and street theatre to culminate in a classical Indian dance recognized in the capital cities of the world, the dance that we know as Odissi today.

Before its new name was spoken, 'Odissi' consisted of a loosely interrelated number of instances that had not yet been drawn together

Jayantika

into a new whole, and these so fragmentary and debilitated, so worn out by age, misadventure, mishap and neglect that their fundamental unity could only have been discerned by individuals driven by a relentless obsession to find and re-embody them in a new unity.

In that sense, the synchronic one, the gurus of the Jayantika Movement were archaeologists. Their work was in the first place the excavation of whatever material could still be uncovered to give a fuller and more elegant form to the classical dance whose dimensions they had already essentially imagined. What they found in the main were the following:

The dance of the *maharis*
The dance of the *gotipuas*
Folk dance
Songs and poetry
Texts on dance
Sculpted relief panels depicting old dance postures
The revivalist teaching available at *Kalakshetra*

Drawing on and collating these materials, they sought to re-imagine:

An aesthetic structure and repertoire
An applicable conception of classicism
An underpinning mythico-philosophical trope

The dance of the *maharis* (*mahari nacha*) turned out in the end to be the most valuable source for achieving the final cultural goal they had in mind, the grounding of their reincarnated dance in an antiquity that also rendered a strong sense of cultural and spiritual continuity. Yet the *mahari nacha*, in the depleted and devitalized state in which they then encountered it, was not an extensive source for the steps and structures that they were envisaging. The *maharis* themselves were a rapidly dwindling institution whose repertory in the temple consisted of a *sakala dhupa* once daily and a song from the *Geet Govind* at night. Their *mudras* were few, their *abhinaya* expressons limited, and their postures and steps insufficient to guide the gurus towards a more enriched repertoire. Yet, five *bhumis* and five *charis* (which

172 ESSAYS ON CLASSICAL INDIAN DANCE

include the all-important *chauka*) were still contained in the extant choreography.

There was a repertoire, albeit rather shapeless and brief—a dance sequence that lasted from ten to twenty minutes, and which lacked anything resembling the sinuous glamour of the postures depicted in the temple and cave sculptures of Odisha. In order, however, fully to exploit whatever was still redeemable from the *mahari* tradition, the founders of Jayantika—years before the association was actually established—took lessons in *mahari nacha* from Pankaj Charan Das and Mohan Mohapatra, dance teachers to the *maharis*.

It is important to recall at this point that, as regards their vocation as dance archaeologists, the members of Jayantika themselves only realized this much later in life, during the period when it became clear to them that Odissi was a distinct and necessary possibility. The lessons they received in the surviving forms of Odiyan and other dance were taken from the days of their childhood up, at various times in their careers, and not in a continuous, systematic manner. It was only later that all their acquisitions evolved and coalesced into a single idea and ideology of dance.

The dance of the *gotipuas* (*gotipua nacha*) was more serviceable to them than that of the *maharis* because it was much more elaborate. It was also popular as a public entertainment and therefore needed to be kept up as well as expanded and re-embellished from time to time. It was, in a word, a more truly living phenomenon. Its supple liveliness, intricacy and grace seemed much closer than the *mahari* legacy to the ideal of a secular classical dance that could be staged on the proscenium. It had only to be trimmed of its vulgar acrobatic element (the *bandha nritya*) in order to provide a rich source of steps, postures and *lasya bhangis*. Its repertoire consisted of a flux of *nritya-abhinaya* pieces interspersed with *nritta* ornamentations, known then as *palevi*. At the end of the recital they danced a *natangi* item, very sprightly and also incorporating *bandha* elements. The *natangi* prefigured the lively steps of the *moksha*, the final item in the repertoire as we have it today. The *gotipuas* sang as they danced, usually vernacular versions of the *Geet Govind ashtapadis* which were episodes of the *Raasleela*. In this regard, their *abhinaya* was a Vaishnavite one, expressing the many emotions associated with the love and love-play between Krishna and Radha.

It is well to bear in mind that the Jayantika gurus were themselves trained *gotipua* dancers, so that this item of their archaelogical materials had already been metabolized, so to speak, into their own flesh and blood.

They were also familiar with, and danced, certain folk dances, such as the Paiko and Naga dances, as well as the military Chhau, aspects of which were later woven into the *paddhati* of Debaprasad Das. But, on the whole, these folk dance influences were removed from the finalized Odissi repertoire in order to render it, as the gurus described it, more *natyadharmic* (i.e. more classical in the general sense prescribed by the *Natya Shastra*, which distinguished between the *marga* or *natyadharma* form and the folk or regional *lokadharma*).

The poetry and music to which these dances were set were derived from the great Odiyan poets, the greatest among whom is Jayadeva. It was his verses that were sung to the deity by the *maharis* in their evening ritual, and many of the songs to which the *gotipuas* danced were vernacular renderings of Jayadeva's Sanskrit *ashtapadis*. But other lyrical medieval songs were also used in the repertoire, all of them reflecting the dual carnal and transcendent planes enacting the love-sickness of the *sringara* and *sringara-bhakti rasas*.

As to the classical dance texts, it seems that by 1954, after a decade of archaeological work by the individual members of the Jayantika Movement (which did not in fact adopt that name until 1959) they had remained mostly unconsulted. Most of the gurus had not even heard of them. It was only after the presentation of a proto-Odissi performance (a single continuous item combining *nritta* pieces with an *abhinaya* sequence, the whole lasting about twenty minutes) in Delhi in 1954 that old dance and *natya* texts were recognized as seminally important to the entire endeavour of unifying into a single classical form the whole range of regionally excavated materials. After this point, with the subsequent involvement of the dance critic, Charles Fabri, and especially after Mayadhar Raut had spent four years studying at *Kalakshetra*, the texts played a prominent role in their classicizing mission. Among others, these texts included the *Abhinaya Darpana*, *Abhinaya Chandrika*, *Sangeet Ratnakara*, and Bharata Muni's *Natya Shastra*. Even then, these were mostly read

at second hand, in vernacular or English translations, and probably only partially. Still, they proved a rich resource for re-identifying and expanding the scope of dance steps, postures, *mudras* and so forth, and for re-imagining the kind of formal structure that a classical dance was supposed to exhibit.

The sculpted temple dance reliefs yielded visual information of a similar kind. The gurus travelled widely in Odisha and elsewhere to study, photograph, sketch and document these stone-bound postures. These were painstakingly incorporated into the Odissi work-in-progress and made to stand out prominently if momentarily in the new choreographies. Their presence lent a gravity and antiquity to the repertoire, as well as an aesthetic stamp that marked the nascent dance form as distinct in itself, dissociating it especially from the new Bharata Natyam of the South with which it had been wrongly bound up along the early course of its slow reincarnation.

Mayadhar Raut's *Kalakshetra* interlude may be regarded as a catalytic force that drew the other materials more clearly to the surface, rather than as itself an item of archaeology —and this would be a valid interpretation of the part it played. But I am listing it under the archaeological materials because it also offered so much of the modifying material that was added to the other items.

Kala Vikas Kendra, the first proto-Odissi *gurukul*, was already partially established in Cuttack when Mayadhar chose to study at *Kalakshetra* on a rather meagre scholarship awarded him by the Odisha *Sangeet Natak Akademi*. There, under the fiercely benevolent rule of Rukmini Devi, he had his first opportunity to become more closely conversant with the *Abhinaya Darpana* and the *Natya Shastra* (probably in the form of the recensions/translations of Manmohan Gosh). These texts were revelations insofar as they confirmed the direction that should be taken by the gurus' classical vision and the details of codified construction that would have to be implemented. Apart from these texts, Mayadhar learnt a number of Kathakali items, basic Bharata Natyam, and a wealth of *mudra* and *abhinaya* techniques from Gauri Ammal. In the main, it was these elements that he would take back, after four years of study in Chennai, to his fellow gurus and their associates in Cuttack. These were enrichments that finally tilted

the balance in favour of the design of a five-movement repertoire that mirrored the movements in Bharata Natyam.

In addition, the experience he gained in staging *Kalakshetra natya-nritya* productions infused the maturing Odissi idea with those elements of Western, orientalist, balletic dance-drama that were embedded in the Adyar revivalist movement. It became apparent that Odissi could be imagined as a regional Odiyan classical dance, yet also one of pan-Indian and eventually international import. Which is in fact how it really turned out.

And at this stage it becomes crucially important to remark that the idea of the Jayantika Movement can't be authentically entertained without the inclusion of its female members, the dancers themselves. In fact it was the most prominent of them, Sanjukta Panigrahi, who first went to *Kalakshetra* in 1952, at the age of eight. There she was taught Bharata Natyam by Rukmini Devi, as well as the elements of the two main texts that Mayadhar Raut would later study. It is a fact that even as a child at *Kalakshetra*, Sanjukta would return to Cuttack during the summer vacations and impart the knowledge gained, including *abhinaya* and *viniyoga*, to Kelucharan Mohapatra. She was thus part of the archaeological and imaginative force which drove Odissi onward to its future as a classical form, a form to which she later imparted her own choreographies while elevating its status through her excellence as a practitioner. And something of this sort holds true for the other girl and women dancers too.

The above list of items then, roughly speaking, makes up the tally of the excavated materials finally available to the gurus, the dancers, their supporters and collaborators. These components, as they had been gradually unearthed, examined, tried and refashioned over a period of about twenty years, would go into the melding and moulding of the neo-orthodox form of Odissi that was, across that period of time, being coerced into a cumulative emergence from its prototypical structures and patterns.

These materials would also, by a sort of diachronic inevitability, give rise to the new myth about the reconstruction of Odissi that rested on the old one drawn by Jayantika from the archaeological materials themselves.

I have already spoken above of the movement's need to re-imagine, on the basis of the materials available to them:

An aesthetic structure or repertoire
An applicable conception of classicism
An underpinning mythico-philosophical trope

The task facing Jayantika once all their archaeological materials had been brought to the surface, studied, and applied to the dance form they were re-imagining, was to delve diachronically into the meanings these materials had yielded in the course of their history, and to draw from these meanings the three authenticating factors that would clothe Odissi with the respectable air of being grounded in a continuous past.

Their first and most concrete problem was the shaping and vivifying of an aesthetic form that would endow Odissi with a distinct and discernible body-in-motion, a recognizable and harmonious bodily persona. The second was to define for themselves the meaning of the whole notion of classicism, in both a national and an international context. The third challenge involved furnishing this classical idea with its own mythical and philosophical premises. Only by solving these three problems would they be able to establish a corporeal repertoire enlivened by an indwelling soul, and so impart to it the full attributes of a new and living *avtaar*.

To compass these ends they turned in the first place to the lessons they had drawn from *Kalakshetra*. It is true that *Kala Vikas Kendra* was by this time already staging dance-drama productions which included an updated proto-Odissi repertoire that was still rather sparse and amorphous. Taking their cue from the fivefold movement of the *Kalakshetra-bani* of Bharata Natyam already enjoying international acclaim, they decided to replicate that structure in their own dance form. It was also to be in this final concrete structure that they would discover the answers to the problems posed by the notions of classicism and myth.

The deliberate *devadasi* imprint on Bharata Natyam, made conspicuous by the opening movement of the *pushpanjali* or *alarippu*, was transferred to Odissi with reference to the *mahari* tradition

Jayantika 177

and its clinging, evocative mystique. It was named *mangalacharan*. This opening movement is an invocatory one whose finale sums up its quasi-religious intention: the salutation to and imploring of blessings from the deity, the guru and the assembly of *rasikas*. The idea is thus evoked of a dance recital that is spiritually grounded and salubrious, incidentally paying homage to the *shastric* idea of the *Natya Veda* and at the same time removing the stigma from the *mahari* practice by insisting on its obvious place in a secular and public presentation. At the same time it paid deference to the orientalist (largely Theosophical) conception of Indian dance as a quasi-mythical entity throughout. One sees this pervasive Westernized conceptualization everywhere present in the stage design, *costumerie*, make-up and jewellery, as well in the tone of the arm movements. Its undertone infuses the early *Kalakshetra* and *Kala Vikas Kendra* dance-dramas. The *mangalacharan* was therefore not only an indispensable first gesture of obligation to the *mahari* tradition, it also aligned Odissi with the up-to-date orientalist fashion.

The *batu nritya* (so-called although it is a *nritta* item) is a dance in honour of Shiva (*batuka bhairava*). The genius of its inclusion lies in its reference to the ancient Shaivite traditions of Odisha, thus deepening and extending the idea of a revived continuity of classical and religious antiquity. Here again there is a straightforward reference to the ancient beginnings of the temple dance custom which reaches back to the epoch before Vaishnavism was universally adopted in Odisha. The *batu nritya* thus evinces the presence of an aboriginally primal gene or what, for my own purposes, I will think of here as a karmic trace.

The *pallavi* pure dance item, though still present in name (as *palevi*) in the *gotipua* repertoire, has its origins, too, in the *mahari* tradition. It has been plausibly argued that the *mahari sakala dhupa* was a *pallavi* dance ritual, in which the *mahari* shed her 'sexual essence' as an offering to the deity and a blessing to the temple, its worshippers, and society. I don't wish to elaborate on this idea here, except to note how the *palevi* preserved by the *gotipua* dance was none the less able to preserve itself as another karmic trace that would find its way into the newborn *avtaar*.

The *gotipua* trace itself comes to the fore in the *Odiya gito* movement in which medieval songs about the love-play of Krishna and Radha are

danced with complex blends of *abhinaya* and *bhava*. Here is the stamp of a later stage in Odiyan song and dance, but one that still retains its tracery of continuity with the temple dance in that these medieval *gito* all draw their theme and inspiration from the richly classical Sanskrit poetry of Jayadeva's *Geet Govind*.

Immediately following the *Oriya gito*, Jayadeva's *ashtapadis* are brought to the fore in the *gita abhinaya* movement. Here is a rich reference to the entire karmic endowment of the Odissi repertoire. In the first place we have the textual reference to the *Geet Govind* itself. But through the danced re-enactment of the poetry other textual references are accessed: the *abhinaya* elements from the *Abhinaya Darpana* and the *Abhinaya Chandrika*, as well as the *shastric* idea of the dance-drama as a Vedic ritual (but here with its Vaishnavite myth and implications). There is also a reference back to the *gotipua* songs of the *Oriya gito* movement and, as is the case throughout the preceding movements, to the sculpted relief panels. Again the *Kalakshetra* revivalist influence is present in the orientalist insistence that the *sringara rasa* of the *Radhamadhavan* be interpreted in a transcendental manner (Mayadhar Raut always insisted on this sublimation).

The final movement, the *moksha*, was technically elaborated on the basis of the *gotipua natangi* item. What had been for the *gotipuas* a finale of sheer *nritta* celebration with a strong virtuoso emphasis had now to be reformed into an endpoint that would summarize, give unified purpose to, and sublimate all the items preceding it in the repertoire. The choice for the *moksha* was thus almost inevitable. Yet it also raises a faint echo of Odisha's Buddhist epoch, and in this respect is in itself a genuine karmic trace. We can't, however, avoid the obvious force of a strong Theosophical impress here, which is surely one of the reasons why the *moksha* still rings as untrue for many Odissi exponents as it did for Debaprasad Das.

Such then was the repertoire which the Jayantika gurus incarnated bearing the name of Odissi. And this was the repertoire which gained classical status for Odissi in 1964, when their decades of ramifying labour culminated in the achievement at which it had always been directed.

It should be clear by now that my usage of the term 'reincarnation' has been a deliberate and considered one. It seems to me that the karmic

traces present in the disparate archaeological materials available to the Jayantika movement were always in themselves predisposed to be reincarnated as a single, new *avtaar*. Even its name was chosen to reflect both its *anchalik* gestation and its *margi* embodiment in that its regional roots were destined to become the object of worldwide admiration and practice. 'Odissi' was thus the attainment of an aggregated, composite rebirth of previously scattered particularities.

This fact surely points also to the composite genius embodied in the Jayantika Movement as a whole and to its fine attunement to the demands, meek and humble at first, then growing more insistent, of a dance entity craving a new incarnation. This sort of reincarnation is true to its own mythological tradition and to the elegant philosophies that have been extrapolated from it. For we know that reincarnation never implies the replication of the selfsame entity manifested in a previous lifetime. It is always rather a set of karmic traces passing from time into timelessness and then back into time in a new realization that bears the imprint of its features but never exactly its previous face. And this the Jayantika movement must surely have suspected. Its members had themselves handled and imbibed these traces, to such an extent and across so many years, that they became for them a way of thinking, feeling and being.

It is no surprise then that the potent activity involved in the karmic reincarnation of Odissi should have given rise to a double myth arising from its own karmic source.

In the first place it supplied the sub-textual narrative, if only subliminally, for the idea that Odissi was a dance form that had existed from time immemorial, and that the gurus and their associates had done little more than rediscover and revivify it. It had been there all along, before even the *Natya Shastra* had been composed. This idea is of course historically false—not least because, shall we say, the very name 'Odissi' was only contrived in 1948, and then in the rather unglamorous setting of Kalicharan Patnaik's All India Cuttack Radio Station. But no more of this.

The truer truth may well be that Odissi was present in *pre-shastric* times in the karmic embodiment it then enjoyed, an embodiment that was to change with each new incarnation but whose karmic traces remained genuinely present, even in the most concrete historical

sense. All that was needed in the Jayantika period was a composite and arduous imagination powerful enough to perceive their active presence for what it was: a tracery of potent cultural imprints waiting to be reborn in a new and beautiful body. The search for an ideal classicism was itself resolved in this fluid beauty, which rested on a karmic inheritance as formal as mathematics and as old as the hills, and whose mythico-philosophical premises were embedded in its own codified patterns.

From this perspective then it is also no myth that Jayantika accomplished a miracle no less miraculous even when its archaeological mechanisms are understood. We know the mundane facts, from the gurus' first excited unearthing of the array of archaeological materials to the last conditions of their eventual squabbles and jealousies in later years. We know that they rose up from the village, the street theatre, the local radio station and the movies, and that they were by no means *sanskriti* types.

They were poor boys and poor girls caught up single-mindedly in a singular filament of karmic activity that compelled them to dream a vast incarnational dream. They dedicated themselves to that dream, strove to fulfill it, and in the event gave birth to a new dance-*avtaar*.

No wonder then that they agreed to sign the Jayantika manifesto with their own blood. And perhaps it was this same karmic force that prompted Sankjukta Panigrahi in later years to offer her services as an occasional *mahari* doing *seva* at the shrine, and to suggest that other Odissi dancers do the same. Her offer and suggestion, though firmly declined at the time, nevertheless testify to the enduring imaginative power of the myth that was brought to rebirth.

'Odissi'

This lovely name must remain forever associated with a myth that is essentially and karmically authentic, no matter how frequently some commentators may strive to expose it as an illusion.

29

Sanjukta Panigrahi's Contribution to Odissi: 1944–1964

To prospective readers of these essays on Sanjukta Panigrahi I have to confess in advance that I consider myself among those persons least qualified, either as a dance historian or as a biographer, to have attempted to write them.

My reason for doing so, then, would have to be a good one indeed—and I think it is. As my interest in the history of Odissi has deepened, and as I have read more and more about the fascinating process of the reincarnation of the dance, I have noticed how little of any real substance has been written on Sanjukta Panigrahi's contribution to this project; very little, at any rate, that is readily available to the general reader. These essays are a personal attempt to collect, collate and analyze the available information for my own sake in the first place. My hope is that the information I have gathered, arranged, and in some cases speculated upon, will be of benefit also to others interested in the life, work and meaning of this dancer of genius.

I have concentrated on the period 1944–1964 because these were the two decades that witnessed the first concentrated forging of renascent Odissi, from its almost amorphous manifestation as a brief dance item in the theatre repertoire of Odiya to its recognition by

Essays on Classical Indian Dance
Donovan Roebert
Text copyright © 2021 Donovan Roebert / Photographs copyright © 2021 Arun Kumar
ISBN 978-981-4877-47-3 (Hardcover), 978-1-003-12113-8 (eBook)
www.jennystanford.com

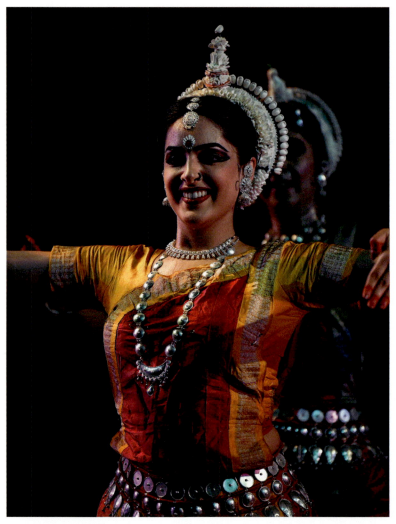

29. Divya Chowdhary, Odissi Dance Company, Seattle.

the *Sangeet Natak Akademi* as a classical Indian dance form. Indeed, the first version of the *Dashavatar*—that early proto-Odissi sequence danced by Kelucharan and Laxmipriya Mohapatra, and which is still being danced today—was composed in 1947, when Sanjukta was three years old. These were also Sanjukta's formative years, and the years in which, despite her youth, she was in a position to impart to the construction of Odissi the knowledge and prowess which she had gained both at *Kalakshetra* and during the ten years during which, as

Sanjukta Panigrahi's Contribution to Odissi 183

an experimental dancer, she had been a vital part of the reshaping of Odissi itself. She was an intrinsic element in the process of designing the dance throughout these crucial years of her own development.

Anyone sifting through the material that I have had to hand will notice how many discrepancies occur among the various narratives. These involve, among other things, disparities in recorded dates and incidents. (An example occurs in the paragraph above: Laxmipriya Devi remembers the first performance of *Dashavatar* as taking place on 1 October 1947, whereas Durlav Chandra Singh, who co-choreographed it with Pankaj Charan Das, gives the year as 1945). This seems inevitable in a body of data consisting in the main of recollection, reminiscence and anecdote. It applies even to narratives spoken or written by the gurus and dancers themselves. In all of these cases I have selected from the variations those that seemed most likely to make sense in the correlative frame as it relates to other contemporary incidents.

I have derived much pleasure from this little task. It gives me real joy to have been perhaps the first to have paid to Sanjukta Panigrahi the best tribute of all: that of trying to reconstruct the elements of her contribution to the moulding of Odissi in a fuller way than has yet been done.

My task would not have been possible without access to certain source documents vital to it, and I must record a debt of gratitude to Madhumita Raut, and to Guru Mayadhar Raut himself, for granting to me in correspondence some crucial insights and information that have helped in rounding out the picture.

My thanks go also to Madhavi Puranam and the board of the *Nartanam* dance journal for sending me a very data-heavy e-copy of Dayanidhi Das's Jayantika records edited by Dr Ileana Citaristi. And I must thank Kedar Mishra, the Odiyan art critic, for his efforts and support in this matter.

It was indeed Mr Mishra's article posted at academia.edu which first brought home to me the urgent need to make a start at recording Sanjukta Panigrahi's contribution to Odissi in an ordered and detailed manner, with reference to dozens of scattered articles hosted at numerous online sites. This work of research has taken many months to complete.

I must also express my gratitude to Aadya Kaktikar, whose biography of Guru Mayadhar Raut is replete with references to Sanjukta, a close friend of Guruji's throughout her life. The fact that I was given permission to quote freely from her work has provided much colour and substance that would otherwise have been absent from these pages. Her informal correspondence with me has also been invaluable in casting light on many aspects of the story.

Likewise I must thank Sabyasachi Panigrahi, Sanjukta's younger son, for answering a number of queries and clearing up some difficulties when I was nearing completion of my research.

In all honesty, though, the task has been a lonely one. I cannot say that I was overwhelmed with offers of assistance and information while I was in the process of carrying out the necessary research—even though there were many who knew about the task I had set myself and who were in a position to clarify and amplify certain points. There were cases, indeed, where important queries simply went unanswered.

I want to stress again that these essays on Sanjukta are the work of an amateur and that they can as such make no pretense to any kind of authority or finality. One of my hopes in writing them has been that they should inspire more qualified persons to undertake the task of a detailed critical biography. Perhaps, if and when this task is undertaken, these essays may be of some use in providing a preliminary framework of reference for the early years of Sanjukta Panigrahi's life and work which they attempt to describe.

I will end by citing Binod B. Nayak, who has recently said that 'the story of Odissi's reconstruction is so fascinating that it needs to be deconstructed and reconstructed time and time again.' There is much truth in this saying, not least because the story of Odissi is still in the process of unfolding. Something new and unexpected is always just on the verge of coming to light, or something old of being cast in a new light.

I say this not in order to avoid responsibility but rather to stress my own awareness that a number of factual and interpretative errors are bound to have occurred in the narrative as I give it here. My hope is that someone more qualified than I will eventually do the job of replacing these with documented certainties.

Sanjukta Panigrahi's Contribution to Odissi

Note: Chief sources are to be found at the end of the third of these essays.

Sanjukta Panigrahi's First Eight Years: A Tentative Reconstruction

'People would express their censure of a Brahmin girl dancing by spitting as they passed her door.'

'With the decline of the Odissi dance and of the culture in Orissa, this saying emerged: People who have little shame sing, people with no shame play musical instruments and those who are totally shameless, dance.'

Sanjukta Panigrahi

If, as she later maintained, Sanjukta Panigrahi began dancing at the age of three, we may take the statement literally and make the fanciful assertion that she started dancing only nine days after an independent India was born on 15 August, 1947.

In the year of her own birth—she was born on 24 August 1944—the tumultuous late period of British rule was drawing to an inevitable close. The Second World War, too, was coming to an end in the final fierce months of fighting in Europe. In India, Subhash Bose had advanced with his pro-Axis Indian National Army to the outskirts of Imphal, the capital of Manipur, from where he hoped, with Japanese help, to liberate West Bengal and eventually Odisha, where he had strong popular support. There were rumours among local political commentators that Cuttack would soon be bombed. In the event, however, Bose was driven out and died in an airplane crash while fleeing to Japan in 1945.

Zooming in from this larger context of national and international conflict to the small town of Berhampur (now the city of Brahmapur) around 200 kilometres south of Cuttack down the Odisha coastline, across Chikla Lake from Puri, we arrive at Sanjukta's birth-place, the home of her parents, Abhiram and Shakuntala Mishra.

Abhiram was an engineer, a conservative, traditional Brahmin family-man. About Shakuntala we know that she came from Baripada,

186 ESSAYS ON CLASSICAL INDIAN DANCE

the commercial and cultural centre of Mayurbhanj in the far north-east of Odisha, near the border with West Bengal.

Baripada was then, as it still is, the town at the centre of the Mayurbhanj Chhau dance—now one of the recognised classical dances of India—so that we can more easily understand why this is the dance that was patronized by Shakuntala's cultured parents. In addition to their support for the dance, they encouraged their daughter to take up singing, and Sanjukta spoke of her mother in later life as 'an amateur singer of some calibre.' As an artist, then, she too was a person of some accomplishment.

Abhiram, the civil engineer, perhaps a little less enamoured of the arts, more the typical period-man making his practical way in the world, would nevertheless in the end prove amenable to allowing his little daughter to dance outside of the home, to lavish public applause. We may wonder a little at the kind and degree of persuasion that was needed to bring him to this point.

He was an engineer in government employ. We are told that he was subject to intermittent transfers, working on construction sites in various parts of Odisha. This may explain why Sanjukta was born in Berhampur while her family life, school and dance tuition were all centred in Cuttack.

There were five siblings, six children in all. Four of them were boys, two older and two younger brothers. And she had a younger sister. But she seems to have been the special little *kumari* who drew both so much affection and so much solicitude not only from Abhiram but also from his brothers, her paternal uncles, who were engineers too.

Sanjukta herself remembered it this way:

My story goes back to those times when dancing by young ladies was considered a taboo in my society. To make matters worse I came from a very conservative and orthodox family. My mother's vivid interest in cultural activities was due to her life amidst great Chhau dancers in Baripada. She was also an amateur classical singer of some calibre.

My knack for dancing first became noticeable when I was just over two years old and I could spontaneously dance to the tunes

Sanjukta Panigrahi's Contribution to Odissi 187

> and songs on the radio. This motivated my mother to think on the lines of making me a proficient dancer and her determination in this regard grew day by day …

And she adds elsewhere:

> My father was absolutely against it.

There were many good reasons why a father at that time should not want his daughter to dance. The art had for decades since come to be associated with moral lassitude and the abuse of the rights of girls. The Prevention of Dedication Act was promulgated in 1947 and implemented in January 1948. Though aimed in the first place at the devadasi practices in Tamil Nadu, it had its reverberations in Odisha too. Though it did not much affect the dying ritual art of the Odiyan *maharis*, who were still dancing at some local temples until around 1960, it had its deleterious effect on the middle- and upper-class attitude to public dance.

Here is more from Sanjukta:

> My mother comes from Mayurbhanj, Baripada, and was the daughter of the renowned Kailash Panda, the great patron of the local dance, Chhau. Appreciation for the arts ran in her family, so when my mother saw how I moved, she thought of having me take dancing and music lessons. My father's entire family was vehemently against this. They accused my mother of wanting to ruin my life. 'She won't be able to marry, she won't be able to mingle in society,' they said. My mother responded: 'All right, let her learn as a child, especially if she has talent. If she wants, when she's older, she can stop.'
>
> My parents went regularly to the theatre and they used to take me with them. My interest in dancing grew when I saw Padmabhushan Kelucharan Mohapatra and his wife Lakshmi Priya on stage. After their performance, I tried to imitate them in front of a mirror at home. Like all little girls of that age, I was fascinated by beautiful clothes and ornaments. My mother said to me: 'If you learn dancing, then you will be able to wear those clothes' … So

my determination to learn grew. I was only four years old when I began dancing.

The theatre and travelling theatres, though patronized, were also viewed as iniquitous and certainly no place for decent girls and boys to be trained and employed. Many girls of the *mahari* community were then being offered work in the Annapurna theatres and there were many instances of extramarital relationships ripening in their exuberantly creative atmosphere. This problem became so severe that Mayadhar Raut, when he began working at *Kala Vikas Kendra*, was asked to leave Annapurna for a time because he was unmarried and, if attached to the theatre, would not be suitable for training girls in dance.

The stigma in fact did not only extend to girls. It was considered shameful for *akhada* boys to learn the *gotipua* art or for men to admit in later life that they had been boy-dancers. In addition, the traditional question of caste played its role. Kelucharan Mohapatra experienced difficulties for his having come from a *pattachitra* painter community— and even as a member of that community his father was disgusted by his son's involvement with dance and theatre.

There were other problems too:

My guru did not belong to a Brahmin family, but to a family of painters and traders. Our neighbours were amazed my guru was allowed into our home. I remember one day my father had given Guru Kelucharan Mohapatra a lift and a neighbour asked him who he was. When my father told him, the neighbour spat and exclaimed: 'You, a responsible engineer and a man of society, you take people like this in your car, you mix with commoners?'

When I was about six years old, the school authorities complained to my father that I was always arriving late at school. I was late arriving home as well. The reason was simple: friends and neighbours I met in the street would say 'Sanju, dance for us.' I would willingly put down my books and dance. My father was very angry and stopped my dance lessons for fifteen days. I cried day and night, and my father, who couldn't stand to see me like this, called back the guru.

> But he also said to me: 'Your mother wanted you to dance and I, going against the social rules and the will of the family, consented. But if you don't study, they will say it is because of the dancing. You must promise to study books as well as dance.' I promised.

On the other hand, there was a way forward. The air of sanctity and renewed traditionalism with which classical dance was being imbued by Rukmini Devi at *Kalakshetra* was becoming lodged in the public consciousness too. This revived idea of the inherent classical value of Indian dance and music was quickly being absorbed by the pioneers of theatre at Cuttack.

The cultured public would have been aware of it too, and it would have been known to Sanjukta's parents. At any rate, Shakuntala, seeing the unmistakable genius for dance erupting in her little daughter, who would dance to the sound of vegetables being cut or firewood being chopped, began earnestly seeking a reputable dance master.

But who were these masters and what kind of dance were they teaching? These would surely have been the questions Abhiram Mishra wanted answered before he could be persuaded to allow his daughter to be taught.

To begin with the teachers, I will deal only briefly here with the three that were involved with Sanjukta before her *Kalakshetra* period. It is perhaps not generally well known that Debaprasad Das gave tuition to Sanjukta, on invitation from her father, at the Mishra home. These lessons probably came to an end when Guru Debaprasad moved to Chowdar. Meanwhile, at the age of five or six, while still under Debaprasad's tuition, she danced *Batika Bihar*, a piece taught her by Kumar Dayal Sharan, the student of Uday Shankar, the early Indian expressive dancer.

Certainly Sanjukta was by then dancing in productions in Annapurna Theatre B (Cuttack). It is on record that she danced an item taught her by Debaprasad during a program in which a very young Chitralekha Das Mohapatra, daughter of a local doctor, also danced a folk dance choreographed by Mayadhar Raut.

Mayadhar Raut himself was treated very cordially by Abhiram and seems to have spent much time in the Mishra home. It was Abhiram

who advised the young Mayadhar, then only eighteen or nineteen years old, to preserve his press-clippings and other memorabilia. There was a sense, then, in which Sanjukta's father was already beginning to look to the future of dance in Odisha. Later, it was Mayadhar who would accompany Sanjukta and her father on their trips to and from *Kalakshetra*. Whether Mayadhar gave any technical tuition to Sanjukta in these pre-*Kalakshetra* years isn't known, and he himself doesn't claim to have done so. But it seems unlikely that his visits to the Mishra home were always merely social—though such social visits would have been less controversial as Mayadhar was of the *Kshatriya* caste.

Of course, Sanjukta's career is inextricably entwined with her life-long guru, Kelucharan Mohapatra, who by 1945 had left the Roopashree theatre group and was giving private tuition in Cuttack. By 1946 he was performing at Annapurna B in Pankaj Charan Das's composition *Mohini Bhasmasura*, in which Laxmipriya, whom he married in 1948, played Mohini. She danced the two pieces *naheen ke kari dela* and *jaana re mo rana paranan mita*, regarded as two of the earliest proto-Odissi items.

In 1947 Kelucharan and Laxmipriya danced the duet *Dashavatar*, choreographed jointly by Durlav Chandra Singh and Pankaj Charan Das, and which has since, with later adaptations, become a standard item in the Odissi repertoire. It is said that it was during rehearsals for this item that Kelucharan fell in love with Laxmipriya and that Lingaraj Nanda, the director at Annapurna, decided for this reason never again to use unmarried dancers for this composition. *Dashavatar* was a landmark in proto-Odissi design.

Kumar Dayal Sharan taught various aspects of what was called 'creative dance' (probably a fusion of South Indian dances) to Kelucharan in 1948, the year in which Sanjukta began receiving tuition from him too. He was then twenty-two years old. At this time he was still actively increasing his own competence at *gotipua nacha* and so-called *mahari nacha*. These studies, and perhaps his romance with Laxmipriya, inspired him in the same year to compose a sequence for her which contained the elements of *pushpanjali*, *bhumi pranam* and *trikanda pranam*, later to be elaborated into the offertory Odissi item, the *mangalacharan*.

By 1949, cycling to and from his pupils' homes, he was teaching a number of students besides Sanjukta, among them Minati Mishra and Meera Das. It would seem then that, at least for intermittent periods in the years of her early dance tuition, Sanjukta was being taught by three teachers. (The appellation 'guru' was certainly not used by them at this time. They referred to themselves only as 'teachers of *nacha*.' It was only much later, after the Jayantika Association had completed its project, that they assumed this honorific, and then only on condition that they had choreographed their own items or rendered conspicuous service to the dance).

These and others of the early gurus were young men trained mainly in stage- and theatre-craft, with acting and dance as nodes of specialization. Coming as they had from a background of *gotipua* and *akhada* training, they were also rather footloose and, for their time, morally adventurous. They had probably used *bhang* many times, and it is known that both Mayadhar and Kelucharan smoked *beedis*, the latter somewhat to the detriment of his health. They were proficient in all aspects of theatre, from the labour of the stage-hand, painting of stage scenery, devising *ad hoc* costumes and applying stage make-up to the playing of a variety of percussion instruments, and of course acting and dancing. It is profoundly to the credit of their composite developing genius that they were able only a little later to recognize the inherent classical qualities of emergent Odissi dance, born as it was being in the furnace of the theatre, and to extract it with a finesse that would uplift it within a mere fifteen years to the status of a classical dance.

We get some idea of the ongoing training they were receiving in these years from a later tribute paid by Mayadhar to his earliest teachers:

Shri Kalicharan Patnaik taught him acting. Shri Harihar Raut and Shri Durlav Chandra Singh taught him dance, music and acting, and dialogue delivery. From Mohan Mohapatra and Singhari Shyam Sundar Kar he learnt *gotipua* dancing. Pramarth Nath Bose taught him dance. At Banapur he learnt *Dakhini Nata* from Yudishthir Mohapatra. At Annapurna he studied music and acting under Master Ramachandra Maniya, dance and acting from Kartik

Kumar Ghosh. His other teachers were Mohan Sunder Dev Goswani in *Raas Leela*. He learnt *Mahari Nacha* from Master Pankaj Charan Das, and creative style dance from Kumar Dayal Sharan.

Other influences included the cinema, the music played by the AIR Cuttack Radio Station, and the 'orientalist' type of dance-drama that had been extrapolated from the Western balletic tradition.

It was into this world of eclectic theatre-dance that Sanjukta was at first inducted for her training in dance. (As we have seen above, she soon gave up the singing component.)

She has left us a short idea of an early training session with Kelucharan:

> Kelucharan Mohapatra has been my guru since I was four years old. When I went to him for the first time, he asked me to sit down with my body upright and my legs crossed, pick a point on the wall and concentrate.
>
> Because I was getting impatient, he asked me to do two things at the same time: to vibrate my fingers and rotate my eyes with power. Later I had to do various exercises to strengthen each part of the body. We started with the toes, practising an exercise with knees bent and open as wide as possible, the back straight, the body leaning on the heels and jumping up in the air.
>
> Each exercise had to be done one hundred times; if you stopped before the end, you had to start again from the beginning. Then we did exercises for the legs, thighs, hips, waist and torso, and other exercises for the head, neck and eyes.

(At the time little Sanju complained to her mother, 'My guru doesn't know how to teach. He just makes me sit and look at a wall.')

The monthly fee for home tuition was between ten to fifteen rupees, and, in exceptional cases, twenty.

> I started learning dance even though my father's family and the neighbours were against it …

The extent to which her father's attitude changed across the years is a remarkable transformation in itself. By 1955, when Mayadhar Raut was

about to leave Cuttack for *Kalakshetra*, and was talking in the Mishra home to Sanjukta and Debaprasad Das, Abhiram Mishra addressed himself to the departing Mayadhar: 'Please remember, you have to do us proud at *Kalakshetra* and keep up the name of Odisha and Odiyan culture.'

It seems clear that by this time the family was living in Cuttack although none of the narratives I have consulted mention the event or the year of the move from Berhampur. Nor do I know which school in Cuttack Sanjukta attended, walking home from which, as we have seen, she would drop her books and dance. We do know, however, that Sanjukta joined the Hindi evening classes presented in Cuttack by the *Rashtra Bhasha Prachaar Seva Samiti*, and that these classes culminated in an examination.

We see then, in a girl of seven years old, this taking thought for the future, and we can hardly doubt her unusual perseverance and dedication to the goal she seemed already at that age to have set for herself as a dancer. She was no doubt a budding child prodigy and would soon become a local child-star.

Her own evident genius and stubborn determination must surely have contributed largely to her father's final acceptance of the situation too. We have seen above, in any case, that he couldn't stand to see her cry. And Sanjukta's inert determination could be utterly persuasive in itself, as we note from a comment made decades later by Eugenio Barba:

> There still lives in me the profoundly kind action, all solidarity and consent, with which Sanjukta refused one of the tasks I proposed to her with a stubbornness so unshakeable as to appear pacific.

And this quality appears to have belonged to her mother too.

Along with her teachers little Sanju shared the eccentricity of a vision and genius common to them all. For *eccentrics*, given their time and their social environment, we can hardly doubt they were. To this eccentricity, with its attendant industry, commitment and perseverance—as well as the charm of its created art—Abhiram succumbed, no doubt with unrelenting help from his equally dedicated wife.

Besides, patriotism, especially cultural patriotism, both local and national, was very much in the air. Since becoming a Dominion in the first years of independence, India had experienced an extremely traumatic time. By the time the first national elections were held in 1950, Gandhiji had been assassinated in 1948, and the terrible massacres and displacements in Kashmir, the Punjab and West Bengal had shaken the nation with their extreme levels of violence and communal hatred. The public socio-political consciousness was alive and responsive to these tragic occurrences that were taking place throughout the first years in which Sanjukta was learning dance. The general striving and hope, as well as the central political will, were set on a pacific pan-Indian ideal that would calm the situation at home and look well abroad. And this endeavour was closely bound up with the state of Indian culture, with a special focus on music and dance.

Rukmini Devi had shown at *Kalakshetra* that dance could be turned into a representative art, a cultural quantum that could be used—after having been re-mythologized—to good purpose in making the case for the high state of Indian civilization, and for its precedence in terms of antiquity. The teachers in Odisha were no doubt aware of these things and, to some extent at least, they were beginning to think and work towards duplicating, in strictly Odiyan terms, the kind of eminence and success that was being enjoyed by *Kalakshetra's* Bharata Natyam. By the time Sanjukta began her dancing lessons the launching of Jayantika was only a decade in the future.

It is a matter of record that she began taking tuition at the age of four, in the latter part of 1948, so that her first period of learning, before the establishment of *Kala Vikas Kendra*, and before her departure for Chennai, would have run its course across the four years and some remaining months before her entrance to *Kalakshetra* in 1953. What kind of dance was she learning in this period?

The fundamental way to get at the answer is by a consideration of the availability to her teachers of the classical texts at that time. The *Natya Shastra* and the *Abhinaya Darpana* were already being taught at *Kalakshetra*, though Manmohan Ghosh's translation of the latter was only fully available in 1960 (the first volume was published in 1950). The *Abhinaya Chandrika* had not yet come to light (or, had not yet been written), and D.N. Patnaik's English (and later Odiyan)

translations would not be fully available until the late 1950s, in the Jayantika period.

None of Sanjukta's teachers were able to read either Sanskrit or very much English, and it is unlikely that they began to rely on these texts for direct teaching or dance reconstruction until some time into the work of *Kala Vikas Kendra*, the academy established by Babulal Doshi in August, 1952. This means, of course, that a systematic codification was not yet in use, or not much used in any case.

The common teachers' memory usually recalls that four styles of dance were current: the *mahari nacha*, the *gotipua nacha*, the *raso nacha* and the *dakhini nata*. These, together with various folk dances, were being taught separately and in conjuncture with one another, still mainly for theatrical purposes. It was a mixture of these, together with 'creative' dance, with its own orientalist undertones, that would in the main have been imparted to Sanjukta. In the absence of standardized and standardizing texts, these currents of dance styles had been transmitted in a loosely practised teacher-student tradition. And they formed part of the teaching course as much as they were part of the mixed repertoire of all the early teachers. Though the idea of a purified Odiyan *aanchalik* or regional style was starting to sprout tentative roots, it was not as yet a drive urgent enough to have formed the core idea of what was being taught by the teachers in their students' homes— though its evolution, slow at first, much more rapid as it saw its goal approaching, must also have been intuitively sensed by teachers and students alike.

It seems fair to conclude then, in a survey as brief as this one, that Sanjukta was trained in what may be thought of as early and pre-proto-Odissi dance, if such nomenclature can be excused.

At the same time it is important to remember that true proto-Odissi items such as the first *Dashavatar* had been composed in 1947, one year before Sanjukta began her classes. This is why her training in dance in the years before her time at *Kalakshetra* can best be thought of as grounded in a loose, varied and rather shapeless tradition, but tending always towards the full-bodied reincarnation still awaiting the fruition of the developing classical dance form in the fifteen years to come.

So far as the four main styles enumerated above (explicitly at

least by Mayadhar Raut) are concerned, we no longer have much conception of what the *mahari nacha* entailed in its fullness. We do know that it was largely *abhinaya*-based, with some *nritta* steps devised for a smallish ritual temple area. We get some idea of it (or of the remembered conception of it) in the 1972 film *Odissi Dance* produced by Ghanashyam Mohapatra and choreographed by Guru Kelucharan. What we see is a graceful dance with limited *nritta*, some understated *mudra* and much *abhinaya* of a supplicatory kind.

It is certain by now that the *gotipua* dance constituted the largest living aspect of what was then being taught. Probably, in the case of Sanjukta, the charming *lasya* elements would have been emphasized though it is on record that the gymnastic-acrobatic *bhanda* aspect would have been taught her too.

The *raso nacha* was an expressive item representing the *Raasleela* or *Krushna leela* drama. To what extent its *abhinaya* aspect was in any way formalized is unknown to me, and it is probable that its expressive qualities were adapted from acting techniques current in the Odiyan theatres.

The *dakhini nata* has been loosely described to me as a 'dance form from the South'—possibly a regional variant of sadir/kuchipudi from Andhra Pradesh.

It is noteworthy that Laxmipriya Mohapatra reminisced that students were taught by *gotipua* boys (more probably, *the gotipuas* demonstrated the steps) while Kelucharan adapted and refined them *in situ* because they were 'rough at the edges.' Kelucharan once said that Laxmipriya had herself given Sanjukta her very first lesson.

The following extract from a 1988 interview with Richard Schechner is illuminating. Kelucharan Mohapatra ruminates:

In the earlier days the art came more naturally. I just did what my guru did. But now it is more mathematical, everything is figured out ... Now you know the mathematics. In the earlier days art had more truth, now it is like stone figures ... Now you study the mathematics to make it perfect. Before, you didn't study that ...

And Sanjukta interposes:

It is more mechanical these days.

Sanjukta Panigrahi's Contribution to Odissi

We are probably justified in concluding that, of that which was taught to Sanjukta in these years, as least as much was excluded as was retained in the final shaping of Odissi by the Jayantika Association.

These then would have been the sort of dances that she presented on stage in the three *Bisuba Milan* competitions in which she took part between 1950 and 1952. The *Bisuba Milan* (or, *Bisuba Sammelan*) is a cultural festival which hosts a variety of events, from literary readings to music and dance, on the day of the Odiyan New Year celebrations.

About these years Sanjukta later recalled that:

> During the fifties, schools started organising a lot of cultural events. They invited me everywhere to present small dances. I represented my school and I became a very special student because I generally received the first prize. My teachers were very proud of me. At home, my younger brother Himanshu, was jealous. My first public performance took place when I was five years old. I was supposed to dance for only five minutes, but I loved the applause so much that I refused to get off the stage. My Guruji (the name of respect for Guru Kelucharan Mohapatra) and my mother were very irritated and kept making signs at me to come down ...

At the age of six, then, she was making her first transition from the experience of the student-dancer to that of the public performer. What this kind of intense exposure must have meant, in roughly opposing ways, to her mother and her side of the family, and to her father and his, is not difficult to imagine. Her father, ever-cautious, ever-conservative, became concerned that the public adoration she was enjoying would spoil her as a child, and deprive her of the sedate innocence that the life of the girl-child in those days was supposed to evince. Her mother was probably more concerned that these interludes of celebrity, aroused by short dance pieces five to ten minutes long, would spoil her seriousness about dance as an art and threaten her innate discipline.

When she danced, in 1951, at the New Empire Theatre in Calcutta, the public, as they say, went wild. There were rave reviews about 'Baby Sanjukta' not only in the Odiyan press but nationwide. The situation must have had its resonance in the home, with the strains incurred by various responsibilities in a household having six children to support.

Sibling rivalry, as we have seen, was raising its head too. While the public and the press reviewers roared with enchanted approval, it was for her parents the moment in which final decisions as to their daughter's future as an artist must be arrived at.

At the same time, there were wider implications for the dance-scene in Odisha:

> Odissi was not known. When I danced as a little girl in 1952, it was the first time that Odissi dance was mentioned in the national press. In Bhubaneswar my gurus were trying to reconstruct the dance, from the little they had at hand.

The teachers and their dance were being taken seriously in a new, deeper and more future-orientated way. Babulal Doshi, who owned Utkal Jewellers in Cuttack, decided to invest time and money in the establishment of a teaching institution where lessons and research could be centrally conducted on premises of its own. Babulal, committed to this vision absolutely, swore that he would walk barefoot and drink no water after sunset until his aim had been achieved. On 28 August 1952, four days after Sanjukta's seventh birthday, *Kala Vikas Kendra* was founded in two rooms at Oriya Bazaar. In a photograph from the time we see Mayadhar Raut, now twenty-two years old, the *Kendra's* first teacher, seated on a chair in one of the two rooms surrounded by six of his students, five little girls and a boy, all of them thin, barefooted and bearing severe expressions. It is the very picture of the modest concrete means on which the beginnings of Odissi rested.

While Sanjukta was revelling in her latest triumph at the *Bisuba Milan* in 1952, and while her family was exercised over her future, Samar Chatterjee was seeing his own dream finding completion in Calcutta, some 400 kilometres north of Cuttack. Chatterjee was a children's playwright and composer of children's rhymes whose goal it was to bring into being an institution that would cater to youngster's educational needs in the fields of theatre, music and dance. His Children's Little Theatre with its pedagogical annex, the *Aban Mahal*, was finally established in this year.

So far from being only a venue for children's performances, the CLT had been conceived as a means for supplementing their education

Sanjukta Panigrahi's Contribution to Odissi

by training them in creativity and by the encouragement of gifted child artists. Its establishment, and the support it received from various political leaders, including Jawaharlal Nehru, give us some idea of the extent to which children of middle- and upper-class families were being introduced into theatre, dance and music in that period.

Sanjukta's parents were among the first to seize the opportunity that it offered for showcasing their daughter's talent, and perhaps there were thoughts, too, of enrolling her there for further training. It is clear, at any rate, that they were at that time considering several options available for the provision of a full and rounded higher education. In the event the decision was made for *Kalakshetra*, which had by then become a venerable institution under the stern direction of Rukmini Devi.

Meanwhile Sanjukta was entered into the very first of the CLT's performance seasons, usually held in December.

She takes up the story:

> In 1952 I danced at the International Children's Festival in Calcutta. The next day I was in all the newspapers. I was only seven years old. I became famous all over Orissa as 'Baby Sanjukta' and the consequences were disastrous.
>
> I became so busy that sometimes I gave two performances a day, even though they were dances of barely five minutes. My father's friends were telling him that I would become spoiled, so my father thought of sending me to *Kalakshetra*, to Rukmini Devi Arundale's school in Madras, in Southern India. My mother also wanted to send me to study there. It was the only school where I could learn to dance and study at the same time.
>
> My father had six children and it was not possible for him to finance my schooling at *Kalakshetra*, so he asked for a government scholarship for me. It was the first government scholarship awarded to a child ...

The scholarship was awarded by Rajkumar Amrit Kaur, India's first central health minister, and a women of high distinction. Oxford-educated, a deeply committed Gandhian who spent sixteen years as one of Gandhi's secretaries, a member of the committee which had

drafted the Indian Constitution, she would later distinguish herself through her tireless work and support for a number of girls' and women's causes. The list of her other accomplishments is too long to adduce here. She was imprisoned twice for her activities in the cause of Independence.

It isn't clear exactly why she, as Minister of Health, should have dealt with Sanjukta's application. Probably her acquaintance with Rukmini Devi, with whom she participated later (in 1959) in the promulgation of the Prevention of Cruelty to Animals Bill, played a decisive role. It is probable, too, that she had been following the run of little Sanju's successes in the national press.

At home, among the tight-knit family, there was much concern:

> My parents wanted to send me away from Orissa, the town where I was born, to a place where I could concentrate totally on both dance and school. They sent me to Madras, in the Southern part of India, about 1200 kilometres from my home. I was only eight years old. As soon as the decision was made my father began to worry. They don't speak Oriya there, but Tamil—a language I didn't know—and also their eating habits are different ...

We may suppose also that Kelucharan Mohapatra didn't part willingly with this excellent student who had done him so much credit and with whom, in the public eye, he was beginning to be so closely associated. There was a new dance in the offing and still so much work to be done. On the other hand it must surely have occurred to him that the high success of *Kalakshetra* could one day be reduplicated in Odisha, and especially through the medium of *Kala Vikas Kendra* where he was employed as its second teacher, probably early in 1953.

That would have been the same year in which, at the beginning of the academic year in January, Sanjukta Panigrahi, now in the early part of her ninth year, was to be enrolled by a still severely doubtful and rather unwilling Rukmini Devi.

But that is matter for the next essay. We take leave now of little Sanju, together with her family, teachers and friends, as she departs for Chennai.

Since its inception in 1936, *Kalakshetra* has been flourishing under the guidance of its idealistic and disciplinarian founder.

Kala Vikas Kendra is still in its early infancy.

Odissi dance is yet to be born.

Sanjukta Panigrahi at Kalakshetra: A Key Episode in Odissi History

When, at the start of 1953, Sanjukta Mishra, now in her ninth year, was accepted as a student at *Kalakshetra*, she was already laden with the theory and practice of dance, music and theatre. Having begun her dancing career at the age of four, she was already five years into the continuum of experience in the world of dance that would progress ceaselessly until her early death in 1997.

Not only had she had tuition from and been influenced in technique—the developing and evolving theoretic building blocks of early proto-Odissi—by such figures as Pankaj Charan Das, Debaprasad Das, Mayadhar Raut and Kelucharan Mohapatra, but she arrived at *Kalakshetra* also as a child-celebrity, having won a number of dance competitions in Odisha, and having staged, to popular acclaim, a performance at the famous New Empire Theatre in Calcutta and another at the Children's Little Theatre in the same city.

At the time she left for Chennai, with her devotedly supportive mother in tow, *Kala Vikas Kendra* was a mere five months old and existing in two rooms in the Oriya Bazaar. Founded by a visionary Cuttack small-businessman, Babulal Doshi, this little kernel of a dance and music academy had then as its President Sri Pran Krishna Parija, former vice-chancellor of Utkal University and a friend of Rukmini Devi. It may well be that Parija's standing played a role, together with the scholarship arranged by Rajkumari Amrit Kaul, in assuring Sanjukta's enrolment at Rukmini Devi's by then formidably prestigious institution.

We therefore encounter little Sanju at this stage of her childhood in the thrall of a variety of creative personalities, theories and techniques of dance and theatre, and two dance schools, one in its infancy, the other in its teens. It is in relation to these persons and factors, apart from her immediate family, that the next six years until the end of 1958—years in which her childhood crosses over into puberty—will unfold.

202 ESSAYS ON CLASSICAL INDIAN DANCE

About the personalities we have already learnt something in my previous essay on Sanjukta's first eight years, and their lives are outlined in a number of accessible online sites. What I would like again to emphasize here is the variety of backgrounds and talents belonging to her teachers—all of them male—with which Sanjukta was surrounded in her formative years. In this creative hodge-podge, itself constituting a composite entity of genius, she was expected and was being schooled to play her unique part.

Her significance in this regard was manifold. In order better to understand its implications we must inquire a little into what the whole of the agenda was—bearing in mind always that the modest beginnings of *Kala Vikas Kendra* were inevitably directed at the forced blossoming of Odissi that would be accomplished through the work of those of Sanjukta's mentors who would, by the time she graduated from *Kalakshetra*, undertake the complex, imaginative reconstruction of a classical Odiyan dance under the collective name of the Jayantika Association.

It is not too much to say that, by 1953, the idea of an Odiyan dance form as a pinnacle of the regional culture of Odisha was very much in the air throughout Odiyan society. It is remarkable, in studying the period, to find how deeply and widely the idea was supported by business people, lawyers, advocates, regional government officials and the public at large—all of whom seem to have been conscious of a general renaissance of local culture occurring in the first place through the medium of theatre, music and dance. There was therefore, in addition to a multifarious support, an equally high degree of expectation levelled at the gurus and their student dancers. If anything, Sanjukta, through her childhood achievements, had drawn towards herself a particularly acute pressure of responsibility in this field.

The gurus themselves were espying the beginnings of a vision for Odissi (so named by Kalicharan Patnaik) that was itself drawn from the socio-political and cultural esteem in which *Kalakshetra* Bharata Natyam was being held in Tamil Nadu and indeed throughout India as a pan-Indian embodiment of ancient classicism. To this notion of high classical dance were attached several conditional criteria.

The dance should be purged of all vulgar associations, especially those attached to the *devadasi* practice and to the general sentiment

Sanjukta Panigrahi's Contribution to Odissi 203

that dance was a licentious and lascivious tradition that should be confined to the lower castes and classes. It should, in a word, be morally and aesthetically elevated in the public consciousness by being made accessible to higher-class girls.

By 1953 this step had been fully achieved in the case of Bharata Natyam by Rukmini Devi's shrewd positioning of the art. It was clear that any Odiyan classical dance would have to draw its first existential lessons from this example. For these purposes Brahmin girls such as Sanjukta were perfect exemplars of the public success of such an endeavour, the more so when one bears in mind that Odiyan dance had up to that point been given over to the *gotipua* boy-dancers. Just to be a *non-devadasi* (or *non-mahari*) girl dancer was already sufficient to show that the dance had been redeemed.

(It was Lingaraj Nanda, director of the Cuttack Annapurna Theatre, who had first made the outrageous suggestion that it would be more reasonable if girls rather than boys danced the female parts in theatre dance sequences—an inspiration that led to the employment of young, displaced *mahari* dancers at first. And here, incidentally, is another example of the hard-nosed, rough-and-ready material that took part in the reconstruction of Odissi: Nanda was a man who, if you crossed him, would pay a ruffian to beat you up, as he once tried to do in the case of Mayadhar Raut.)

Together with the necessary intention to 'brahminize' the Odiyan dance went the self-evident purpose, at that time, of nationalizing and internationalizing it, and of providing it with a codified, formal classicism of the 'shastric' kind—that is, having ostensible ideological, moral, religious and aesthetic roots in Bharata Muni's *Natya Shastra*. It is questionable whether in 1953 these intentions were consciously and articulately present in just these terms, but it can't be doubted that they formed part of the subconscious reasons for the establishment of *Kala Vikas Kendra*. In the next two or three years they would certainly come much more to the fore, and in clearer ways, and it would become part of Sanjukta's responsibility to embody and emanate them too.

Not that she would content herself with the role of a mere embodiment. One intention of the present essay is, indeed, to demonstrate the extent to which she contributed to the shaping of the dance itself.

204 ESSAYS ON CLASSICAL INDIAN DANCE

But I am jumping the gun. It is well to remember that, in the year that she departed for Chennai, *nach* teachers (for so they called themselves) at *Kala Vikas Kendra* were teaching an eclectic mix of folk, *gotipua* and *mahari* dance, as well as the Kathak-Bharata Natyam fusion being disseminated by Kumar Dayal Sharan. The teachers were experimentalists, informal perfectionists with an experienced and intuitive eye for the elegant moment of dance. And it was precisely this imaginative, improvising, tentative quality that qualified them so eminently for the formalizing work they later did—though there are signs that they regretted in later years the loss of their artistic extemporizing freedoms and the spontaneity of the pre-classical era.

There were shenanigans too: Mayadhar, the *Kendra's* first dance teacher, was dismissed on a flimsy excuse—probably because he was still associated with the moral rough-and-tumble of the Annapurna Theatre—but later beguiled to return after almost half of the 33 students left the school to be taught by him privately. Kumkum Mohanty tells us that the young girl dancing pupils were sent by Doshi to beg money from house to house for the financing of the school.

To get some idea of the *Kendra's* early status, we may make the observation that it staged a ten-minute dance performance at an event organized by the office of the National Saving Certificate, and took part in a competition at the All India *Baalkanj Bari Diswas* in Patna. By now it had moved premises to the Ganga Mandir and was offering courses in tabla, sitar, *Rabindra Sangeet* and *Odissi Sangeet*, as well as foreshortened forms of Bharata Natyam, Kathak and *Gotipua-Mahari Nacha*. It was around this time, perhaps in mid-1953, that Kelucharan Mohapatra joined the *Kendra* as its second dance teacher, Pankaj Charan Das (the *mahari nacha* master) having declined the post owing to teaching commitments in Puri and Bhubaneswar.

This, more or less, was the state of affairs when Sanjukta left for *Kalakshetra*, accompanied by her mother. Having arrived at her destination, she was confronted by a very doubtful Rukmini Devi, who professed to think that the girl was too young and vulnerable to venture so far away from home.

Sanjukta herself takes up the story:

> Eventually I made my way to *Kalakshetra* where I met with yet another hurdle. Rukmini Devi ... rejected me on the grounds of

Sanjukta Panigrahi's Contribution to Odissi 205

my tender age and my inability to speak Tamil ... However, after watching me perform an audition, she relented and admitted me on the condition that I would give up after three months if I was not up to the standards. She was subsequently more than pleased by my progress.

And, in a more elaborate version:

My parents wanted to send me away from Orissa, from the town where I was born, to a place where I could concentrate totally on both dance and school. They sent me to Madras, in the southern part of India, about 1200 kilometres from my home. I was only eight years old. As soon as the decision was made my father began to worry. They don't speak Odiya there, but Tamil—a language I didn't know—and also their eating habits are different. I had begun to study English just a few months before.

We arrived at _Kalakshetra_ and, after having seen me, Rukmini Devi refused to accept me in the school: 'She is too young, she does not know the language, and she is not vegetarian. Bring her back when she is fourteen years old!'

My mother insisted on pleading with Rukmini Devi to see me dance before deciding, given that we had come from so far away. Finally Rukmini Devi agreed to let me stay, but warned my parents: 'I will keep her for three months, and if within that time she is not able to look after herself, is not able to mix with the other children, if she cries, I will send her back.'

So I stayed under these conditions.

Initially I was very lonely and homesick, and I remember I used to cry at night so that I would not be discovered. I did not want to be sent back because I knew this would greatly disappoint my mother. The other children made fun of me because I didn't speak their language. I communicated with _mudras_, the hand gestures, in order to say 'I'm hungry' or 'I must wash my hands,' and then within three months I learned Tamil.

We got up at five in the morning. I remember the sound produced by our feet beating on the mud floor ...

It was Sabyasachi Panigrahi who pointed out to me that Sanjukta was accompanied to *Kalakshetra* only by her mother, Shakuntala. When Rukmini Devi gave her reasons for not accepting the girl, Shakuntala insisted that she see the child dance, and sang the *Dashavatar* while Sanjukta performed. This was the nature of the little impromptu recital that changed Rukmini Devi's mind.

(He also told me that Shakuntala usually sang the vocal accompaniment whenever Sanjukta was practising or rehearsing at home in Odisha.)

I have heard it said more than once that Rukmini Devi conducted herself cruelly towards Sanjukta on this and other occasions, and one commentator has ventured the comment that *Kalakshetra* was a desert-experience for the little dance pupil, the implication being that Rukmini Devi herself made it into that kind of negative experience. Perhaps Sanjukta said as much in private conversation—though I have no record of her having done so in public interviews. Certainly she experienced Rukmini Devi as stern and rigorous, but then so did all the other students. This, however, was not the only side of her character. Though an uncompromising disciplinarian with an occasional sharp tongue, downright in her criticism of faults and flaws, there is abundant evidence, too, of her compassionate response to children in need or in trouble while at *Kalakshetra*. She was capable, too, of great spontaneous generosity and sober praise when these were merited.

G. Sundari gives us an interesting insight into Rukmini Devi's detailed attention to individual students, which extended to her pedagogic practice:

> Rukmini was very good in teaching the dance to suit the physical body of each dancer. For instance Sanjukta had knock-knees, you see, so she would teach her to suit it that way . . .

She was forty-nine years old in the year that Sanjukta was almost not admitted, and to add to her forbidding presence she had been elected to the *Rajya Sabha* in the previous year. Her institution had been drilled and formed by her to impose expectations of unusually high standards both in dance and the other subjects taught there, but also in the training of moral character.

Sanjukta Panigrahi's Contribution to Odissi

Again, though, this was not the only side of the school. It was not all austerity, *khadi*, modest sarees and grimness. There was the usual quotient of student mischief and pranks. There was the famous incident when the students went on strike over the poor quality of the unrefined rice—they wanted white rice, and on this occasion Rukmini Devi acceded to their demand. Mayadhar Raut, who came to *Kalakshetra* in 1955, smoked on the quiet until he was caught at it and quietly upbraided. And there is the piece of fun recorded by Tulsi Badrinath:

> Over at the girls' hostel there was a bigger subversion. A Sri Lankan girl whom Balagopal had a crush on, and Sanjukta (later famous as the Odissi dancer Sanjukta Panigrahi) found the vegetarian food— no onion, no garlic, no fiery spices—too tame, even though the *masala dosa* they got once a week actually had onion in it.
>
> An *ayah* would smuggle in non-vegetarian food for them, stuffed inside a loaf of bread. Once, a pious vegetarian got a whiff of the forbidden aroma and told the teachers. Shanta happened to hear and sped to the hostel to warn her friends. They ate as much as they could of their supplies and buried the rest beneath a jasmine plant outside. The teachers could not find anything. The next morning the girls woke to discover bones strewn near the hostel door. The three campus dogs, Andal, Mohan and Susheela, had excavated a jasmine-scented feast for themselves ...

But this does not detract from the fact that Sanjukta must have found it more than a little difficult to settle into such a strangely rigid environment, completely alone, without family or friends, and only in her ninth year—the more so as her experience of dance and the world of dance had until now been one of such creative freedom in the vibrant atmosphere of the quasi-bohemian theatre groups and theatres proper in which she had performed and in whose vicinity she had learnt her craft. One may ask the question whether this might not have been one of the reasons why Rukmini Devi had seemed at first so unamenable: might it not have been the case that she did not want a national child-star, who might prove difficult and willful, on her hands in a school whose keynote was humble obedience and the

willingness to start from scratch? And then, what *was* this strange dance from Odisha, after all?

It is at any rate clear that, as the months passed, Sanjukta did make new friends and became assimilated into the *Kalakshetra* routine—so far as friendships and camaraderie go, her lot was to improve once Mayadhar and Minati Mishra joined her at the school, and she struck up a friendship with the same Shanta mentioned by Badrinath, and who later became Shanta Dhananjayan. Minati stayed for only a year, though, and then left to continue her tuition under Meenakshisundaram Pillai, who had been Rukmini Devi's teacher too.

As to the routine, it was one of serious and unrelenting learning, not only dance (Bharata Natyam and, for the boys, Kathakali as well) but also a number of other liberal subjects, including painting, Sanskrit, English, Tamil, Carnatic music and dance-drama. Students were up at half-past-four in the morning and attended classes until well into the afternoon.

Accommodation was modest but sufficiently comfortable. The boys' hostel, Damodar Garden, was situated in the Theosophical Society's high school compound. Vasant Garden, where the girls were housed, was in the compound of *Kalakshetra*. Rukmini Devi herself lived privately on the banks of the Adyar,

Teaching was by curriculum and was tightly constructed, but this does not imply an absence of imagination and free creativity. On the contrary, the record seems to show that students were expected in many cases to take care of stage production needs, sudden improvisations of costume and make-up, and so forth, without recourse to the teachers.

It is worth recalling that Rukmini Devi, since the founding of *Kalakshetra* (as 'The International Academy of the Arts') in 1936, had not settled for accepting the Pandanallur Sadir dance as she had found and been taught it. She had adduced, by her own lights, a number of refinements and additions to the repertoire and the steps themselves. And then, of course, she had reintroduced the composition and staging of what she conceived of as 'shastric' dance-dramas, which had their ostensible source in the *Natya Shastra*, and were consciously reconstructed to represent a pan-Indian version of the Western balletic tradition. It was indeed no small part of her business to demonstrate that such a dance-drama tradition had existed millennia before the

modern ballet had ever been brought into being. For the dance-dramas composed by her we know that she created some new *adavus* too, as Jayanti Vaishampayan notes:

> In her various dance-dramas, Rukmini Devi has introduced a number of new *adavus*; each pertain to the character being depicted. For example, in *Ramayana*, Jatayu is shown performing *adavus doia hasta* and *garuda hasta*. Similarly, in the same dance-drama, *adavus* performed by the *apsaras* have been so constructed that the dancers seem to float ... *Krishnamari Kuravanji* includes *adavus* that resemble snake movements, which, though they simulate the forceful movements of a snake, totally avoid vulgar hip movements.

One might say, though, that in addition to introducing her own modifications, she had also straightened up the dance, wishing—for prevailing ethico-cultural reasons—to obscure to some extent the sensuous dancing body behind a facade of pure geometry. But this was never the wish of the Odissi teachers, who wanted geometry and flux to display the body's sinuous *sulu*—a wish that was to some extent proper to the *sringara* element of Tanjavur Sadir too. I risk this generalization in order to show how different and disorientating the systematic theory and teaching at *Kalakshetra* must at first have been to Sanjukta.

Nevertheless, it was the example of both these aspects of Rukmini Devi's work at *Kalakshetra*—both the innovations and the systematic codification—that were needed and used by *Kala Vikas Kendra* and later by Jayantika in the labour of reincarnating Odissi. As Gaston says, perhaps with some understatement:

> Although no one discusses such a process, the presence of a role model in the form of Bharatanatyam, for both the standardizing of the basic movements and the final repertoire, makes it hard to believe that the creators of Jayantika were not at some level conscious of the classical *margam* of Bharatanatyam. Moreover, three of those involved in the evolution of Odissi studied at *Kalakshetra* in the 1950s: Mayadhar Raut, Sanjukta Panigrahi (Misra) and Minati Misra. Sanjukta returned to Orissa to make

210 ESSAYS ON CLASSICAL INDIAN DANCE

further studies of Odissi and became an essential vehicle for the newly created style, as Kelucharan's muse for many of his new creations.

This statement of affairs, in addition to its guardedness, is also rather provocative in its interpretation of Sanjukta's role. Was she really only an essential vehicle and a muse for Kelucharan Mohapatra's creative force?

The idea is well-worn and has already become something of a tradition in the analysis of the part played by Sanjukta. As late as 2016, we find Nandini Sikand telling us:

> In practical terms, the physical reconstruction and revival initiated by these gurus was conducted by male gurus of the form and put into practice by a group of prominent middle to upper class woman dancers who brought the dance to national and international audiences. Sanjukta Panigrahi, Indrani Rahman, Yamini Krishnamurthy, and Ritha Devi ... popularized Odissi in the US and Europe.

Though she adds that

> Panigrahi used her experience at *Kalakshetra* in Jayantika's efforts to codify Odissi.

Whereas we find Sanjukta herself, reminiscing in 1991, telling us:

> In 1958 I, along with guru Kelucharan Mohapatra and Dhiren Patnaik, composed and choreographed a two hours long Odissi dance recital for Annapurna Theatre. This was performed before a select audience and the innovation was tremendously appreciated and received wide acclaim. Since then the structure of the Odissi dance form has become broader and more open.

If what she said is true, and if we pause to take in the full implications of this statement, we realize that she was co-composing and co-choreographing, with Kelucharan the finely-honed artist and

Dhirendranath Patnaik the profound intellectual theorist, by the age of fourteen. And this goes directly to the heart of my suggestion that the degree of precociousness implicit in her especial genius for dance would have equipped her to begin sharing the fruits of her experience at *Kalakshetra* from the very first year she spent there.

To return to our story, then, we can imagine little Sanju, now nearing her ninth year, returning home for the first major two-month vacation, from 15 May to mid-July 1953, to plant the first tender and tentative theoretic and practical seeds of Jayantika in the mind of her teachers, by then established at *Kala Vikas Kendra*. It is at this age that she becomes the first cross-pollinator between the vision of Rukmini Devi and that of the designers of the new Odiyan classical form. And this was to become the pattern of her dancing career for the next six years, a pattern which grew in intensity after she was joined at *Kalakshetra* by Mayadhar in 1955.

I reason that both the theoretic shaping as well as the embodying praxis of the nascent Odiyan classical dance were twin and equal aspects of Sanjukta's personal mission from the outset—from the moment when such a possibility began to present itself in concrete form. Though she learnt Bharata Natyam at *Kalakshetra* it seems never to have been her intention to practise this form once she got back to Odisha. And in fact, unlike Minati Mishra, she never did present herself as anything but an Odissi dancer in later years. Her choice was for the nascent form exclusively. Her having come to this choice was certainly to a large extent owing to her mother, Shakuntala's, influence, who might accurately have foreseen that her daughter had the makings of an Odiyan Rukmini Devi. This surmise rings truer when we bear in mind that Sanjukta herself, in her last years, spoke often of her desire to found in Bhubaneswar an Odissi *gurukul* that would resemble *Kalakshetra* in its outlines.

1954 saw the establishment of the *Odisha Sangeet Natak Akademi* (at first known as the *Utkal Sangeet Natya Kala Parishad*), of which Dhirendranath Patnaik would later become secretary. This national and regional body for promoting dance, theatre and music constitutes, together with *Kala Vikas Kendra*, the two arms that would lift the Jayantika Association into existence within five years (though Babulal Doshi is known to have protested that the work of Jayantika should

have been carried out solely under the auspices of the *Kendra*—which seems only natural since he had so heroically invested so much of himself in this school).

The *Akademi* was a crucial instrument for promoting regional Odiyan dance in the wider pan-Indian context, for supporting the ongoing work of *Kala Vikas Kendra*, and for arranging scholarships for promising dancers and musicians. Indeed, two among the first scholarships it awarded went to Mayadhar and Minati Mishra.

By 1954, too, *Kala Vikas Kendra* had evolved an elementary syllabus for teaching its proto-Odissi and other dance forms. This early curriculum was devised by Dayanidhi Das, who later did sterling and conscientious work as secretary of Jayantika throughout the period of its reconstructive work. Since, at this time, Sanjukta was the only local dancer enrolled at *Kalakshetra*, one may put the question to what extent she had contributed by then to the *Kendra's* insight into the methodology of Rukmini Devi's institution.

(Mayadhar Raut would join her there only in January 1955, two years into her own Bharata Natyam studies.)

What remained was for the proto-Odissi dance to be staged and witnessed in the Indian capital, where it could be subjected to valuable critical evaluation in the pan-Indian sphere. This occurred in 1954 at the Inter-University Youth Festival in New Delhi. This key event is usually glossed over briefly in the standard histories of Odissi, but it is worth taking a closer look at some of its details.

Two proto-Odissi dances were performed at the youth festival on 5 November in the presidential Talkatora Gardens, one by Dhirendranath Patnaik, who danced Durlav Singh's and Pankaj Charan Das's *Dashavtaar* (taught to him that year by Kelucharan), the other by Priyambada Mohanty who, besides never becoming a career dancer, had had her lessons from outside the *Kala Vikas Kendra* circle. She had been taught Bharata Natyam and Kathak (such as these forms then were) by the Bengali dance teacher, Ban Bihari Maity, and later by Singhari Sundar Kar, who taught rhythmic *nritta* without *abhinaya* for pieces of about ten-minutes' duration. Kalicharan Patnaik composed a special Odiya song, *Gumana Kahinki*, to be danced by Priyambada at the festival.

Sanjukta Panigrahi's Contribution to Odissi

She recalls:

> While a student at Ravenshaw college, I was chosen to perform Odissi at the first Inter-University Youth Festival. Odissi in those days was ... a 'one or two piece' performance ... Singhari insisted that I wear a 14-yard sari with a *kachha* in traditional style. My make-up would make any performer revolt today ... When I was selected to compete in the Delhi Youth Festival, I went to Kavichandra Kalicharan Patnaik ... He polished my dance to enable me to present a good impression of Odissi ...
>
> In Delhi, people were curious to know about this unheard-of form. I went on the stage dressed in traditional style, with a *kachha*, the *aanchal* of the sari pinned to my blouse. The costume was a black velvet blouse, with *zari* trimmings and a white *Cuttacki* sari with a black border. My dance received thunderous applause ...

In the event she won third prize, but more important for Odissi is the fact that Indrani Rahman's husband, Habib, and his daughter, Sukanya, were present at the performance, together with Charles Fabri, the eminent Hungarian-born Indologist, art historian and dance critic for *The Statesman*.

Habib and Fabri encouraged Indrani to learn the elements of the evolving dance form, which she was later taught in Delhi by Debaprasad Das. She went on to popularize Odissi throughout India and in the United States (it certainly helped the cause of the dance that she was crowned Miss India in 1952).

More to the point is that Fabri's enthusiastic appreciation of the performance led, much to the credit of his insight, to his championing the idea that these two small dance items represented a classical essence that stood in need only of a suitably stylized form. Fabri, who had taught at *Shantiniketan*, was a figure taken seriously in the Indian art world, and his support for Odissi was undoubtedly significant. It was he, also, who urged Sanjukta to embrace Odissi to the exclusion of the other forms she had learnt.

Still, we can see from Priyambada's recollection, how undeveloped and unrefined the dance at that stage yet was. While not exactly a shambles, we must surely be struck by the recognition how badly

it stood in need of the fund of experience that had been built up at *Kalakshetra*. It had got as far as its success at the youth festival not without a fair amount of luck. We can hardly blame Rukmini Devi, given her stringency and sometimes ungenerous tongue, for referring to it in the press as 'a poor imitation of Bharata Natyam' (a remark that could not have endeared her to Sanjukta).

To press the point home we may note such facts as that, by 1954, Pankaj Charan Das was still using almost only the *pataka hastha* in all his choreography (when Mayadhar, on a return to Cuttack from *Kalakshetra*, pointed out to him how many *mudras* there actually were, Das became offended; 'I taught you dance and now you presume to lecture me?'), there was little in the way of formal *abhinaya* and *viniyoga*, a large gap in systematization, no extended solo repertoire, no 'shastric' dance-drama, and no foundational texts for grounding the dance in a classicism with a claim to antiquity. In short, Odissi lacked almost everything that Rukmini Devi had borrowed, modified and honed from Sadir for her classicizing purposes with Bharata Natyam.

These were all the missing factors that were being inculcated in Sanjukta while her proto-Odissi teachers were flailing about and often at loggerheads in the effort to draw their still rather scattered dance form into the unified classical whole that they were already sensing in many of its intrinsic lineaments. Odissi, we might say, was born in a fire of experimentation much hotter than the far cooler re-establishment of the Sadir and other dance forms, which were revived out of a more protracted and calmer deliberateness.

Let us turn for a moment to what Sanjukta was being taught, if only in the area of the classical texts. In doing so I am not suggesting that a child in her tenth year was being fed the *Natya Shastra* and the *Abhinaya Darpana* whole. But certainly, in conformity with *Kalakshetra* doctrine, Bharata Natyam students would have been made familiar with the fundamental ideas and uses of these texts.

It has become nowadays a popular stance to ridicule Rukmini Devi for her claims to a 'shastric' status for her dance when she herself had not read the *Natya Shastra* (though it seems hardly likely that she had not consulted it at all since the first volume of Manmohan's Ghosh's English recension had been available by 1950—besides

which, Rukmini Devi had been taught the elements of Sanskrit by her father). Yet not having read it does not mean that she was not familiar with the drift of its teachings and themes. What she chiefly selected among these was the notion of the tightly structured classical dance-drama, strictness and consistency of design and presentation, and the idea of dance as a religious practice, the *Natya Shastra* having been described by Bharata Muni as a fifth Veda given him directly by Brahma.

In simple, direct form, these ideas would have been familiar to Sanjukta in her second year. Moreover, the idea of dance and drama as vedic teachings, as a gift of God, as salutary for human well-being, would also have appealed to the girl who so loved to read and muse over the old Indian myths. And, simple though these ideas may have been, at least in the manner in which they were conveyed to her, they would have struck a chord with her teachers in Cuttack seeking classical foundations for the structure of the dance they were designing at *Kala Vikas Kendra*. This, at any rate, was how it turned out in the end, with Odissi enacted as a flowing devotional ritual on the proscenium stage in the presence of a statue of Jagannath, a re-enactment so obviously drawn from Rukmini Devi's *Shiva Nataraja* equivalent.

Of course, in the Jayantika years, the *shastric karanas* became the driving symbol for the study of dance sculptures undertaken by the researchers in search of unique (and uniquely ancient) Odissi postures.

The later Odissi dance-dramas, too, show clearly the *Kalakshetra* imprint: things in the line of the *Panchapushpa Nrutya Natika*, *Geet Govind*, and *Meghdut*, productions of the kind that we are used to seeing staged by the students of *Nrityagram*, and which, in less refined forms, were one of the staples of Odissi theatre presentation once the *Kalakshetra* doctrine had been imbibed.

As early as 1955, in fact, while Mayadhar Raut was still finding his feet at *Kalakshetra*, Kelucharan composed his dance-drama, *Saakshi Gopal*. I take this as a sign of Sanjukta's influence even at this early stage of her schooling. After all, by this time, Rukmini Devi had composed her first three dance-dramas, *Kutrala Kuravanji* (Tamil, 1944), *Kumar Sambhavam* (Sanskrit, 1947), and *Sita Swayamvaram* (Sanskrit, 1955), which were regularly performed at *Kalakshetra* and on tours of India.

For the Bharata Natyam *margam*, too, there was a prescriptive text in Nandikeshvara's *Abhinaya Darpana*, the erstwhile primary text of the Tanjavur Quartet. Again I am not suggesting that Sanjukta was reading this text at first hand, and yet she could not have been working towards her *arangetram* without reasonably good knowledge of its contents. These, too, at least in their nature and outline, would have been conveyed by Sanjukta to *Kala Vikas Kendra*, and mainly to Kelucharan Mohapatra.

Such knowledge, for Odissi at this stage, was priceless, and this in fact remains the case today. As Kaberi Sen asserts:

> In the context of hand gestures, after studying *Natyasastra*, *Abhinaya Darpana*, *Abhinaya Chandrika* and *Nartananirnaya*, it can be said that *Abhinaya Darpana* is followed by Odissi dancers primarily ... In the syllabus of Rabindra Bharati University, in the department of dance, the *chari* of *Abhinaya Darpana* is taught in Odissi class.

(We must note here, too, Dr Dinanath Pathy's contention that the *Abhinaya Chandrika* is a 20th-century manuscript, which amounts to an assertion that it was the work of an impostor. Into this heated debate, however, I do not propose to venture here.)

In 1960, too, the year in which the *Marg* Journal dedicated an entire volume to Odissi, we find Mohan Khokar writing:

> Odissi is essentially a *lasya* dance and embraces both *nritta* and *nritya* ... It is based on Bharata's *Natya Shastra* and Nandikeswara's *Abhinaya Darpana*, but also incorporates elements from other Oriya manuscripts.

It is true that there were differences over the *Abhinaya Darpana* among the gurus at *Kala Vikas Kendra*. Some thought that this text was not needed because the *Abhinaya Chandrika* had been unearthed (or perhaps recently written). But such an argument was simply not tenable—what is lacking to the latter is supplied by the former, and the reverse is not the case.

Sanjukta Panigrahi's Contribution to Odissi

But, turning from this question to what Sanjukta herself was learning through the practice of *Abhinaya Darpana*-based Bharata Natyam, we see that the geometric rigidity and sheer physical perseverance demanded by the form were in themselves important elements in the furtherance of a far more structured presentation of Odissi, in addition to the stylized *abhinaya* and *viniyoga* that were got from *Kalakshetra*. It enabled Sanjukta to embody a more complex and more patterned Odissi choreography of the kind that Kelucharan would eventually himself favour.

Sanjukta summed it up in this way:

> If one asks me how I benefitted by graduating from *Kalakshetra*, I have to say that *Kalakshetra* taught me the most important aspects of any dance form—east or west. These are discipline, dedication and practice, not to mention the hidden veins of sanctity which run through such metaphysical activities. The real strength of the foundation of any dance form lies in the perfect mix of dedication, discipline and endless practice or rather perspiration. This is what *Kalakshetra* taught me.

But there was the other side of this gain too, and one which, incidentally, has been remarked on by more than one commentator. Ritha Devi explains it:

> At the beginning of my study under him, (her guru, Pankaj Charan Das, who taught the very sinuous, *sausthava*-laden *panchakanya* theme which he had learned and developed from the *mahari nacha*) he could not even bear to look at me struggling to get this lyrical style into a body hardened by years of practising Bharata Natyam!

Be that as it may, we can hardly deny that her arduous and lengthy training in Bharata Natyam equipped Sanjukta for the more strenuous and elaborate Odissi repertoire that was still to be devised by Jayantika. And it brought home to *Kala Vikas Kendra* and to the individual teachers the need for a higher standard of praxis and artisanal prowess, both in choreography and in performance.

To return to the progress of our story: 1954 had further significance for Odissi and Sanjukta personally in that it was in this year that Mayadhar Raut was awarded a study scholarship by the *Utkal Sangeet Natya Kala Parishad*. The standard histories tell us that he was 'sent' to *Kalakshetra* by *Kala Vikas Kendra*, but Guruji himself remembers it differently.

He says that by November of that year he was still undecided as to where he should study, and had favoured the option of going to *Shantiniketan* because it was closer to home. Finding himself in a quandary, he asked advice of Abhiram Mishra, Sanjukta's father, who was one of those who had provided Mayadhar with letters of recommendation (Pran Krishna Parija was another).

It seems that Abhiram had long since taken a strong liking to Mayadhar, who often visited at the Mishra home. Then a young man of twenty five, and a highly-gifted *nach* teacher, it was natural the Sanjukta's father would like to have him present with his daughter at *Kalakshetra*, where his presence would alleviate her foreignness and loneliness as well as provide a feeling of greater security. It would also mean that Sanjukta would in future be able to travel home by train in the company of Mayadhar, saving her parents this twice-yearly trip to and from Madras. Of course these practical advantages don't exclude the probability that both her parents, on the basis of Sanjukta's own development, would have thought *Kalakshetra* the most useful choice for the young dance master.

Aadya Kaktikar, recording verbatim Guruji's memories, sketches the following homely picture:

> On the 5th of January 1955, Babu Bhai and Debaprasad Das dropped Mayadhar at Sanjukta's father's house in Bhubaneswar. That night Sanjukta's father, her mother, Mayadhar, Debaprasad Das and Sanjukta sat around talking after dinner. Her father told Mayadhar, 'Please remember, you have to do us proud at *Kalakshetra* and keep up the name of Orissa and Oriyan culture.' On 6th January Mayadhar left for *Kalakshetra* with Sanjukta and her father.

Abhiram had come a long way since the days when he was 'absolutely against' Sanjukta's dancing.

In the same year, as has been said, Minati Mishra was admitted at *Kalakshetra* too. This meant that Sanjukta had at least two fellow Odiyans for company, both committed to the cause of Odissi, and both put out by South Indian cuisine. But it was Mayadhar, personable, helpful and unfailingly courteous (his *Kalakshetra* graduation certificate tells us so) who was to prove her most affectionate friend and companion.

Sanjukta was present on the day Mayadhar had to dance for Rukmini Devi as a test for admittance to the school. Mayadhar danced *Dashavatar*, while Shankar Anna sang the accompanying song and Sanjukta recited the *ukutas* (*bols*). His presence with her throughout the rest of her time there—they both graduated at the end of 1958—made the experience easier for her in many ways, while lifting a burden from her parents' minds.

The school day began at five in the morning (the bell was rung at 4.30) and study hour began at 5.30. Morning prayers were from 6.15 to 6.30. Then followed breakfast. From 7.30 to 8.15 there were a variety of curriculum classes, then a *sarva dharma* prayer from 8.15 to 8.30. After this the main subject would be taught until 10.00, and from 10.00 to 10.45 the secondary one. Teaching continued in the afternoon, with lessons and demonstrations in the Central College by Rukmini Devi and Gauri Ammal, the elderly *devadasi* from the Mylapore Temple, who had been displaced by the anti-Nautch Bill and was subsequently co-opted by Rukmini Devi to teach *abhinaya* at the school. It is said that the children loved her, though, in the tradition of children everywhere, she was sometimes subjected to their mild pranks. She was called by the children 'pattiamma.'

All three Odiyans were present on the basis of a meagre scholarship, amounting to about Rs. 75/- per month, which just covered the cost of accommodation, food and tuition fees. Therefore life at the school for Sanjukta was a frugal matter, and must have remained so throughout. Her father, after all, though he is referred to in standard narratives as an engineer,—a position we ordinarily associate with affluence—we are told by Sangeetha Tripathy that Abhiram was a 'modest government official' who had, besides Sanjukta, five siblings to support.

220 ESSAYS ON CLASSICAL INDIAN DANCE

It was also in 1955 that Sanjukta was inducted by Mayadhar into the *Madras Oriya Samaj*. There is a photograph of this group of six young people, including Mayadhar, among whom Sanjukta is the only girl. But this was another tie with home and a means for sharing experiences and juvenile politics in Tamil Nadu.

During the summer holidays of this year, Sanjukta returned—as she did every year—to her lessons with Kelucharan at *Kala Vikas Kendra*. During the 1955 vacation she was kept busy enough rehearsing and playing the part of Madan in a production of *Panchapushpa* choreographed by her teacher. This dance-drama was performed at a *Nrutya Sangeet* Seminar at Puri, and its purpose was to provide an example for an audience of scholars of the quality and classicism achieved in Odissi so far. It was attended by Indrani Rahman, and it was on the strength of this performance that she asked Debaprasad Das to come to Delhi to teach her Odissi.

Heather Parker-Lewis, citing Dhirendranath Patnaik, records another performance in 1955, at *Kala Vikas Kendra* in Cuttack, to which Rukmini Devi was invited as chief guest:

> On this occasion Odissi was danced by Smt. Lakshmi Devi, wife of Guru Kelucharan Mohapatra. When journalists sought the opinion of Smt. Rukmini Devi Arundale, she said of Odissi dance: 'Oh, this is a poor imitation of Bharata Natyam.'

This, then, was the occasion to which I have alluded earlier. It does not show Rukmini Devi at her best. And I would venture to add that, though Sanjukta respected her for what she had achieved at *Kalakshetra*, she could never have grown fond of her. It must indeed have been a pungent irony to be taught the elements of classicism through the medium of an alien dance by a teacher who despised your own dance form. Julia Varley has ventured the opinion that Rukmini Devi was probably the only person in whose presence Sanjukta could never be playful.

What all of this shows in Sanjukta's case is how very hard she worked at dance and how gravely and responsibly she faced her commitments to it. Not only was she acting as a close intermediary between Kelucharan and *Kalakshetra*, but she was also learning simultaneously to perfect

Sanjukta Panigrahi's Contribution to Odissi 221

in her own practice two linearly opposed dance styles across a single period of six years. Her vacations were spent refining her Odissi practice, while Mayadhar taught at *Kala Vikas Kendra* to earn extra money for supplementing his insufficient scholarship grant.

She also danced in Rukmini Devi's own dance-dramas, which were taken on the customary *Kalakshetra* tours to Delhi, Mumbai, Patna, and Kolkata. There is one commentator who says that Sanjukta travelled both in India and abroad on one of these tours in 1958, but there seems to be no further evidence by which to verify this claim. It seems to me in any case unlikely that she toured outside of India in her years at *Kalakshetra*.

I want to turn now to the question of the Odissi repertoire, which was beginning to be shaped in this period. By 1955 Sanjukta would have been well aware of the movements in the five-part Bharata Natyam repertoire or *margam*. This structure would already have been reported by her—together with a report of the demands it placed on the body (it was of about two hours' duration)—and it would have been noted by *Kala Vikas Kendra*, whose teachers had usually seen forms of Bharata Natyam and Kathak that were danced as piece-meal entertainments, often in a fusion presentation, and as decorative pieces for the plays produced in the local theatres, and of course in films.

Indeed, the part played by movies and movie-going in the development and popularization of Odissi is one that is usually purged from the record. This aspect of the story does not easily fit in with the often flighty accounts of the gurus' regeneration of the dance. Yet most of them were involved with Oriyan cinema one way and another, and Mayadhar is known to have been something of a movie addict. Babulal Doshi himself produced a number of films.

A brief and foreshortened survey shows that proto-Odissi was danced in the following films, among others:

There is a 25-second clip of proto-Odissi in the Odiyan movie *Lalita* (1949), ostensibly representing *mahari nacha*, and with music composed by Kalicharan Patnaik. Kelucharan choreographed the dance in *Maa* (1958) in which his wife, Laxmipriya, danced a *Kela Keluni* tribal dance. Other movies with dance items choreographed by Kelucharan include *Mahalakshmi Puja* (1959) in which the *Dashavatar* is danced by Jayanti Ghosh and Sanjukta, one year after graduating

from *Kalakshetra*; *Nirjana Saikate* (1963) in which Minati Mishra danced a *Kalyani Pallavi*; and *Arundhati* (1967) with multiple dances by Minati.

Most surprising in the list is *Kedar Gouri*, in which dances were performed by Gloria Mohanty and a ten-year-old Sanjukta in 1954, during her second year at *Kalakshetra*. Rehearsals and filming of this sequence must have taken place during one of the vacations in Odisha that year. Again we see Sanjukta in the role of the working girl-child and child-star, with little or no time for holiday pastimes.

Rukmini Devi would not have taken this amiss: she herself had danced the *padam Padari Varuguthu*, composed by Vazhuvoor Ramaiah Pillai, at the end of the 1936 Tamil movie, *Raja Desingu*. She was also filmed dancing by Vikram Sarabhai, husband of Mrnalini, in 1942 or '43. Sadly, the footage of both of these films seems to have gone irretrievably lost.

The point is that we should not make the mistake of thinking of the gurus' labours at Odissi as taking place in a consecrated unworldly vacuum of high-classical thinking and endeavour only. Essentially both these teachers and their dancers were all very much in tune with the modern world and the forms of entertainment and exposure it offered. Within seven years of graduating from *Kalakshetra*, for instance, Sanjukta again danced in a film, this time the famous Odiyan movie *Kaa*, with music by her husband Raghunath and choreography by Mayadhar. They were artists and performers in tune with their time, enjoying and using any and all of the artistic media available to them, including popular theatre and cinema. But this does not in the least detract from their ultimate achievement. The story of Odissi remains one of the greatest tales, anywhere in the world, of modernist re-classicization of an art form achieved in the 20th century.

In returning to the question of the repertoire, I quote Gaston again:

> The experience of Mayadhar ... and Sanjukta at *Kalakshetra* would have impressed on them the importance of a teaching syllabus which included basic movements, a classical repertoire, theory in Sanskrit texts ... as well as the creative use of this knowledge in dance-dramas.

Sanjukta Panigrahi's Contribution to Odissi 223

By 1956, Sanjukta's third year at *Kalakshetra*, the Odissi repertoire was still rather shapeless, and recitals continued to consist of one or two stand-alone items of about fifteen minutes' duration. The creation of a *margam* resembling in outline that of the *Kalakshetra-bani* would require not only the work of dance-design to be done by the teachers but also an insightful theoretician with a *Sanskriti* background capable of expounding it in classicists' terms. This intellectual backdrop was provided by such proponents and ardent supporters of the Odissi ideal as Dhirendranath Patnaik (who would later translate the *Abhinaya Chandrika*), Mohan Khokar, Mayadhar Mansinha and Charles Fabri, whose contributions on Odissi in the March 1960 edition of *Marg* represent a crucial staging point in the theoretical statement of the case for granting to the dance the classical status which it was officially to receive at the Hyderabad seminar in 1964. While the teachers took care of shaping and improvising the dance form, these intellectuals were shaping and extemporizing not only the theory but also the myth.

In that landmark 1960 publication, we find the Odissi *margam* described by Patnaik as follows:

> *Hastas* or *mudras* (hand gestures) are a characteristic feature of classical Indian dance. They are mostly used for *abhinaya*. *Belis* are the principal body positions. *Bhangis* are the basic poses and movements of *nritta*. *Karanas* are the basic dance units consisting of a stance, a pose, *hastas*, and movements. The repertory of Odissi consists of the following: *bhumi pranam, bighnaraj puja; batu nritya; ishta deva bandana; svara pallabi nritta; sabhinaya nritya;* and *tarijham*.

Although we do not yet see any sign of the *moksha*, we do espy the tendency of the evolving repertoire towards the devotional, *bhakti*-laden *mahari* ideal, the idea of a religious quasi-ritual presented on the proscenium stage, and representing a fundamental departure of the dance from its roots in theatre as a purely entertaining aesthetic embellishment.

Here, in the mythological aspect, was another fortunate convergence with *Kalakshetra*. It is common knowledge that the

devadasi and *rajadasi* of the Thanjavur tradition had been largely sidelined by Rukmini Devi, and there were contemporary moral and social reasons on which her decision to do so rested. I don't want to rehearse that history here since it falls outside the scope of this essay. What I want instead to remark on is the lucky confluence between the *devadasi* tradition in Tamil Nadu and that of the *maharis* in the temples of Odisha. Students at *Kalakshetra* would have been made familiar with the narrative of the day: that Bharata Natyam was a redeemed renewal of the corrupted *devadasi* practice in which the *sringara* element (on which the potential for corruption rested) had been replaced by its more fitting *bhakti* counterpart. Dance was an essentially devotional manifestation according to this theory, and this interpretation would have appealed to Sanjukta with her love of mythology and of the temple. It certainly had a very useful appeal to the re-moulders of Odissi, who made of their own regional *mahari* legacy the basis of their claim that Odissi, too, had *devadasi* roots. To what extent this facet was conveyed to them by Sanjukta herself is impossible to say—though it must have formed part of the description of the *Kalakshetra* Bharata Natyam that she brought back to Odisha from year to year.

This process of refining the repertoire, theory and mythology would certainly already have been well underway near the end of 1956, when Sanjukta danced the *Dashavatar* at the annual function at the Theosophical Society's High School, an event more often than not attended by the celebrities and cinema personalities of the day. On this occasion, no suitable item being available among the props at *Kalakshetra*, Mayadhar manufactured for Sanjukta a cardboard crown. It is also remarkable that Rukmini Devi, who must have had a hand in such an important yearly event, saw fit to include this item in the program. Perhaps by that time, impressed by the perseverance of the Odissi proponents, and by the inexorability with which the cause of Odissi was advancing its purposes and claims, she had come to think a little better of the budding dance—though she is reported still to have called it 'vulgar' in 1967.

At the Inter-university Youth Festival of that same year, Priyambada Mohanty was again invited to perform a proto-Odissi item, and this time, two years after her first performance at this event, she was awarded first prize. It is hard not to view this prize as having been

awarded to the evolving shape of Odissi too, which means that the dance was enjoying growing appreciation both among the public and the connoisseurs of dance.

It was sometime in this year too that a Sri Lankan girl at *Kalakshetra* began taking a romantic interest in Mayadhar. This was probably the same girl—she remains unnamed—involved in Tulsi Badrinath's anecdote about the smuggling into the college of spicy food. In this case, Sanjukta played the role of matchmaker to a very unwilling Mayadhar, who refused the girl's advances. The girl then attempted suicide but was saved by the resident doctor.

Certainly there was a happy, confident, romantic streak in Sanjukta. She was capable of understanding the *Raasleela* in purely human terms, just as she was capable of sublimating it. She was, as I have noted, an obviously precocious child, as is shown by her falling stubbornly in love with Raghunath Panigrahi at first sight. But I am anticipating a little: this episode belongs to 1958, her final year.

Meanwhile, in 1957, Sanjukta took part, together with Mayadhar, in the *Kalakshetra* tour to Mumbai. It was perhaps on this tour that she danced with a young Dhananjayan in what seems to have been a performance of *Sita Swayamvaram*. The evidence for this is an untitled photograph in which Sanjukta seems to be dancing the role of Sita. It was on this tour that she introduced Mayadhar to one her father's relatives resident in Mumbai, who, it is said, would later be of great help to the young Odissi teacher. We are not told any more than that.

Yet this note does make us aware again of the close ties that Mayadhar had formed with Sanjukta and her parents. It seems they often spent time together in the summer vacations during which Sanjukta was also receiving teaching from, and sharing information with, Kelucharan.

The following account by Aadya Kaktikar, recording Mayadhar's recollections, gives us an idea of the bond:

By the end of summer vacations of 1957, Mayadhar came to Aasika (Sanjukta's father was transferred there). They were to go together to Madras from there. A letter came from *Kalakshetra* advising them to come a few weeks later as there was a brain fever epidemic in that area. So Mayadhar stayed on at Sanjukta's house.

It is pleasant to imagine the family, with Sanjukta and Mayadhar, sitting around the table to discuss what they were learning about both Bharata Natyam and the future of Odissi. It gives us the sense of the deep friendships that were shared around the common cause of promoting the dance, friendships that were later to be severely tested during and after the Jayantika years.

In this case, the visit had an unpleasant ending. Driving back to Asika from a wedding ceremony, the family car met with an accident on a muddy road in rainy conditions. Mayadhar sustained a shoulder injury and was nursed in the Mishra home until he was fit to return to *Kalakshetra*. Sanjukta herself emerged unscathed.

Also in 1957, Indrani Rahman witnessed a proto-Odissi recital by Priyambada Mohanty, Mayadhar and Sanjukta during a seminar on Odissi at Puri. It was this occasion that stimulated her directly to receive tuition in the new dance form from Debaprasad Das. Again we see Sanjukta juggling her commitments to Odissi with the pressures of her ongoing studies in Chennai. To add to these dual commitments— which she appears to have relished, being, as Sangeetha Tripathy describes her, a 'bubbly' young teenager (she was now thirteen years old)—there was the tour to Mumbai already mentioned above.

It was in her last year at *Kalakshetra* that she met Raghunath Panigrahi and determined to marry him.

Jelhum Paranjape tells the story briefly and vividly:

While she was at *Kalakshetra*, a musicologist, Nilamani Panigrahi (her future father-in-law) visited. He seemed to like Sanjukta for his son Raghunath, who was a popular singer in Madras (Chennai). Back in Orissa, the proposal was put forward to the Misras—Sanjukta's parents. Mother was for it, father against. Both are artistes, how can they earn a good living?' But her mother was adamant. 'She loves dance. Only a musician will understand this passion. Nobody else.' Meanwhile in Madras, Sanjukta had heard Raghunath singing and fallen in love with his voice. She was willing to marry him. Raghu would visit them but Sanju's father would not relent. After a year, Sanjukta's father packed her off to Bombay to learn Kathak from Pt. Hazarilal and incidentally to forget Raghunath too. But that was impossible. Raghunath followed Sanjukta to Mumbai!

One can't but smile.

In the event, the marriage did take place and, though it had some rather inauspicious moments in the first six years, turned into a lasting bond of love, friendship and professional collaboration until Sanjukta's death in 1997.

Still in 1958, though, Babulal Doshi 'used his connections' (as Kaktikar puts it) to arrange an Odissi presentation for the *Sangeet Akademi* festival in Chennai, which also turned into an occasion for his visiting *Kalakshetra* with Sanjukta and Kalicharan Patnaik, who presented a paper on Odissi at the *Akademi* festival. Sanjukta performed at this event too.

Dr Sunil Kothari recalls, in a 2015 article in *The Hindu*, the well-known Odissi presentation in Delhi:

> I saw a demonstration of Odissi and also a performance by one Jayanti Ghosh from Cuttack during the Dance seminar in April 1958. Kavichandra Kalicharan Pattanaik, the poet, dramatist, and scholar had read a learned paper on Odissi for which Debaprasad and Jayanti Ghosh had performed. Earlier I had only seen a small booklet 'Orissi Dance' by Kalicharan Pattanaik in Bombay University library, with photos of Priyamvada Mohanty.
>
> My odyssey of Odissi dance started from then as I met Babulal Doshi, a Gujarati Vaishnav from Cuttack who had brought Kalicharan Pattanaik, Debaprasad and Jayanti Ghosh and accompanists for a demonstration for the seminar to Delhi. We both being Gujjus, spoke in Gujarati. He invited me to come and stay and research and write about Odissi during vacations at Cuttack at *Kala Vikash Kendra*, an institution he had established to train Odissi dance to young children and girls.

Kothari's later reference to this event, written in 2019 for the *Asian Age*, recalls:

> I met U.S. Krishna Rao and his wife Chandra (U.K. Chandrabhaga Devi) during the All India Dance Seminar held at Vigyan Bhavan, New Delhi in April, 1958. That was a historic conference with a week-long dance festival in the evening at Talkatora Gardens.

I was a greenhorn, up and coming scholar interested in dance. I had gone from Mumbai to attend the seminar, thanks to Professor Mohan Khokar's suggestion, as all leading lights of the dance world were to meet there. Chairman Justice Rajamannar, vice-chairman Kamala Devi Chattopadhyaya, legendary dancers Balasaraswati, Rukmini Devi, great Sanskrit scholar Dr V. Raghavan, Mrinalini Sarabhai, Kitappa Pillai, Swaminath Pillai, *Kalakshetra* dancers, including Sanjukta Panigrahi (nee Mishra), who was studying Bharatanatyam at *Kalakshetra*.

Kaktikar's account reads:

> In the 1958 summer vacations, Mayadhar returned to Cuttack and continued with his intensive teaching at *Kala Vikas Kendra*. During this time Babubhai, Kalicharan Patnaik and others like them were trying to make Odissi popular. The movement to work towards getting Odissi recognised as a classical dance form had begun since 1954. Babubhai used his connections and arranged a programme at the Music *Akademi* festival at Madras in 1958. The programme coincided with the International Arts Festival at *Kalakshetra*. Kalicharan Patnaik read a paper and Sanjukta performed. In the evening they visited *Kalakshetra*.

In earlier drafts of this essay, I expressed the fear that I had here run into a snag, with Kothari remembering the event in Delhi and Mayadhar another, less well-known presentation, in Madras, and with Kalicharan Patnaik presenting a paper at both venues. It seemed to me unlikely that so much travel and exertion would have been considered necessary at a time when Jayantika had hardly begun its own project.

A paragraph from Ileana Citaristi's article, *The Rise and Fall of Jayantika*, however, clarifies the question fully:

> One should take note that by this time some important events had already taken place in the history of Odissi dance; in January 1958 Kelu Babu had accompanied Kalicharan Patnaik to Madras on the occasion of the All India Dance Seminar held during the 31st Conference of the Music Academy. On behalf of the *Kala*

Vikash Kendra, Sanjukta danced *lalita lavanga lata* accompanied by Kelucharan on the *mardala* and Balakrishna Das as vocalist while Kalicharan Patnaik read a paper on the historical and practical aspects of Odissi. On the 5th of April of the same year, Jayanti Ghose and Deba Babu presented a demonstration in New Delhi during the All India Dance Seminar organised by the *Sangeet Natak Akademi* at Vigyan Bhawan. On this occasion too Kalicharan Patnaik read a paper on the classical aspects of the dance and Jayanti danced *mangalacharan, batu, dekhiba para asare* and *mokshya* although still presented as one single item of about 15 minutes.

Sanjukta's presence at the Delhi seminar is recorded in Kothari's later article but we are not told whether she danced or not, though it seems very likely that she did perform in the course of the 'week-long dance festival.' Why else come all the way from Chennai with the *Kalakshetra* group?

Though Citaristi, citing Dayanidhi Das, mentions that Sanjukta danced *Lavita lavanga lata* at the 1958 Madras presentation, we must recall that Sanjukta, in that same year, had co-choreographed and danced a two-hour-long Odissi recital, and this choreography— if Sanjukta remembered the occasion correctly—would have been accomplished some months before the Jayantika Association began, in mid-1959, to tackle their task in earnest.

As a reminder, here is the passage from her reminiscences already quoted earlier:

In 1958 I, along with guru Kelucharan Mohapatra and Dhiren Patnaik, composed and choreographed a two hours long Odissi dance recital for Annapurna Theatre. This was performed before a select audience and the innovation was tremendously appreciated and received wide acclaim.

Though the members of Jayantika first met on 22 June 1958, their real work was only begun at the end of July 1959—which is when some of them signed the blood-and-ink oath. Given that Sanjukta's Madras performance of *Lalitha Lavanga Lata* took place in January of 1958, it seems likely that this later two-hour piece of lengthy choreography was

230 ESSAYS ON CLASSICAL INDIAN DANCE

completed nearer the end of that year, once her course at *Kalakshetra* was over.

In previous versions of this essay, I speculated that this may have been a collaboration at choreographing an early extended *margam*. A rough idea of the structure of such a *margam* must, after all, have been present to the teachers and dancers by the latter part of 1958. But the fact that it was staged at the Annapurna theatre in Cuttack militates against this assumption because, as I have meanwhile been informed by the Odiyan art critic, Mr Kedar Mishra, the Annapurna theatre 'presented no *margam*-based Odissi ever. They presented random dance-dramas or ballets based on Odissi or *Odia Nata*.'

Sharon Lowen's account of the choreography and the event itself seems to contradict this assertion, but leaves us none the wiser as to the nature of the 'repertoire expanded to two hours.' She writes:

> In 1958 she (Sanjukta) presented a repertoire expanded to two hours at the Annapurna Theatre, Cuttack, after working with several artists and scholars.

This might therefore be an important early form of Odissi choreography and its performance that are yet to be definitively identified.

Sunil Kothari goes on in his 2015 article in *The Hindu* to describe another significant performance that year:

> For the first time in Bombay at Regal Cinema Indrani performed Odissi on Tuesday the 23rd September 1958, which I saw. I wrote in Gujarati *Janmabhoomi* newspaper a review. I had sent her the review with English translation, and that was pasted with a date in her scrap book! I was thrilled. I did not expect that I would ever find it ...
>
> Indrani was a beauty and was compared to 'celestial *apsara* in Indra's court,' by Rita Chatterjee (Ritha Devi) who also used to write reviews for *The Times of India* in those years. She too was mesmerised seeing Odissi and started learning Odissi from Guru Pankajcharan Das.

Indrani's performance was the last important Odissi presentation outside of Odisha that year (and let us again note the connection with

the cinema). Two months later Sanjukta would complete her Bharata Natyam *arangetram*, a full *margam* of two hour's duration, for which she was awarded her *Nrityapraveen*. At the end of that year, back in Odisha, she was presented with her *Nrityashri* from *Kala Vikas Kendra*, having mastered the dance that was yet to be given a final shape by the young adventurers of Jayantika, who signed their oath of commitment to the search for a classical Odissi repertoire in a mixture of ink and their own blood.

Julia Varley records Sanjukta's summing up of her *Kalakshetra* experience:

> I stayed in *Kalakshetra* for six years and passed my high school exams there. I grew up, matured, learned to be disciplined and to rely only on myself for everything. I learned concentration, how an artist should behave and how important it is to practise to keep the dance alive. It was a complete education.
>
> Rukmini Devi used to say to me that modern civilization was becoming superficial and was losing the spirit of dedication. She used to ask herself how many young dancers knew about Indian culture and how many of them loved it. She wondered how many dancers were aware that their bodies were instruments of the divine, that their lives should be noble and pure, that their bodies should be healthy and disciplined in order to fulfil their mission as artists. She would say to me: 'We want to dance, we love the Indian dance because it gives joy, but we must remember that there should be integrity and reverence.'
>
> When I received the diploma, Rukmini Devi bade me farewell with these words: 'Sanjukta, you have completed your course, but this is the beginning of your life. Take care.'

She had in fact taken the first and most important steps in preparing herself to convey a classicized form of Odissi—and especially Guru Kelucharan Mohapatra's *paddhati* (and himself) out into the wider world. And she had helped immensely to prepare the way for the coming of Jayantika. In 1958 she attended her first Jayantika meeting, at which other girl-dancers—Priyambada Mohanty, Sushama Mishra, Laxmipriya Mohapatra, Jayanti Ghosh and Premalata Das—were also present.

The six-year period which I have attempted to record in this essay, and which began when she was only eight years old, had been an extraordinarily busy and productive time. This pattern of total dedication and commitment to the dance would continue throughout her life.

On 24 August 1958 Sanjukta Mishra celebrated her fourteenth birthday.

Sanjukta Panigrahi and Jayantika: A View on Her Contribution

I must begin this attempt at a clarification by reverting—I have already mentioned it in the previous essay—to the statement made by Sanjukta Panigrahi in 1991:

> In 1958 I, along with guru Kelucharan Mohapatra and Dhiren Patnaik, composed and choreographed a two-hours-long Odissi dance recital for Annapurna Theatre. This was performed before a select audience and the innovation was tremendously appreciated and received wide acclaim.

In earlier writings I was unsure whether the co-choreography to which she is referring here involved a dance-drama or an early attempt at codifying an Odissi *margam*. I have also opined earlier that it seemed to me more likely to have been a *margam* of sorts because Dhirendranath Patnaik was one of the collaborators—the implication being that his interest in this year (the year of the founding of Jayantika) was very much taken up by the question of the development of a complete Odissi repertoire.

If this was indeed the case, I argued, it would follow that Sanjukta was one of the contributors to the design of an early *proto-margam*, a contribution that puts her creative input on the same level as that of the recognized members of the Jayantika Association—all of them male—to whose labours the reincarnation of the full repertoire is usually exclusively ascribed.

This argument seems to have been rebutted by the assertion, made to me by Mr Kedar Mishra, the Odiyan art critic, that no Odissi *margam* was ever performed at the Annapurna theatre in Cuttack. I

Sanjukta Panigrahi's Contribution to Odissi 233

am content to defer to his knowledge in this, but must also note (as I did in my essay on Sanjukta Panigrahi's period at *Kalakshetra*) that Sharon Lowen contradicts this opinion, and states that an 'expanded repertoire' (see below) was indeed performed at this theatre. Neither of these commentators provides a source for their respective statements and the matter still rests unresolved.

Yet even if it is the case that the choreography in question was that of a dance-drama, we are still confronted by the fact that Sanjukta was collaborating at a creative level, in her fourteenth year, with two of the foremost designers of the dance. In saying this I should add at once that the deeper implications of such a collaboration, and the fact that such a creative collaboration often occurred, is not an entirely new proposition. It lies under the surface of many brief biographical accounts of and tributes paid to Sanjukta Panigrahi, and it makes brief flashes of appearance in a number of interviews given by Sanjukta herself. Notable among these is the allusion to co-choreography made by her in the 1988 interview with Richard Schechner, at which Kelucharan Mohapatra was himself present:

> Guruji works on his own choreography, and I work on my own too. Then when we get together ... he is open and if I make a good suggestion he always takes it.

In the same interview she speaks of her tendency to improvise, 'slowly putting more ideas into it.'

The idea of her work as an Odissi theorist is also alluded to in a 2019 interview with Kumkum Mohanty:

> ... When the Odisha Government decided to establish the Odissi Research Centre, the chair of chief executive was presented to Kumkum since she was a foremost Odissi exponent in Odisha. 'Sanjukta genuinely helped me to record the documents and decipher the tradition. She was there when we prepared the nomenclature drawing from our experience,' she said.

These and other passages yet to be given do strongly hint, it seems to me, at a creative and theoretic role that, perhaps by force of habit

234 ESSAYS ON CLASSICAL INDIAN DANCE

and tradition, remains as it were subconsciously withheld from the public record. In this regard one should bear in mind that the formal *guru-shishya* relationship did not take root in the teaching of proto-Odissi dance until the beginning of the 1960s, after which it became important to separate more firmly and formally the respective creative roles of teacher and student.

Before taking this premise any further, though, I must outline the scope of the material with which this essay will perforce have to deal in assessing Sanjukta's contribution to the design and exposition of Odissi from late-1958 to the end of 1964, by which time the Jayantika project had dwindled away for various reasons, not least among them the fact that Odissi had received official recognition as an Indian classical dance at the All India Dance Festival and Seminar held in Hyderabad in that year, a landmark with which I will deal more fully in due course.

It is important to bear in mind that Sanjukta, together with Mayadhar Raut, returned to *Kala Vikas Kendra* with a wealth of new and useful knowledge gained at *Kalakshetra*. In Sanjukta's case this experience formed the basis of what she had to offer in theoretic and formal aesthetic terms. She and Mayadhar had acquired first-hand insights into the broader and more detailed tradition of classical dance that the other members of Jayantika simply lacked.

In principle, and at the risk of stating the obvious, it is reasonable to insist that Sanjukta brought from *Kalakshetra* to the Odissi dialectic neither more nor less than Mayadhar did. It is true that she was still an adolescent at the time, but this does not constitute grounds for denying that she had substantial new knowledge to impart and that she actually did impart it.

One of the most startling statements I have come across in my research is this one by Julia Varley, included in her tribute to Sanjukta:

[Sanjukta Panigrahi] was an outstanding exponent—and virtually the re-discoverer of—Odissi dance.

This is no doubt an exaggeration, yet it is one that seems to me to derive from Sanjukta's repeated insistence in later life on her creative and research role in the reincarnation of the dance, to some of which

statements I will refer later. She may have laid stress on this aspect in private conversation with Varley too. It is as well, at any rate, to keep all this in mind in the attempt to arrive at a just assessment of the extent of the part she played.

One may add that the Jayantika Association's work was to centre around the creation of dance-dramas in addition to the formal solo-performance *margam*. At this juncture, by mid-1958, following the example set by *Kalakshetra*, the formalized dance-drama—so eminently suited to Odissi's favoured text, the *Geet Govind*—was considered to have its roots in the *Natya Shastra*, while the solo *margam* had its essential precedent in the *rajadasi attam* of the South Indian Sadir tradition, which had been taken up by Rukmini Devi. These were the two essential links which were brought back to *Kala Vikas Kendra* by Sanjukta and Mayadhar, and which were soon to be incorporated into Jayantika's classicizing vision. Put in this radical way, Sanjukta's crucial contribution to the project is made more lucid—and one would have to add, even more crucially, that these goals, together with their supporting texts (*Natya Shastra* and *Abhinaya Darpana*), had at this stage hardly crossed the minds of the proto-Odissi *nach* teachers as being fundamentally important to their classicizing endeavour.

To quote Madhumita Raut, speaking about the contents of Kalicharan Patnaik's pamphlet (1958) on the budding dance:

> Most techniques in the booklet are stated in the form of *lokvaani*, colloquial sayings. The *Natya Shastra* and *Abhinaya Darpana* were not yet taught in the study of Odissi ... Most of the Odissi practitioners had not even heard of these texts.

Other factors that come into play around Sanjukta's own activities for Odissi in this period include, firstly, in a very personal way—though a way by no means to be separated from her growth as a dancer—her romance with the classical vocalist, Raghunath Panigrahi, which led to their marriage in January 1960 and had some early detrimental effects on her career. The development of *Kala Vikas Kendra*, in the beginning so closely intertwined with the thrust of Jayantika, must also be taken into account. And finally there is the influence exerted on Sanjukta's own professional and artistic unfolding by the fiercely committed

and demanding labour of the Jayantika Association itself—in which nothing less was at stake than the successful and globally acknowledged reincarnation of a quasi-mythical Odiyan classical dance.

As regards Jayantika, we must note that its beginnings were very informal, so informal indeed that there is some difficulty in establishing exactly when its work was begun. Gaston asserts the earliest date, sometime in 1957, whereas other writers prefer 1958. The most reliable dating that we have is given by Citaristi, based on the secretarial records conscientiously kept by Dayanidhi Das, who retained the position of Jayantika's secretary throughout the period of its sporadic activities.

She writes:

> From the introductory speech given by the president Biranchi Narayan Routray (a journalist who was working for the *Prajatantra* newspaper) during the first meeting of the association (which was known at first as *Nikhila Utkala Nrutya Silpi Sangha*) at 3pm on the 22nd of June 1958 at Banka Bazaar, we come to know that the need of the moment was to do research on different aspects of classical and folk dances, to establish rules in the teaching system to assure uniformity in the execution of *bhangi* and *mudra*, to aim at a broader publicity for Odissi dance, and to secure cooperation among the different gurus and institutions.

This agenda looks very much like the one which Babulal Doshi wanted to have carried out by *Kala Vikas Kendra* in the same year, and about which he approached Dhirendranath Patnaik. But there was a series of sharp disagreements among the teachers in this year, some of it stemming from the tide of new information flowing into the *Kendra*, in the persons of Mayadhar and Sanjukta, from their experience gained at *Kalakshetra*.

It is doubtful that, even by this late stage, the *Kendra* had any final vision as to its mission for the resurgent Odiyan classical dance. The article on Dayanidhi Das in the July-September 2018 issue of *Nartanam* asserts that he had created a syllabus for teaching Odissi in 1952-53 (Mayadhar says 1954), but this syllabus should be regarded as a proto-Odissi course for the obvious reason that Odissi as we know

it today did not then exist. The dance at that stage was still mainly a *gotipua*-derived sequence, a single continuous item subsuming a *pallavi*, a *sabhinaya*, and a *natangi* section.

As Dhirendranath Patnaik wrote in 1960 (cited in Kaktikar):

> For over a decade Odissi was confined to a chain of items of both pure dance and *abhinaya*. Music was not developed, the costume was poor, repertory items were few, and the duration ... was very limited ... Jayantika, an association of practising gurus, dancers and scholars, rebuilt the whole repertory.

Lessons were being given in Bharata Natyam and Kathak, as well in regional folk dance, and there was much controversy over the use of texts, especially the *Abhinaya Darpana*, which Kalicharan Patnaik and Pankaj Charan Das did not want employed. One may perhaps wonder whether there was a strong initial resistance, especially among the older teachers, to the idea of the dance being finally constrained within the framework of a restrictive codification—after all, their intuitive experience of dance in the atmosphere of the theatre had become used to ongoing experimentation and innovation. Strict, rule-bound and textual confinement might have appeared to them injurious to their art.

Nevertheless, in 1958, Kalicharan Patnaik authored the booklet on Odissi mentioned above. It was published by the *Utkal Nrutya Sangeet Natyakala Parishad*, and was probably based on the papers that he delivered at the proto-Odissi demonstrations in Madras and Delhi in January and June of that year respectively. Some small progress was being made.

Sanjukta herself attended only one meeting of Jayantika in this year. Other dancers also present were Priyambada Mohanty, Sushama Mishra, Laxmipriya Mohapatra, Jayanti Ghosh and Premalata Das. Sanjukta's name appears on the list of Jayantika members drawn up in July 1958 (No. 26, Sanjukta Misra).

Returning to Citaristi's article, however, we are told that:

> In spite of all the good intentions of the founding members, it took almost one year for the new association to consolidate and

238 ESSAYS ON CLASSICAL INDIAN DANCE

start producing some results. By July 1959 the need to become more united and to safeguard the purity of the style became more and more urgent. During a meeting held on the 3rd of July 1959, Deba Babu refers to the case of a certain Vinod Chopra who had approached him for learning Odissi in a couple of days. In spite of all the pressure put on him and also the possibility to earn good money, he refused. These and other similar episodes made the members more and more convinced of the necessity of establishing a research wing for research on Odissi and folk dances.

Kaktikar informs us that, by May 1959, 'there were serious discussions every day but very little work was done.' It was then that Gora Chand Mishra suggested the name 'Jayantika' as referring to 'the birth of a new era of dance.' From this point on the problem began to be tackled in earnest, with an emphasis on research and the right design for the dance.

To quote Kaktikar again:

In the meetings there were discussions on the authenticity of different movements, *bhangis, charis* etc. in dance. Each master would try and authenticate his style. There were comparisons of the existing practices with the methodology written in scriptures. If something was not in accordance with the dance texts such as the *Natya Shastra* or *Abhinaya Chandrika* or *Abhinaya Darpana*, it would be deleted ... Whatever was *natyadharmi* ... was kept and whatever was *lokdharmi* ... was to be discontinued. The aim was to weed out the colloquial influences that had come into the practice of Odissi and realign it to the scriptures.

During the last months of 1958, however, while the members of Jayantika were still finding their feet, Sanjukta was completing her studies at *Kalakshetra*. But this does not mean that she was out of touch with Odissi developments in Cuttack. She and Mayadhar regularly returned to Odisha together for the annual holiday periods during which she was known to have continued her Odissi tuition with Kelucharan as well as taking part in endless dance discussions with various teachers who visited the family home. It is hardly implausible

Sanjukta Panigrahi's Contribution to Odissi 239

that most of these talks would have centred round the various theories proposed for the new regional classical dance.

Sanjukta recalled:

> Besides learning Bharata Natyam at _Kalakshetra_, I managed to keep up my practice in Odissi (squeezing time out of leisure hours and holidays), including various performances and seminars.

Staying in 1958, we must remember that Sanjukta had danced the _Geet Govind ashtapadi Lalitha Lavanga Lata_ (composed for her by Kelucharan, Mayadhar and Dhirendranath Patnaik) at the Sangeet Natak Akademi festival in Madras in January of that year, and this performance has been dealt with in my essay on her time at _Kalakshetra_.

And there is that other, still undefined, two-hour-long performance on record, with an allusion to which I began this essay.

If her recollection was accurate, and if this performance did take place, it seems unlikely that her collaboration in the choreography of this lengthy dance sequence would have been carried out in the early part of that year, before the June-July holidays. Rather, I would date it to some time in the period from 22 June 1958, after the first meeting of Jayantika had taken place. This dating strengthens the argument that this sequence might have been an early attempt to choreograph a formal proto-Odissi repertoire (or part of a repertoire embedded in a dance-drama) under the auspices of the early Jayantika institution.

As to the staging of this item, we are told by Sanjukta that it was presented to 'a select audience' and 'to wide acclaim' at the Annapurna Theatre, but we are not given a date. In an article on Sanjukta in the Deccan Chronicle (24 October 2014) Sharon Lowen tells us only that 'In 1958 she presented a repertoire expanded to two hours at the Annapurna Theatre, Cuttack, after working with several artists and scholars.'

It would be highly interesting and of great importance for the detailed documentation of the reincarnation of Odissi in the last century, and Sanjukta's role in it, to know exactly what this performance was, when it was performed at the Annapurna Theatre in Cuttack (Annapurna B), what the nature was of the 'wide acclaim' that it enjoyed, and who made up the 'select audience' to which it was presented.

240 ESSAYS ON CLASSICAL INDIAN DANCE

In late 1958 to early 1959 there was a dramatic personal twist in Sanjukta's development when she met Raghunath Panigrahi, then still a young, aspiring classical vocalist, known to admiring audiences as 'Geetagovindam Panigrahi.' She takes up the story herself:

> When I was at Kalakshetra, any visitor from Orissa who had heard about me came to visit me. I suppose they were curious to see how such a small child was living so far away from home. One visitor was Nihamani Panigrahi, a musicologist, who had adopted the Brahmin son of the Maharaja of Jaipur. He saw me when I was fourteen years old and decided I was the perfect bride for his son Raghunath Panigrahi, who was twenty years old.
>
> So Nilamani Panigrahi visited my mother and told her: 'My son is a singer and your daughter is a dancer, it would be very nice if they married.'
>
> ... I heard about this possible marriage when I returned to Bhubaneswar. My mother thought it was a good idea, but my father was totally against it ... But my mother answered: 'Sanjukta loves dancing, if she marries anyone else, she will have to stop and she will get depressed and upset. You are trying to avoid problems for her, but she will really be in trouble if she marries another man. She will be unhappy and that is much worse'
>
> ... These arguments continued for a year ... To make me forget Raghunath, my father organised another scholarship for me, this time to learn Kathak at the Bharatiya Vidya Bhavan in Bombay, 2500 kilometres from home. He thought I was too young to get married. However, Raghunath followed me to Bombay and my father saw that it was impossible to separate us. Guruji, who is like a father to me, intervened so as to try to convince my father.

I have quoted her at length here since there is hardly a more appropriate way to introduce the facts that led to her marriage in 1960. The period from that year to 1966 is regularly described as 'difficult' and 'filled with hardships.' Any interested reader can find the details of these years—during which both of her sons were born (the first in 1961, the second in 1963)—in any number of accessible documents. These personal and as it were 'private' details will not much concern me

Sanjukta Panigrahi's Contribution to Odissi 241

here, except insofar as they bear directly on Sanjukta's contribution to Jayantika.

So far as her dance studies are concerned, the interesting fact here is that she was taught Kathak of the *Janki Prasad Gharana* by Guru Hazarilal at *Bharatiya Vidya Bhavan*, the theatre and educational complex in Mumbai, in the first half of 1959, during which time the members of Jayantika were at last beginning to make real progress. By the middle of that year, then—the year in which she turned fifteen— she had been learning proto-Odissi for a decade, Bharata Natyam for six years (with Kathakali as a second subject), and Kathak for several months.

It is no wonder then, as she herself tells us, that she began experiencing confusion over how she would cope with this variety of styles. It was her mother, as always, who advised her to adopt only one of them and to concentrate all her energies on it. It can hardly be doubted that both mother and daughter instinctively preferred Odissi, the dance in which the daughter had invested so much of her creative energies and the mother so much of her headstrong willpower, and to which, as Odiyan cultural patriots, their own hopes and ambitions were intrinsically linked.

In pursuit of the Odiyan dance, then, Sanjukta returned from Mumbai to Odisha in the latter months of 1959. The rest of that year and the first half of 1960 seem to be the time in which the Jayantika members collaborated at their most intense and committed level to bring a full-fledged Odissi *margam* into existence. Between July and December they were meeting almost daily, mostly at night after their teaching in the day was done, to compare notes and discuss the details of the repertoire. This, at any rate, was the period of research and theoretic activity that resulted in the substantial arguments set out in the March 1960 edition of *Marg*, which was dedicated entirely to Odissi and contained articles by such capable theorists and expositors as Dhirendranth Patnaik, Mohan Khokar, and Charles Fabri.

Throughout these months, Sanjukta was present and available in Cuttack, and is known to have attended meetings with the other Jayantika members.

On 26 July we find her present at a meeting to discuss the public demonstration of the developing dance form and on 31 July her name

242 ESSAYS ON CLASSICAL INDIAN DANCE

is recorded as one of the members of the advisory committee to the 'Executive Body of Research.'

It is interesting to note that the *mokshya* (or *moksha*) was selected as the closing movement of the repertoire by the time the first demonstration of the full *margam* was performed by Sanjukta in September that year, though none of the Jayantika members had offered it as their first proposal.

Here is Citaristi citing Dayanidhi Das's record again:

> Kelu Babu proposed five items (*bhumi pranam, batu, pallavi, abhinaya, pahapata*), Deba Babu seven items (*bhumi pranam, bandana, batu, ista deva bandana, nartana, ragurupa, pallavi*), Dayanidhi Das five items (*mangalacharan, batu, pallavi, abhinaya, ananda nrutya*), and Dhiren Pattnaik seven items (*jagarana, bandana, pallavi, abhinaya, jhantari, batu, sabdam*).
>
> At the end they decided for *mangalacharan, batu, pallavi, abhinaya, mokshya nata.*

A further point of interest among their original proposals is Patnaik's choice for a *shabdam*, a sure indicator of the influence of Bharata Natyam on Jayantika's thinking in the course of their search for a final design. It seems to me that Dayanidhi came closest to the eventual consensus for the *mokshya* in his notion of the *ananda nrutya*. Be that as it may, both the records kept by Dayanidhi Das and the memories and documents of Mayadhar Raut remember September 14, 1959 as a landmark in the work of Jayantika. It was on this date, as Kaktikar writes, that:

> The *Sampoorna Nrutya* (complete dance repertoire as decided by Jayantika) was performed by Sanjukta Panigrahi (Mishra), Jayanti Ghosh, Krishna Priya Nanda; all *Kala Vikas Kendra* students who had been trained in the Jayantika style by Mayadhar Raut, Kelucharan Mohapatra and Debaprasad Das. They performed *Ganesha Vandana Mangalacharan, Batu, Basant Pallavi, Bhangi Chahan* (*Abhinaya* on Oriya song) and *Moksha*.

Sanjukta Panigrahi's Contribution to Odissi

Citaristi confirms this as follows:

> During the program, which was held at the Nari Seva Sangh in Cuttack, Deba Babu gave demonstration of *bhangi* and *pada bheda*, Mayadhar Raut of *hasta mudra* and Jayanti Ghose and Sanjukta Misra (not yet Panigrahi at that point) danced for about twenty-five minutes presenting *mangalacharan, batu, basanta pallavi, odia abhinaya* and *mokshya* as separate items.

My point in citing Citaristi's version is to show how important it was to Jayantika to present their *Sampoorna Nrutya* as a string of discrete items, a clear indicator that the Bharata Natyam pattern brought back to Cuttack by Sanjukta first, and later by Mayadhar, was the favoured template for the re-design of their evolving classical dance. This point becomes clearer when we adduce in part Kaktikar's more detailed description of the consideration that went into this question before the September event (she is drawing directly on Mayadhar's reminiscences):

> In one of the Jayantika meetings, Surendra Mohanty asked Mayadhar how the Bharata Natyam repertoire was organized. When Mayadhar elaborated the way the Bharata Natyam repertoire was divided into five main parts, it was decided that the Odissi repertoire should follow the same pattern.

And she adds that, at the event itself,

> D.N. Patnaik demonstrated the *karanas* (while) Mayadhar demonstrated the various mudras based on the comparative studies of the *Abhinaya Chandrika* and the *Abhinaya Darpana*, and the *Natya Shastra*.

I am labouring the point somewhat here, but only in order to emphasize from the mouth of one of the main teachers himself the intrinsic part played in the design of the new dance by the experience gained by both Mayadhar and Sanjukta during their years at *Kalakshetra*, and which

must have been imparted by both of them to Jayantika teachers and scholars at various times during the formation of the Odissi margam.

I will take leave of this argument with one more quote from Sharon Lowen:

> Along with Panigrahi returning to Orissa with her disciplined *shastric* training in dance, Guru Kelubabu introduced and gradually increased *shastra* into his teaching of the dance form at the elementary level, systematizing the training technique and exercises to be understood and hopefully mastered before going on to complete dances, essentially the traditional starting point. Year by year this developed as Sanskrit names from the *Abhinaya Darpana* were assigned for *mudras, sirabheda, dristabheda, grivabheda, padabheda, charis, karanas, bhangis,* etc.

Turning now to a consideration of the bare foundational elements with which the re-designers of the dance, including Sanjukta, were preoccupied, I quote the list of them as I stated it in an earlier essay of my own, framed in the context of dance archaeology:

> Before its new name was spoken, 'Odissi' consisted of a loosely interrelated number of instances that had not yet been drawn together into a new whole, and these so fragmentary and debilitated, so worn out by age, misadventure, mishap and neglect that their fundamental unity could only have been discerned by individuals driven by a relentless obsession to find and re-embody them into a new unity.
>
> In that sense, the synchronic one, the gurus of the Jayantika movement were archaeologists. Their work was in the first place to excavate whatever material could still be uncovered to give a fuller and more elegant form to the classical dance whose dimensions they had already essentially imagined. What they found in the main were the following:
>
> The dance of the *maharis*
> The dance of the *gotipuas*
> Folk dance

Sanjukta Panigrahi's Contribution to Odissi

Songs and poetry
Texts on dance
Sculpted relief panels depicting old dance postures
The revivalist materials available at Kalakshetra

Drawing on and collating these materials, they sought to re-imagine:

An aesthetic structure or repertoire
An applicable conception of classicism
An underpinning mythico-philosophical trope …

And, before discussing what Sanjukta's contribution to the archaeological endeavour might have been, let me begin by quoting her own words on the matter:

The Odissi style has been reconstructed based on paintings, manuscripts and temple sculptures. There are thousands and thousands of temples and we had thousands of sculpted figures to refer to; no one really knows how many there are. For us they are like open textbooks. We find different attitudes from them: a lady looking at herself in the mirror or holding an instrument like a sitar, or playing the drums or washing her hair; and each of these attitudes is carved in thousands of ways. We have to visit the temples, see the paintings, and then reconstruct in practice what we have seen.

I went to the *mahari*, who by then only remembered a few movements. I referred to the *gotipua*, to sculptures, to paintings, and began to collect sketches working with my guru. We wanted to resurrect the style and transform it into a classical dance. We choreographed various dances. We worked day and night.

We never looked at the time. If there was a dance to build up again, that was the only thing that mattered. I thought obsessively that I had to make Odissi dance known. It was not the work of one night, it came little by little, facing many difficulties. Given that I knew Bharata Natyam, I took advantage of this in order to make demonstrations in which I pointed out the difference between the two styles. But to do all this I needed to be surrounded by the

> temples of my region and by the inspiration that my Guruji gave me ...

The dance of the *maharis*, which, among others, Pankaj Charan Das and Mohan Mohapatra claimed to be teaching in the proto-Odissi years, is almost uniformly referred to as not having much to offer to the formation of the reconstructed dance. The temple *margam* seems to have been much depleted, though whatever real *mahari nacha* had been brought into the sphere of Odissi by the teachers already mentioned must obviously have been incorporated as part of its DNA. It is interesting to see Sanjukta speaking of a personal visit to the *maharis*, and it is on record that Mayadhar and Debaprasad Das recorded detailed interviews with five *maharis* in Puri at the Jagannath temple at the time.

It is possible, though this is pure speculation, that Sanjukta's father, Abhiram, may have driven the Jayantika members in his motorcar on some of the travels to the temples and caves where they saw the *maharis* and photographed the temple relief sculptures (in cases where photographing was not allowed and the sculptures had to be drawn, they would pay five rupees per sketch to local artists). Abhiram, at any rate, is known to have taken the teachers about in his car on several other trips, and my point in speculating in this way is that, on such occasions, Sanjukta would probably travel with them. From a technical point of view though, her studies of the sculpted poses would have been filtered through her knowledge of the *shastric karanas* as she had learnt to understand them and value their primal antiquity and classical aesthetic during her studies at *Kalakshetra*.

As to the *gotipua nacha*, she would have known it, as it were, from the inside out. Her pre-*Kalakshetra* childhood lessons from Kelucharan and Debaprasad Das who had themselves been *gotipua* dancers, would certainly have been squarely based on the dance of the *gotipua akhadas*—which was after all the prime basic template for the budding dance. So deep was its influence that six types of acrobatic *bandhas* were still being taught to first-year students in 1959. Two photographs of Sanjukta at six years old show her in two distinct *gotipua* poses, and wearing the *gotipua* head-decorations.

As we have seen, the influence of folk dance was deliberately excised from the envisaged Odissi *margam*, and in that sense it played a catalytic role in the ongoing work of sanskritization. But as to the Odiyan songs, these remained central to the envisaged repertoire. In this case Sanjukta was as much a connoisseur as any of her teachers. Her mother, Shakuntala, was a classically-trained singer, and this was probably one of the reasons why Sanjukta 'fell in love' with the young Raghunath's voice rather than with his person. This is also one of the obvious reasons why she was able to collaborate so regularly in the kind of choreographic work that she mentions in the passage above.

It is in any case clear from her own testimony that she was actively engaged 'day and night' in Jayantika's work of reconstruction, and this must surely be sufficient reason to differentiate the image of her legacy from the usual one given: that she was a only a perfect embodiment for the teachers' (and especially Kelucharan's) choreographies, a leading global Odissi exponent, and a popularizer of the dance, though she certainly was all of these things too. In this regard it is well to remember also the often stated fact that her sheer virtuoso prowess as a dancer, including her talent for complex footwork, was one early factor that enabled the kind of intricate choreography for which Kelucharan later became renowned.

It is clear too that her dedication, verging on obsession, to the recreation of the dance was equal to that of the other young pioneers who mixed ink and drops of their own blood on a *bel* leaf (sacred to Shiva) and signed an oath of unity in the cause of Odissi.

As for aesthetic structure or repertoire, the applicable conception of classicism and the underpinning mythico-philosophical trope, we know that Sanjukta possessed the needed instinct for dance design (having 'designed' her own dances from her earliest childhood up) and the well-rehearsed knowledge of the revivalist notion of classicism that she had been taught at *Kalakshetra*. Her popularization of the dance on the global stage in later years also shows her quite capable of grasping and perpetuating the significance of the mythico-philosophical trope— indeed, it was one of the main reasons why she was so successful in introducing it into her work with the International Society of Theatre

248 ESSAYS ON CLASSICAL INDIAN DANCE

Anthropology from the mid-seventies onwards. She was, after all, as Eugenio Barba insisted, 'an intellectual' too.

Returning to the latter part of 1959, we are told by Madhumita Raut (based on Mayadhar's memories and press clippings) that '*Prajatantra*, in the months of September and October 1959, carried reports and reviews of Jayantika Association's performances and various dance conferences.' These were made possible in large part because the president of Jayantika was then Lokenath Mishra, the leader of the political opposition.

Apart from the important 1959 Odissi demonstration on September 14, Citaristi mentions another on October 6 in Puri, which 'involved not only Odissi dance but also folk dance and classical music.' Kaktikar mentions yet another series of performances in December (with no date given) at Pragati Maidan in Delhi, which staged mainly folk dances. She adds, though, that 'Charles Fabri, the eminent art critic with *The Statesman* was frequently present and very often Odissi performances used to take place in the evenings ...'

It was clearly a very busy time, as Citaristi confirms:

Another important program organised on behalf of Jayantika, the preparation for which started in December itself, was the one put up at Cuttack in June 1960. While on 6th of October 1959 the program put up at Puri involved not only Odissi dance but also folk dance and classical music, the one planned for June 1960 (the date for this was changed several times) was to be a comparative demonstration between Odissi, Kathak and Bharatanatyam.

From December 1959 onwards, the meetings devoted to the planning of this important demonstration were attended not only by the gurus but also by the dancers involved, Krishnapriya Nanda, Priyambada Mohanty, Jayanti Ghose and Sanjukta Misra. On 30th of June (1960) in the program 'Comparative study-Bharatanatyam, Kathak and Odissi,' Raghunath Dutta presented Kathak dance, Mayadhar Raut danced the *ashtapadi hari riha mugdha* in Bharatanatyam style and in Odissi the following items were demonstrated: *mangalacharan* in a group by all the 4 dancers, *batu* by Jayanti and Krishnapriya, *pallavi* and *abhinaya* by Sanjukta and Priyambada and *mokshya* by all the 4 dancers.

Sanjukta Panigrahi's Contribution to Odissi

One other goal that was being worked at in this period was the composition of a formal syllabus for Odissi dance and music. This was completed by the syllabus committee, formed on July 31, 1959, of which Sanjukta was a member together with the dancers, Priyambada Mohanty, Krushnapriya Nanda and Jayanti Ghosh. The completed syllabus was published in 1960 by *Kala Vikas Kendra*. From these months too we can date the beginnings of the split that was widening between the *Kendra* and Jayantika mainly because Babulal Doshi, for whom the *Kendra* represented his life's work, did not want the credit for all the new developments to go to Jayantika to the detriment of his own institution. The seeds of discord were also now sown between the teachers and dancers of Jayantika itself, in some cases on account of genuine differences in their conception of the dance, in others because of tussles for credit and precedence. By 1964 these disagreements and jealousies had torn Jayantika apart.

We see from Dayanidhi's record, at any rate, that Sanjukta was still present and dancing in Odisha by mid-1960. The material available to me for this period now becomes somewhat intractable, and the story blurred. I am told that Sanjukta and Raghunath were married in Mumbai in January 1960, which means that the couple would have had to do a lot of shuttling between Maharashtra and Odisha so that Sanjukta could perform in the 1960 programs mentioned above. And it is not clear to me from what date the couple settled down in Mumbai and Chennai to pursue their fortunes in music, dance, radio, theatre and film. What is very clear, though, is that it was a disastrous period for both of them.

Here is Jhelum Paranjape's version of events:

In 1960 Sanjukta got married at the age of sixteen. She had her first son when she was seventeen and second when she was nineteen. Circumstances made her lose her childhood and her youth. Even later, it was a struggle for establishing oneself. Raghunath had left his lucrative career in Madras for marriage to Sanjukta. They tried their luck in Mumbai, and did not succeed. They went back to Madras, but there too success evaded them ... Marriage in 1960 and the birth of two sons till 1964—these years were very hard on Sanjukta and Raghunath—economically and otherwise.

250 ESSAYS ON CLASSICAL INDIAN DANCE

Sanjukta recalled:

> As my father had rightly anticipated, it was not easy. Raghunath
> and I decided to live in Bombay because we thought it would be
> easier to survive as artists there. But we had to struggle hard. There
> were times when we walked for hours because we couldn't afford
> the bus; other times when we had only one meal a day. Raghunath
> did some radio programmes, and this was our only income. I was
> trying to get myself known as a dancer and I had to face many
> humiliations.

I am in the dark as to the details of the troubles the couple endured
during these years. It is known that Raghunath had some radio work
which may just have kept body and soul together. Presumably they had
help from Sanjukta's parents, especially her mother who, after all, had
always urged Sanjukta to stick to her dancing career and promised to
support her if that ever became necessary.

She probably returned to Odisha for short periods during this time
and in that way kept in touch with the progress of the dance and the
ongoing work at *Kala Vikas Kendra*, at which Kelucharan continued
to teach. Mayadhar Raut had also returned to Cuttack, having given
up his teaching post at the Natya Ballet Centre in Delhi. But by 1963
Jayantika's project had all but ground to a halt.

From this year there is a photograph of Sanjukta dancing in the
Geet Govind with Mayadhar. I can find nothing more that is said about
this performance—but I know from Mayadhar's own recollection that
he considered this performance with Sanjukta to have been a high-
point in his experience. He says that he 'never danced like that again.'

This is a warm tribute not only to Sanjukta's excellence and
empathy as a dancer but also to the friendship that had sprung
up between them. Their relations were to remain cordial for the
remainder of her life, even after the rift between Mayadhar and *Kala
Vikas Kendra* had become cemented, and Mayadhar departed to Delhi
for good.

Sanjukta and Raghunath returned to Odisha in 1964, having
failed to find a foothold in the music and dance scene either in

Sanjukta Panigrahi's Contribution to Odissi

Bombay or in Madras. She took up a teaching post in the newly-established dance and music school, the *Utkal Sangeet Mahavidyalaya* in Bhubaneswar, which had been opened under the auspices of the Odisha *Sangeet Natak Akademi*. At this post she remained for two years, and the school still honours her as one of its former illustrious teachers, but does not mention that she was then only nineteen and twenty years old.

It seems odd that she was not given a teaching post at *Kala Vikas Kendra*—but in this regard we should remember that these were years of some discord between the teachers, which led within three years to the dissolution of the Jayantika movement, together with its oath of unity of purpose, and the scattering of its former members.

Yet Sanjukta did dance in the Odissi program presented at the All India Dance Festival and Seminar in 1964. This was the program that led to the formal awarding by the *Sangeet Natak Akademi* of classical status to the dance, and was thus the successful culmination of the years of labour put into the project by the founders and members of *Kala Vikas Kendra* and Jayantika.

At this performance, Kaktikar says:

> Dhirendranath Patnaik read a paper and demonstrated various *karanas* and *bhangis*, Mayadhar demonstrated the use of *mudras* and other theoretical aspects of the dance, Sanjukta Panigrahi performed *abhinaya* based on an Odiyan song, *Bhangi Chahan*, and Ramani Ranjan Jena performed the *Dashavatar*. Students of *Kala Vikas Kendra* performed the *Basant Pallavi*. Kelucharan Mohapatra played the *pakhawaj* and Raghunath Panigrahi gave vocal support.

This goal of many years' collective travail had been achieved, as I have tried to show, with a variety of essential contributions by Sanjukta, both in the role of exponent and that of researcher-theorist—contributions that were at least as important and influential as those made by any other members of the *Kala Vikas Kendra* and Jayantika projects.

Perhaps this is now beginning in small way to be generally recognized.

Chief Sources

ACHARYA, RAHUL
2009. *Dr Dhirendranath Patnaik*
Narthaki.com

BADRINATH, TULSI
2013. *Master of Arts: A Life in Dance*
New Delhi: Hachette

BARBA, EUGENIO
2010. *On Directing and Dramaturgy: burning the house*
New York: Routledge

CHOWDURIE, TAPATI
2017. *Interview with Dr Priyambada Mohanty Hejmadi*
Narthaki.com

CITARISTI, ILEANA
2018. *Introduction* to the volume on Jayantika.
Nartanam vol. XVII no. 3 July–September 2018

2018. *The Rise and Fall of Jayantika*
Narthaki.com

DEVI, RITHA
1991. *Name of Article not Found*
Orissa Society of the Americas Souvenir Issue

FABRI, CHARLES LOUIS
1960. Article in *Marg* vol. 13 no. 2

GANDHI, AASTHA
2008. *Who Frames the Dance? Writing and Performing the Trinity of Odissi*
Dance Dialogues

GASTON, ANNE-MARIE
Undated. *The Creation of Odissi and the Influence of Bharata Natyam*
Chennai: Kalakshetra Journal

KAKTIKAR, AADYA
2011. *Odissi Yaatra : The Journey of Guru Mayadhar Raut*
New Delhi: B.R. Rhythms

KHOKAR, MOHAN
1960. Article in *Marg* vol. 13 no. 2

KOTHARI, SUNIL
2015. *The Celestial Beauty*
The Hindu, June 11

2019. *Krishna Rao and Chandra leave Behind a Rich Legacy of Dance Scholarship and Practice*
Asian Age, Feb. 26

KUMAR, AASTHA
2013. *Constructing and Performing the Odissi Body: Ideologies, Influences and Interjections*
New Delhi: Journal of Emerging Dance Scholarship, Jawaharlal Nehru University

LOPEZ Y ROYO, ALESSANDRA B.
2007. *The Reinvention of Odissi*
in KYRIALIDIS, EVANGELOS, *The Archaeology of Ritual*
Los Angeles: University of California Press

LOWEN, SHARON
2014. *Remembering Oriya Girl Sanjukta Panigrahi*
Article in Deccan Chronicle, Oct. 24

2004. *Kelucharan Mohapatra, the Undisputed Master*
Dallas: Orissa Society of the Americas Souvenir Issue

MANSINHA, LALU
2004. *Guruji—a Retrospection*
Dallas: Orissa Society of the Americas Souvenir Issue

MANSINHA, MAYADHAR
1960. Article in Marg vol. 13 no. 2

MISHRA, KEDAR
2019. *Correspondence with the author*

MOHANTY, KUMKUM
2010. *Steps to Success*
The Telegraph, Aug. 9

MOHANTY, S.G.
2004. *Guruji's Life and Work*
Dallas: Orissa Society of the Americas Souvenir Issue

NAYAK, BINOD B.
2019. *Adi Guru Pankaj Charan Das: Life and Times of an Iconoclast and Pioneer of Odissi Dance*
Atlantic City: Orissa Society of the Americas Journal, 50th Annual Convention

PANIGRAHI, SANJUKTA
1991. *My Life—My Story*
Chicago: Orissa Society of the Americas Souvenir Issue

PARANJAPE, JHELUM
2004. *Sanjukta Panigrahi—a Phenomenon*
found at Narthaki.com, Oct. 19

PARKER-LEWIS, HEATHER
2016. *The Space Between the Notes*
Cape Town: Ihilihili Press

PATHY, DINANATH
2008. Culture Changes and the Orissan Dance Tradition
Toronto: Orissa Society of the Americas Journal, 38th Annual Convention

PATNAIK, DHIRENDRA NATH
1960. Article in *Marg* vol. 13 no. 2

RATH, PUNYA PRAVA
2019. *I was her Radha and Sanjukta Panigrahi was my Krushna: Kumkum Mohanty*
Odishabytes, Aug. 24

RAUT, MADHUMITA
2007. *Odissi, What, Why & How?*
New Delhi: B.R. Rhythms

RAUT, GURU MAYADHAR
2019, *Correspondence with the author*

REDIFF ON THE NET
Date and author not given: *The life and Times of Sanjukta Panigrahi*

ROEBERT, DONOVAN
2018. *Jayantika: Archaeology and Imagination in the Reincarnation of Odissi, Parts One & Two*
Academia.edu

SCHECHNER, RICHARD & ZARILLI, PHILLIP
1988. *Collaborating on Odissi: an Interview with Sanjukta Panigrahi, Kelucharan Mohapatra and Raghunath Panigrahi*
TDR vol. 32 no. 1

SEN, KABERI
2017. *Assessment of the Manifestations of Chaitanite Vaishnavism on Odissi and Manipuri Dance*
Kolkata: Rabindra Bharati University (Thesis)

SIKAND, NANDINI
2016. *Languid Bodies, Grounded Stances: the Curving Pathway of Neoclassical Odissi Dance*
New York: Berghahn Books

SUNDARI, G.
2019. *History of Kalakshetra: In Conversation with G. Sundari*
Kalakshetra Foundation, Feb. 22

TRIPATHY, SANGEETHA
2003. *The Life and Times of Sanjukta Panigrahi*
Princeton, New Jersey: Orissa Society of the Americas 34th Annual Convention Souvenir Issue

VAISHAMPAYAN, JAYANTI V.
1976. *The Contribution of Rukmini Devi to Bharata Natya*
Maharaja Sayajirao Univ. of Baroda (Thesis)

VARLEY, JULIA
1998. *Sanjukta Panigrahi: Dancer for the Gods*
New Theatre Quarterly vol. 14 no. 55 Aug.

VENKATARAMAN, LEELA
2005. *Heroine by Chance*
The Hindu Magazine, Jan. 23

VIDYARTHI, NITA
2014. *Odissi, then and now (An interview with Laxmipriya Mohapatra)*
The Hindu, Aug. 28

WOLPERT, STANLEY
1965. *India*
New Jersey. Prentice-Hall, Inc.

30

The Foundational Ambiguity in Classical Indian Dance

The language of art bears a burden of ambiguity because, rather than only speaking about life, it speaks life, and life for us human beings is ambiguous in all its ways. We need look no further, if we wish radically to confirm this for ourselves, than at the simple and essential truth that death is present to life at every living moment that is also a moment of dying. It is perhaps from this quintessential and inexorable paradox that our quotidian struggle against ambiguity derives. We want to be sure that we understand and that we are understood. But art, if it is the kind of art that speaks life, never satisfies our craving for the lucid grasp: we are left always slightly in the dark, groping our way towards its meaning.

The classical Indian dances, because they do speak life, inevitably treat us in the same way, leaving us fulfilled but famished, enlightened but suspicious, and wondering what it is that we ought, in the moment of illumination, to have seen while blinded by their radiance. I am not referring to the things we have been taught to understand in the regular course of the dance. We are all familiar enough with those, so familiar in fact that the only way we can know the dance at any depth at all is to look beyond them, to ignore them with the vague idea of

Essays on Classical Indian Dance
Donovan Roebert
Text copyright © 2021 Donovan Roebert / Photographs copyright © 2021 Arun Kumar
ISBN 978-981-4877-47-3 (Hardcover), 978-1-003-12113-8 (eBook)
www.jennystanford.com

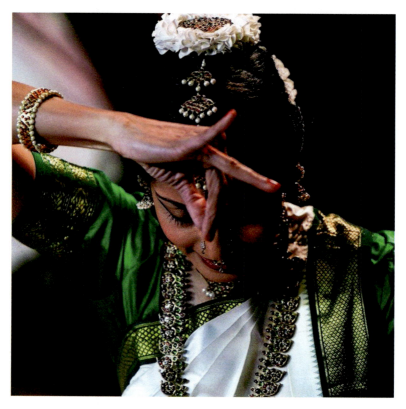

30. Ramya S. Kapadia, Artistic Director, Natyarpana School of Dance and Music, Durham.

their presence that one maintains in ignoring the literal meaning of a poem.

Ambiguities in art may be incidental or accidental, providential of intended or unintended moments of ironic paradox. We may meet them with a smile or a feeling of discomfiture, or we may be thrown off balance. In any case we experience these shifts of consciousness as being themselves true to the ambiguous vagaries of our felt and examined lives. We know what they are meant to mean, even when we don't know precisely what they mean.

Though classical Indian dance can and does afford ambiguities of the incidental and accidental sort, its strongest ambiguities are of the structural kind, which support and inform the mindset and construction of the dance itself. These are on the whole well known to both dancers

The Foundational Ambiguity in Classical Indian Dance 259

and *rasikas* as contributing to the architectural superstructure of the dance.

The foundation of that architecture is the dualism, monist at its core, of the *Shiva-Parvati* dynamic. Its presence introduces us to the cosmic continuum of creative essence on the one hand and creative transformation through destruction on the other. I depart from the more simplistic formulation, the binary idea of mere creation and mere destruction because, as I see it, the *Shiva-Parvati* symbol gives entry to two radically intertwined givens: the fact of existence itself and the fact of existent things, the ontological and the phenomenal. But let us simplify this for ourselves by asking and answering two questions:

Q: Why is there absolute being rather than absolute nothingness?
A: Because Shiva dances.
Q: Why does the fact of absolute being give rise to a relative realm in which existing things come into and go out of existence?
A: Because Parvati dances with him.

Immediately we see that the existential ambiguity of the cosmic dance can be perceived in three ways. We can look at each of the two facets, male *deva* and female *devi*, in turn, or we can rise above that dualism to realize their simultaneity and mutual superimposition as a single essential *datum*. The two are inseparably one.

In classical Indian dance this nuclear singularity of the male-female force, of the ontological and the phenomenal, of the absolute and the relative, is represented in a humanized and humanizing work of kinetic art. In it the cosmic absolute and its tendency to a relativizing mobility (as creation and transformation in a concrete, material realm) are both felt and transmitted as a microcosmic structure-in-motion, the absolute principle of being and its relativized principle of becoming, the static *sthanaka* and the kinetic *adavu-jethi-thirmanam* contiuum.

In the dance, the discrete moments of posture and gesture, their momentary fixitude, represent what is absolute in the underlying choreography. No wonder then that these moments have been preserved in mysterious stasis in a myriad temple and cave sculptures, where they persist in relief as symbols of the first principle of being whose essential *mudra* stands fixed behind the variegated *bhavas* and *rasas* of *maya*.

260 ESSAYS ON CLASSICAL INDIAN DANCE

What is not absolute, what is relative and therefore in ongoing motion, undergoing the process of Parvati's creative transformation, is demonstrated in the flux of the dance, itself made up of the discrete postures and their connective tissue of geometric flow, the absolute and the relative dancing together.

I have said above that we can look at each of these aspects in turn or else see them fused together in a superimposed singleness of manifestation. This indicates that there are three disparate ways of viewing the constitution of the dance, and implies that these three views can be adopted sequentially. If we do consider them separately and in turn, however, we sacrifice the higher insight into the fundamental ambiguity of the dance together with its accompanying sentiments.

The achievement of the genuine *rasa* of this foundational monism-in-duality comes by sharpening the attentive mind, the concentrated mind, so that it is able to discern the subtle co-presence of this triune vision at one and the same time. Seeing then, in the *maya* of the dance, the simultaneous presence of the static and the kinetic, of discrete moments bound up with continuous flux, separate and yet inseparable, we attain to those exquisite moments of delicate equipoise that the dance is designed to elicit.

More than this, we arrive at the key to the fuller experience of its other ambiguities: mystical yet sensuous, classical yet evolving, intellectual but instinctual, symmetric and asymmetric, and so forth. We see why the dancer's charming innocence is yet so replete with alluring experience.

We are infected by the *Raasleela* in the blood and in the brain.

31

The Karma of Classicism in Indian Dance

In an earlier essay on the Jayantika Movement I tried to make a case, based on the reincarnation of karmic traces, for the genuine classicism of Odissi. I argued there that these traces were present in a number of historical givens to which the Movement had access for the purpose of re-embodying the dance, and that the classicism of Odissi resided in the fact that these traces were a composite classical 'meme' waiting to be reincarnated in a new *avtaar*.

I want to take this idea a little further here in the hope of clarifying for myself how the earlier argument which I made with reference only to Odissi may be applied now to the concept of classicism as it relates to the Indian dances generally.

Before proceeding any further, however, I must emphasize that I am using the notion of karma and karmic traces in a non-religious manner, as a symbol and an analogy for certain ideal cultural and artistic traces that survive and are carried forward in the course of the history of ideas.

In speaking of them and of their potential for a variety of 'reincarnations,' I am really only pointing to the elements of a tradition that have managed to outlive long periods of cultural change,

Essays on Classical Indian Dance
Donovan Roebert
Text copyright © 2021 Donovan Roebert / Photographs copyright © 2021 Arun Kumar
ISBN 978-981-4877-47-3 (Hardcover), 978-1-003-12113-8 (eBook)
www.jennystanford.com

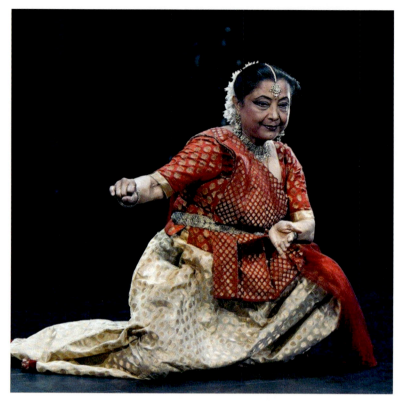

31. Saswati Sen, New Delhi.

destruction and decadence, so that their filaments can still be traced and lifted out of the remaining fabric. I do so not in order to adduce a spiritual flavour to the classicism of Indian dance but simply because the Vedic and Buddhist theories of karma are more apposite to the case I hope to advance here. They will serve more lucidly to illustrate the few simple points I will be trying to make.

The neatest understanding that we have of karma is that it operates exclusively in the mental domain. Karma, the law of creative and destructive action, works to shape the mind of the acting agent, to determine its mentational particularities, its attitudes, predispositions and so on. Then, when that agent reaches the end of its present lifespan, it passes through a zone of formless-timelessness before being reborn as a new reincarnation whose mind and mindset are informed by the karmic traces carried over from its previous lifetime. By this theory,

The Karma of Classicism in Indian Dance

too, the kind of embodiment that is attained, whether healthy, beautiful or otherwise, is determined by the karmic forces operating through the mind. Throughout this process of repeated deaths and rebirths there are innumerable opportunities either for making progress or for backsliding into retrogression. Someone born beautiful and healthy, for instance, may abuse these auspicious bodily marks and take on an unfortunate embodiment in the next lifetime.

(I must stress, for the sake of avoiding difficulties, that I am neither espousing nor disavowing this orthodox view of karma. I don't claim to know one way or the other. I am using it only as a model for my argument.)

The primal operation of the karma of classicism is the enforcement of order on chaos. It is no surprise then that Bharata Muni's first successful *natya* production was *The Churning of the Oceans*, a creation myth depicting the emerging out of chaos of the formal cosmic order. From the outset the philosophy of the *margam* has been based on the principle of strict codification, as the *Natya Shastra* also insists that it should be.

Classicism in Indian dance is concerned with the imposition of heightened formalism on the primitive freedoms of the dancing body. It does this not only in order to insist on the necessity of structural restraints as a spiritualizing and civilizing force but to intensify the experience of formal beauty. There is nothing beautiful about chaos. The abyss is only the abyss. Beauty is snatched from the brute arbitrariness of chaos when it is humanized through human formalization.

The karmic traces of classicism all originate and are defined by this central force of formalism, codification and structure. We can say that the classical impulse tends to the form that has the highest degree of structural organization and therefore the strongest potential for aesthetic and moral expressiveness—because these dimensions of beauty and sanity are implicit in the imposition of order on chaos.

It seems possible, at least from the tentative dating of certain dance sculptures, that the discipline of form and moral sanity has been applied to the dance from *pre-shastric* times, and this possibility gives us a strong clue to the validation of the *natya-nritya* practice as a yoga of the *Natya Veda*. From those remote times, then, the karma

of classical Indian dance has existed in the common mental realm and taken reincarnations, sometimes more fortunately, sometimes less so, in a variety of historical embodiments.

Bharata Muni took upon himself the huge task of making explicit the meanings, purposes and codes of the dance-drama—its *karma-dharma*—and since then there have been a number of commentators and codifiers who have carried on this humanizing tradition. But I don't want to revisit the repository of dance manuscripts here. I wish only to point to the ongoing re-embodiment of the karmic traces of dance in sculptures, treatises, the *devadasi* and *mahari* traditions, the *guru-shishya parampara*, and so forth. And, more emphatically, I want to insist on their continuity of historical presence in the thousands of dancing bodies that have embodied and expressed them.

Today the karmic traces of classical dance are in the hands (or rather the minds) of dance teachers, dancers, critics, *rasikas* and theorists. What we have to ask ourselves is whether they are being maintained and transmitted with the same purity that obtained in their aboriginal intention: the enforcement of disciplined form and code on the dance of primal chaos, including the chaotic dance of individual dancers.

These karmic traces are present and working in two categories of praxis, that of the generality of dance pedagogy and theory, and that of the individual dancer. The point to bear in mind here is that, for classicism in dance, every informal, heterodox gesture partakes in the retrograde, in the anti-classical trend back towards chaos, including the 'chaos' of the free dancing body. Now I am not interested in arguing against 'liberated' or 'contemporary' or 'fusion' types of dance. Their karma is their own, and they will take their own course. My concern here is only with the attempt radically to define what is classical and orthodox about the classical dances, and to speak for the purest possible preservation of their karmic traces in the mindset of dance.

Karma is inseparably intertwined with *dharma*, and there is a *dharma* of classicism in dance. The aim of its embodiment is to refine the minds of practitioners and *rasikas* alike, and its path to refinement is a strictly codified, formal one.

But let us remember also, when we speak of form, codification and organized structure in the dance, that we are pointing at a discipline of artistic and philosophic expression that surpasses those of all the

The Karma of Classicism in Indian Dance 265

other arts, because in the dance these details of formalism are in the end embodied not only in a poem, a sculpture or a painting, but in the living, moving body of the dancer.

Its organization is an *organicization*.

That is why I am convinced that the karma of classical dance is the most fundamental and ancient humanizing force that we human beings possess. We ought therefore to consider how we treasure or squander it, and what reincarnational forms, whether healthy or unhealthy, we might yet bring it to adopt.

32

A Note of Thanks

When I think how much poorer my life would have been without the dance, I grow thankful.

In the afterglow of an absorbing recital, I take thought of the tireless travail and dedication that have gone into giving this gift to me.

How easily, in the presence of the dancer's grace, the stringent physical machinery of the dance is forgotten: the pain and sweat and the tearing of muscle and the cracking of bone.

The self-spun spell seems to unwind itself effortlessly, leaving me at ease in my illusions. A moment's reflection undeceives me. It isn't as easy as crossing a field.

Thousands of years of toil and determination are summed up in the dancer's work, because *work* is what it is: work whose only purpose is to make us happy, to lift us up when we are life-sick, to restore our sense of inwardness and re-open our access to joy.

Though I seldom remember that it is just so. Perhaps because the dance is too entrancing, too medicinal, to lay such a large burden of debt on me. But when I pause to reflect on it—how big a debt it is!

Just today, tired and a little irked with the business of life, a little unnerved too, I turn to a number of dance-clips online, and immediately the remedy is at hand. I watch in wonder, I smile, bite my lip, my eyes widen and come awake and are touched to life again. And afterwards,

Essays on Classical Indian Dance
Donovan Roebert
Text copyright © 2021 Donovan Roebert / Photographs copyright © 2021 Arun Kumar
ISBN 978-981-4877-47-3 (Hardcover), 978-1-003-12113-8 (eBook)
www.jennystanford.com

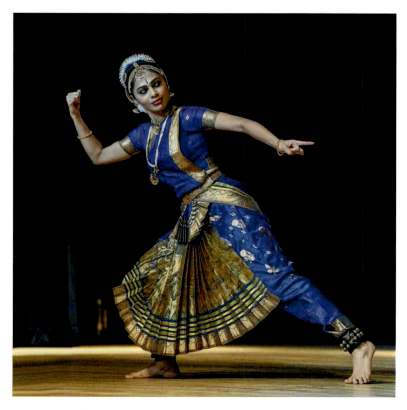

32. Neha Mujumdar, student of Dr Parimal Phadke, Chandler, Arizona.

recalling the imprinted flux, I am still smiling with an inner flicker of contentment. I have been witness, once again, to these little miracles of accomplishment.

Then multiply all my busy days across the years, and see how often and unfailingly dance has come to my rescue. From myself, and sometimes from others too. How then can I fail to cherish the dancer? How not know the dance as a sacred art—of healing, of edification, of the sobering of self and the riddance of self-love?

There is no other art like this one.

And the question I often ask myself but never can answer: to what do I owe the privilege of eyes that are able to see the dance and recognize its enduring importance, its centrality? That gift alone is a great one.

A Note of Thanks

But it would be nothing, would it not, if the dancer did not exist to dance? Caught up in the yielding *jadu* of it.

Grateful, I am. Millions can't see it. Millions have no idea what the dancer is.

Thank you for dancing. Without you, what would life be? This a question that deserves to be asked and answered over and over again.

33

On the Dancing Feet

The dancer's feet are *aalta*-painted as those of the bride on her journey to her betrothed, the *deva*. Recalling those of the *devadasi*, her feet cross the threshold of the temple-stage to dance the preliminary *pushpanjali* in the presence of her divine bridegroom. The remainder of the recital, progressing from movement to movement, and culminating in the *nritta* of *tillana* or *moksha*, constitutes stages of love-intensity directed formalistically at a formless infinitude, the unknowable and unmeasurable, which the *deva*-groom represents.

Her feet are naked not only for technical reasons. They step on to the stage as on to sacred ground, and sacred ground can only be trodden unshod. Her feet are those of the holy bride and of the worshipful devotee. They stand ready and decorated in the first position for a tantalizing act of *bhakti*. (Let us not fool ourselves about the purity of true devotion lest we cast away *bhakti* for the sake of immaturity and are left with nothing instead).

Such is the symbolism.

Its chief interest for the *rasika* lies in the way in which he himself, his place and position and disposition, are indicated by the dancer's feet. He is not the *deva*-husband for whom they stand ready in *araimandi* or in *chauka* and for whom every *pada bheda* has been designed as a pedestrian *mudra* of strength, balance, beauty and locomotion. If that

Essays on Classical Indian Dance
Donovan Roebert
Text copyright © 2021 Donovan Roebert / Photographs copyright © 2021 Arun Kumar
ISBN 978-981-4877-47-3 (Hardcover), 978-1-003-12113-8 (eBook)
www.jennystanford.com

33. Sujata Mohapatra's workshop at the University of North Carolina at Charlotte.

were the case, he should be welcomed on the temple-stage, while his presence there in fact would be a signal disgrace.

His place, instead, is a little lower down, looking slightly up at the feet whose purpose is to inveigle the deity that is also the *rasika's* deity and the bridegroom to whom he is situated as friend, fellow-worshipper and, in the manner of the *Ardhanarishwara*, as *sakhi* too. Because the *rasika*, in essence, partakes of the dual-gendered genderlessness of the deity, of the dancer, and of the dancing feet themselves.

Sometimes the dancer's left foot is Radha, her right foot Krishna, or it may be Shiva or Parvati. And sometimes it is the other way round. Sometimes the left is in *tandava*, the right in *lasya*, and only the mode of the *pada bhedas* closely studied, and with efficient imagination, will show that it is so and, being so, how which is which, and when. For the dancing feet, though two, are one thing working closely together, interchangeably male and female, towards a single transcendent end.

Like the dotted palm of the *pathaka*, there is an eye on each foot, on the upper instep, looking sometimes in the same and more often in different directions to cover all of space. These are eyes of blessing in constant motion and from them in the first place emanate the *tejas* in multi-directional showers of unseen light, like that from a secret lamp seen only by the initiated.

The *ghungroos* or *salangai* are their vocal chords which speak in complex rhythms as an intrinsic part of the holistic voice of the *vachika*

abhinaya. The dancing feet have eyes and mouths and ears for rhythm in a hidden place known only to the dancer and the groom. Otherwise it would not be possible for her feet to dance, the distance from her ears to her soles being far too great to move her feet in tempo. Indeed, there are some philosophers who contend that her feet have a mind of their own. And that the essence of this mind, its *chitta-purusha*, is founded on the *sollukattu*. For the feet are able to pay auditory attention to nothing else besides.

So much for the constitution and philosophy of the dancing feet, though volumes could be written if all were examined and told.

From the aesthetic point of view her feet are the metrics of the poem which without them could not exist. They capture its thought and sentiment in patterns of syntax that dance along lines which simulate the movements of categorical mentation, their swift and unreflecting semantics quicker than the relatively sluggish cogitations whose vital substructures they sustain.

But they are present too in their concrete corporeality whose protean shapes have been known since long before the days of the *karanas*. Dressed as they are, and endowed with a sense of their own bold *atma*-hood, they perform in the role of separate bodies, epitomizing, by reflecting in themselves, throughout the range of the lovely *bhedas*, the whole dancing remainder which rests upon them as the superstructure fulfilled in its own plenitude and completion of beauty.

Therefore, and rightly, technically speaking, the calligraphic feet become the starting point for the journey that is the reading of the whole kinesthetic performance. Without the dancing feet there can be no foothold for either the dancer or the receiver of her subtle significations.

Thus brilliant footwork perfectly written, albeit as an unconscious scribble of speed, can act as an undue distraction in the same way that the perfected penmanship of the calligrapher stands out as a digression from the meanings of the words whose first purpose it was to transcribe and make present to the light of the eye and mind.

Here the only remedy (for all perfection demands a remedy) can only be supplied by the *rasika* himself, by the application of a discipline whose theory is that the dancing feet are gateways granting access to

274 ESSAYS ON CLASSICAL INDIAN DANCE

the greater temple of the far-flung cosmos of the dancing body entire. (Thus it is a crime against the art when film-makers deprive us of these gates and leave us vaguely bewildered as at the sight of chariot moving gracefully along without its wheels).

The dancing feet are points of departure, foundations leading the eye upwards and outwards across all the major and minor limbs of the imposing architecture of the mobile temple moving within and among other temples, especially the temples of the mind. Like the hooves of the gazelle, they make sense of its whole shape in graceful movement, but also of the contours of its horns.

It is something of an open question, therefore, what too-brilliant footwork signifies: is it indiscipline and a lack of corresponding artfulness in the work of the rest of the dancing body? Or do these particular dancing feet have unusually stronger minds of their own?

34

Rukmini Devi and the *Devadasi* Question: An Opinion

Today, all over the place, online and elsewhere, one comes across overt or oblique attacks on the once esteemed person of Rukmini Devi. Behind these onslaughts there lurk a variety of activist agendas that seek not only to reinterpret and restate the historical record but also to demand redress for certain 'historical injustices.' This pattern of academic and 'social justice' agitation has by now become an integral part of the postmodern approach to biography and historiography. It wants not only to amend the given narrative but also to destroy the positive achievements and legacies of individuals who played the major parts. Such ventures often stem from a fashionable celebration of a vicarious claim to victimhood and its accompanying clamour for restorative justice.

Rukmini Devi makes for a perfect target in the wide-ranging predatorship of the 'social justice' jungle. She was a Brahmin married to an eccentric English Theosophist, and decidedly part of the pan-Indian cultural-political elite. This elite had come to the fore in a specialized way to conduct both the preliminaries and the actual business of Indian national independence, including its cultural counterpart. She was therefore framed by powerful historical forces

Essays on Classical Indian Dance
Donovan Roebert
Text copyright © 2021 Donovan Roebert / Photographs copyright © 2021 Arun Kumar
ISBN 978-981-4877-47-3 (Hardcover), 978-1-003-12113-8 (eBook)
www.jennystanford.com

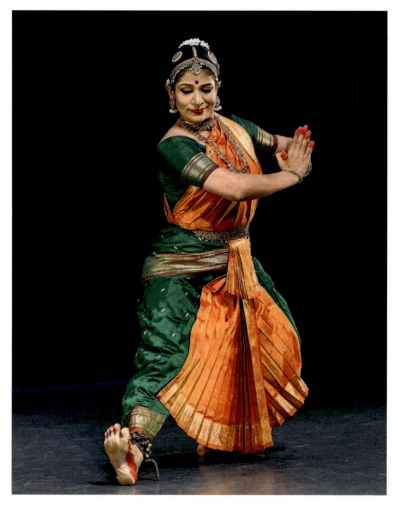

34. Divya Devaguptapu, Bharatanatyam dancer, Chennai.

within a context that played mightily on her social role as no doubt it also did on her individual personhood: her intellect, spirit, ambition and imagination—and that from a very early age.

In time, as her grasp of her own role was clarified by her ongoing education in the intellectual stream of the renewed national cultural environment, she learned to use her influence, charm, ability and forcefulness to compass the ends that she had adopted (or, as she always maintained, that had adopted her): the establishment of a

pan-Indian classical dance, enriched by all the other arts, that would take its rightful place in the world community of dance. Her passion for dance, conceived under the influence of Anna Pavlova, became quite naturally conflated with the pervasive force of the Indian independence movement. The growing symbiosis between culture, its specific arts, and the organism of nationalism was as inevitable as it has been in all of history everywhere, and especially in the history of the twentieth century.

In her case, though, the desired symbiosis was complicated by the fact—however interpreted and judged—that dance in India had fallen into a deep disrepute that may have had its deleterious effects on the standards of the dances that then obtained and were practised by the generality of the *Isai Vellalars*. Apart from this, there was the other fact that the *devadasi* system itself had become the object of public opprobrium for reasons that are nowadays as familiar as they are intensely contested.

What followed was an unmitigated catastrophe for the temple dance vocation and its caste-bound art, both in the shrine and to a great extent on the proscenium Sadir stage. And the first accusation levelled against Rukmini Devi is that she connived with Dr Muthulakshmi Reddy deliberately to suppress the temple tradition so that her own vision of Indian classical dance would triumph without competition.

The second criticism is that her own accomplishment, the reconstruction and redesign of the dance that became known as Bharata Natyam, was a vitiated art undeserving of genuine classical status, a thing of lesser worth than either the original *dasi attam* or the Sadir of the Tanjore Quartet still being performed as a *kacceri* and theatre entertainment by members of a corresponding *devadasi* upper echelon, including most notably Tanjore Balasaraswati.

The third is that she exploited and abused, for her own purposes, in the establishment of *Kalakshetra*, the dancers, teachers, scholars and musicians of the Sadir tradition. Again, one of the implications here is that she had a deliberate hand in the displacement of the *devadasi* system so that its practitioners would be left with no option but to labour for her own project.

The fourth aspersion is that she wrecked the true *parampara* and the hereditary local classicism of the dance by incorporating Western

balletic, Orientalist and Theosophical notions, and that she did this in order to claim the dance for the educated Western-orientated Brahmin classes and their nationalist-cosmopolitan agenda. She wrested the dance, so the claim runs, from the castes to which it had traditionally belonged, so that it could be modernized, secularized and 'sanitized.'

The fifth category of criticisms takes the form of a detailed investigation into her personal life and conduct with the aim of painting her, simplistically enough, as a deeply flawed human being: ill-tempered, intolerant, absolute, tyrannical, ruthless, cynical, and so forth. More recently, attempts have been made to expose her as financially dishonest too. We even find her being made to shoulder the blame for a series of minor scandals involving *Kalakshetra* that have occurred long after her death.

Beyond these aspersions, for my present purposes, we need not go.

It is important to note that criticisms of this kind are not only made by apologists for the *devadasi* tradition. There are other agendas and interests at play here too, and these, which deserve treatment in their own right, often converge with the *devadasi* plaint.

I want also to take into account the specific instance of the *Isai Vellalar* caste or community, who bear the most direct burden of having been collectively excluded from and humiliated during the revival period of classical dance, who suffered reputational and other losses, and who are still affected by the taint of the normative *devadasi* narrative.

In working my way towards my own conclusions, I must begin by considering the *Devadasi Act* which effectively put an end to their vocation and its rewards, and which to a great extent excluded them from the classical dance revival, which we may for purposes of convenience date from 1936, the year of *Kalakshetra's* establishment under the name of 'The International Academy of the Arts.' I don't wish to retell the whole tale, which is in any case available in numbers of writings easily accessible to interested readers.

What I intend instead is to interrogate the notion that Dr Muthulakshmi Reddy and Rukmini Devi herself were somehow complicit in a tacit but effective conspiracy of assent to destroy the *devadasi* tradition so that the *Kalakshetra* vision could triumph in its

Rukmini Devi and the Devadasi *Question*

stead. What is often ignored here is the fact that much broader and coercive historical forces were at play. The *devadasi* system, too, might very well have been a vehicle for sexual predatorship and other forms of exploitation, as well as a dance form somewhat depleted by the social rejection it underwent from the late nineteenth century through the first three decades of the twentieth.

It is difficult to see why, confronted as we are with the reality of sexual predators in the dance world today, there is at the same time such a pervasive reluctance to acknowledge the probability that hereditary *devadasi* girls were suffering the same sorts of abuse.

Of course, and fairly enough, the argument is made that it was the problem of the predators themselves rather than the *devadasi* practice that should have been addressed by the lawmakers and punished by the judiciary. But this appeal, we should bear in mind, is being made with hindsight and from a platform on which women's rights—and especially their sexual rights—are being taken much more seriously and in an affirmative atmosphere.

But beyond this there is the question of the hereditary *devadasi* system itself, in which choiceless young girls were handed over to temple functionaries and their patrons, who trained them and put them to work at a religious-ritualist vocation without further ado. Here indeed is a picture of female disempowerment that can surely not be condoned. Yet in the arguments for the *devadasi* today this deprivation of the rights of the girl-child usually goes unmentioned, even while the position of the *devadasi* as *nityasumangali* is painted for us in admittedly interesting, convincing and picturesque colours.

It is only when these two fundamental and obvious questions are honestly and meticulously answered that we can begin the task of reconsidering Dr Reddy's motives—recalling that her mother stemmed from an hereditary *devadasi* family herself—and how and why they would have been taken up for intensive consideration by Rukmini Devi when she undertook her project. After all, they posed both a challenge and a threat to her vision, and it is of some significance to recall that she herself sought Reddy's explicit approval for her work at *Kalakshetra*. We must recall also that Dr Reddy had met with Rukmini Devi's mother in 1933 to advise her to put a stop to her daughter's intention to study Sadir under *Isai Vellalar* teachers.

The entire saga of the movement to abolish the *devadasi* system that culminated in the *Devadasi Prevention of Dedication Act of 1947* (implemented in January 1948) is a long and tortuous one, vexed by simplistic and partial opinions. It stretches over a period of some eighty years and involves a nexus of political, bureaucratic, social and artistic activity that is nowhere near as simple as the assigning of blame to 'Victorian puritanism' or a Brahmin upper class imbued with Western moral tropes. Moreover, it is a controversy which played itself out mainly in Tamil Nadu and Andhra Pradesh, where the temple dance tradition was omnipresent and entrenched. Other states of India, such as Delhi, Maharashtra and Odisha were affected, but the heart of the tragedy was enacted in Tamil Nadu and Madhya, and especially in and around old Madras.

It was the *Madras Social Reform Association*, founded in 1892, that moved the Governor General and the Governor to take action against the *devadasis* for the unwholesome role they were perceived as playing in 'dance parties' for the elites. When, in 1894, the Governor General returned an unfavourable response to its petition, a local public outcry ensued and was taken up in the regional press.

M. Ramachandran, secretary of the Arya Mission, published pamphlets against the 'debauchery' of the *devadasi* system as early as 1910. Rukmini Devi was at this time only six years old. In 1912, the *Protection of Women and Girls Bill* was moved with little effect, and this was the case also with the 1913 bill 'to prevent dedication of girls under sixteen' (later amended to 'under eighteen'). Many other bills were proposed in the twenty-year period before we first hear of Dr Reddy's involvement in the 1920s. These were all aimed at preventing the dedication of girl-children, often adopted by *devadasis* for the purpose of ensuring perpetuation of their land grants and general *inam*, which would otherwise have expired with the end of their service. In fact, it was a bill devised by Reddy (the *Religious Endowment Act of 1926*) that allowed the *devadasis* to retain their *inam* without the need to dedicate girl-child successors. It would seem then that the main purpose of the many forms of social activism taking place was really to halt the perpetuation of a system that demanded the ongoing religious trade in the girl-child. This motive becomes even clearer when we bear in mind that the actions taken against the *devadasi* vocation formed part of a larger movement of reform, which included the addressing of

Rukmini Devi and the Devadasi *Question*

prostitution, child marriage, the remarriage of widows, *sati*, 'dedication of girls to idols' and 'use of girls for immoral purposes.' Today we would think of it as social activism for the rights of the woman and the girl-child.

In addition, laws were being enacted that aimed at the curtailment of the customary autonomy enjoyed by priests and temple functionaries. The net of social activism and proposed legislation in which the *devadasis* were swept up was therefore one that covered a broad expanse of local reformist agendas, including that of the Self-Respect Movement espoused by Muvalur Ramamirthammal, herself of *devadasi* stock. Her *anti-devadasi* novel, *Web of Deceit*, paints a dismal picture of the moral life and social influence of the temple- and *kacceri*-dancer of those years. The same attitude is seen in the work of other insider abolitionist activists, such as Yamini Purnatilakam, in the same period.

The question becomes more complicated in that there existed an elite sector among the *devadasis* themselves, a group whose prowess, locality (usually urban) and situation in life (family background and connections) ensured for them a level of patronage that might keep them above the depredations suffered by their less privileged sisters. It is usually with these more elevated members of the hereditary caste in mind—dancers in the position of Mylapore Gauri Ammal—that the attacks on Dr Reddy and Rukmini Devi are carried on by activists and critical historians.

We should also note that the elite sector must further be divided into those dancers who danced for the temples and those whose performances were staged for the secular elites, traditionally the local royal courts. These it is to whom the *Madras Social Reform Association* probably referred in its complaints against the 'dance parties.'

The same principle applies to questions regarding the quality of the *dasi attam* itself. It may be that the higher echelons of the *devadasi* community had better access to capable teachers while the majority performed the temple dances at a lower level of proficiency. If this was the case it would provide a plausible explanation for Rukmini Devi's assertion that the technical qualities of the dance had been degraded and stood in need of regeneration of standards, codification and presentation.

However that may be, and reverting to the more important point, we must note that the agitations around the problem of the *nautch* had been current for at least thirty years by the time she was born in 1904 (if we date the process from 1873 when the Governor General in Council decided to put a stop to the 'dedication of girls to idols'). She grew up while the anti-*devadasi* mindset was being decisively cemented, and was only twenty-two years old when Dr Reddy began to tackle the problem in earnest. It seems wrongheaded, then, to place Rukmini Devi in any sort of position of connivance. The cultural and social climate in which she was raised would have settled the question for her by the time she was a young woman, and her Theosophist parents would have driven the matter home.

I would think rather that it says much for her independent character that, in spite of the air of moral decline attached, whether scurrilously or not, to the dance in her formative years, she should nevertheless have taken it up in 1933, receiving lessons from hereditary *devadasi* teachers despite exposing herself to further criticism on the back of the scandal of her early marriage to George Arundale. Besides this apparently unwise step, she worked closely with E. Krishna Iyer to explore the Sadir dance as it then existed, to applaud the best exponents (including T. Balasaraswati) and to employ teachers, musicians and dancers from the lineage when she established, at the age of thirty-two, the dance-and-arts-orientated school that a little later was named *Kalakshetra*.

It seems plausible to conclude that her decision to rescue the dance from the crisis in which it then found itself could be carried out in no other way than the one she was coerced by historical factors and the prevailing moral mindset to adopt.

As one starting point for debating the situation in which she found herself, we may use the profile recorded on the programme for the *All India Dance Festival* of 1945:

Rukmini Devi has regenerated this art and rescued it from degradation and virtual extinction and restored it to its pristine beauty by permeating it with a religious and devotional spirit ... and has rescued it from all monopolies, especially as regards teaching and conducting.

Rukmini Devi and the Devadasi *Question* 283

Though this does read like a piece of heavy-handed propaganda, it is probably fair to say that it was a necessary form of justification for the suspect work she was carrying out. The public, and especially the upper classes, would have needed this kind of reassurance, not only in order to justify their attending the dance performances but also to convince them to allow their own daughters to dance.

These considerations formed a large part of Rukmini Devi's vision. It is hard for us to understand today the power of the stigma that was attached to dance in India. But if we can begin to grasp it, we can also see how difficult was the situation in which she found herself. Her own ambition was not only to make dance accessible to all girls (and boys) as the core-component of a wider, liberal, arts-centred education, but also to bring it to secular audiences throughout India and across the world. It would therefore obviously have needed to be freed from the moral obloquy then attaching to it.

We have to be careful here of a tendency to give credence to the idea of a *devadasi* 'Golden Age' that was destroyed by the dance revivalists working consciously and insidiously in concert with the moral reform agendas of the day. In the first place, as I have already pointed out, the social reformist antipathy to the *devadasi* system was already a *fait accompli* by the time *Kalakshetra* was founded. Second, the grand era of the *devadasis* had gone into decline by the late 19th century—so that the notion of the dance having 'degenerated' may well not be an implausible one. To speak of its 'virtual extinction' also makes sense when we take into account the extent to which it must have been enfeebled and its communities ostracized by 1945, only three years before the *Prohibition of Dedication Act* was passed into law.

It must have seemed necessary to Rukmini Devi, as politic in her nature as she was both shrewd and determined, to create a completely new discourse around the whole conception of Indian dance, which she saw could only be re-established not as a religious ritual but as a secular, public art with a 'religious and devotional spirit.' Hence, too, her famous argument with Balasaraswati over the *sringara* element.

In this regard, curiously enough, it is Douglas M. Knight, Balasaraswati's biographer and son-in-law himself, who tells us that

284 ESSAYS ON CLASSICAL INDIAN DANCE

> Bala's outspoken criticism of carnality in *sringara rasa* ... had been
> a matter of record by the 1930s

and that

> If Bala objected to the carnality in *sringara* of *most dasi* dancers,
> she was equally against puritanical and artistically impoverished
> Brahmin dance. (My italics)

We have only to ask ourselves what is meant in this case by 'carnality,' and then to apply the epithet to 'most' *dasi* dancers. Today such an approach would seem risibly narrow but in 1945 these moral aspects would obviously have weighed heavily with the cultivated Indian public for whom Bharata Natyam must become acceptable if it was to be widely appreciated and practised throughout the whole country and among all its various communities.

The claim to have returned the dance to 'its pristine purity by permeating it with a religious and devotional spirit' is possibly best understood by placing the stress on 'spirit.' Given her stated aversion to ritualistic religion, one can see what might have been meant. Her views on Shiva Nataraja would almost certainly have been aligned with those of Ananda Coomaraswamy. They placed Chidambaram as a symbol for the centre of the universe and made the Orientalist conception of Shiva available as a source of spiritual impulse and insight to a globalized human fraternity. This sort of approach to spiritual 'purity' would have appealed to her strong Theosophical convictions.

The claim to have rescued the dance 'from all monopolies, especially as regards teaching and conducting' is a particularly interesting and telling one. Knight's comment that her

> reference to monopolies was perhaps directed at the *nattuvanar*
> teachers at *Kalakshetra* from whom she wrested control of teaching
> and conducting concerts, which she then placed in the hands of
> non-hereditary teachers of music and dance, including herself

seems to me a rather disingenuous deflection.

Rukmini Devi and the Devadasi Question

It is after all common knowledge that the hereditary teachers were on the whole averse to transmitting their caste-bound knowledge to outsiders. They would surely have been even more inclined to resist such teaching when it entailed changes to the technical and aesthetic qualities of the kind envisaged by Rukmini Devi.

I don't want to enter into the forbidding complexities of caste relationships here, but it is on record that the *Isai Vellalars* were reluctant to universalize their hereditary art. And this, from their point of view at the time, is surely understandable too. But what choice would have been left to Rukmini Devi in this case but to 'wrest control' from the community whose inward-looking parochial traditionalism was so much at odds with her own universalizing vision?

In saying this I don't mean to imply that a battle for control at *Kakakshetra* did not occur. It did. Nor would I want to leave unemphasized the fact that she herself, as well as her early *Kalakshetra* students, were taught by hereditary teachers. I am only concerned with making a plausible case for the very different vision espoused and instituted by her at *Kalakshetra* and the traditional practice of the hereditary dance establishment: the one traditionally localized and ritualist, the other global and secular. The struggle was not so much for competing interests as for competing world-views.

That Rukmini Devi's attitude to dance in India was not directed at wholesale dominance is evidenced in the fact that so far from inhibiting she actually encouraged the emergence of the regional classical forms that we know today. Even though it is true that she disparaged Odissi when she first encountered it, we also know that she was willing to teach Sanjukta Panigrahi. More tellingly, she extended extraordinarily cordial treatment to Mayadhar Raut, one of the leading Odissi gurus, during the years he spent studying at *Kalakshetra*. By that time *Kala Vikas Kendra* had already been established to design and teach the reconstructed Odissi form. Her control over the development and spread of Bharata Natyam was largely limited to the situation as it obtained in Tamil Nadu.

Rather than that of a cynical tyrant of the Indian dance world, the picture that confronts me is one of a determined, ambitious and powerful woman who did not disdain politics to achieve the ends she had in mind when she first set out to revitalize, reform and make

universally accessible the art to which she devoted the remainder of her life.

That her vision was a deeply personal one can however not be doubted, and to that extent it was bound to clash with those of a variety of opponents and detractors. So far as the history of this kind of renewal goes, the traits of the individuals who bring it about evince a good deal of similarity. They are single-minded, dedicated and rather 'tough' specimens, uncompromising, perfectionist and often intolerant of differing views, a strange mingling of the genuinely altruistic and the unselfcritically egotistical.

Those who record their memories of Rukmini Devi often and usually inadvertently allude to her tenderness and kindness only after hinting at a tendency in her to a severe and unforgiving stringency. She was certainly demanding and headstrong, and the record shows little evidence of self-doubt. But these qualities, again, seem inherent and even necessary to radical cultural and artistic visionaries.

It is probably owing to these same traits that, until the end of her life, she seemed incapable and uninterested in showing any remorse at the tragedy that had befallen the hereditary dance community, and in which she had played the role of unprotesting affirmer of the *status quo*.

While the *devadasi* community suffered outright dismantling and outlawing of their hereditary vocation, including its remunerations and perquisites, the hereditary artists working outside the temples became the objects of public suspicion and legislated prejudice. It is recorded that some *Isai Vellalar* teachers had to obtain police clearances in order to conduct their profession, and that they were forced to display notices on their premises declaring that they were not involved in the coaching of prostitutes.

Encumbered by demeaning obstacles of this kind, it is self-evident that they would not have enjoyed much patronage, and we know that most of them lived and laboured at their art in penury. I am reliably assured, too, that the contempt and antipathy shown towards them by the public and especially by the reformed dance community had not abated by the 1980s. Gurus who had received their training in the hereditary tradition rather than at *Kalakshetra* had to keep the fact to themselves or risk being ostracized afresh. It is a dismally unjust picture.

Yet Rukmini Devi, who must have been intimately acquainted with their circumstances, kept steadily silent about these injustices and, so far as is known, never did try to right them or even to speak up on behalf of her fellow artists. Her culpability in this regard seems even more egregious when we recall, as I have said, that it was teachers from this community who taught her to dance and who later imparted their inherited knowledge to her early students at *Kalakshetra*. Without them, indeed, *Kalakshetra* could never have been brought into existence.

From the point of view, then, of personal morality, we can hardly exonerate her on this score—especially when we bear in mind that, two years before her death, she did not oppose in a BBC interview a commentator's statement that 80% of the *devadasis* were prostitutes. This calls to mind echoes of Muthulakshmi Reddy's infamous and rather hysterical *riposte* that, 'out of a 1000 *devadasis*, 999 were prostitutes and one the mistress of a married man.'

The most we can do is try to understand the position in which she perceived herself and her project to be at the time when these injustices were being perpetrated. If she did not act or speak against them, why was this the case?

Any number of reasons can be proposed here but not without the qualifying reminder that she was in no way morally deficient in the ordinary sense. On the contrary, she had an extremely articulate awareness of justice and charity and sct very high standards of discipline and duty for herself. Her many socially-engaged and private kindnesses are a matter of record, but so are her intolerance of slackened standards and the extreme demands she made on those who worked and danced for her. One remembers how she could never forgive a certain girl who had not properly tied her ankle-bells, which almost came off during her performance. Years later she was still berating the unfortunate offender (it was Shanta Dhananjayan): 'How *could* you have done that?'

For my own part, I am not disposed to find reasons in public for defending her so far as the *devadasi* question goes. I only want to examine the single possibility that the vision she had so carefully and meticulously fostered during half a century of forceful activity had become for her larger than any moral blame which, though suppressed, it must have carried within itself.

Her claim to have rescued the dance from degradation (which had its own historical truth) could not be seen to have been achieved on the basis some other moral failure, some other form of degradation. Like most great visionaries she harboured a large blind-spot which she turned towards any counter-narratives that might stain the total achievement. To her, the humiliation and displacement of the *devadasis* and hereditary artists was simply the result of the historical situation into which, through no fault of her own ambition, they had allowed themselves to decline. In order to keep *Kalakshetra* and everything it was conceived to represent blamelessly alive, this single ongoing act of expedient ignorance was unavoidable.

Apart from this there is the other possibility, that the dance as we know it today, in the ways in which it is open to evolution and freely accessible to all who want to practice and appreciate it, is to a great extent present to us as a result of her efforts, her blind-spot notwithstanding.

It is at any rate staggering to consider what she accomplished in the light of the small beginnings she made in 1936, when she founded not much more than the idea of her 'International Academy of the Arts,' and gave the following address to those present on the occasion:

This is an informal meeting of what for the present we are calling the 'International Academy of the Arts.' Possibly we may find a better name for it afterwards. Our objects will be:

(1) to emphasize the essential unity of all true Art.
(2) to work for the recognition of the Arts as inherent in effective individual, national and religious growth.

For the time being we shall have no formal organisation, as we want to begin in a small way, so that as we work we may sense the lines along which we should develop. The spirit within all our work will be to reflect as best we can Art as a pure power of Divine Nature, God in His Aspect of Beauty.

I feel particularly happy that we are inaugurating this movement on a day sacred to Nataraja, the Eternal Lord of the Dance, the Lord of Divine Rhythm, to whom I offer whatever I can give.

35

A Note on *Sringara Rasa*

Most *rasikas*, when speaking about *sringara rasa*, will strike out in the direction of the sublimation of the erotic or some such phrase. Then, when you ask them to explain what they mean, you find they hardly know, or do not know at all, because the phrase has become not much more than a convenient escape route from the threatening notion of *sringara* itself.

This, I surmise, is generally the case because *sringara* can't with any conviction be reduced to a theorem which is 'safe.' Insofar as a theory of *sringara* pretends to exist, it doesn't exist with the mathematical inevitability that is able to dissociate it from the person. Which is to say that the reason why *sringara* is usually such an uncomfortable topic is precisely because it's such a personal one. If you have a theory about it that you accept absolutely, the odds are you probably haven't experienced it. The strange corollary to this point of view is that *sringara* says much more about the person experiencing it than about the *bhava-abhinaya* which evokes its *rasa*. In that sense, which is the simplest and most basic one, it stands as a path to self-knowledge as distinct from knowledge of some other kind.

In taking a view on *sringara* myself, I can't of course steer clear of instigating a theory of my own. But, in so doing, and in thus inadvertently casting some light on my own body-mind continuum,

Essays on Classical Indian Dance
Donovan Roebert
Text copyright © 2021 Donovan Roebert / Photographs copyright © 2021 Arun Kumar
ISBN 978-981-4877-47-3 (Hardcover), 978-1-003-12113-8 (eBook)
www.jennystanford.com

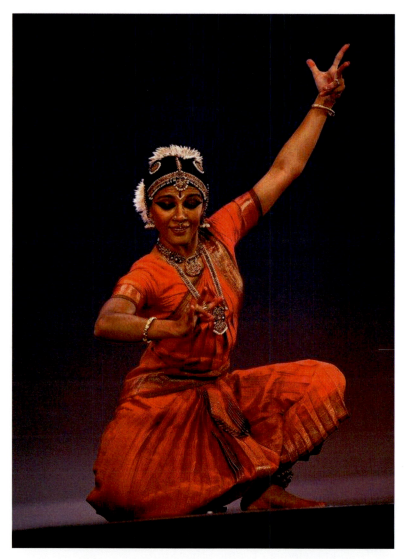

35. Aparna Ramaswamy, Bharatanatyam dancer and Co-Artistic Director, Ragamala Dance Company, Minneapolis.

I propose to allow my theory to grow out of a concrete soil. That soil self-evidently can only be the corporeal dancing body.

 I don't want to go into detail here about all the major and minor limbs put to artistic-philosophical use in the course of a classical Indian dance recital. I'll confine myself only to muttering such truisms

A *Note on* Sringara Rasa 291

as that every physiological aspect of the *abhinaya* technique must be constrained to a perfect pitch of harmony—from the dancing feet to the dancing eyebrows—if the pure sensibility of the purely erotic is to be provoked into an inward manifestation leading to epiphany. But here of course, in resorting to such terminology, the old worn-out idea of sublimation raises its head concurrently—as it must, but only as a preliminary, a somewhat tedious concept to be borne in mind subjunctively until, at the end, it may perhaps be surprised into clarity.

Returning then to the more technical-experiential question of the compound dancing body-in-motion in pitch-perfect harmony, I must acknowledge at once that the only measure of this harmony that I am able to trust is the extent to which it persists as memory. Its memorableness, that is to say, is directly proportionate to its exquisiteness. If the dancing body in question doesn't linger dancing in memory, it hasn't the power to elicit a genuine *sringara rasa* any more than an unmemorable perfume is likely to awaken a justly associated moment of sentiment-thought. *Sringara rasa* that doesn't linger long can't fulfill its function as a growth-inducing given, which function is neither more nor less than the provision of acute insight into its own nature.

Speaking again in a corporeal-technical vein, I note that no dancing body can ever be memorable to a sufficient degree if it is not dancing alone, if it moves through too much space, and if it dances for too long a time. Multiple dancers, spacious trajectories and rhythms too-long repeated scatter concentration and as such become obstacles to meditative retention of the mental object. The single and unified, the oneness-of-particulate-parts, is a necessary harbinger of the degree of serenity in which *sringara rasa* is awakened, because *sringara* and excitement are in fact incompatible. *Sringara* is not an arousal but an awakening.

Moreover, the single embodying body of the solo dancer points to the inward unity of the *advaita* dynamic of Radha and Krishna, or Shiva and Parvati, or you and your other-gendered self. I don't want to go out on a limb here to prove again what genetics, psychology and physiognomy have already conclusively demonstrated. But I will venture the opinion that this acknowledgment, this inevitably personal recognition, provides the only authentic starting point for

the true reception of *sringara rasa*, the receiving that is fulfilled in understanding rather than only in a vaguery of flutters—that increases self-knowledge because it holds a right preliminary view of the self in mind. I say these things too in order to make clear why the dancing duet is rather a distraction from this bi-gendered monism: it splits the nuclear whole by presenting it as a twosome, as though having two eyes must somehow eventuate in a split experience of vision.

(To cast a rough light on what I mean, let me consider the relatedness of Krishna, Rukmini, Radha and Ayana. Now where marriage is concerned the matter of sexual union is part of a recurrent cycle of coming together and parting at intervals, but as this relationship bears on the *Radhamadhavan* there is no climactic instant of satisfaction followed by a return to homeostasis. There is only an infinite deferment, a ceaseless yearning whose experiential nature points to the eternally unsatisfiable because eternally unknowable, which indeed finds its completion not in knowledge but in love, whose roots are *sringara*-roots. The essence of bliss is the tantalus, ever incomplete because ever withholding the climax that is in itself a spasm of delusion.)

The solo dancing body also informs us that the love-tryst and its intimate delights occur within a single psychosomatic continuum. This is true even when the lovers are two. We, the *rasikas*, can never be convinced to encounter these love-intimations and intimacies when two or more dancers are enacting them. What we see in that case are only two lovers existing for each other in external space, which is not *sringara* but, in the final analysis, eroticism, no matter how subtle its aesthetic flavour.

The extended use of space in balletic mode, apart from stretching the principle of unity to its tearing point, at the same time draws us away and outside of the confined inner chamber—we may call it the sanctum if we like—in which the sweet spot of the *sringara*-tryst is located. It removes the eyes from their focal point, which is the dancing body, dispersing their gaze across the utilized area instead, chewing at the air around the bread. It is the dancer and not the *rasika*-eyes that are supposed to be dancing in a *sringara*-orientated recital.

A dance too-long protracted, rhythms and forms too-often repeated, dull the receiving body-mind continuum which their shorter duration is designed to whet. The *sringara-citta* is awakened only to be

lulled into slumber again, a relapse into nebulousness of the almost-illumined mind. What has been subtilized to a tenuous visceral moment of insight thickens again to mere observation.

These constraining factors together with the physical proportionality-through-control of which I have spoken above create the pressurizing dynamic by means of which *sringara* is compelled to enter through the *rasika's* eyes and ears. But only if those eyes and ears are open.

And what then? How is one to analyze and state the purely affective which, like the tantalus itself, simultaneously shows its meanings and hides them from the deadening intrusion of discursive thinking? So that, even pondering it in the aftermath, in the effulgence cast over it in memory, the affective pain continues to elude a descriptive account. Because pinning it down would be in itself both a deceit and a factitious endpoint of the kind that belongs to the metaphor of mundane marriage.

Which is why my own allusions to *sringara rasa*, so far from involving a resort to the idea of 'sublimation,' refer rather to a re-awakened innocence, a childlike eroticism (if that can ever be the phrase), abiding unspoilt by the wiles of desire, and precursive as to essential gender. But I am speaking in metaphors only.

What I am calling unspoilt is the unspoken experience of the cosmic *Shiva-Parvati* engine at work (as necessarily it must also be in the microcosm) in the personal psyche as principle of sustenance and decay. Its recognition unvitiated by words demonstrates inwardly the rightness and singleness of its apparently competing activities: its infinite making and undoing.

We arrive, therefore, at a stasis-in-kinesis, which is not homeostasis but another thing, a still-point of dance in the very course of dancing, which would be destroyed utterly by any climactic intervention.

This monism-in-duality is brought home to us at the heart-centre as an illuminating glow, a pulsation of warmth, an at-homeness while astray among *tamaala* trees.

36

Classical Indian Dance at the Crossroads

As recently as twenty years ago classical Indian dance was still able to find wide public support and institutional means for artistic sustenance through its status as a national treasure and a major product of the national-independence-cultural syndrome. It subsisted, and grew used to subsisting, on this almost politically-favoured basis until, in the last two decades or so, while public and institutional attitudes have changed and adopted new cultural symbols for progress, the dance ecology has in this same period had to cast about for new avenues of support and artistic nourishment.

Today the search for its place, value, meaning and identity both in India and globally is reflected in any number of writings, from posts on social media to journalistic and academic articles, and it is clear from these that the most urgent and credible answers are yet to be discovered.

In this essay I would like to examine the question a little for myself in the attempt not so much to offer my own replies as to consider in one place the complicated nature of the crossroads at which classical Indian dance has arrived in recent years, and at which it still stands in something of a fluster.

Essays on Classical Indian Dance
Donovan Roebert
Text copyright © 2021 Donovan Roebert / Photographs copyright © 2021 Arun Kumar
ISBN 978-981-4877-47-3 (Hardcover), 978-1-003-12113-8 (eBook)
www.jennystanford.com

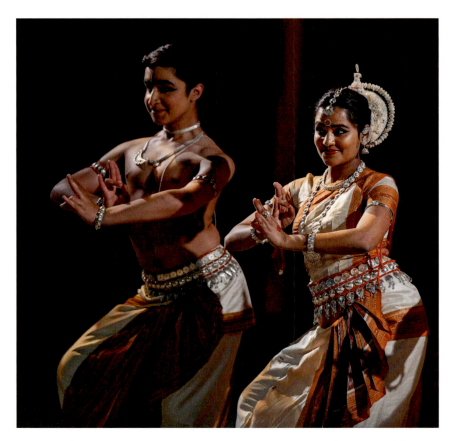

36. Akhil Joondeph and Swati Rout, Guru Shradha Ensemble, San Carlos.

The most fundamental question it has yet to answer for itself has to do with the changing nature of its religio-classical pretensions—because one of the most crucial aspects of its classicism (and therefore of its cultural centrality) has been the derivative idea of its role as preserver and disseminator of the Indian spiritual idea, as a *sadhana* and a *dharma*. In many circles this conception of the dance has been steadfastly and even a little frantically retained (as though to lose it would be to lose the life of the dance itself), but very often nowadays one comes across a variety of challenges to the notion, and these challenges are becoming more vociferous as the spiritual idea itself is interrogated under the many rubrics of postmodern socio-cultural thought and activism.

Classical Indian Dance at the Crossroads 297

The religious idea, in a dance community increasingly aware of insidious and invidious power-relations, and in which feminism, gay rights and a number of other 'social justice' priorities are being articulated, is coming more and more to be associated with such concretely domineering forces as the 'patriarchy' and its institutional and cultural instruments, including the overarching religio-philosophical superstructure which these have always taken for granted. According to the more socially-aware section of the dance community, if dance is to transmit a religious impulse, it should at least be an impulse not contaminated by traditional forms of religious oppression.

(One recalls here Rukmini Devi's assertion that the 'almost inhuman treatment' of Sita by Ram must have been a later and corrupt insertion into the body of the *Ramayana*. One thinks also of Debaprasad Das's replacement of the Jagannath idol on the proscenium by an entity much more abstract and religiously ambivalent. I mention these two instances as illustrative of revisionist leanings that have already been seeded decades ago.)

Apart from these considerations, but strongly related to them, there is the matter of the visibly growing rift between hereditary and non-hereditary practitioners. The question of the role of the *devadasi* is, I think justly, being manoeuvred to the foreground again today. In being re-represented to us now as an aboriginally religious art form unrighteously persecuted out of existence, it raises the concomitant and challenging question whether the dancers and dance forms of revivalist classicism have any just grounds for pretending to be staging dances that have any real spiritual legitimacy—and efficacy.

It is a vexed question and one whose intricacies can't be gone into here. Yet it does seem to many an issue that demands both social and academic attention. At the heart of it lies the unhappy sense that dancers from the secular schools have really no right to appropriate to themselves the original religious idea which properly belongs to those born or adopted to the tradition and from whom it was forcibly wrested during the anti-*nautch* period. It seems to some, indeed, that the offertory opening movements on the proscenium stage amount to little more than a formal mockery of what once was a living tradition.

It is the case, fortunately, that a small number of practitioners and scholar-practitioners have expended the labour necessary to rescue the

devadasi dances from complete extinction, and that the religious idea in the hereditary dance community has been kept alive by hereditary dancers too. The total loss of these pure forms, their replacement by revivalist styles and approaches, would of course have been catastrophic. The question at the crossroads is whether these earlier, purer practices will prove durable and sustainable in the long run.

But this is a question that holds good for the revivalist and other classical *gharanas* too. In fact it seems to me that the religious idea and its transmission in 'secular' performances has already become a matter of formality only, especially to the majority of audiences and critics whose focus in the main is on technique, and often on novelty in technique and staging. The *rupa* of Shiva or Krishna or Jagannath on the stage has become largely a prop for the inducement of a certain quasi-religious warmth and the sentimental homeliness of mere tradition.

One of the more obvious and inevitable trends both in dance theory and practice is the replacement of the religious idea by one that intends to play a social role. Here immediately we come up against the multiplicity and intersectionality of these roles in the fragmented atmosphere of the rapid aggregation of postmodern virtues and values. Yet still the intention does lend to the dance a purpose that goes beyond the idea of art for art's or beauty's sake. The beauties of the dance are not considered sufficient (as in the history of classical Indian dance they never have been) to justify its retention as a *dharmic* art.

If, as seems likely, the spiritual element eventually comes to be replaced by other, more pressing and more immediately meaningful symbols vivified through dance, this will happen not only because the religious myth has been displaced by more socially just and needful-seeming concerns.

It will happen also on account of the fact that the revivalist mythology has itself been exposed and discarded. Together with this exposure and the willingness to acknowledge the concrete historical facts, all sorts of possibilities for monopoly have been eroded, a process that has resulted in dance being taught at schools and universities, outside of the *guru-shishya parampara* and without its air of sacred transmission and religious bondedness.

Classical Indian Dance at the Crossroads 299

With the gradual or even partial rejection of this line of teaching and reception the world of dance becomes naturally more open to purely secular expressions and usages, and these in their turn are informed by the more liberal, less reverent, mindset of the postmodern academy. This mutation may yet prove one of the most promising (or destructive) crossroads that classical dance will negotiate in the next decade or so.

The palpable shifts experienced in the last two decades by dance in relation to the religious idea will no doubt leave a deep impress on the kind of classicism, and the fundamental conception of it, that we will know in decades to come. Because a religious idea does not secularize itself without losing its religious nature.

Perhaps we shall see at least three forms of classicism emerging as these shifts and conflicts yield traceable results:

1. A re-quickened and rekindled hereditary dance form replete with its traditional spiritual life and transmission.
2. A variety of classical *banis* whose 'religious' element openly acknowledges and stands critically above the mythico-religious enactments it performs.
3. Something utterly new, thoroughly secular and yet classical in itself because it has firmly retained its classical codifications, philosophy and formalism.

It is the first of these possibilities that seems to me the most exciting, the most difficult to sustain in the world we inhabit, and yet ultimately the most rewarding, though this is far from implying that the others would not deserve one's love and attention to the utmost too.

Still there remains a pressing sense that the growing conflict between revivalist classicism and what I will here call 'orthodoxy' is set to intensify in years to come. In the first place, as I have said, there is a feeling among hereditary artists that the injustices done them in the 20th century have yet to be set to rights. And the restorative justice they are seeking doesn't amount only to the making of sincere formal apologies (from the directorship of such institutions as *Kalakshetra*, for instance) but also to a renewed recognition of the inherently orthodox

300 ESSAYS ON CLASSICAL INDIAN DANCE

qualities of their art. What is wanted, in other words, is a full act of restitution that restores honour both to the *Isai Vellalar* community and to the dance that had traditionally belonged to them for more than two centuries before it was disrupted by the Prevention of Dedication Act and appropriated for renewal by the revivalist movement. Over and above this, there is a demand that more public room should be made for the orthodox *dasi attam* and Sadir forms that have been shouldered out of the national and international dance scene by the engineered predominance of revivalist classicism.

There is therefore on the one hand this clamour for re-emplacement and re-empowerment of the old orthodox form, while on the other hand space and allowance are sought both for new expressions of the classical forms and for so-called 'contemporary' dance. I put this epithet in scare quotes not because it scares me but because I feel that a more apposite term is needed. 'Contemporary' means nothing more than that something is occurring in the same span of time in which something else is happening too. As a provisional designation it does have its uses but for my purposes I prefer to think of this dance as 'emergent'—which is how I shall allude to it in this essay—because the idea of a dance that is 'emerging' points not only to its newness and freshness but also raises the implicit question as to what, in terms of its artistic forms and values, it is emerging from. The answer to this question (one that is still, so far as I can tell, not only unanswered but actually unasked) will also enable us to get some idea of the direction in which 'emergent' dance is moving.

Such an analysis of affairs, at any rate, puts us before the following dance forms whose combined interactions, decisions and intrinsic artistic merits constitute the still-unsolved artistic problem at the present crossroads:

Orthodox classical
Revivalist classical
Neo-classical
Emergent

It would be untrue to contend that these four forms co-exist in harmony today. On the contrary, there is between them much bad

blood. A large portion of this fraught disharmony arises from real and perceived historical and present injustices whose revelation has been both enabled and even necessitated in the postmodern atmosphere of 'progressive restorative justice.' In this pervasive trend of the righting of historical wrongs the following sets of opposites make up the largest part of the struggle in the dance *oikumene*:

Religious—secular
Mythic—profane
Hereditary—non-hereditary
Classical—spontaneous
Traditional—novel
Parochial—global
Elitist—popular
Nepotist—merit-based
Feminist—patriarchal
Hierarchical—egalitarian
Normative—individually free
Egoless—self-expressive

I will stop here, although this list is by no means exhaustive. But even in its abbreviated form it serves to highlight the way in which forms that are purely artistic become merged with issues related to traditional versus updated moral perceptions and practices, and with matters concerning fair social relations. We should bear in mind too that 'social justice' controversies have nowadays a very marked personal dimension in which collective injustices, travelling along the trajectory of identity politics, are keenly experienced and publicized as individual (i.e. personal psychological) injuries. Hence all the 'space' made available for the expression of personal outrage, and the easy acceptance of public shaming.

It seems to me that this nexus of art and socio-individual justice is quickly and inevitably becoming the bigger part of the province of emergent dance. Over and again we see how the emerging dance forms (though strictly speaking as yet unformed, and possibly committed to remaining so) fall to depicting social evils and expressing the freedoms and rights that are supposed to counter them. The very freedoms

of emergent dance itself bespeak an outrage directed at a generality of wrongful hegemonies. This is such a big part of the new arts as a whole in the world today that I can see no reason why dance should be exempt, nor can I find honest reasons for declaiming or denigrating this trend. Nor, in the final analysis, is emergent dance bound to follow it. Its themes can be as wide, as discursive or as abstract as it eventually wants them to be. And there is no reason that I can see why it shouldn't develop its own universally spiritual symbology too. And of course it is the most appropriate means for dancing the many ways of self-expressiveness too.

Far more important, so far as emergent dance is concerned, is the need to define its own standards and criteria for critical judgment. Of course the claim could be made that a dance form liberated from the classical and the orthodox stands beyond critiques that rely on codes and standards for the assessment of artistic quality. But such an argument could quickly be run to ground in a simple *reductio ad absurdum*: if no criteria are brought to bear, then any and all physical movement becomes presentable dance.

This need of standards holds good too for the new forms of experimental and innovative classicism that we encounter more and more frequently among the classical dance schools and independent musicians, dancers and choreographers. One of the keynotes here is the fusion of classical styles and *banis*, as well as the adoption and reworking of balletic themes and techniques. These again, as I see it, pose no dangers to the conservation of the classical and the orthodox as long as the latter continue to insist on strict classical purity in teaching and practice.

The point being that there really is no call for any one of these types of dance to exert critical or clique pressure on any of the others, the more so as they will naturally continue to exist whether or not they dislike and seek to impede one another. The real issue at hand is not whether they can safely co-exist but whether they might not all exist more easily without the ongoing disruptive tremors of internecine conflict.

We are led then by what has been said to the acknowledgment that fractures in the dance world are present both to its inward and to its outward aspects. Dancers and dance forms at odds with one another

and within their own communities are also in many respects at odds with the immediate and global environment in which they dance.

These outward-directed conflicts involve matters as divergent as being paid decent fees for their work and being treated fairly by their peers and critics, as well as more far-reaching squabbles such as the poppycock of so-called 'cultural appropriation' by non-Indian dancers across the world. And there is the far more grave and heinous matter of sexual exploitation and abuse.

But rather than seeking to list all these problems (which will in any case be clear enough to dancers themselves), I would like to suggest that none of them can be either fully addressed or adequately solved until the fissures within the dance community itself are remedied and healed at every level, from the artistic to the social and the individual. In saying this I am not at all inclined to believe in a possible paradise in the dance community. That would be ridiculous, even to someone far less cynical than I am. It is harder than ever in the postmodern *milieu* for 'issues' to be resolved in ways that satisfy every complainant and every emerging victim. But there must surely be many practical and politic means for making it easier to arrive at a communal *modus vivendi*.

Which brings me back to my starting point: the religious idea in Indian dance. It is in the first place an idea that seeks oneness through the overcoming of ego, and many dancers frequently speak in this language. Now whether this idea is understood as one that is either spiritual, philosophical, moral, social or psychological—or as a combination of all of these—it is surely an idea that should be permeating the ecological organization of the dance community to a far greater extent than it actually does: to the extent, at least, that tolerance prevails.

Only then, as I see it, will there be clear evidence of discernible lines of progress in the several forms of the art itself. A community of artists embattled and confused as to its own standards and vision confuses the public and leaves the formation of critical taste in disarray. It emanates an infectious *rasa* of indifference to the health and status of the dance.

37

On Filming Classical Indian Dance

If I have claimed in other essays only to be clarifying the obvious on my own behalf, I must make that claim with especial emphasis in this case. The points I will be making should, it seems to me, be self-evident to all camera-persons filming dance and to all dancers being filmed. And yet, when it comes to watching filmed dances, these simple factors seem almost always to be ignored, nor does one readily come across articles that speak about them.

I propose to discuss here some of these practical and technical points, if only to make them seem more obvious than they actually are. And I will go on to ponder a little some other aspects of the subject, having to do with standards.

In starting out it is necessary to distinguish between live performances that are being filmed and recitals that are presented only for the camera. It is clear that to a large extent the camera-person filming a staged performance has little choice as touching such elements as stage design, lighting, sets and the use of space. They must be taken as they are found and the best possible use made of them. But even in this case film-makers have at least full control over their own cameras and editing.

They can prohibit themselves from employing such devices as split-screen and screen-insert techniques, for instance. These are

Essays on Classical Indian Dance
Donovan Roebert
Text copyright © 2021 Donovan Roebert / Photographs copyright © 2021 Arun Kumar
ISBN 978-981-4877-47-3 (Hardcover), 978-1-003-12113-8 (eBook)
www.jennystanford.com

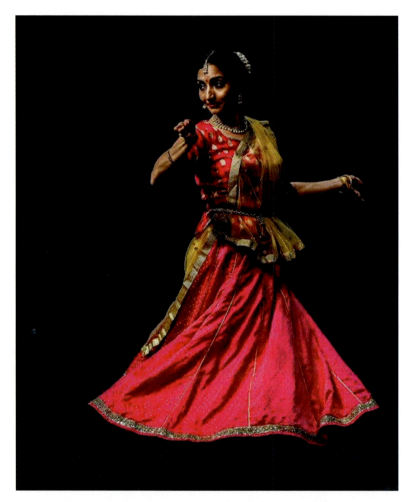

37. Tanu Sharma, Gurukul Kathak Dance Academy, Cary.

not only a waste of effort and a distraction from the dancer to boot, but they are also faintly absurd. We do not want to see the dancer from multiple angles simultaneously; neither do we want to view her footwork or facial *abhinaya* in an insert occupying one corner of the screen while the full or truncated dancing body dances as it were to avoid the insert.

There is no need to zoom into or out from the dancing body. It is not necessary to offer to the *rasika* a closer picture of the dancer from the waist up while the feet or eyes are dancing alone in an upper or

lower corner. There is no need for this because the filmed performance is not for a single public viewing, as it would be in the cinema. There is no rush to cram it all in. Filmed dances are for home viewing, or for viewing by selected groups, on the computer or television screen in an intimate environment. The DVD or other recording device is available for repeated viewing, and the *rasika* who wants to consider the several aspects of the dance separately can do so by concentrating on the footwork in one screening, on the *charis* in the next, on the facial *abhinaya* on a subsequent occasion, and so forth. There is no need for the camera to dance. That work is best left to the dancer, and to the *rasika's* eyes.

Dance should be filmed by a static camera, holding the dancing body as tightly framed as possible, with due allowance made for the maximum of space that the dancer intends to occupy. In dance specifically performed for the camera these dimensions can easily be ascertained and set beforehand. There is therefore no good reason why the camera-person should move, or move the lens, during filming. Creative filming uncreates the dance.

On the other hand, every effort at precision should be made when it comes to crispness of focus, staging, backdrop and lighting. Here, too, misdirected creative intentions leave the dance stranded amid experimental techniques whose real work ought to be to exhibit it for its own sake, to make it stand forth, to capture and depict it as fully and concretely as possible, and with no distracting or diminishing factors. We do not want a *chiaroscuro* dance recital, or one that expires at each changing of the light-colour, or that waxes and wanes with alternating intensities of light and shadow.

So far as lighting goes, both the dancer and the *rasika* should surely be content with a fresh, cool, definitive light whose function should amount to nothing more than the presentation of the dancing body as distinctly and roundly and vividly as possible. A clean, illuminating and constant light should be the basic rule. Of course this can be beautifully achieved, when possible, by filming the dance outdoors, on a platform in a garden or even, as I have seen it successfully done, with an urban backdrop—on a flat rooftop, say, or in a quiet street.

Filmed dance becomes too cluttered when there are too many props on the stage. Ideally, there should not be much more to film than

the dancer and perhaps a single icon or statue, itself kept as undramatic and unobtrusive as possible. The rule here is that it is the dancer that interests us, not only in the first place, but as the sole occupant of the whole of our attention.

This is why there is really no need of a decorative backdrop either. What works as theatre, as an holistic theatrical performance, becomes merely overdone when filmed, unless the whole has been particularly designed for filming. The backdrop, then, should be as nondescript but also as tranquil and revealing as an uncomplicated sky behind a beautiful bird in flight.

(I would like to admit here to a pointed contempt for advertisers who think it a good idea to park their hoardings behind the dancer. Not only are they insulting the dancer and the art of dance by gesticulating obscenely at their backs, they are also sticking their tongues out at the *rasika* even as they aspire to hawk their wares to him. Sponsoring the dance does not grant the right to obtrude on its space and impede its *rasa*.)

The exceptions in the case of backdrops or stage sets are naturally occurring features or background scenery that just happen to be there without intruding. Trees, flowerbeds, shrubs, mountains, as well as buildings, houses, temples or what-not, will not detract from the dance if their presence is an innocent one. The point is to avoid any misguided attempt, by means of background items, to decorate and in so doing to enhance the presentation of the dance. Nothing serves to enhance the dance save the quality of the dance itself. Dancers who deliberately place themselves against the backdrop of the ocean, for instance, are always guilty of an error of taste. What is contrived will seem contrived, and it is usually a distraction too.

I don't believe that it is a good idea to film a dance sequence having more than two or three dancers. Even on the stage at a live performance such extravaganzas, while they may amaze one's theatrical faculties, don't generally conduce to an appreciation of the dance as dance. The ideal is, and for a long time has been, the solo dancer not using extensive space but rather filling out time with rhythm, pattern and expression.

Filming her or him should not prove demanding or even, in monetary terms, expensive. The camera-person should have little else

to do than properly to set up the filming equipment and let the dance unfold in its clear, unimpeded, immobile eye.

What is wanted is a solid frame within which the full dancing body, from some way below the feet to some way above the head, has perfect freedom to execute its steps. The camera, as I have said, should not have to follow the dancer as if it were the *rasika*. The camera is not the *rasika*. It is not the *rasika's* eyes. It is only the window whose curtains should be properly parted so that the whole work of the dancer can be viewed and absorbed in a well-lighted, uncluttered space.

No discussion of filming dance, however brief, would be complete without at least some mention of the dance videos and clips available on Youtube, Vimeo and other public platforms, and which are shared on social media. It is in this context that the question of standards, both of dance-filming and of dance itself, makes itself most palpably felt.

On the whole, the standards of filming are very poor indeed. Of course one knows that many of these clips are posted by dancers who have nothing better at their disposal than a cellphone camera and a friend willing to wield it. And I could not possibly bring myself to chide these often heedless enterprises. Many of them, indeed, turn out lovely in spite of themselves, like children with unwashed faces. Some are very well done, and there are others whose quality surprises. But the fact remains that most are rather shoddy and do disservice both to the dancer and to the propagation and appreciation of dance.

Even as someone who usually has an axe to grind with the artistic taste of the academy, I would still suggest that some way should be found for collecting and identifying dance clips of high quality. These should be made available in a place where their high standards have been noted and approved. Perhaps this is a task for a group of dance critics who might award accomplished dance-clips with a tag of approval. This sort of thing would make it easier for all those among us who don't have hours for searching through the dross to alight on a gem only every few days or weeks. And it would be a place to which newcomers to the dance could be directed to see the best of it.

This brings me, finally, to the optimum duration of a dance clip. How long or how short should it be to qualify as genuine example of classical Indian dance?

I would say at once that it should ideally represent at least the complete form of its item in the repertoire. A clipped *tillana* or *moksha* is like a song cut short in mid-bar. It cannot possibly satisfy. But even worse is the clip that is edited to move on brokenly from one bit of sequence to another.

But at the same time one understands that there are constraints and one is grateful for even this much. It puts dance readily at one's disposal, and the real *rasika's* patience is not easily exhausted. Mining the Youtube field will yield its treasures if scanned with diligence and love.

But only let the dancers and filmers make it easier for us. After all, as I have tried to show, it is not as difficult as all that to film the dance. An interested and dedicated amateur could surely pull it off if the dancer insists that it be as well done as possible.

38

Rasa in Filmed Classical Indian Dance

Filmed dance seems to me an artistic entity almost entirely different from the live recital. But I don't want to revisit here arguments of the kind that were made in the early 20th century by audiences who resented the switch from live theatre to celluloid: the loss of personal intimacy, the charged group atmosphere, the elements of risk, extemporization, spontaneity, the smell of theatre paint, and so on.

Instead I want to try to consider the unit of filmed dance, of well-filmed and excellent dance, as a thing-in-itself, a presentation of the art whose chief difference from its live counterpart is found in its capturedness, its identicalness, its permanence, and its repeatability. I want to suggest that, so far as these qualities are concerned, it differs in much the same way that the printed poem differs from the single occasional oral recital.

The live recital, the unrecorded dance, the thing that by its nature occurs only once because it can never again be exactly replicated, is qualified by the fact of its living momentariness. Any pleasure or insight we can derive from it, any criticism that we can make of it, can refer only to those vital moments that will never again be captured with identical exactitude. The *rasa* we receive from it, in all its fullness

Essays on Classical Indian Dance
Donovan Roebert
Text copyright © 2021 Donovan Roebert / Photographs copyright © 2021 Arun Kumar
ISBN 978-981-4877-47-3 (Hardcover), 978-1-003-12113-8 (eBook)
www.jennystanford.com

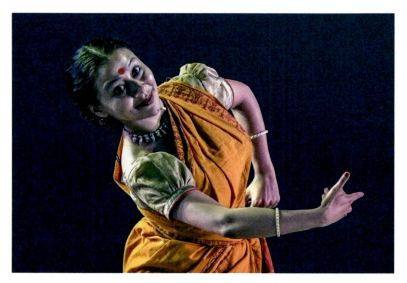

38. Kaustavi Sarkar, Asst. Prof. Department of Dance, University of North Carolina at Charlotte.

and with all its limitations (on the part both of the dancer and of the *rasika*) will be experienced in precisely that way only once, and never again. Whatever we can say about it cannot be said of a subsequent live recital by the same dancer dancing the same steps with the same *abhinaya* because these can only ever be apparently identical: they will never be exactly the same. And, for that matter, neither will the receptive capacity and mood of the attendant *rasika*.

With filmed dance the case is completely altered. What is captured on film nowadays endures permanently and is exactly replicable and infinitely repeatable, at least in theory. What we have is the poem on the page. We can re-read it as often as we wish to, and we can study and contemplate the replicated recital from as many angles, and approach it in as many states of mind, as seem possible and desirable to us. The potential for critical appreciation and the *rasika*-experience of the same recital is therefore immensely broadened and multiplied.

But it is only broadened and multiplied to the extent that a filmed recital is acknowledged to exist in a way that is fundamentally different from a live one. We can't shift between the two. We can't speak of the filmed version as though it were actually a live one in another guise. The reasons for this are obvious and I will not spend time elaborating

on them, except to make the self-evident observation that we are in this case as absent from the dancer's real presence as she is from ours. Whatever she is transmitting is arriving at second-hand through a medium which, because it is a medium, can only ever serve to *mediate* the genuine first-hand conveyance.

To say this is to admit, I think, that the dancer's *abhinaya* and *bhava*, the twin vehicles for the conveyance of *rasa*, come to us in a different way in filmed dance by reason of the interposed medium, together with its false permanence, through which they are transmitted to us. To put the matter rather baldly for the sake of impressing the point on our minds, we cannot communicate directly with the dancer, by visual, tactile or other means, even if that were ordinarily permissible or desirable, and the converse is therefore necessarily also true: the dancer cannot communicate directly with the *rasika*. Her *abhinaya* and *bhava* are to this extent, if not veiled and muted (though they probably are), coming to us by means of a two-dimensional, lifeless representation. We can watch her dance and experience its *abhinaya* and *bhava* though she herself may have died years ago.

I think it important to consider this rather morbid point because it serves to reinforce the idea of the utter absence of the real dancer who, for all the intents and purposes of the filmed sequence, is dead to us. She is dead to us in the sense that, at the very moment we are watching the film, she may be dancing elsewhere on a live stage as a live person, or in another film as yet another mediated version of her several artificial representations.

So far as her filmed *abhinaya* and *bhava* are concerned then, they can't in any way be said to rely on her dancing 'presence.' If we are thinking of anything resembling *tejas* as emanating from the film, we must surely be deceiving ourselves. Or else we must be willing to make the extreme case that films of the *devadasi attam* could efficaciously be screened in the temple for the deity and constitute in this form an acceptable service.

In the case of *abhinaya* in its four interdependent guises, *angika*, *vachika*, *aharya* and *sattvika*, we may argue, I think fairly, that these (as regards both facial and bodily-*shariraja* expression) can be reduced to formal gestures technically exactly replicable, the donning of external, artificial attitudes designed to represent, without actually being, a set of

affects or sentiments or emotions. In today's language we might think of them as very complex, subtle and nuanced 'emoticons.' Of course I don't make this comparison with the intention to demean them: my point is to show that, in the case of filmed dance, their effect does not rely on the real, living presence of the dancer behind the *abhinaya* mask. Like the printed words of the poem on the page, their part in the evocation of an apt quantum of *rasa* is not dependent on the audible voice of the poet (as it would have been before poems were committed to writing). In filmed dance, then, we can take and experience them at their full face-value, so to speak.

When it comes to *bhava*, though, there is a rather different dynamic at work. *Bhava*, in the live performance, being the complex of emotions aroused and sustained in the living person of the dancing dancer, is supposed to touch the *rasika* on precisely those grounds. The *rasika* experiences them as genuine *rasa* because they are genuinely felt and transmitted by the dancer through whose immediate presence their energies are awakened in the receiving mind. Can we speak of a similar order of *bhava* being radiated us-ward from a film in which, as I have said, the dancer cannot in any way be said to live because she may in fact be genuinely dead while the film is being absorbed?

Let us turn at this point in the investigation to two salient facts which confront the critical mind in consequence of the 'deadness' of the filmed recital. In the first place we must note that the absence of the dancer makes the *rasika*-experience a solitary one. In the live performance we should have to conclude that both dancer and *rasika* are working together at the *rasa*-project, the one travailing to convey, the other to imbibe, in a collaboration of art that conjoins them existentially for the enacting of their shared purposes. Where filmed dance is concerned, this can't possibly be the case. The living dancer is nowhere to be seen, her work in this instance has long-since been completed. She is at rest or at work elsewhere. Only the *rasika* is active now, put before what is effectively a remembered dance, a memory recorded, cut off from the moments of its living intentionality: an intention disembodied in order to be recalled, a document and a record.

The technical result of this displacement is that an elision of vital *bhava*-instants (present and active in the live performance) has

been transmuted into a juxtaposition of visual fragments, a series of photographic frames that can be isolated one from the other in a way that is inconceivable in the live rendition. The film can be paused at any point and that particular moment-in-frame studied as a unit for critical analysis, much like the stanza, or line, or even the single word, in the written poem.

What this means is that the original *bhava* felt and emitted by the filmed dancer, during the period of filming, must be both utterly absent from the film itself and, on account of its utter absence, prone to being minutely dissected as a particulate sequence of recorded physical representations lacking both quintessential vitality and the third dimension in which alone such vitality can manifest itself.

Insofar as we can in this case speak of *bhava* and *rasa*, then, we can do so only if these are known and experienced as abstractions from the original living source. Insofar as we are moved by the flavour of a filmed recital, we are moved through the medium of an abstracting mechanism. The rest, the vital and vitalizing *rasa*, can only be extracted by a strong and informed act of applied imagination. We must enter the poet's mind through the word on the page because her real mind, her dancer's mind, is elsewhere and otherwise involved, or simply not involved at all.

What this means is that filmed dance throws the *rasika* very much on his own critical resources and on the power of his own imagination to give life to the onscreen dancer. Clearly then a tremendous act of will, too, is required to do critical and 'rasic' justice to the recital. In the final analysis, I would say, nothing short of an act of love can achieve the *rasa* that, in the live performance, would arise as a matter of course.

Otherwise we may applaud the film without knowing what we are doing, and the applause will be something merely in the order of a flattering compliment. But we will not know why we are saying it.

Which is not to contend that recorded dance doesn't offer vast opportunities for intricate and sustained criticism of the analytic and technical kind. It most certainly does, and those opportunities should be utilized more thoroughly and insightfully than they usually are. As a corollary it must be said, too, that the opportunities for learning proffered by filmed dance are as great and unlimited as those for exacting analysis. It is therefore a thing to be celebrated.

But only a generous, informing love—by which I mean, among other things, a profound conscientiousness and a fierce fidelity—will give it the kind of life that makes it ultimately meaningful and personally transformative. And if the reader of this essay should think me naïve and a child for saying so, so be it.

39

The Ineffable in Classical Indian Dance

An ineffable experience is one that lies beyond the reach of any words to analyze or describe it. This kind of experience can only be approached by way of symbol, poetry, or metaphor. From the perspective of analytical criticism there is nothing than can accurately be said about it. So far as practical criticism is concerned, however, we can't avoid the occurrence of the ineffable by the expedient of just ignoring it—unless of course we have never experienced it and feel ourselves capable of clear analytical statements about the whole of our experience of dance. But I don't think any *rasika* would imagine so foolish a thing.

This doesn't mean that the ineffable experience of dance is exempt from anything at all that criticism has to offer. But the criticism that speaks about the ineffable must always be a meta-critique: it can, for instance, try to show us the aesthetic means by which dance leads us towards that palpable yet incomprehensible experience of itself, it can theorize about the psychological mechanisms whose interactions open pathways to the ineffable, and so on. What it can't do is tell us what the ineffable is, or in what it consists, because what it is able to state by analysis must for that reason be no longer ineffable.

Essays on Classical Indian Dance
Donovan Roebert
Text copyright © 2021 Donovan Roebert / Photographs copyright © 2021 Arun Kumar
ISBN 978-981-4877-47-3 (Hardcover), 978-1-003-12113-8 (eBook)
www.jennystanford.com

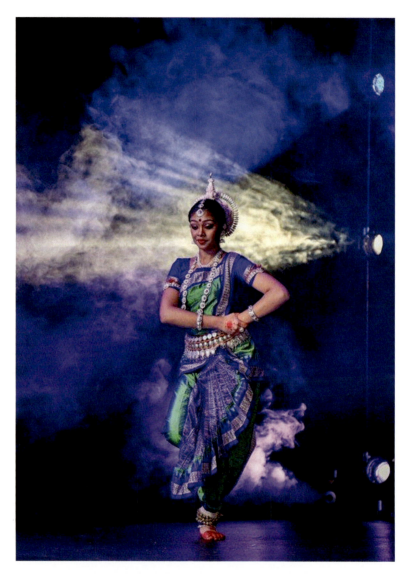

39. Sweta Tripuramallu, Morrisville.

When we recognize this central, existential nature of ineffability together with its intrinsic exclusion of direct discursive criticism, we immediately see more clearly why it tends to be referred to in religious or quasi-religious terms. Because it is an ineffable experience we think that it must be a religious or a spiritual one. We equate the experience

of aesthetic ineffability with that of religious transcendence, and this is probably a large part of the aboriginal reason why dance was taken up into religious practice in the first place. Whatever lies beyond the verbal must belong to god.

Inevitably then two experiential concepts proper to dance become entwined as twin aspects of our ineffable response: that of *sringara*, which is born in the flesh, and that of transcendence which blooms in the mind or spirit. We say then, more or less, that the corporeal practice and effects of dance give rise to the inward response that is beyond analysis. If I am safe in saying this much, I have touched on an essential element to which classical Indian dance in any case openly lays claim, if with fitting diffidence.

But I am not at all sure that the religious reading of aesthetic ineffability in the experience of dance is the only possible one or even the right one. By this I don't mean that we can't call the effect a religious one. What I mean is rather that, in relegating it to the domain of religious experience, we might end up thinking that it is an experience impossible to us if we are not prone to the religious sensibility. We might feel then that our being touched by the exquisite in dance is merely the ephemeral experience of a moment, that it can't possibly hold any permanent and transformative meaning for us who shun what we perceive to be the sham of the overplayed religious orientation. The ineffable becomes a passing instant, to which we may return again and again, but whose only meaning is the momentary pleasure of its strangeness.

In my search for some kind of descriptive equivalent for the enduring and transformative experience, I will begin then with the simple statement that the dance awakes the dancer within the *rasika*. I have said something rather like this in my essay *The Humanization of Rhythm and Form* but I was not speaking there of the ineffable itself but of the reduction of the cosmic dance to what is humanly comprehensible. What I want to try to approach here is the response of the human being to the dancer as dancer, and to the single dance as dance.

This inner dancer, this dancer within the *rasika*, with whom the dancer resonates even as she stirs it to a previously unknown life, must be I suppose a normally vacant capacity for the inward realization of

rhythm and form as part of the individual personal being. I think of it more or less as a Kantian 'spatio-temporal' capaciousness which, unlike the block of marble in which the sculptor must find his sculpted object, finds its form through being infused with dance rather than by the removal of excess material. The inner dancer which the external dancer quickens, the dancing image finding form in our inwardness in the course of the dance, seems to me then to represent an isomorphic pattern which is replicated as a conscious mental state.

The internalized outer pattern of the dance elevates itself into a condition of mental being, a condition, indeed, of well-being. Yet it doesn't seem to arrive with the force of something utterly new and strange. What it lifts up into awareness is rather a potential (the inverse of the sculptor's marble block) that we recognize as our own in the moment we perceive it.

To say this is to admit at once to the Socratic idea or ideal of *maieusis*. There is within every human mind a capacity for pre-recognizing the shapes and motions of dance. They exist within us before we ever see the dance externalized by the dancer. Thus we are awakened through the dance to nothing other than a pre-existent aspect of our own knowledge, as aspect that is drawn forth into the light of consciousness rather than implanted from outside.

What I mean by this can perhaps best be explained by a consideration of the function of the *mudra*, the gesture without words, that imparts to us a unit of wisdom by casting its light on its counterpart pre-existing within us but usually dwelling in darkness amid the clutter of our ordinary mental states. The *mudra* exposes its indwelling existence merely by illumining it, and the dance, after all, is a complex, evolving *mudra*. What it illuminates is not a replication of its external self but itself as it pre-exists within the receiving *rasika-mind*. When we see it, we know that we have always known it.

This leads immediately to one possibly valid definition of its ineffable efficacy. It accomplishes its ends by leading us along the path of profound inner resonance with an externally unfolding pattern. And this resonance bespeaks not only a relatedness, or a relationship, but a unity through identification, an at-one-ness. So far from only knowing what the dance is, we know it as something that we also are. Thus the experience is an existential rather than only an epistemological one.

The Ineffable in Classical Indian Dance 321

Then, too, it becomes clearer to us what the nature and functions of *sringara* are. The *sringaric* or 'erotic' is not a quality of human selfhood that is confined to areas of knowing. If we know it, we know it in the first place as a force inhabiting our very humanness, as a principle that we can only study as knowledge because it is inseparable from what we are. If it were not inseparable from our essential human experience of it, our knowing and speaking about it would be a kind of farce—as some dances actually are, and for the same reason.

The ineffable then has its roots in *sringara*, and *shringara rasa* develops and unfolds not into patterns imbibed from outside, but as a calling forth through its luminous activity a pattern whose inward existence we recognize only too well once the dance reminds us that it is there.

It is this kind of awakened self-knowledge that we experience as ineffable, and we experience it as ineffable because it is so close to us. Like our own faces, it is so close to our being that we can't see it unless in a mirror, and even when we have seen its reflection, its features, strictly speaking, remain indescribable. We can only recollect them in the most general terms. No one could draw us as we really are on the basis of a description given in a letter. The ineffable can only be known to us by a direct act of seeing and sustained in us by the memorableness of that insight.

Dance is the lustrous mirror that reflects our dancing inwardness. What it reveals to us is the part of ourselves that dances without normally being seen to be doing so. The experience of dance as ineffable knowledge is above all an experience that is genuinely self-revelatory.

What is being revealed—what I have called the inner dancing self—is that aspect of our minds which, because it is an ordinarily unrealized potential in 'inner-space,' is not able to see itself as such. But when it does see itself in the mirror of dance, it transcends both space and time. And that is the experience that can't be described.

When this is grasped, the abiding transformative power of dance becomes more easily apparent.

40

On the Movement from One *Adavu* to the Next

The movement from one *adavu* to the next is always a fresh remobilization of a static posture that is not only ancient but captive to stylization. It is a setting free of an imprisoned idea, a letting go of a captured unit of code into the forum of the vital, the liberation of a codified insight from the field of death into the pastures of the living. The dancer reaching from *adavu* to *adavu* is in this sense a partaker in the miraculous, a worker of the impossible act of transubstantiation, the dead letter re-made into living flesh.

The accomplishment of each *adavu* in its turn is recognized in the first place as efficient and in the second as efficacious. It achieves what it has set out to do both mechanically and artistically. In adopting the only form proper to itself it speaks itself into existence as much in the dancer's presence as in the *rasika*'s. Its coming into being is a rebirth of itself as though it were being born for the very first time. This is why it touches the mind with the force of the really new, the really innocent, the as-yet-unsullied and inexperienced.

As a movement its aesthetic keynote is therefore one of poignancy. The slipping out of one *adavu* into the next is the discarding of one moment of life for another, the setting in motion of a cycle of sudden

Essays on Classical Indian Dance
Donovan Roebert
Text copyright © 2021 Donovan Roebert / Photographs copyright © 2021 Arun Kumar
ISBN 978-981-4877-47-3 (Hardcover), 978-1-003-12113-8 (eBook)
www.jennystanford.com

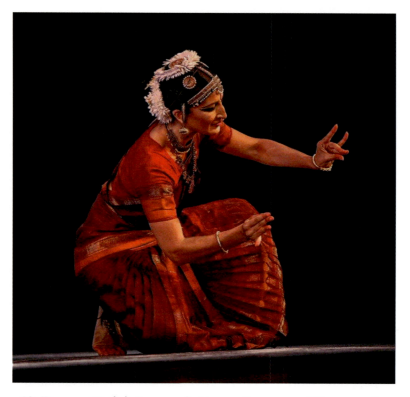

40. Tamara Nadel, Ragamala Dance Company, Minneapolis.

births, deaths and rebirths. Between one *adavu* and the next the shadow of timelessness interposes itself. There is the faint anti-moment that cannot but occur before life in the form of the next *adavu* is resumed as a new beginning.

This anti-moment between *adavus* is the necessary abyss of meaninglessness in which every instant of meaning has its first cause. The *adavu* arising from its previous incarnation across the void of nullity is for this reason a thing of great beauty, like the fire-bird. In expressing itself as a recuperation from nothingness, it reveals itself as the manifestation of primal beauty, as does every uttered word the very first time we speak or hear it. Meaning begins with beauty, is born of beauty, or else despair would never permit the notion of meaning to arise.

On the Movement from One Adavu *to the Next* 325

Every successive *adavu* is a movement then of beauty to which in the course of the dance-recital meaning is given and from which it is taken and to which it is again returned.

At the heart of each *adavu* rests an unfindable stasis, the anti-beauty whose own embodiment is neither in the static photographic moment, nor in the choreographic sign, nor in the stillness of the choreographer's mind. Its essence is unfathomable formlessness. The word not only unspoken but unconceived. When it breaks forth like sound from soundlessness it does so with infusive joy—the joy of the beauty that makes meaning not only possible but desirable.

The motion from one *adavu* to the next is therefore an exchange of one joy for another, and of meanings multiplied in every joyous nuance. To say this is of course to say that these movements are leaps from life to life, and in the highest sense.

Therefore the surge from *adavu* to *adavu* is also a thrust from light to light, one instance of light being cast in the already cast light of its predecessor, and all acting in sequence to nullify the darkness in which lies the seed from which they all germinate.

The blooming of every new *adavu* is also a succession of mental states known only by the *adavu*-light in which they are realized, made known and grasped briefly before being replaced by their nearest neighbour, the next *adavu*-moment emerging as the possible from the utterly impossible because utterly unknowable.

The movement from one *adavu* to the next is a slowed-down analogy for the rapid motions of human mentation, the flitting from sentiment to sentiment, from idea to idea, riding on the *adavus* that are the transient forms of the formless mind in which they have their being.

The movements of dance, before they ever can be anything else, can only be something meaningfully more than themselves if they first align with the movements of mind, so that we can know them as indwelling and familiar.

Otherwise we would not recognize the *adavus* stooping one after the other to retrieve one another. We would look on baffled and terrified, as if *adavus* were manifestations of the horror of insanity rather than the sane and well-ordered flux of loveliness that we instinctively know them to be.

The movements of one elegant *adavu* to the exquisite next are preeminently symbols of sanity and lessons in joy. I suppose one ought to be careful, therefore, to dance them aright, and to appropriate them purely.

And I suppose one ought also to beware the dances of darkness whose aim is trance, the suppression of light and the confusion of ideation, sensation and sentiment. This is the other side, the moral side, of what classicism in dance has to teach us. Because the movement from one *adavu* to the next is also a step from clarity to clarity, from one state of sanity to another.

This is why we know the flow of the *adavus* as happiness, and not as absurdity or fear.

41

The Personal Approach to Dance Criticism

The personal approach to dance criticism is never the one that begins with a theory about dance, nor will theorized preconditions advance us much beyond the theoretic. The personal approach begins with the question: *Why does this particular form of dance, and this particular rendition of it, have these particular effects on me?*

The question, because it is as fundamental as it is close to the bone, admits before anything more is said that dance is a reciprocal act occurring between itself and the self that I call myself. This makes it personal before it ever becomes theoretical and leads to fruitful further inquiries. The answers these inquiries attract may eventually give rise to a personal theory and if the personal theory turns out to have a universal application, so much the better.

Why does this dance have these effects on me?

The extent of the theoretical knowledge I may have gained before I ask this question will not be of much use to me. If I say to myself that, in terms of the theory, this or that kind of dance should result in this or that sentiment or insight or wisdom, I am not asking but begging

Essays on Classical Indian Dance
Donovan Roebert
Text copyright © 2021 Donovan Roebert / Photographs copyright © 2021 Arun Kumar
ISBN 978-981-4877-47-3 (Hardcover), 978-1-003-12113-8 (eBook)
www.jennystanford.com

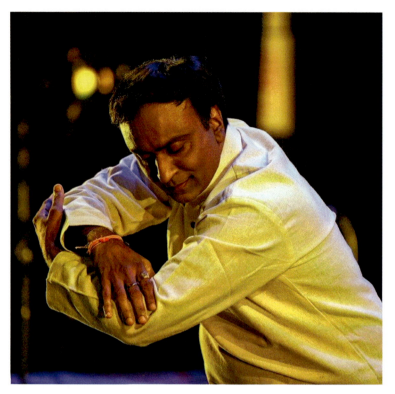

41. Prashant Shah, New York.

a question. I am adjusting my expectations according to a tailored formula, like the deaf man who puts his trust in a treatise on sound rather than having his own hearing restored.

If I say,

'This dance has deft and accurate footwork and the shift from the *trasrapada* to the *suchipada* is executed with firmness and ease; moreover the sole and heel of the right foot are correctly rectilinear, while the flat left is firmly planted, with just the right effect effect of balanced weight that perfects the angles of the curvature of the knees and will allow for an eventual *mahapada* of the kind that will prevent the toppling of the equilibrium, and so leave the *tahiya* straight, as it ought to be. The rest of the body, carried on these deftly manoeuvring feet, presents kinetic *bhangis* that do not go too deep so that the *atabhangi*, if and when it comes, will at least be perceived to be deliberate. The facial *abhinaya* is not overdone, so that it doesn't tilt into the grotesque or the comical,

and the movements of the eyes and eyebrows belong sufficiently to the dancer's own personality so that a just balance is struck between the stylized and the spontaneous ...'

I am in fact only noting that this dance is being recited in a just accord with the choreographic notation and with the fixed codification that underlies it. I am confirming that the notes being played on this instrument aren't false notes and that the instrument itself is well-tuned. I am only describing the elements of technique and technical accomplishment that are having this particular effect on me, all of which elements comprise the given, the *datum*.

But why does this datum have these effects on me?

The critical usefulness of the kind of technical appraisal I have pointed to above only becomes apparent when I transfer it to the operation of the dancer's mind and body, when I add to what I have already said that this dancer has learnt properly to speak the language appropriate for conveying her intended *rasa*. I see then, in this acknowledgment, her conscientiousness, her integrity and her intentionality. I see, that is, by means of the poetic accuracy of the language she is using, the moral seriousness which she brings to bear on her art. And, seeing her thus, she becomes worthy of an equally conscientious and serious apprehension on my part. I am, so to speak, captivated by the earnest rhetoric of her charisma.

But this—the captivation through technique— is only a first step, the step in which the dancer has succeeded in convincing me that her dance has something worthwhile to communicate. Which is not to say that the accomplishment of this step is not greatly to her credit. In taking the step rightly she has achieved, after all, the foundational *sine qua non*. She has confirmed her right to credibility.

If I have decided to credit what she has to offer, I must also then, on account of that same seriousness, believe that she has something worthwhile to say. In doing so I open my mind and as it were my heart to her (these two are distinct though inseparable critical instruments, no matter the terminology we use to denote them). I put my faith in her linguistic and communicative conscientiousness and render myself vulnerable to whatever she may have to transmit.

330 ESSAYS ON CLASSICAL INDIAN DANCE

Now what she is transmitting is always sent across the façade and through the energies of *abhinaya* and *bhava*, even in the pure *nritta* where these may (wrongly) be disclaimed. She is sending usward two streams of presence, those of her dancing body and those of her radiant mind. She is speaking to us in the language of sentiment coerced through the medium of flesh, blood and bone. This is unmissable and there is no hiding from it, even if one were inclined to want to. What we have in the full, intelligent presence of the dancer are choreographic notations designed to elicit and display ultimate physical beauty as a language all its own. We may emphasize this point by stressing the fact that nothing will be achieved by the dancer if she fails to convince us that she is speaking in the language of physical beauty, in the language of the strictly erotic insofar as this term is understood in all its wider shades of meaning.

But this language, too, is only a means for achieving incisive and stirring communication, for the conveyance of its own kind of rhetoric specifically. If we stop at this point, imbibing and construing it as an end in itself, we are not involving ourselves with classical dance but with something else entirely—something both ultimately boring and finally useless. We are listening to words for the sake of their sound only.

Having in mind this notion of dance linguistics, itself of course a theory, though not one necessarily to be imposed at all times, I have proposed to study a particular Odissi *pallavi* rendition by a dancer whose work I have esteemed for some time for its regular precision and commitment to purity of enunciation; a dancer, too, of especial charm and wit.

Without entering on a close description of the enacted choreography, I wish to note first that the neat, highly-patterned footwork, with much frontal display of nimble sideways motion using the *swastikapada*, immediately translates into a sense of this dancer's sheer technical ability, as well as, in its aesthetic function, of her air of graceful (though tricky) mobility. We have here someone or something that is able, so to speak, to lead us a merry dance. She may disappear as quickly as she has appeared, leaving no trace except a baffled memory of her flitting painted feet.

At the same time, moving upwards along the flowing body-lines,

The Personal Approach to Dance Criticism 331

there is the repeatedly punctuated switch between curvaceous *bhangis* and strong, steady, fulsome *chauka-stops*. The total effect here is of the change at will between a generous sensuous giving followed by a sudden withdrawal into the formally static, if only momentarily. The resumption of the dance, then, breaking from *chauka* into a series of *brahmaris* becomes a further evasion from, though not quite a retraction of, the original frontal promise. We are being invited not to withdraw but to wait for what is yet to be yielded at the end of these fetching turns, after which we are offered the dancer's back as her body circles in a display of curving bends, her face now fully absent from us. And all this while the complex footwork, reaching forward from heel to ball, with that soft 'stickiness' peculiar to Odissi, reminds us that this dancer (and this dance) are firmly planted in a mobile poise. From one rapidly passing instant to the next we are not allowed to forget that these wily evocations, this calculated *sulu*, is coupled with a relentless self-control. The arms reaching out for a series of *hastha mudras* finally return frontally to us, now in *pataka* form, conveying the idea both of greeting and blessing, but also of an introspective diffidence.

The facial *abhinaya*, when we are returned to it, affords an insight into the self-seduction of the acolyte at the place of tryst, which is the space that is filled by the *dancer-rasika* relational continuum. The work of the lips, eyes and eyebrows, exaggerated but never a caricature, assure us that this is a place of love-play but also, in the nature of things, because we are where we are, a place of intense vulnerability. The blooming face, the flowering body, the reaching limbs, all stringently tied down to the cold, hard, unremitting choreography, tell us at the same time that what we have before us in full *sringaric* display is in fact just that: an illusion. The proof that it is an illusion can easily be established by reverting from a warmly lyrical description of this dancer's dance to a sterile technical one (though of course we do not want to do that).

Because we have between us now, in the apprehending mental plane between dancer and *rasika*, a representation of dance that is purely mind-based, a picture of the dance replicated in a space where neither she nor we are present; a free-floating picture that is able to inform by indwelling the receiving *rasika-awareness*.

It speaks to us in the language not of seduction but of witty

beguilement. And what is beguiling, while it beguiles, must remain, unlike seduction, forever unfulfilled. This impossibility of fulfillment, which constitutes a large part of the dancer's intentionality, is the first condition indeed of her capacity for arousing bliss. What is beguiling becomes the basis for our ongoing yearning.

Profoundly considered, this ever-unfulfilled yearning signifies both the reason and the will that empower the wish to go on living, infusing the conviction that living one's life is after all a worthwhile matter. This has been achieved by the dancer through her unsuspected encroachment on what is incorrigibly vulnerable in the *rasika*: the wounded spot that marks the humane, compassionate capacity of every human being.

Here, in the vulnerable place that she has exposed by beguiling it into self-awareness, lies the only area of mind where the seeds of *bodhicitta* can be planted and nurtured into leaf and eventual fruitfulness. This particular *pallavi* has led me to encounter the wisdom-compassion whose chief characteristic is the ability to perceive the vulnerable vitality of all other living beings, including especially (and especially represented by) the dancer while she dances.

It is this kind of intimacy that we properly associate with eroticism as it appears in its *sringara* expression. This isn't to say that it doesn't share with its coarser counterpart a certain and potent visceral energy; but the visceral in this case is that of the heart and mind, though it comes at them by way of the blood. It is an intimacy of yearning which remains, as the dance has just demonstrated, subject to a rigorous internal control and entertained in unfaltering equipoise.

This dancer dancing this particular *pallavi* has shown me that beauty is always vulnerable, whether in its physical or its spiritual manifestations. It is prone to sickness, old-age and death, and it is under constant attack by temptations to delusion.

The yearning for meaningful beauty, in spite of these adversaries and the suffering they imply and actually effect, is an heroic affirmation of life and love, an affirmation drawn out by beguilement.

Here are the beginnings of a philosophic investigation, but with it we pass from the domain of dance criticism and into that of psychology and perhaps metaphysics.

42

The Sanitizing and Cleansing of Bharata Natyam

Before I move on to the substance of this essay, let me try to make clear immediately what I mean by 'sanitizing' and 'cleansing' in the context in which I intend to use these terms:

Anyone who has read something of the modern history of Bharata Natyam will have come across the idea of its having been 'sanitized' by prudish Brahmin revivalists (often summed-up in the person of Rukmini Devi Arundale), who objected to its erotic, *sringara*-based content and form. The idea of its having been thus sanitized has other connotations too, and to these I will return in due course. The clarification I want to make here, at the outset, is that I will be employing this term, well-worn in general recent usage, with reference only to the revivalist movement and the alleged depredations it wrought on the hereditary Sadir tradition. It is not necessarily the case that I agree with these implications.

'Cleansing' is a word I have deliberately chosen, together with all of its own connotations, for describing the current beginnings of the backlash against the erstwhile 'sanitizing' of Bharata Natyam. What I will be arguing, in short, is that a variety of interested parties

Essays on Classical Indian Dance
Donovan Roebert
Text copyright © 2021 Donovan Roebert / Photographs copyright © 2021 Arun Kumar
ISBN 978-981-4877-47-3 (Hardcover), 978-1-003-12113-8 (eBook)
www.jennystanford.com

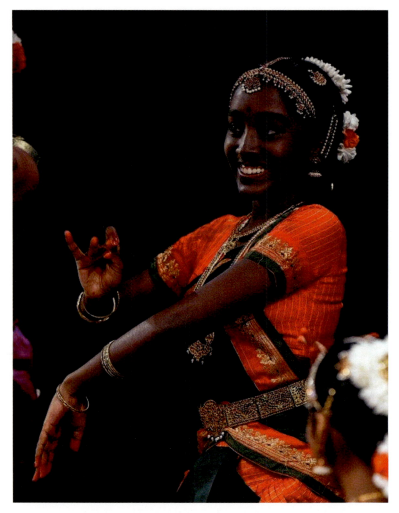

42. Krithika Vellapan, Kalasrishti School of Performing Arts, Cary.

are presently involved, ironically and paradoxically enough, in the cleansing of Bharata Natyam from its former sanitization.

I will turn first to a brief consideration of the sanitizing of the dance by those forces and persons involved in the so-called 'revival' of Bharata Natyam that took place roughly during the period 1930—1980 by which time the new 'sanitized' form had established itself as the premier classical Indian dance form both at home and internationally.

The Sanitizing and Cleansing of Bharata Natyam 335

In doing so I don't want to rehearse, even in condensed form, the whole of the saga that is coming in for its due share of activist and revisionist criticism today. Readers interested in knowing my own opinion and the evidence on which I have based it might consult my earlier essay, *Rukmini Devi and the Devadasi Question: An Opinion*.

Instead, what I wish to review very briefly here are some of the correctives brought to bear on the dance by the revivalists: correctives which, often with the angry wisdom of hindsight, are now considered to have been misguidedly, mendaciously and even ruinously applied in the course of their sanitizing work.

First, there is the contention that the element of eroticism was frowned upon by the Indian upper classes under the influence of the sterile moral worldview of the Victorian British colonialists. The idea here is that the earthy sensuousness of the *deva-* and *rajadasi attam* was not only wrongly but deliberately viewed as a grave impediment to the advancement of classical dance as an Indian national art form.

Second, that, in order to make dance available to everyone in Indian society, the taint of eroticism was used as an excuse to wrest the art from its only legitimate practitioners, the community of hereditary artists. This allegation goes hand in hand with a number of conspiracy theories that reach all the way up from Dr Muthulakshmi Reddy to Jawaharlal Nehru himself. Again, Rukmini Devi and the Theosophists generally feature large in this conception of a shrewdly planned and executed collective injustice.

Third, that the art itself, in the course of its being adjusted to the new cosmopolitan morality and colonialized tastes, suffered loss to its purity and integrity, while consigning the pure and capable artists to virtual oblivion when not using them to train students and teachers for the revived and re-named Bharata Natyam. (I note here for interest's sake that studies show in any case that this name has been in use, though infrequently, since the 13th century).

I don't want to go any further than this in stating the grounds for the accusations levelled against the revivalists, viz. that their 'sanitizing' of the dance involved a confluence of moral, social, political, caste, religious and artistic values, and that this value-set was cynically employed to appropriate the dance for their own purposes. What we are dealing with then is a 'social justice issue' in which the revivalists

336 ESSAYS ON CLASSICAL INDIAN DANCE

become the one-dimensional villains, and the dance they modified, in the ostensible effort to 'revive' it, a vitiated symbol of their villainy.

We can see too how very easily this conjunction of accusations makes itself amenable to the so-called 'intersectional' interests of the social justice campaigner. The battle becomes one waged against an unjust, hegemonic and monolithic entity whose past injustices continue in the present to oppress, exclude, stigmatize and dominate not only its original historical victims but also a variety of other interest groups now considered victims too. Thus we have radical feminists, women's rights advocates, contemporary dancers, anti-patriarchalists, caste interests and others beginning to clamour for a revision of the 'whitewashed historical myth' perpetrated on the public by the revivalists. Together with these 'social justice issues,' there are insinuations that a revised, mainly unfavourable view, should be taken of revivalist Bharata Natyam, as well as of the institutions that brought it into being, especially *Kalakshetra*. It is argued that Bharata Natyam should be seen for what it is, a dance form with a bad conscience, spuriously 'revived' through acts of appropriation involving adulteration of its pure historical Sadir-prototype. In this low-key but intensifying struggle, Balasaraswati comes to stand for the pure displaced hereditary artists and Rukmini Devi for the ruthless expropriators.

In essentializing the matter in this way I am hardly putting the case too strongly. Reading between the lines of the more restrained and courteous activist discourse on the subject, it is hard to avoid this kind of coarse restatement of the complaint. And there can be little doubt that, in the current search for justice and redress, some form of historical punishment is being looked for too. Of course this punishment is already being inflicted by means of an ongoing, often muffled, public shaming exercise in academia, the media and on social media. But in these soft beginnings there is an unmissable harder edge scraping destructively at the legacy and status of *Kalakshetra*, and of its founder, its teachers, its dancers and its dance.

In the age of the social-media 'social justice campaigner' this sort of thing is no longer surprising. But, even if this scenario were not playing itself out by means of this specific technology, we would have to recognize that this pattern of cultural and artistic reversal was bound to establish itself eventually as one possible instance of postmodern

The Sanitizing and Cleansing of Bharata Natyam 337

socio-artistic revolt. No art form in practice globally since the mid-20th century has been free from the urge to socio-political liberation, self-expression and, of course, justice. The coming to the fore of the practices and force of identity politics has been a great enabler of this tendency too. Its legitimizing of public vilification of the persons it identifies as perpetrators of one or another instance of injustice has by now become the norm. Evidentiary substance, apart from what is circumstantial and anecdotal or merely accusatory, isn't needed to justify retributive public actions, statements and the promulgation of narratives of blame.

In this spirit then the present activism against the revivalists and their art is gradually gaining momentum. And, as is usual with all such cases in the history of art and ideas, the struggle for redemption, redress and reinstatement becomes inevitably also a struggle for precedence. So far as this aspect goes, we hear more and more frequently that the 'hegemony' established (on unjust grounds) by revivalist Bharata Natyam, together with its institutions of patronage and favour (many of them indubitably unsavoury) must be toppled to make way not only for new dances but also for the pure old Sadir forms. One can't help spotting the classical revolutionary tendency here, but in its Foucauldian power-relations guise.

The admittedly truncated summary I have offered here will have to serve as the basis for putting the questions that seem to me important:

First, is this narrative of historical injustice a valid one? It seems hard to deny that the *Isai Vellalars* and their associated advocacy groups have a very strong case to present, at least in so far as their communities were caught up in a cultural-historical storm which devastated their heritage and way of life. But to what extent will the personal apportioning of blame be found justified and accurate? To what extent can the claim be validated that the revivalists acted deliberately and cynically to take that way of life away from them and pass it on, modified, to other, more 'privileged' classes? As the matter is pursued with increasing resentment and vociferousness, one wonders how carefully both activists and historians will be inclined to tread. The old maxim that history can't be seen in the round until at least a century has passed has an obvious relevance here: a fuller, more considered, more impartial history may end up showing that the

sanitization and subsequent cleansing of Bharata Natyam form two episodes of single continuum of injustice.

My second set of questions hangs on just this point: will some new instances of injustice have to be carried out in order to see 'justice' done? Will new and equally innocent victims be needed to effect the emerging changes in the order of artistic precedence? Will the cleansing of Bharata Natyam from its earlier sanitization involve the creation of new structures of hegemony, both institutionally and artistically?

I have good historical reasons for thinking that it will. So much of the current activist debate is already very busily pointing fingers, both overtly and tacitly. This is a debate that is set to become heated when its practical consequences begin to be felt. The shift from an old to a new dance-elite is unlikely to be a pacifist one. After all, what is at stake here in the cleansing phase just as it was before in the sanitizing period are an art form and the path it cuts in the life of its devotees and practitioners.

One of the most remarkable claims implicit in this ongoing narrative is that a stolen and adulterated form of dance, a thing inferior to its purer prototype, a thing moreover tainted by the commission of a collective socio-cultural crime, has been for the last eighty years or so the premier dance form in the pan-Indian artistic scene.

To such as myself, mere innocent onlookers having *rasika*-hearts if not *rasika*-discernment, this comes with the force of the shock of having been slyly deceived, if indeed one has been deceived. At present I still prefer with some tenacity to believe that this can't possibly be the case. The absence perhaps of a finer perceptiveness continues to fool me into accepting the revivalist form of Bharata Natyam as one of the most beautiful jewels to be seen in the world of dance.

It also places, from the point of view of someone in my position, a heavy onus on those championing the reinstatement of the purer form of Sadir to demonstrate conclusively why their cleansed and restored style of hereditary *Bharatam* should eventually take artistic precedence over its sanitized predecessor. Unless, fool that I am to hope against hope, the question of precedence will never again be allowed to arise.

43

On 'Pseudo-Spirituality' in Classical Indian Dance

The occasion for this essay is a remark made about Bharata Natyam by the author of *The Undoing Dance*. In the course of an interview about her novel, Srividya Natarajan referred to much of what passes for classical dance nowadays as 'pseudo-spiritual' and 'boring.' It would be hard to misread her statement as not making a comparison between the hereditary and revivalist forms, but I want to leave that aspect aside for the moment. I think, at any rate, that I know what she means, which is that much of what pretends to spirituality in the dance today is really only a shallow sentimentalism, its superficiality emphasized by its own stress on fastidious coyness and false charm. So far as that goes, I agree with her, but without going so far as to confine this fault to the revivalist form alone.

In addition, I don't believe that one can arrive at any useful notion of its 'pseudo-spirituality' unless one can at the same time define for oneself what is genuinely and functionally 'spiritual' about any classical Indian dance form or *bani* that makes spiritual claims for itself.

But I must also say at once, before attempting even a partial definition for myself, that I am speaking from the viewpoint of the *rasika*. Whether any dance whatsoever is spiritual for any individual

Essays on Classical Indian Dance
Donovan Roebert
Text copyright © 2021 Donovan Roebert / Photographs copyright © 2021 Arun Kumar
ISBN 978-981-4877-47-3 (Hardcover), 978-1-003-12113-8 (eBook)
www.jennystanford.com

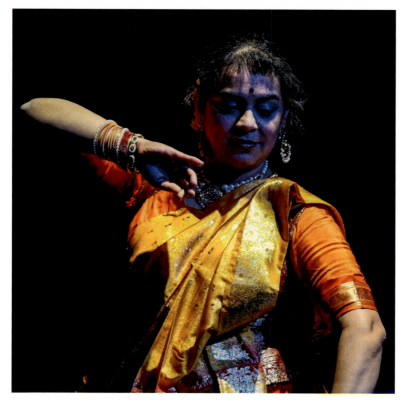

43. Ruee Gawarikar, student of Smt Prabhatai Marathe and Pandit S.N. Charka, Lawrenceville.

dancer is hardly for me or for anyone else to say. This question must in the nature of things always remain strictly subjective. The only perspective from which to attempt any sort of judgment on the matter must be one that is able to examine certain objective factors that are internally and externally present in the art itself. But even before we resort to that kind of approach we will surely be required to have before us some idea of what we mean by the 'spiritual.'

I will have recourse for this purpose to two phrases belonging to F.R. Leavis, phrases which I feel are both simple and complex enough, as well as sufficiently suggestive, to strike a chord with most readers. In referring to what is not strictly material (or materialist) about humanity, Leavis speaks of 'the unknowable and unmeasurable to which we know we belong' and of 'the full intelligent possession

On 'Pseudo-Spirituality' in Classical Indian Dance 341

of our full humanity.' These are the sorts of idea, at any rate, that denote, however ambiguously, what seems to me spiritual about my own human experience. The question regarding what may be really spiritual about dance revolves therefore, for me at least, around these and similarly allusive conceptions. They are also especially useful in this case because they can be related to the appreciation of the art of dance in its technical and other aspects.

So far as the 'unmeasurable and unknowable' is concerned, it seems clear that it refers to that part of human experience that eludes our everyday personhood, together with our limited capacity for thought and sentiment, by rising above these towards transcendence. We know only too well, once we have considered these things in their depth, that we are surrounded by and grounded in a *mysterium*: we grope our way towards a tentative grasp of its subtle, aloof and intransigent significations, only to find them evading us in the very moment we think we have grasped them. Still, the nature of that reality and the effort we make to realize it for ourselves is always a reaching above and beyond ourselves, a striving towards not-selfness, a spiritual endeavour.

In this regard the classical dances, properly understood in their intrinsic nature, do lead us in this direction. In saying this, however, it is necessary to make the qualifying statement that, for the *rasika*, the dance is not the meditation itself—as it may well be for the dancer— but only the object of meditation. What is subjective for the dancer is objectively received by the onlooking recipient. The form-in-flux indwelling the dancer becomes for the *rasika* a significant external form leading the closely attending mind somewhere rather than nowhere. And these forms, these dancing forms, are supra-linguistic— they draw the mind beyond what is normally utterable in ordinary, mundane language, towards a mental spaciousness where discursive formulations are perfectly useless. The language of the dancing body is an imagist-symbolist language which in the final analysis leaves even its own provisional formal meanings behind itself-in-motion.

What is needed for the successful completion of this process is not a perfectly spiritual dancer but a perfectly articulate technique. So long as the classical form-in-motion is abiding by its own codified norms and structures, so long as the language it employs rests on a perfected use of its own forms, that language will point and lead the mind away

from what is bound up with ordinary selfhood. But this process surely also requires a degree of preparedness and education on the part of the *rasika*. No object of meditation, be it ever so inherently efficacious, can draw the ignorant mind along in its wake. Thus it is certainly also possible that a 'pseudo-spirituality' may be imputed to a dance (or dance form) by a mind whose expectations and understanding of the mechanisms of the art are deficient in themselves: a tarnished mirror levelling criticisms at what it itself imperfectly reflects.

Apart from technique as it relates to pure dance, the matter of 'pseudo-spirituality' enters its most dangerous terrain when it comes to dance-drama in its *natya-abhinaya* aspect. Here we depart from the non-discursive into a field of dramatic representation whose techniques and stories are perfectly amenable to representational language. The *navarasa* conveyed through their correlative *abhinaya* expressions are all describable in the ordinary language of thought, emotion and sentiment, as are the mythic tales which they are used for telling. It is to this area—an area particularly and sensitively prone to questions of taste and the correction of taste—that I believe Srividya Natarajan to be mainly referring when making her criticism about 'pseudo-spirituality.' But she goes on also to bedevil the question by relating this criticism to what, in the dancer, she execrates as 'a patriarchy-affirming coquetry.'

Now clearly she is speaking chiefly about the way in which dancers of the revivalist Bharata Natyam tradition portray Radha in relation to her love-yearning for Krishna. Here is confusion indeed: not only is she relegating the *deva* to the socio-cultural realm of 'the patriarchy,' she is also conflating this ideological stance with her idea of what is 'pseudo-spiritual' in the portrayal of Radha's *sringara-bhakti*. There are thus two critical trains of thought to be pursued separately here, apart from the intrinsic question about the technical qualities of the *abhinaya* itself.

Whether a culture is patriarchal of matriarchal, or neither, has nothing at all to do with a genuine or a false spirituality. The art produced in any cultural *milieu* can only be evaluated, in so far as it is art and not some other thing (for instance, ideology disguised as art), in terms of its conformity to its own artistic standards and principles, and its intrinsic intentionality as art. In any case, if the Krishna-Radha

On 'Pseudo-Spirituality' in Classical Indian Dance 343

or Shiva-Parvati dynamic is reduced to a symbol for a social system the whole of classical Indian dance must fall with it into becoming a debased 'art' of social politicking. That is the real 'pseudo-spiritual' problem confronting the dance today, especially in the ongoing discourse between the *Isai Vellalars* and revivalist Bharata Natyam.

As to the criticism of 'coquetry' itself, why should it be viewed as 'patriarchy-affirming'? And why is the portrayal of coquetry (for which there are other, less derogatory words) in itself detrimental to the art? Can we not at least accept the possibility that the devotional heart is in an important sense a 'coquette' in its search for and relationship with the divine? Yes, why not? So far as the primal yearning for the divine is concerned, and in the ploys it uses to ensnare the divine, the human heart is pure coquetry throughout, whether it beats in a man or a woman!

But to return to the pure art of *abhinaya* itself, it is useless to speak of 'pseudo-spirituality' when all we can really mean is bad artistry. Coarsely put, then, *abhinaya* becomes bad art not when it displays coquetry (for any artistic reason whatsoever) but when it displays coquetry in a melodramatic or otherwise unconvincing way. At the same time I don't wish to be seen to be misunderstanding Srividya Natarajan's more precise and apposite point, which is that coquetry divorced from the representation of genuine and fully-realized aesthetic eroticism is an exercise in artistic immaturity. The fullness of *sringara rasa* in all its implications is a necessary part of its convincing portrayal. Coquetry of the real kind, the kind that seeks to fulfill its deepest purposes, is never asexual. But neither is it 'patriarchy-affirming.' It is what it is in the nature of things, and the business of the *Raasleela* in the dance is to stylize that naturalness so that it becomes a refining and empowering channel for increasing self-knowledge and eventually for awakening the kind of insight that leads beyond selfhood towards *bhakti*.

The other possibility we must address is that Srividya Natarajan might actually be saying that the dance as we now have it is pseudo-spiritual because it should in fact not be pretending to any spiritual qualities at all. In other words, she might be contending that Bharata Natyam through its Sadir roots should be a purely mundane expression of cultural refinement by *sringaric* means—that its effects ought rather to be sought in the merely material socio-psychological sphere,

through the somatic-psychic efficacy of its 'magic' as an aesthetic-erotic datum. In this case we ought surely to read her as meaning that, whereas revivalist Bharata Natyam makes unrealized and unrealizable spiritual claims for itself, this was not the case with the hereditary art. But, if this were the case, we would still be dealing with dance as a spiritualizing force if we can accept that the function of spiritualization is not the same as that of religion: that 'spiritualization' is really a process by which we arrive at the just design of our humanity in all its plenitude—our 'spiritualization' as our 'humanization.'

Which leads me to the other phrase quoted from Dr Leavis, referring us to 'the full intelligent possession of our full humanity.' So far as this nicely turned idea is concerned, I take it to imply two further humane qualities that seem to me characteristic of the spiritualizing function of good art: the cultivation of moral seriousness on the one hand and the refinement of poetic discernment on the other; the right cultivation, that is, of what is most reasonable, most consonant with the best in human nature, and the most beautiful and refined expressions of both.

In order to deny that the dance in both its *nritta* and *nritya* expressions is designed for such purposes (as all good art also is), we would have to make the argument that the classical Indian dances direct us towards what is morally reprehensible or merely frivolous. Immediately we see how such an argument would perforce strip the dance of any claim to the classicism whose structures and formalism rest on the idea of humane *gravitas* and dignity. We would be making the argument, in an ultimate sense, that the dance is intended for chaos and insanity.

But we surely don't find this to be the case. On the contrary, the classical qualities inherent in the dance speak to us rather of such virtues as discipline, conscientiousness, fidelity, and the striving towards high ideals of cultural and artistic accomplishment. When it fails in this task it does so not through its pseudo-spirituality but through lack of skill, commitment and taste in the artist. And the lack of these is certainly apparent in much of the classical dance that engages our attention today. At the same time we have surely to acknowledge that this is far from being the whole picture. Throughout the forms of classical Indian dance, including revivalist Bharata Natyam, we have enough

to rejoice in for purity of form, gracious embodiment and exquisite execution.

Even then, if we can agree that the criticism of what is 'pseudo-spiritual' about the dance can only legitimately be construed as a criticism of bad artistry, we are still immediately driven to the further and even less happy possibility that it might be a dire criticism levelled at an art form itself. Is it possible that Srividya Natarajan means that some one particular form or *bani* of classical Indian dance is 'pseudo-spiritual,' not on account of bad artistry practised within the field of the art but because the art itself is so fatally flawed as to be incapable of rendering what is artistically and technically pure?

In this case her axe would be laid to the root, and entirely different and more radical arguments would have to be made in defense of that art.

44

On the Freedom of Odissi to be Itself

While it was still in the making, the reconstruction—or what I have preferred to call the 'reincarnation'—of Odissi was subjected to the kind of simultaneous myth-making that characterized other classical Indian dances being revived in the same period. I am speaking of the period, roughly 1930-1960, when these dances were being refashioned not only for their own sakes but for larger cultural, national and international ends. In these decades the rebuilding of these dance forms was accompanied by much trumpeting of their great antiquity and their direct derivation from ancient texts, temple sculptures and so on. It became the norm that these myths be invoked in order to affirm the dances' classical status and the preeminence of their own particular classicism above the other classical dances of the world.

It was a time of self-conscious mythologizing from which Odissi was among the first to recover, probably because the real circumstances of its reincarnation were more compelling and laudable than the myth itself. Besides, it was a myth in this case too tenuous, too overborne by the fascinating facts of reconstruction, to hold out for very long against those facts. And it seems to me that Odissi breathed a sigh of relief

Essays on Classical Indian Dance
Donovan Roebert
Text copyright © 2021 Donovan Roebert / Photographs copyright © 2021 Arun Kumar
ISBN 978-981-4877-47-3 (Hardcover), 978-1-003-12113-8 (eBook)
www.jennystanford.com

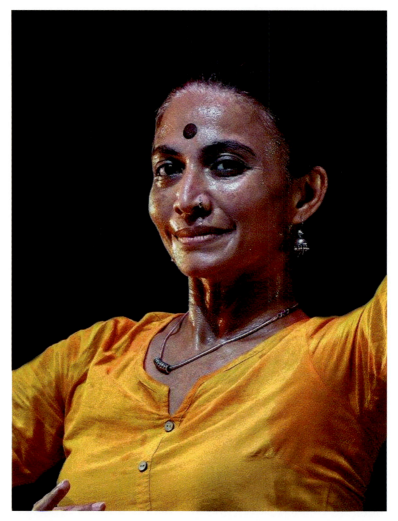

44. Bijayini Satpathy, Odissi dancer and teacher, Bangalore.

when the intricate handiwork of its modern re-embodiment, together with the breadth of thought and imagination infused into that labour of love, were put plainly in the light as the more obvious reality on which its claim to classical status must be founded.

It set Odissi free in the historical sense from having to lie about its immediate origins, while still remaining on classical ground that could claim in a roundabout but credible way its relatedness to an ancient form and the codifications demanded by that form.

I have already written about this in my essay on the *Jayantika* Movement and don't want to repeat here what I have already said there. I only want to point again to the genetic or 'karmic' aspect of the argument which I set forth in that piece on the reincarnation of Odissi.

What I was arguing was that the claim to antiquity was rightly based on pre-existent ancient traces that were reassembled and re-engineered as a code for the modern *Jayantika* body of Odissi. The fluidity of that code and its multiple potentialities for a variety of possible embodied features were engineered with a genius that hit the perfect note—the one that could and did in fact lend itself to the myth that was needed to launch those features as being indisputably classical by the politico-artistic criteria of that time.

It is this genetic or karmic fluidity and interchangeableness of fixed ancient elements, used so effectively in the modern recreation of Odissi, that lends to this classical dance form its peculiar propensity for ongoing experiment and re-adaptation; in short, for authentic evolution, by which I mean an evolutionary potential that remains true to its own inherent nature through the force and solidity of its own DNA, the 'karmic traces' proper to it.

Thus the historical freedom from formal fixation won by Odissi, by having come into the open as to its true concrete history, has gained for it also a right to the acknowledgment and practice of a genuinely classical fluidity and an openness to new creative flowerings. The way remains open, that is to say, for evolving expressions of lyricism to occur within its accommodating and commodious classical form: because Odissi is a living organism. The genius of *Jayantika* is demonstrated in the fact that, so far from only reconstructing a dance form, it breathed into that form the very breath of life, and gave it a spirit moreover.

The self of Odissi, thus made alive, is therefore in possession of all the proper qualities, as well as the proper limitations, of other manifestations of vital selfhood. In coming to terms with the real *modus operandi* used in the making of its most recent incarnation, it understands more than most other classical forms how new embodiments can authentically be manufactured, even while the myth remains integral to that process.

From this condition flow the other freedoms of self-expression-in-classicism that Odissi has evinced across the decades. When Debaprasad Das introduced his subtle but meaningful innovations, these were adopted without controversy into the mainstream established by the earlier designers and exponents. Similarly, the theatrical orientation and reticent extravagance of the *Nrityagram* programs on the international stage have been accepted and even celebrated with a tolerant calm. There is no obsession with an artificial purism though the purer forms are maintained in the stable succession of Odissi's own *guru-shishya* tradition. Even the squabbles between the early gurus and the uncomfortable displacements that occurred in consequence have by now become by common consent mere matters of quiet regret. Odissi sighs over them but does not grow strident.

It is this spirit of self-knowing and self-confident modesty—amounting almost to an absent-mindedness (take, for example, the quiet facility with which the *natangi* or *tajhiram* was transmuted into the *moksha* movement)—that has made it relatively easy to bring Odissi onto the global stage and into international prominence. We recall here the fruitful collaboration between Sanjukta Panigrahi and the *Odin Teatret* and her work with Eugenio Barba of ISTA. Almost from its first beginnings the new incarnation was open to the world at large, insisting on its freedom from confinement to the parochial and the local.

In coming within a comparatively short span of time to an open acknowledgment of its own immediate sources, Odissi has also escaped the bad conscience of dances that have been less than frank about their indebtedness to the traditions that preceded them. There is not much bad blood between the *devadasi-mahari* legacy and the dance as we have it today. Thus Odissi can go out into the world with an open countenance. In being willing to reveal itself to itself in the first place it has become more accessible to other selves, to other traditions, and to other cultures.

Of course there are dangers to this kind of frankness when it is put into the hands of the naïve. Not the least of these is the sort of openness that might be willing to compromise with its own nodal classical selfness. This is why it is so important that the true facts

concerning the process of its most recent incarnation be kept always in mind, together with the inward-looking myth that constitutes the heart of its classicism and of its metaphysics.

Or so I think. And, if I am right, there is something to be learned from Odissi by other, less self-revealing, yet more self-assertive classical Indian dance forms.

45

Why I Choose to Write about Classical Indian Dance

On terms that are perhaps only my own, I do accept that the dance is in some way a true Fifth *Veda*, a *Natya Veda*, or perhaps even a sixth, a *Nritya Veda*. This being the case, it has serious implications for my life and for my thoughts and sentiments about life. It is neither mere craft nor mere entertainment. It is a source of insight that goes well beyond these. For that reason it exercises a coercive fascination while it continues to yield an unending stream of insight.

In saying this I don't mean that the classical Indian dances ought to be used as a point of departure for writing about anything at all. In my own writing about dance I have tried scrupulously to avoid this kind of contemplative meandering. I have always sought to keep my recorded thoughts grounded in their source and tethered to their midpoint, which is dance as dance and as no other thing. And even where I have strayed a little, I have deliberately worked to revert to dance so that what I have written should either be deleted or brought home in the end authentically to its source.

But all this only by way of introduction. Let me now go on to enumerate some of the reasons why, for me, dance is not only worth

Essays on Classical Indian Dance
Donovan Roebert
Text copyright © 2021 Donovan Roebert / Photographs copyright © 2021 Arun Kumar
ISBN 978-981-4877-47-3 (Hardcover), 978-1-003-12113-8 (eBook)
www.jennystanford.com

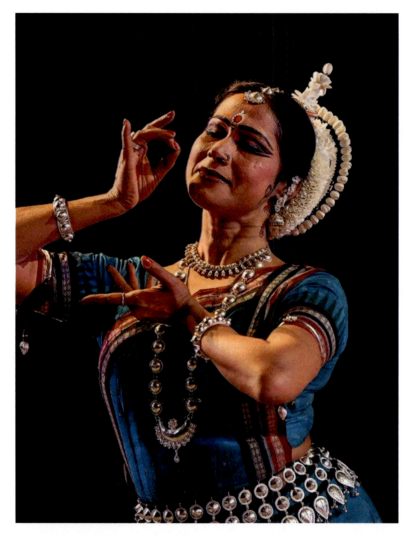

45. Sujata Mohapatra, Odissi dancer and teacher, Bhubaneswar.

writing about (which effectively means examining) but more worth writing about than anything else.

First, it is worth writing about on account of its moral seriousness. By this I don't mean that it has any particular moral points to make (though it does) but rather that it is a complete classical metaphor for the kind of life that is worth living because it is examined and therefore rooted in a moral soil. Now this morally serious quality of the dance

Why I Choose to Write about Classical Indian Dance 355

is present to us in so many guises that it would be tedious to list them here. Instead we can get an immediate idea of what I mean when I compare the classical Indian dances with another dance form, the ballet. At once we get a sense of the difference between the dance of beauty as entertainment and the dance of beauty as truth. This is my first entry point for studying the dance as an object of grave and fruitful contemplation, even if some choose to see it only as a beautiful display.

Its next value is found in its insistent classicism. Here of course we come up immediately against an array of possible counter-arguments and qualifying points of view. 'Classicism' is in some ways a much bigger subject than the classical art-forms themselves, including the classical dances. But what I am concentrating on here is the element of vitality in a living tradition, which amounts to a certain way of living. The classical dance as metaphor for life also instructs us in the importance of a lived tradition capable of yielding what is genuinely new because it hasn't discarded the old. This, as I see it, is the difference between what is born organically by the genes and what is constructed by genetic engineering. And this, too, is a principle of the felt life: that one may make choices that bear the traditional in mind or rashly do away with the old in the rush to create and experience the untried.

The mythico-religious imprint of the dance is one that goes, whether we know it or not, down to the depths of the human unconscious. And even though I am not always a Jungian, I find it impossible to escape the belief that the mythico-religious principle is a first principle of human mentation. This is why, in my case, it is both so easy and so delightful to relate to its honest, forthright and earthy expressions in the many *nritya* depictions which bring home the rightness and primeval motive power of the simple motifs offered in the *leelas*—because we human beings are really not essentially more complicated than these first principles of *sringara-bhakti*. From them, at any rate, we elaborate all the complexities that more often than not bring our mental life to such crises of complication. So there are rich essential and primal lessons to be drawn from these apparent simplifications of our existential dilemma.

And this leads me naturally to the language of dance, a language that also addresses us at many non-discursive levels of consciousness. I have already written at some length on the language of the dancing

body and don't want to reiterate those details here. What I would like to emphasize instead is the importance of this broadening, deepening and refining function of the linguistics and grammar of dance. It brings us into a more articulate relation with our own thought, a thought that becomes more subtle and disciplined as a result, as well as refining the sentiments that always accompany our thinking. Examining and writing about this aspect is extremely challenging and opens up new channels to a fuller comprehension of the lives we live. What makes the language of classical Indian dance particularly pertinent here is the general continuity of its stylized antiquity: we are learning not only to think across a vast new range of communicative possibilities but also to look into the etymology of the language of dance itself.

Bearing in mind only what I have so far said about the dance as a worthwhile object of study, it is evident that the scope of its potential for philosophic extrapolation is immense. Even if we strive, as writers about dance ought always to do, to confine ourselves exactly to the bases of thought and the beginning- and endpoints offered to thought by the dance as dance (and not as any other thing), we find, by dwelling on them as we also ought to do, that we are led to existential and ontological insights that only the dance can afford us. Not least among these is the entry we gain into a non-dualistic phenomenology that points us to the spiritual inwardness of what we ordinarily perceive as being grossly material or coarsely instinctual, thus returning us to the sanctity of our primal humanness. Here again the possibilities offered to those who think and write about the dance are endless.

In their aesthetic properties the classical Indian dances open up a correspondingly infinite range of responses to loveliness that enter and indwell the mental and physical flavours of the whole of our life. In breaching the walls of instinctive defense erected by our human vulnerabilities, the dance allows us a freedom to indulge in both the extremely subtle and the extremely obvious: it extends the width of our appreciative polarities. One of the consequences of this opening-up is that the poetics of thought and writing is itself enlarged to embody a dancing freshness and open-endedness. Writing and thinking about dance become themselves a sort of dance.

Because classical Indian dance is infinitely yielding and thoroughly universal in what it yields: a constantly fructifying tree whose fruits can

never be spoken of as exotic because even as we taste them we recognize their perfume as one that is inherent and thoroughly familiar to us. It is only that we haven't visited that orchard often enough to pluck its natural sustenance for ourselves. Yet this yieldingness and universality don't fling us about towards points of reference that are far to seek; all that we need to mine, examine and comprehend in the dance is gained by going nowhere else than into the heart of dance itself.

Writers about dance are bound to be struck by this pointed centrality while they scrutinize the intricacies of formal dance structure, codification and technique. The attempt to hold these together in the mind, to use them as the inescapable final points of reference that they are by their own nature, is the strictest of all the disciplines that writing about dance imposes on the thinking and writing mind. Always we are drawn back to these patterned and codified first principles because if once we lose sight of them we have lost sight of the dance itself. As an object of meditation their concentrative powers are relentlessly coercive as they drive the mind onward to its unifying work—the work that lies, as this writer sees it, at the heart of the meaning of dance.

There are many more reasons that I could advance to justify my own writing on dance and perhaps also to clarify a little the kind of direction in which my personal examination of dance is inclined to travel. But there is surely enough in the reasons I have already summarized to encourage other writers to explore the dance, each in his or her own personal way.

46

Classical Indian Dance and Social Justice Activism

Increasingly one notices, these days, how classical Indian dance is becoming involved in the toils of various forms of social justice activism. The issues being addressed are themselves becoming more numerous, but those that most frequently present themselves relate, in the main, to three perceived threads of injustice and oppression: the abuse of women's dignity and rights, the 'patriarchy' and its associated structures of power and influence, and the historical and ongoing injustices perpetrated against the community of hereditary dancers, the *Isai Vellalars*.

These all seem to me causes worth supporting, or at least breaches of justice and humaneness existing in the real dance world and therefore deserving of serious attention and sincere interest. There can at any rate be no question that these problems and their grave implications will neither disappear from the dance scene nor solve themselves unless adequate efforts are made to understand and to tackle them.

But this is a statement that has societal implications ranging far beyond the boundaries of dance and the arts in general, and even as touching only the art of classical Indian dance, there are implications for the community of dancers as a whole, in their activities and

Essays on Classical Indian Dance
Donovan Roebert
Text copyright © 2021 Donovan Roebert / Photographs copyright © 2021 Arun Kumar
ISBN 978-981-4877-47-3 (Hardcover), 978-1-003-12113-8 (eBook)
www.jennystanford.com

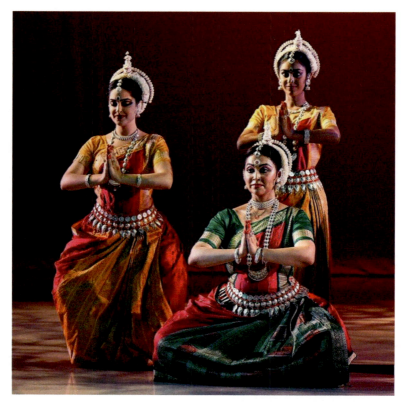

46. Divya Chowdhary (left), Dr Aparupa Chatterjee (center) and Tanvi Prasad (right) of the Odissi Dance Company, Seattle.

activism, that lie outside of the direct praxis and presentation of dance. These more widely ranging ramifications are not what I propose to deal with in this essay: my intention here is only to ask and to try to answer the question whether such activism has any place in the direct and authentic practice of dance and, if so, how that place might most effectively be occupied without detracting from the essential quality of the art of dance as dance and not as some other thing.

The activist conveyance of social grievances can, it seems to me, be carried out in only two fundamental modes of socio-political interaction: the ideological (or, 'nomic' and legalistic) and the cultural (or 'poetic' and humane). In the ideological category I am thinking of the literal, overt and prosaic ways of presentation with their associated

techniques of formulation and rhetoric; in the cultural category I am thinking of those qualities of thought and sensibility that operate at the tacit, ambiguous and organic levels of our humanness.

Ideology may operate to change the way we think about justice in the world, whereas culture (in the best and truest sense) works to humanize us more fully by quickening us to the spontaneous truth of our common humanity as it is actually lived. Of course, we can't speak as if ideology and culture do their work completely independently of each other—they are obviously very closely interrelated and interactive. But they do constitute two definitely differing modes of approach to social problems, the one external and regulatory, the other inward and spiritual. Beyond these simple, preliminary distinctions I wouldn't like to move for my limited purposes here.

Instead I would like to go on immediately to consider the ideological aspect of the classical dances and how this aspect can be used, within the bounds of classical artistic integrity, to address social injustices in the ideological mode.

I have made the case in other essays that the ideology of dance comprises a statement of the humanization of existential forces, and especially those of rhythm and form, and I don't intend to formulate this idea here again. What I want rather to concentrate on is the obvious relatedness of such humanization to the socio-cultural and psychological (or spiritual) ideals of harmonious structural proportionality and the graceful, easy psychosomatic flow that is its natural consequence. It is from this ideology of proportionality and grace, rather than from its chaotic alternatives, that the vital notion of 'justness' and hence of 'justice' derives. The ideology of dance is nothing if not the ideology of primal balance, and it is on this idea of balance, which in our social lives we call 'fairness,' that the idea and practice of justice rests.

The question for the activist dancer, then, is whether her line of social justice activism reflects publicly and is inherently consistent with the dynamic ideology of proportionality which the art both invokes and evinces. I am not speaking here of the dancer as activist outside of her *avtaar* as dancer. That is an entirely different question. But, in so far as she seeks to incorporate her activism into her performance and philosophy as a dancer, the dangers of introducing disharmonies and disproportionalities into her praxis immediately become more

apparent. The end result may well be that her art becomes subservient to her activist cause, so that what we are left with is neither activism nor art but a hybrid that fails to convince us as either.

I am thinking here, in concrete terms, not of dancers today who might be failing in this way, but of great artists who succeeded as activists because their causes were brought to life and with subtle proportionality integrated into the excellence of their dance as dance. They had no need of slogans advertising their activism because their perfection as dancers made the respect and homage due to the dancer clearer than any overt insistence on it could ever have done.

This was certainly the case with such eminent dancers as T. Balasaraswati and Sanjukta Panigrahi. Both of them had an ideological axe to grind: in Bala's case there was the struggle against the revivalist innovations of Bharata Natyam and for her independent place as an hereditary dancer. She represented, that is, not only her own individual interests but those of the Sadir *rajadasiattam* and of her community of artists and teachers. Through her sensitive excellence as a dancer she convinced the broader spectrum of *rasikas* that her art, herself as an artist, and the hereditary community that she represented had an unanswerable place in the domain of classical Indian dance. And she continues to inspire and inform those who are still upholding this cause today.

Sanjukta Panigrahi, on the other hand, stands for us as the type of the dancer and woman of substance who demonstrated, from a very early age, that her role in the reincarnation and popularization of Odissi was just as important and indeed indispensable as those of her male teachers, the founders of the *Jayantika* movement. There is no way that we can look at the recent history and development of Odissi without granting due honour and open recognition to the centrality of Sanjukta, and thus of all dedicated women exponents, in the formation and intellectual development of the art to which she dedicated herself as a little girl.

My point is that these two great dancers—and there are many others that share this distinction—found means, through the force of their intellect and integrity as dancers, to merge their ideologies so perfectly with their art that their art, without compromising itself, was able to subsume and transmit their ideological ends within strictly

Classical Indian Dance and Social Justice Activism 363

artistic bounds. And this rare achievement, in the end, was due in the main to their sensitive awareness of harmonious proportionality.

The same principle holds good at the plane of cultural or 'living' transmission: the conveying not of the ideological formulae but of the living spirit of justness, grace and fairness. There is a plenitude of cultural data that ought to be considered in this regard, but in a small essay such as this one I would like to mention only one, foundational, aspect: that of the ideal of the *ardhanarishwara*.

In this principle—that of the essential and vital proportionality obtaining in the dance of Shiva and Parvati—we recognize what is at heart not an artificial sameness of essence disguised as mere equality, but a proportionality deriving from the equal importance of their respective dancing roles, their respective functions at the root of existence. Here, woman and man, *devi* and *deva*, substance and essence, are revealed as the two inseparable facets of a single jewel.

What we encounter in this dynamic is therefore not only balance but existential symbiosis. And this is the case not only with the classical myths reenacted in the *natya* and *nritya* modes but also with the nuances of radical unity depicted in the organism of the *nritta*. Now this insight comes to us, if the dance is successful and if we are rightly prepared to receive it in its fullness, not as a formal entity of the kind we experience in architecture but as a life-infused quantum of informing energy that has power to transform us as human beings—in the first place by making us recognize essential unities and harmonies to which we were previously blind. We become aware, that is, of the rightness of that which by its nature is just and fair and gracious, and therefore beautiful and true.

And this goes to the heart of much that is problematic in social justice activism as it confronts us today. This is because so much activism that opposes itself to power and the misuse of power is itself seeking power in subtle ways—and power is seldom willing to subject itself to grace and proportionality. If the ideology and culture inherent in the classical Indian dances have anything to teach us in this regard it is that power is necessarily an evil unless it becomes subordinate to the balancing forces of an existentially just relatedness.

Dance, therefore, as activist art has authority to speak directly to our naked humanness, to our ways of individual being and to our ways

364 ESSAYS ON CLASSICAL INDIAN DANCE

of being with one another in the world. But it only has this authority in the extent to which it unfolds itself purely as the art of dance uncontaminated by what is overtly and crassly sloganized by ideology.

After all, in terms of its own ideology, classical Indian dance acknowledges the *bhava-abhinaya-rasa* continuum as the only method for effective transmission of what it sets out to evoke in the *rasika*. The activist use of this continuum in dance is therefore a matter of strategy. How best to convey this particular social justice issue as a *rasa* that will hit the mark and in so doing effect at least some small change of heart in the receiver?

This, in its admittedly limited way, is the question on which I hope this essay has cast some rudimentary light.

47

In Search of the Basis of 'Spirituality' in Classical Indian Dance

In approaching this topic on my own terms and by my own lights, I must nevertheless acknowledge from the outset the important and compelling work of certain dance scholars, work that has over a period of many months set me thinking about the problem of the basis of 'spirituality' in classical Indian dance. I acknowledge these scholars, though, without mentioning them by name because, as a non-scholar myself, I don't want to be seen to be misinterpreting their theses or to be presuming to draw their premises into my own possibly misdirected search. Also, and perhaps more importantly, I don't wish, by the adducing of scholarly sources, to create the false impression that I am myself a scholar. As with all my other essays on dance, this one is again in the first place an attempt to clarify an aspect of dance for myself.

In broaching, then, the 'problem of the basis of spirituality' in classical Indian dance, it is probably necessary to make the preliminary assertion (contrary, no doubt, to what many commentators think) that this question *is* indeed a problem, or has become a problem in recent

Essays on Classical Indian Dance
Donovan Roebert
Text copyright © 2021 Donovan Roebert / Photographs copyright © 2021 Arun Kumar
ISBN 978-981-4877-47-3 (Hardcover), 978-1-003-12113-8 (eBook)
www.jennystanford.com

47. Chandrashekhar Dharmasthala, Shri Yakshadeva Mitra Kala Mandali, Mangalore.

years, or that the 'basis of spirituality' of dance has been taken so long for granted that its problematic nature has seldom been considered.

I must admit also to the very limited aim involved in this essay and the limitations of the means by which I intend to address the problem. I don't propose to touch on the question of spirituality in general, and certainly not to enter into any of its multitudinous ramifications. The

In Search of the Basis of 'Spirituality' in Classical Indian Dance 367

problem as it presents itself to me may perhaps be summed up in the question: 'Was the original and local intention of the temple dance *this-worldly* or *other-worldly*?' Now this apparently simple question incorporates of course a host of attendant details and difficulties which I must perforce leave out of my limited endeavour here. Instead I will try to state the case made *against* the basis of spirituality in dance which I am attempting to tackle, not by arguing against it but by trying to elucidate one of its possible meanings.

This case can be summarized as follows: that the work of the *devadasi* in her local aboriginal *urpraxis* was directed exclusively to the general well-being of the community in *this* world, and not in any way to the welfare of its condition in any possible realm assumed to be entered *after dying*. In this assumption, which seems to me a plausible one, we are confronted with the sort of magico-ritualist practice, typical of pre-scientistic human societies, for averting a range of natural evils and for propitiating the divine forces assumed to be in control of these. In this hypothesis the temple dancer plays a mediating role whose thoroughly auspicious efficaciousness redounds to the benefit of a this-worldly living and working organic community whose heart-centre is the temple. Her place, indeed, is at the heart of that heart, as the female aspect of its rhythmic beating—a real and tangible manifestation of Parvati-Shakti existing physically and working concretely and beneficently into the quotidian life of the society. And here her role begins and ends.

In what I am setting out to do in this essay I don't propose, as I have said, to dismiss this view. Among other reasons for my not wanting to do so, there is the personal appeal that it holds for me, an appeal both highly charming and in its way wholly committed to the joys of living *on this side of death*. (Is there in any case another side?)

What I aim instead to do is to try to define for myself what, in such a scenario, may be taken as the basis for the claims of dance to a 'spiritual' status and efficacy unique among the arts. And I aim to do this by means of a simple examination of the empirical outlook on life—the outlook invoked in modern times by Hume, over-elaborated by Kant, and brought back to a balance by Schopenhauer, who relied for his philosophic sources on the *Upanishads*.

To begin with, I must clarify what is meant, in the strong and strict philosophic sense, by 'empiricism'—a word much misused in common

parlance. What it should mean, then, as I use it here, is that all that we can know and perceive in the world around us comes to us as experience and not as the thing-in-itself. When we see, touch, smell and hear a tree, we do so by means of our senses, whose perceptions are in their turn modified and interpreted by a series of brain-mind functions. What a tree may in itself be, outside of our experience of it, we really have no way of knowing or investigating because the mechanisms of our empirical-experiential equipment stand, as it were, in the way of such knowing, and block it off.

The empirical position, an unanswerable one as it seems to me, has a crucial bearing on the philosophic options of idealism and realism. The position of the idealist is that 'reality' is a matter of mental projection: our minds telling us that something that does not 'really' exist, exists. The realist position, on the other hand, would have us accept that we know and perceive real things as they 'really' are. Neither of these positions is sanctioned in philosophy by any inarguable evidence.

For the empiricist, on the other hand, the fact that all we can know and perceive comes to us as experience, nullifies the difference between idealism and realism. For, if all our knowledge comes to us as experience, it is as perpetually ideal as it is finally real, at least for us who experience it.

Now knowledge and perception, mediated in us as pure experience, include (as Hume incontrovertibly has shown) our experiential knowledge of cause and effect. We have as yet found no reliable means for asserting that our experiential linkage of ostensible causes with their effects aren't merely our own mental constructions. Even insofar as science has 'demonstrated' these causal chains, all we really know in the pure sense of the word, is that two events regularly follow on one another, which is no proof of effective causation. Indeed, our sense of causation relies in the first place on our mental ability to make causal connections, in other words, on our empirical experience.

If we apply ourselves seriously to these considerations, we can see immediately how the assumed *this-worldliness* of the work of dance takes on a whole range of possible 'spiritual' connotations:

First, considered empirically, I can see as little difference between the realm of the concrete and that of the mind (or 'spirit')

as I can between idealism and realism. The 'spiritual' and concrete realms reveal themselves as occurring along the pathway of a single continuum—the single continuum of mental experience. And so far from degrading our connections with the 'real,' it turns them into experiences that are rooted in a kind of magic whose relatedness to the 'real' is far more tenuous and surprising than we had hitherto expected. The mundane begins to shimmer with a disorientating play between the 'real' and the 'unreal'—just as the dance does. As a shift into radical uncertainty, the empirical viewpoint opens us up to illimitable possibilities of seeing, including the possibilities offered us by the poetic, non-discursive, linguistics of dance. Insofar as this grammar and the language which rests on it speak empirically, meaningfully and transformatively to the *rasika-mind* receiving it, I can see no reason not to call it 'spiritual.'

But, more than this, there is the wonderful possibility that, at the level of cause and effect, classical Indian dance, with its specialist ritual language and semantics, has consequences for our total human realm, and also for our universe, of which we are not yet aware, and of which we may never become aware unless all dance ceases to exist so that we begin to understand these consequences only by experiencing their absence.

This thought, it seems to me, is a terrifying one, signifying as it does that we can have no final and complete idea of the 'spiritual' efficaciousness of dance until we have lost the language of dance that provides it for our societies, communities and individuals.

What, in the final analysis and in the full human context, may be the essential and essentially needful causes and effects of the dance, we simply do not know, although we may theorize about the details.

Perhaps we should take care how we tamper with it and alter our experience of dance as a result. Because ultimately, considered from the empirical standpoint, we have not yet begun to know what, in itself, as existing from its own side, dance as dance *really is*.

This sort of admission of our conditioned ignorance together with all its larger implications may at any rate discourage us from resting inertly on the notion that the dances are simply not 'spiritual'—by which I mean not vitally important to the wholesome 'reality' of our full humanness.

Index

abhinaya 75–76, 90, 112–113, 172, 175, 196, 212, 223, 237, 242, 248, 273, 312–313, 342–343
 facial 306–307, 328, 331
Abhinaya Chandrika 173, 178, 194, 216, 223, 238, 243
Abhinaya Darpana 123, 173–174, 178, 194, 214, 216, 235, 237–238, 243–244
absent dancer 77, 79, 81
adavus 25, 95, 209, 323–326
 new 209, 325
art of dance 107, 308, 341, 360, 364

batu 229, 242–243, 248
Bharata Natyam 83, 85, 91, 175–176, 203–204, 212, 214, 216–217, 220–221, 224, 226, 241, 243, 284–285, 333–339
 revivalist 336–337, 343–344
bhava 31, 58, 67, 69, 81, 86, 88, 112, 165–166, 178, 313–315, 330

chauka 71–73, 149, 271, 331
classical dances 40, 49, 51–52, 64–65, 85–86, 105–106, 108–109, 113–115, 123–124, 171–172, 174–175, 234, 243–245, 264–265, 277–278
classical dance texts 173
cosmic dance 102, 259, 319
culture 22, 63–65, 115, 117, 185, 277, 342, 350, 361, 363

dance
 creative 190, 195
 emergent 300–302
 gotipua 177, 196
 new 200, 243, 337
 pure 3, 15, 35, 93, 237, 342
 temple 124–125, 136, 177–178, 281, 367
 world of 201, 207, 228, 279, 299, 302, 338
dance community 297, 303
dance criticism 327, 329, 331–332
dance critics 55, 153, 173, 213, 309
dance forms 176, 179, 212–214, 217, 220, 223, 244, 297, 300, 302, 336, 342, 347, 349, 355
 classical 19, 85, 125, 160, 228, 349
 classical Indian 71, 182, 334, 339
dance items 181, 213, 221
dance linguistics 12, 330, 369
dance movements 133, 325
dance of life 39, 72, 109, 125, 129, 137
dance performances 86, 204, 283
dancer 2–5, 9–13, 17–21, 57–59, 77–81, 105–106, 135–137, 163–166, 247–250, 306–310, 312–314, 319–320, 329–332, 340–342, 361–362
 dancing 17, 46, 109, 314
 dasi 284
 hereditary 86, 298, 359, 362
 inner 319–320
dancer-*rasika* 331
dancer-subject 165

372 INDEX

dance scene 250, 359
dance scholars 51, 108, 365
dance sculptures 215, 263
dance sequence 172, 239, 308
dance teachers 11, 119, 172, 204, 264
deity 9–13, 25, 83, 97, 105, 133, 135,
 137–138, 173, 177, 272, 313
deva 47, 59, 103, 105, 131, 138, 141, 148,
 271, 335, 342, 363
devadasis 51–52, 85, 124–125, 135, 148,
 224, 264, 271, 277, 279–281, 283,
 287–288, 297, 367
devadasi system 83, 277, 279–280, 283
discipline of thought 37–39, 41

emotions 57–58, 172, 314, 342
 sequential 57–59
energies 9–11, 13, 17–18, 21, 73, 75, 108,
 138, 165, 241, 314, 330
experience of dance 81, 207, 317, 319,
 321, 369
eyes 37, 39, 45, 63, 70, 72, 75, 95, 127,
 192, 268, 272–274, 292–293, 329,
 331
 rasika's 293, 307, 309

flaws 4, 111–114, 153, 206
folk dances 171, 173, 189, 195, 236, 238,
 247–248

genius 124, 177, 181, 189, 193, 202, 349
geometry 3, 22, 93, 95–96, 101–102, 106,
 131, 209
ghungroos 43–46, 109, 272
grace 6, 89–90, 172, 361, 363
gramma 63, 65
grammar 1, 11, 22, 28, 31, 61–65, 104,
 142, 369
 study of 62
grammar of dance 63, 356

harmony 79, 107, 153, 291, 300, 363
heart 59, 71, 81, 104, 137–138, 154,
 163, 211, 325, 329, 332, 351, 357,
 363–364, 367

heart of dance 142, 357
hereditary dance community 286, 298
human experience 341

ideology of dance 361
independence 86, 194, 200
injustices 287, 299, 336–338, 359
innovations 22, 209–210, 229, 232, 237,
 350
internal forces 77, 79–81
interplay 7, 79–81
interpreter 15, 17
 dancer as 16
intimacy 35, 81, 154–155, 292, 332
Isai Vellalars 277–279, 285–286, 300, 337,
 343, 359

Jayantika 169, 171–173, 175–177,
 179–180, 183, 209, 211–212,
 217, 228–229, 231–232, 234–239,
 241–243, 248–249, 251–252,
 255
 work of 211, 242
Jayantika meetings 231, 237, 239, 243
Jayantika members 172, 229, 234,
 237–238, 241–242, 246
Jayantika movement 169, 171, 173, 175,
 179, 244, 251, 261, 349, 362

Kalakshetra 87–88, 173–176, 189–190,
 193–195, 199–202, 204–209,
 211–212, 214–215, 217–228,
 230–231, 233–236, 238–240,
 245–247, 277–279, 284–288
Kalakshetra Bharata Natyam 202, 224
Kalakshetra dancers 228
Kalakshetra doctrine 214–215
karanas 47, 49–50, 123, 223, 243–244,
 251, 273
karma 74, 261–265
karmic traces 177–179, 261–264, 349
Kathak 204, 212, 221, 226, 237, 240–241,
 248

Index

language 12, 61–63, 67, 79, 93–97, 99–103, 107, 113, 145, 154–155, 200, 205, 329–331, 341, 355–356
 classical 62–63
language of dance 18, 40, 63, 97, 355–356, 369
lapse 40–41, 113, 117, 148

mahari nacha 171–172, 190, 195–196, 217, 221
maharis 27, 52, 124, 171–173, 177, 180, 224, 244–246
mangalacharan 177, 190, 242–243, 248
Manipuri dances 158–160
margam 121–123, 221, 223, 230–232, 235, 242, 263
meditation 9, 141, 341–342, 357
mind 5–6, 11–12, 25, 27–29, 95–96, 105–107, 138–139, 141–142, 234–235, 262–264, 273–274, 279–281, 312–314, 341–342, 355–357
 attendant 99, 102
 dancer's 3, 315, 329
 dancing 3–6
 human 27, 75, 79, 320
 onlooking 99, 101
 personal 5, 7
mindset 43, 115, 258, 262, 264, 299
moksha 35, 163–167, 172, 178, 223, 242, 271, 310
mokshya 229, 242–243, 248
mudras 25, 171, 174, 205, 214, 223, 236, 243–244, 251, 320
mythos 63–65

natya 3, 15, 93, 123, 133, 135, 363
Natya Shastra 21, 47, 49–50, 53, 133, 173–174, 179, 194, 208, 214–215, 235, 238, 243, 263
novel 40, 57, 67–70, 72, 113, 339
nritta 3, 15, 31, 33–35, 39, 96, 103, 166–167, 216, 223, 271, 344, 363
 dancing body in 93, 95, 97, 99, 101, 103
nritta dances 57, 165

Odissi 73, 165, 169–170, 175–176, 178–183, 197–199, 201–203, 209–231, 233–239, 243–249, 253, 255–256, 261, 347, 349–351
 cause of 219, 224, 247
 popularization of 221, 362
 reconstruction of 175, 203
 story of 184, 222
Odissi dance 74, 185, 198, 201, 220, 227–228, 234, 236, 245, 248
 emergent 191
 train 227
Odissi dance-dramas 215
Odissi *margam* 223, 232, 241, 244
Odiyan dance 203, 241

pallavi 35, 166, 177, 237, 242, 248
performance 2, 4, 16–17, 183, 199, 201, 213, 217, 220, 224–225, 227, 230, 239, 248, 250–251
 live 142, 305, 308, 314–315
perfume 58, 357
personal approach 327, 329, 331
personal selfhood 5–6
poem 12, 15–17, 76, 258, 265, 273, 312, 314
 dancer as 17–18
poet 5, 15, 17, 94, 147, 227, 314
 dancer as 16
poetry 17, 63–64, 67, 94–97, 114, 151, 171, 173, 178, 245, 317
prostitutes 286–287
proto-Odissi 212, 221, 235–236
pushpanjali 133, 135–137, 176, 190

rasa 1, 6–7, 17, 57–59, 69–71, 109, 153, 155, 166, 259–260, 289, 308, 311, 313–315, 364
rasika 1, 3, 5–7, 13, 16–18, 37, 39, 55–59, 76–78, 80–81, 103–105, 108–109, 164–167, 306–309, 312–315
rasika-experience 312, 314
rasika-mind 320, 369
rasika-object 165

recital 2–4, 10, 26, 28, 57, 77, 80, 89, 105, 109, 166, 172, 305, 312, 315
 filmed 312, 314–315
 live 311–312
religious idea 297–299, 303
rhythmic line 45
rhythms 15, 34, 43, 45, 95–96, 101, 106–107, 109, 127–132, 253, 255, 273, 291–292, 308, 319–320
ritual temple dance 123, 135

sadhana 9, 11–13, 296
sculptures 145, 245–246, 264–265
sentiment 31, 35, 57–59, 62, 64, 93, 96, 141, 153–155, 165, 325–327, 330, 341–342, 353, 356
servitude 43, 45–46
situation 12, 124, 148, 193–194, 197, 281–283, 285
social justice activism 359, 361, 363
spirit 87, 115, 119, 136–137, 231, 276, 284, 288, 319, 337, 349–350, 368
sringara 51, 69, 86, 97, 102, 173, 284, 289, 291–293, 319, 321
sringara rasa 12, 19, 81, 108, 178, 284, 289, 291–293, 343
stillness 73–74, 167, 325
suspension 35, 151, 153, 155

teachers 89, 91, 142, 189, 191–195, 197–198, 200, 204, 207–208, 217–218, 220–223, 234–238, 246–247, 281–282, 335–336
 hereditary 285
technique 4, 6, 11–12, 16–17, 31, 33, 77–78, 80, 111–112, 142, 152–155, 201, 298, 329, 342
tejas 5, 10, 13, 18, 21–22, 57, 74–76, 272, 313
temple dancers 49, 83, 89, 124, 136, 367
theatre 28, 51, 187–189, 191, 198–199, 201–202, 207, 211, 223, 233, 237, 241, 247, 249, 308
theory 10, 81, 138, 201, 222–224, 262, 264, 273, 289–290, 312, 327, 330
touch 6–7, 17, 40, 69, 76, 114, 131, 238, 250, 314, 366, 368
treatises 49–50, 52, 121, 264, 328
tribhangi 73–74, 149

union 35, 97, 106, 166
 dancer-rasika 106

values 11, 20, 118, 246, 295, 298, 300
vision 87, 193, 198, 202, 211, 277, 279, 285–287, 292

westerner 11, 19, 21, 157
Western *rasika* 19–22
writers 118, 236, 356–357